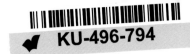
PAINTING
IN SCOTLAND

THE GOLDEN AGE

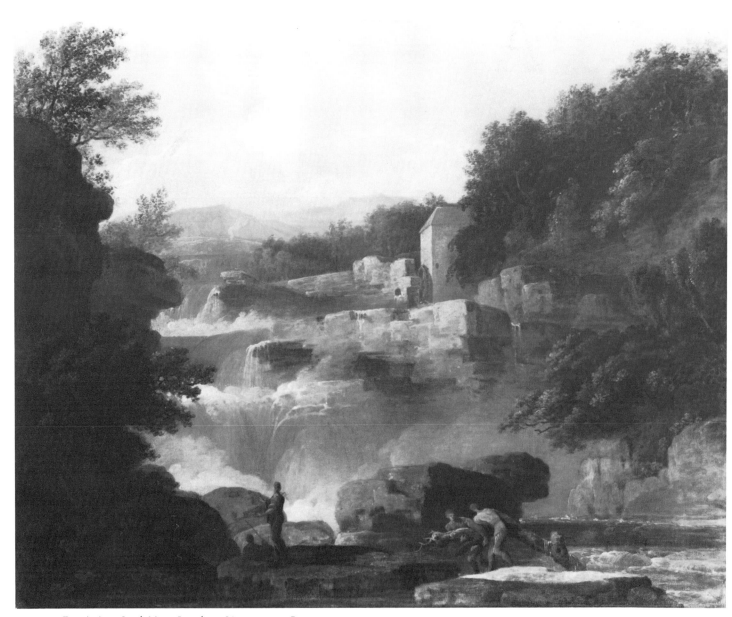

Frontispiece: Jacob More. *Stonebyres Linn.* 1771–73. Cat. 130

To Jean Leith

PAINTING IN SCOTLAND

THE GOLDEN AGE

Duncan Macmillan

Duncan Macmillan

PHAIDON PRESS, OXFORD
in association with
THE TALBOT RICE ART CENTRE, THE UNIVERSITY OF EDINBURGH
and THE TATE GALLERY, LONDON

THIS EXHIBITION IS MADE POSSIBLE BY A GRANT FROM
MOBIL NORTH SEA LIMITED.

Mobil North Sea is delighted to sponsor the exhibition Painting in Scotland: The Golden Age
at the 40th Edinburgh Festival and at the Tate Gallery, London, in 1986. This is the first major
exhibition of Scottish painting for many years. The selection of works by Ramsay, Raeburn,
Wilkie and their followers offers a unique opportunity to reappraise the role of the visual arts
during the period of the Scottish Enlightenment. I believe the exhibition will give great pleasure,
and some surprises.
Mobil North Sea's support for this exhibition is part of a continuing programme of arts
sponsorship by Mobil companies throughout the world.

Carl J. Burnett, Jr.
Chairman
Mobil North Sea Limited

For my daughters,
Christina and Annabel

Phaidon Press Limited, Littlegate House, St Ebbe's Street, Oxford, OX1 1SQ

First published 1986
© 1986 Phaidon Press Limited

British Library Cataloguing in Publication Data

Macmillan, Duncan
Painting in Scotland: the golden age.
1. Painting, Scottish 2. Painting, Modern
——17th–18th centuries——Scotland
3. Painting, Modern——19th century——
Scotland
I. Title II. Talbot-Rice Gallery
III. Tate Gallery
759.2'911 ND475

ISBN 0-7148-2401-1
ISBN 0-7148-2455-0 Pbk

Printed in Great Britain by John Bartholomew & Son Limited, Edinburgh

Published for the exhibition *Painting in Scotland: The Golden Age (1707–1843)*,
organized by the Talbot Rice Art Centre with the support of the Scottish Arts Council

Talbot Rice Art Centre, University of Edinburgh: 8–31 August 1986
Tate Gallery, London: 15 October 1986–4 January 1987

Contents

Foreword

In the eighteenth and early nineteenth centuries, Scotland, and Edinburgh in particular, was one of Europe's leading cultural centres. It was a Golden Age, when philosophers, scientists, poets, novelists and painters lived together in an intellectual community notable for its free and fruitful exchange of ideas. The Enlightenment is the term given to this new cultural ferment that so easily crossed national boundaries, and the Scottish Enlightenment might be said to begin with David Hume's *Treatise of Human Nature* and then to have spread when the enquiry was taken up by writers and painters alike of Hume's own and succeeding generations.

Hume and Adam Smith, Walter Scott and Robert Burns —they are familiar today almost as much from their appearances as from their writings. Many of these portraits come from the great Scottish painters of the period—Allan Ramsay, Henry Raeburn and David Wilkie—who are as distinguished as any of their contemporaries, and it is around them that this book and the exhibition which was its genesis are centred. No such survey of the painting of this particular period has been attempted since 1939, nor have there been recent exhibitions of any of the artists represented. Our sincere thanks go to all lenders for their part in making such an exhibition possible.

The first showing in Edinburgh will play an important part in the 1986 Edinburgh Festival and coincides with a major series, arranged by the University, of international seminars and lectures dealing with this period. The second showing, at the Tate Gallery, will provide another in a continuing series of winter exhibitions devoted to particular movements or periods connected with the Historic British Collection.

No one is better qualified to write of these painters than Duncan Macmillan, Curator of the University of Edinburgh's Talbot Rice Art Centre, whose knowledge of, and dedication to, the art of Scotland is unequalled. We commend this major *oeuvre* to all interested in eighteenth- and nineteenth-century painting, not only for its intrinsic interest but also for the new light it sheds on our understanding of artistic developments in Europe then and subsequently.

We are indeed fortunate to have been able to cooperate with the Edinburgh Festival and with Mobil North Sea in this venture, and are most grateful for their generous support.

Alan Bowness
Director
Tate Gallery

John H. Burnett
Principal
Old College, Edinburgh

Preface

In the history of art in Scotland, 1707, the year of the union of the English and Scottish parliaments, was not really a beginning and 1843, the year of the Disruption in the church of Scotland, was not really an end. Nevertheless these two events, moments of crisis in the still turbulent wake of the spiritual and political upheavals that followed the Reformation, are milestones in Scottish history and they frame the period of imaginative and intellectual excitement in Scotland known as the Scottish Enlightenment.

The importance of some of the philosophers and poets in the period thus defined has been widely recognized. This book and the exhibition that it accompanies will, it is hoped, establish the claim of the painters, too, to a share of that recognition. Their achievement is unified by two principal preoccupations: on the one hand the relationship between seeing and knowing, in which painting followed philosophy; on the other hand the belief, shared with poetry, that the primitive art of the remote past or of the unsophisticated present can provide models through which it is possible to reach a purer sensibility that may offer the key to a better world. Neither of these ideas was the exclusive property of Scottish painters. They became central in the wider history of modern art but they do seem to find expression very early in Scotland. They are also complementary. They meet in the concept of the innocent eye that seemed to be realized in the invention of the camera, with whose earliest exploitation this book and exhibition close.

In presenting this account of Scottish painting I have inevitably had to compromise between coherence and comprehensiveness and I have been limited by the practicalities of scale. This is particularly apparent in the later part, where the period of the exhibition overlaps with the high Victorian era, marked by different preoccupations, but I hope no serious injustice or distortion has resulted.

I am conscious of my indebtedness for help, encouragement and advice in preparing both book and exhibition to a great many more people than I can enumerate here. I hope therefore friends and colleagues will accept my grateful acknowledgement of this without being named individually. For their practical support, without which the exhibition would not have been possible, I must particularly thank the Principal and Secretary of the University of Edinburgh, Dr John Burnett and Mr A. M. Currie O.B.E.; the Director of the Tate Gallery, Mr Alan Bowness, and the gallery staff; the Director of the Edinburgh Festival, Mr Frank Dunlop; and the staff of the National Galleries of Scotland. Special thanks are due to the sponsors, Mobil North Sea, and to the lenders, both named and unnamed, who have been extraordinarily generous in making works available. Finally I owe special debts of gratitude to the staff of the Talbot Rice Art Centre—particularly Mrs May Macnamara, Mungo Campbell, and Joe Rock—and to my wife and family for their patient support.

Duncan Macmillan
Edinburgh, March 1986

1. William Aikman. *Self-Portrait*. Cat. 1

I

Artists and the Union

On 27 February 1703 William Aikman wrote to his uncle, Sir John Clerk of Penicuik, to thank him for three guineas sent in payment for a picture.[1] It was an act of encouragement by a kindly uncle to a nephew in whose welfare he had taken an interest since the death of his brother-in-law four years earlier. Aikman went on to become the most distinguished Scottish painter in his generation, and this little incident from his youth shows how the art that he chose as his career occupied a natural and accepted place in the life of pre-Union Scotland. Sir John's active encouragement of his nephew also reflects his own interest in painting. He and his father had collected pictures for many years and they were not unique. There are a number of houses around Edinburgh where there is evidence of early collecting similar to that at Penicuik. The upheavals of the seventeenth century had shaken Scottish life to its foundations, but it is clear that in the gradual return to normality over the last two or three decades of the century painting had taken an accepted place in ordinary cultivated life.

During this period of recovery several foreign artists had found enough work to keep them in Scotland, the Dutchman Jacob de Wet staying for a good many years, the Fleming John Medina and the French Huguenot Nicholas Heude remaining for life. Medina originally came for a short period to Scotland, where he then settled. He and his son were the last people to be naturalized before Scottish nationality was subsumed into the new British identity by the Act of Union in 1707. He was knighted in the same year, in the tradition established in England with the knighting of Van Dyck, Lely and Kneller. It was an honour that he deserved, for, at his best, he was a distinguished painter as well as a prolific one. His professional practice was limited to formal portraiture, but he was also outstanding as an informal portraitist, as in the paintings of his children (plate 3). He painted subject pictures too, though apparently without finding a market, since several now at Penicuik were bought by Sir John Clerk from his estate.

There seem to have been ideological reasons (its association with Catholicism), quite as much as any limitation of patronage, to inhibit enthusiasm for the Baroque style of the kind represented by Medina's subject pictures, particularly in decorative painting. Jacob de Wet and Nicholas Heude both painted small ceiling paintings and recently an elaborate painted dome, probably by a pupil of the Dutch painter Philip Tidemans, has been uncovered at Hopetoun House, but these are unusual. The fully Baroque ceiling painted in 1720 by John Alexander (c. 1690–1757) for the Duke of Gordon at Gordon Castle (now destroyed) was wholly exceptional and its existence is perhaps explained by the fact that both Alexander and his patron were Jacobites and Catholics. Domestic decorative painting on the other hand was common, and the firm of painters founded by James Norie (1684–1757) had a thriving practice specializing in landscape decoration (plate 2). Against the background of this kind of activity and of gradually increasing prosperity a number of native artists emerged in the years around the Union, and among them Aikman was the outstanding individual.

William Aikman (1682–1731) (plate 1) was a gentleman by birth, though not wealthy. It is a comment on the status of painting that his choice of career lay between following his uncle as a merchant and becoming a professional artist.[2] It may have been in pursuit of the former that he visited London as early as 1704, but by 1706 he had decided to take up painting and with considerable courage, after having learnt what he could from Medina, he sold his patrimony to invest the proceeds in his training. Between 1706 and 1711 or 1712 he travelled to Italy and even farther afield to Smyrna. He returned to Edinburgh shortly after the death of Medina in 1711, but then he was compelled to follow his customers south in the migration of men of influence that followed the Union. He spent a short period in London in 1720 and finally moved there with his family in 1723.[3] He visited Scotland in 1730, already a sick man and perhaps conscious of his impending death, and he died in London in the summer

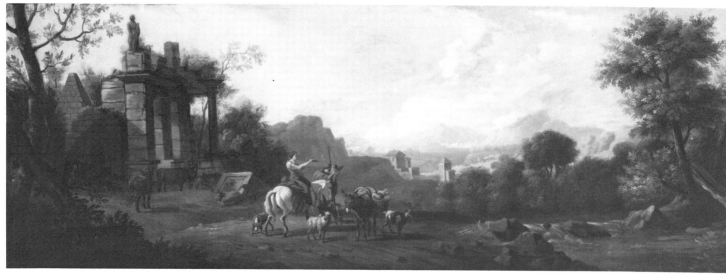

2. James Norie. *Landscape with Classical Ruins*. Cat. 8

of 1731. The elder Allan Ramsay, the poet, who was a close friend, wrote a poem 'Betty and Kate; A Pastoral Farewell to Mr Aikman', when Aikman went away to London. In it Ramsay offers some commentary on the circumstances of the painter's departure, as well as lamenting it and looking forward to his return.

> Sauls of sic a shining Turn,
> For Honours like to range:
>
> Our Laird, and a' the Gentry round
> Who mauna be said nay,
> Sic Pleasure in his Art have found
> They winna let him stay.
>
> O William win your laurels fast,
> And syne we'll a' be fain
> Soon as your wandering Days are past'
> And you're returned again.[4]

Throughout his time in London Aikman corresponded with his friend and cousin, John Clerk, Baron of the Exchequer and, on the death of Clerk's father in 1726, second Baronet of Penicuik.[5] From the correspondence we know that Ramsay's account both of Aikman's mixed feelings on going to London and his anxiety to return were not just sentiment. In 1720 he wrote of his intention to return to Edinburgh as soon as possible and to stay there: 'Unless I find that there is no more to be done in my way at Edinburgh which I fear much will be the case.'[6] He wrote again in 1723 after his final move south, reflecting the same reluctant acceptance of necessity, 'I regrate [sic] much my absence from my friends . . . but as I hope it will prove for the good of my little family I am in duty bound to them to do what seems most probable for their advantage.'[7]

In spite of his reluctance, Aikman was encouraged by early success in London, where he had the backing of influential Scots such as the Duke of Argyll. He described himself as particularly indebted to another Scot Duncan Forbes of Culloden, later Lord Advocate, for an early commission to paint both the Prime Minister, Sir Robert Walpole, and Walpole's brother, and it was no doubt through similar intervention that he painted a double portrait of Lord Burlington and his wife.[8] Thus he started with the top people in politics and the arts, and the social level of his patronage did not decline, for he eventually received several royal commissions, including a portrait of Queen Caroline. At his death he left unfinished a very large painting of all the royal children.[9] At one point, encouraged by this success, he was thinking of taking a larger house in order to improve appearances, and so raise his prices, and he was sufficiently optimistic even to think of building a house with a painting room 'lighted to my mind', that is, with controlled lighting. But in spite of such flashes of optimism his life remained a struggle. As he himself put it, he worked hard to stay poor. He suffered constantly from slow or even non-payment. For example, in 1729 he says Lord Burlington had paid nothing though he worked for him on several occasions, and his letters to Clerk describe a constant struggle against money worries, increasing ill-health and a wife who added to his burdens by her continuous anxiety.[10] He grew more and more homesick, yet was prevented from visiting Scotland by the relentless pressure of the work necessary to make ends meet. He refers with increasing hopelessness to his dream: 'as soon as I am able to, I intend to feu some acres in your neighbourhood, to build me a small mansion and to live retired.'[11]

Aikman was the victim of a dilemma that faced all Scottish artists. The removal of the Scottish Parliament in 1707 had been followed inevitably by the draining away of the patronage that surrounds the exercise of political power. Aikman did not want to live in exile but he was

forced to do so in order to practise his art. His contemporary, John Smibert (1688–1751), who was also a close friend of Allan Ramsay, followed the same path.[12] He was the son of a dyer in Edinburgh, found the means to study in London, returned to practise briefly in Edinburgh and then travelled to Italy. On his return he also settled in London where he worked for about seven years. In 1727 he joined Bishop Berkeley to sail across the Atlantic and become a teacher of art in a visionary scheme to establish 'a Christian College in the Bermudas'. After its failure he eventually settled in Boston, Mass. According to George Vertue, who was a close friend, he joined Berkeley, whom he had first met in Italy, because 'having a particular turn of mind towards honest, fair and righteous dealing he could not well relish the false, selfish, gripping, over-reaching ways too commonly practised here.'[13] Aikman too commented unhappily that 'all business here is managed in the politicks.'[14] It was not that all Scottish artists were necessarily above the day-to-day jobbery of the art world, but it does seem as though both Aikman and Smibert may have had some ideals that they found

it difficult to uphold in a city that was still very much a foreign capital.

In the period of this study, Scottish art took its energy from a continuous exchange with the other branches of Scottish thought, especially poetry and philosophy, but latterly science and religion too. The achievement of Aikman and Smibert is still too ill defined to argue that their painting before they left Scotland reflects a clearly formulated aesthetic, even though Smibert, as father of American painting, has attracted a great deal of critical attention, but we do have the evidence of their friend the elder Allan Ramsay, whose aesthetic aims were very clear, for the kind of thought that they must at least have found sympathetic. Although Ramsay's various poems in praise of his painter friends are on the whole conventional, they give a vivid idea of his admiration for them as painters, admiration that was sincere enough for Ramsay to encourage his own son to follow their example in spite of the difficulties that he knew they had faced. Smibert painted the poet's portrait twice; Aikman did so once. The poet also records Aikman's approval of his 'nat'ral

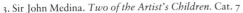

3. Sir John Medina. *Two of the Artist's Children*. Cat. 7

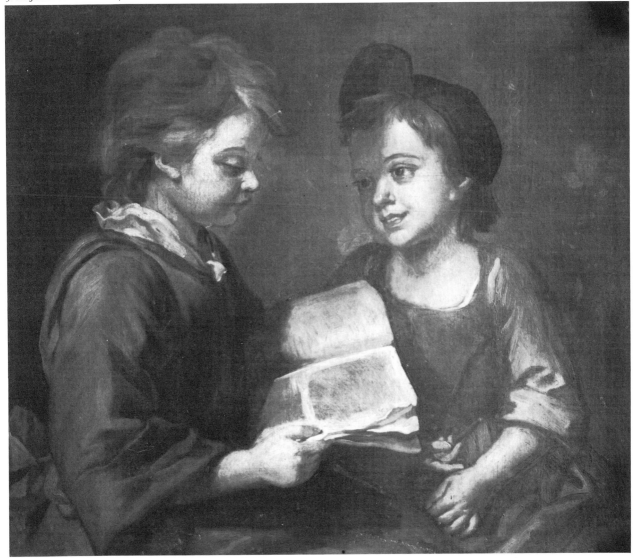

lays', and so to that extent the admiration between pain-
ters and poet was mutual.

Ramsay was a patriot. He believed that the Act of
Union threatened the heart of Scottish life, and saw the
departure of his friends Aikman and Smibert as part of
a drain of talent that would impoverish the whole nation.
He wrote in his poem on Aikman's departure:

> Far, far! o'er far frae Spey and Clyde
> Stands that great town of Lud,
> To whilk our best lads rin and ride:
> That's like to put us wood.[15]

He also saw the removal of Parliament as resulting
immediately in the decline of Edinburgh and he took a
lead in trying to halt this decline. This he did by such
enterprises as building Edinburgh's first theatre and by
supporting his friends in the creation of an academy of
art, St Luke's Academy, formed in 1729. It was, however,
through his poetry that he contributed most significantly
to the continuing vitality of Scottish culture. His post-
humous influence was vital to the vernacular poetry of
Robert Fergusson and Robert Burns, but it was significant
too for the painters, especially David Allan and David
Wilkie.

Ramsay's poetry is immediate and informal. It is close
in its idioms to everyday speech. He did not overestimate
his own talent, as he put it in a poem 'To Mr William
Aikman':

> But comick Tale and Sonnet slee
> Are coosten for my share
> And if in these I bear the gree
> I'll think it very fair.[16]

But he published in *The Tea Table Miscellany* and *The
Evergreen* a significant body of older Scottish verse, and
he saw the naturalness of his own poetry, especially
perhaps in his pastoral play, *The Gentle Shepherd*, as a
continuation of an aesthetic idea that he identified in these
older poems. In the introduction to *The Evergreen* in 1724
he wrote:

> I have often observed that Readers of the Best and most
> exquisite Discernment frequently complain of our
> modern writings, as filled with Delicacies and studied
> Refinements, which they would gladly exchange for
> that natural Strength of Thought and Simplicity of
> Style our Forefathers practised.
>
> When these good old Bards wrote, we had not yet
> made Use of imported Trimmings upon our Cloaths,
> nor of Foreign Embroidery in our Writings. Their
> Poetry is the Product of their own Country, not pilfered
> and spoiled in the Transportation from abroad: Their
> Images are native, and their Landskips domestick:
> copied from the Fields and Meadows we every Day
> behold.[17]

Ramsay identifies a kind of native bluntness and sim-
plicity as primary aesthetic virtues. He also sees this as
a reflection of the more straightforward manners of an
earlier time. Over the next century these ideas recur con-
stantly as objectives for Scottish painting. The painters
among his contemporaries could not yet turn to a visual
tradition as he could in his own art, but there were already
some examples elsewhere of similar attitudes in painting.

Rembrandt half a century before seems to have identi-
fied a comparable bluntness in his painting of *The Oath
of the Batavians* (Stockholm), not only with an aesthetic
rejection of classic forms, but with national pride. The
picture was a celebration of the rebellion of the Batavians,
the proto-Dutch, against the Romans. The characters in
his picture are shorn of 'Delicacies and studied Refine-
ments' to the point of being grotesque. Pliny cites as the
epitome of classical decorum Apelles' painting of the one-
eyed king, Antigonus. He painted him in such a way that
the defect, although his most salient characteristic, was
not visible, so Apelles stressed what tended to the norm
in Antigonus, not what was individual. Rembrandt in the
central figure in his picture explicitly defies Pliny as the
Batavian leader defied the Romans. He presents him full
face and with only one eye. The links between Scotland
and Holland were very close as the architecture of the
period makes clear, and if the elder Ramsay had known
of Rembrandt's painting he would certainly have
approved. In the next generation Burns's 'randie gan-
grel bodies' in 'The Jolly Beggars' were loyal to this
tradition.

To return to the elder Ramsay's contemporaries in
Scotland, though there could be nothing to match Rem-
brandt, there is a small group of their pictures that seems
to mirror Ramsay's aesthetic position. Smibert's first
portrait of the poet was painted in 1717 (plate 4). As a
whole it is a rather uneasy picture. The dramatic contra-
posto is not expressed sufficiently in the tension of the
neck, but the head itself is a bold and uncompromising
piece of painting. Its bluntness breaks the mask of early
eighteenth-century portraiture and gives the picture an
immediate presence. James Caw remarked that such an
unflattering likeness must have been a severe test of
friendship, but in fact the poet seems actually to have
liked the picture.[18] It was in his granddaughter's posses-
sion at her death in 1804 and so must have stayed in the
family. More tellingly, it was the close model for the
younger Ramsay's famous drawing of his father
(National Gallery of Scotland), made about 1729, when
he was still a boy, which was the most frequently reprodu-
ced image of the poet during the next fifty years.[19]
Smibert's portrait of Bishop Berkeley (1720; private col-
lection) and of an unknown man (1723; Wadsworth
Atheneum) are consistent with this Ramsay portrait, but
Aikman's portrait of the poet is more restrained. It was
painted six years later, just before he left Edinburgh in
1723, but one of his earlier works, a portrait of William
Carstares (plate 6), does match the impact of Smibert's
portrait of Ramsay.

Carstares died in 1715, so the portrait is most likely to have been painted between Aikman's return from Italy in 1711 or 1712 and that date. Carstares was a formidable divine, who had been one of the architects of the Revolution of 1688 and was William III's chaplain until the king's death in 1702. In 1703 he became principal of Edinburgh University, and his remodelling of the university on Dutch lines did much to enable it to contribute so effectively to the intellectual life of Scotland in the eighteenth century. Aikman painted Carstares three-quarter length, seated, a scholar in his study. In spite of the clumsiness in the drawing, a sense of energy radiates from him, but, as in Smibert's portrait of Ramsay, it is at the expense of flattery. At first sight indeed, it seems less sophisticated than Aikman's essays in the manner of Medina that he painted before he left for Italy, and it is difficult to see how anything so lacking in suavity could reflect Aikman's Italian experience. In the layout of the picture, he seems to have referred to the very fine anonymous portrait, *John Napier*

of Merchiston (also in the university's collection), dating from the early seventeenth century, but the way that the sitter's physical presence is depicted at the expense of his dignity must have come from Dutch painting. The freedom of handling in the head may reflect Medina's continuing example, but instead of the abstract rhythms of Medina's Baroque, the brush strokes stress the individuality of each feature and force the principal's strong but unhandsome face upon us. The use of light in the painting is also important. It comes from a positive source and falls on the head of the sitter and on the wall behind him to give a real sense of an interior, while also serving to emphasize the head. Aikman breaks with the conventions of early eighteenth-century portraiture even more decisively than Smibert does.

To leave portraiture aside for a moment, something of the quality that distinguishes these two pictures is also apparent in a still life painted a few years after Smibert's portrait of Ramsay. This is the *Still Life with Cauliflowers*

4. John Smibert. *Allan Ramsay Senior.* 1717. Cat. 10

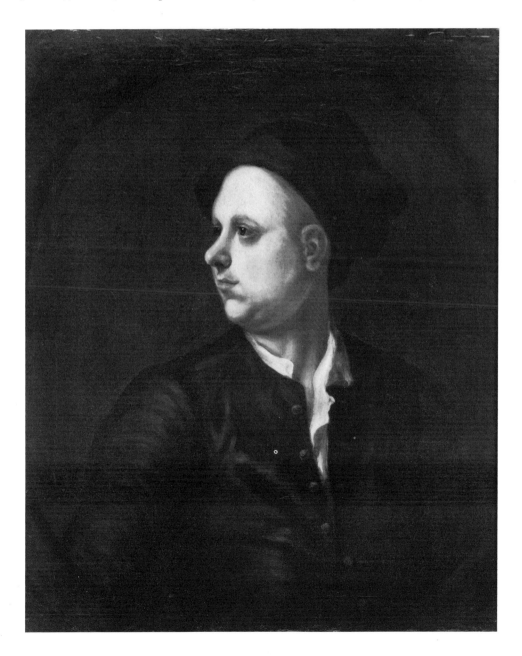

and a Leg of Lamb (col. plate 2) signed and dated 1724 by Richard Waitt (d. 1732). Caw says of the picture as he remembered it, 'It was excellent in colour, full in tone, well drawn, and painted in a firm yet flowing manner, with rich and well modelled impasto, which expressed the textures and contours of the forms admirably.'[20] Caw's praise seems entirely justified. It is a frank, direct and remarkably concrete piece of painting, eschewing polish and sophistication in favour of honesty.

Richard Waitt's *Still Life* seems to be an isolated performance. His other known paintings show him to have been a rather minor portrait painter. Though Smibert's later work shows occasional flashes of the strength that he reveals in the Ramsay portrait, as in *Colonel Douglas* (1727; National Gallery of Scotland), which could certainly have influenced the younger Ramsay, his later career is mainly of interest for the role that he played in establishing painting in New England. Aikman, however, was a more significant talent and was certainly capable of formulating for his own art the kind of aesthetic ideas that Ramsay outlines.

Like the younger Ramsay, Aikman was a painter with a strong literary bent. James Thomson, who wrote a poem in memory of Aikman, was one of his closest friends in London, to which he moved from Edinburgh at much the same time as Aikman, who also seems to have been on friendly terms there with Pope. Aikman even proposed in 1727 to embark on a literary enterprise of his own, a translation of Vitruvius, but this was abandoned when he learnt from William Kent that there was another shortly to be published.[21] He revealed something of the relationship between his ambition as a painter and his self-respect when he wrote in 1726 to Sir John Clerk: 'I have endeavoured as much as my genius allows to merit some esteem since I came here and not without some success for I am sensible of my own improvement.' Vertue confirms this by saying of Aikman that he was 'esteemed the best painter this country has produced of late years.'[22]

Aikman was never again so bold as he had been in the Carstares portrait, but by working in a lower key he developed a less disturbing way of conveying a strong sense of the sitter's presence. In his simpler portraits he does this by strong characterization in the heads, as in *Lady Grisel Baillie* (plate 5) and in the portraits of the Clerk family. It is coupled with a firm and deliberate touch of the brush, which gives a distinct material sense. The most striking of his portraits dating from the end of this Edinburgh period are two three-quarter lengths, the *Earl of Marchmont* of 1720 and *Sir Hew Dalrymple* of 1722 (plate 7). They are both complex in design and show a remarkable improvement in execution over the earlier three-quarter length of Carstares. Both designs are formal however, so much so that they suggest that Aikman had again been looking at early seventeenth-century models. This formality of design is used in each case to act as a foil to the powerful account that he gives of personality. Sir Hew Dalrymple may be passive, held by his pose, but he is alert and watchful.

5. William Aikman. *Lady Grisel Baillie*. Cat. 3

Aikman's later career is more difficult to follow. There is no doubt that he was forced to overproduce. This is implicit in each successive account that he gives of the pressure under which he worked. Latterly, too, he employed an assistant . His work is therefore uneven, and much of it has probably sunk into the pool of anonymous portraits of the period. There are nevertheless a number of datable works to indicate that he continued to develop. An example is the *John, Earl of Stair* of 1727 (Mellerstain), which anticipates a central theme of eighteenth-century portraiture in its firm but sensitive rethinking of Van Dyck. If the attribution is correct, the portrait of *Major General Lord Charles Hay*, formerly at Yester, likewise opens the way towards a new and grander style of portraiture. The double portrait of the Clerk sisters, described by Sir John in the inventory of his collection as among the last that Aikman painted and 'very true and very like' (presumably it was done during his visit to Scotland in 1730), shows that his sense of the individuality of his sitters had not diminished (col. plate 5).

Aikman, and Smibert too perhaps, left their mark on the wider history of art, but there were other artists, also friends of Allan Ramsay who, like the poet, stayed in

Edinburgh and helped to keep alive the idea of a native Scottish art. James Norie, the founder of a family of decorative painters, stood godfather to one of Ramsay's daughters and as an intimate friend he was probably the artist whom Ramsay's son Allan knew best, but Richard Cooper, the English engraver who settled in Edinburgh after a sojourn in Italy, also produced an engraved portrait of the poet (c. 1728). We know that Cooper had a collection of old master drawings as well as copies, and indeed fragments of his drawing collection can be identified in the National Gallery of Scotland. It seems to have been an important asset to the younger generation, as the Runciman brothers clearly knew it. Alexander Runciman was a close friend of the younger Richard Cooper, who was an engraver and landscape painter and who eventually succeeded Alexander Cozens as drawing master at Eton. The elder Cooper ran a private drawing academy in the 1730s.[23] One of his pupils was the engraver Sir Robert Strange who, in spite of a flirtation with the Jacobites, went on to become one of the most celebrated engravers in the later part of the century.

Norie and Cooper were among the half-dozen known practising professionals who signed the charter of the Academy of St Luke in 1729.[24] It was Scotland's first art institution, though it may not have lasted more than two or three years. The academy was modelled on the London academy that had been begun under Kneller's direction and which in 1729 was under Thornhill's. The charter of the new academy summarizes its members as 'Noblemen, Gentlemen, Patrons, Painters, and lovers of Painting'. The noblemen were only two, but they included a friend of Ramsay's, Lord Garlies. Both the Allan Ramsays signed the charter, as did Alexander and James Clerk, who were probably both sons of Penicuik. Alexander certainly was. He was half-brother to Sir John Clerk and went on to become a professional painter. James may have been Sir John Clerk's eldest son, who eventually inherited Penicuik. William Adam, father of the Adam

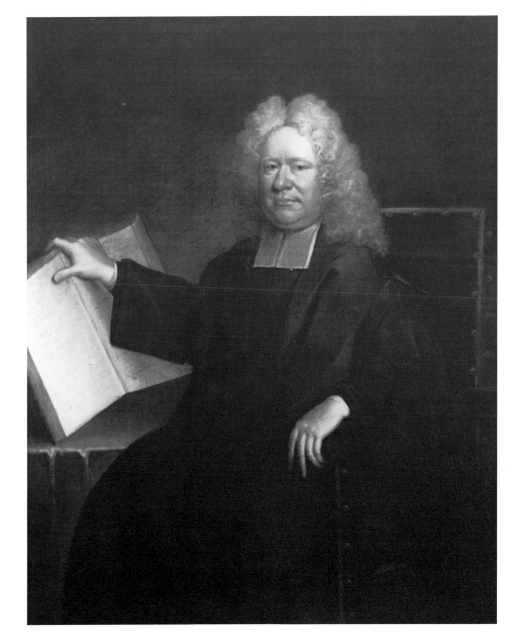

6. William Aikman. *William Carstares.* c. 1712–15. Cat. 2

brothers, and himself a distinguished architect, is listed, so are John Alexander and Andrew Hay, an artist who became a picture dealer. The president was George Marshall, who may have studied with Kneller. The treasurer was Richard Cooper and the secretary Roderick Chalmers, a close associate of James Norie and a decorative and heraldic painter. In June 1731 'the Professors and other members of the Academy of Drawing' were granted rooms in the college (the university) by the city council.[25] Thereafter the academy is not recorded, but that does not mean it fizzled out immediately. Whatever happened to it, the academy shows that the social group to which Ramsay belonged took a conscious initiative in the cause of art in Scotland.

It is impossible to say with whom in this group the initiative lay. It was clearly exactly the kind of project that Ramsay himself would encourage in his campaign to preserve the cultural status of Edinburgh and Scotland.

Among the painters, Norie and Chalmers appear in an earlier attempt to raise the status of painting through the trade guilds' incorporation, the Incorporation of St Mary's Chapel, to which the painters were affiliated in 1703. In 1709 Chalmers presented his trial piece, on completion of his apprenticeship, to the chapel. It was accepted in lieu of the normal fee, and this became customary for the painters.[26] Thus the trial piece was raised to something like the status of a diploma painting in an academy. A little later James Norie undertook to repaint the chapel's chimneypiece, which showed all the trades together. He did so in 1718, but in redesigning the picture Norie somehow upset the order of precedence, presumably to the advantage of the painters. Such a serious row ensued that some members of the chapel broke in during the night and altered the painting. The row went on until the picture was cut in half and divided between the two contending parties, the wrights, to whom the painters belonged,

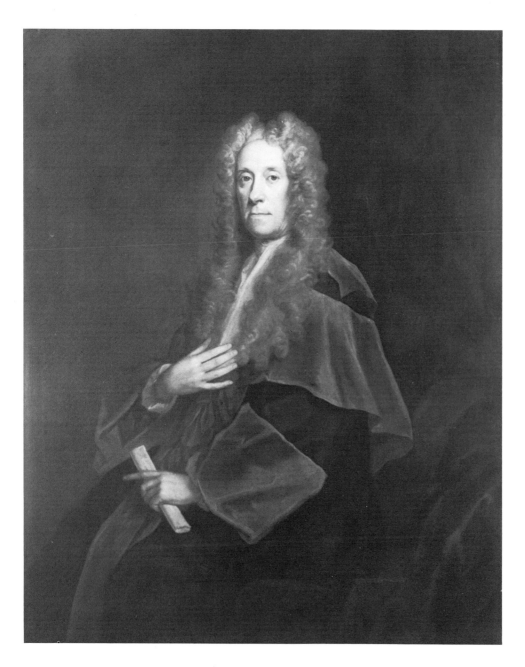

7. William Aikman. *Sir Hew Dalrymple, Lord North Berwick*. 1722. Cat. 4

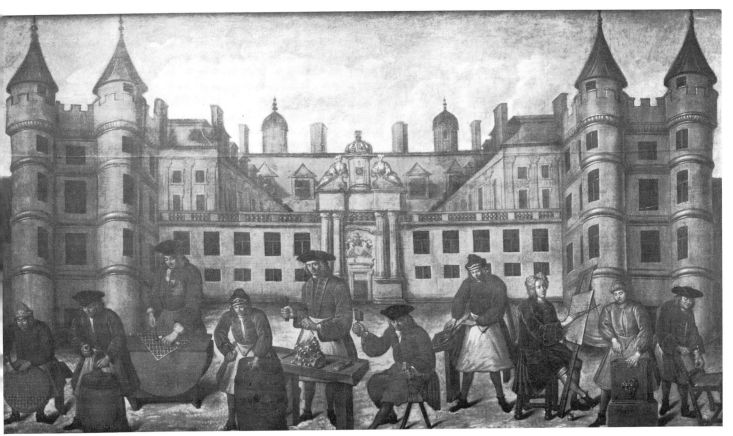

8. Roderick Chalmers. *The Edinburgh Trades at Holyrood.* 1720. Cat. 6

and the masons. In 1720 Chalmers was invited to paint a new picture restoring the original precedence (plate 8). This he did, but if the row was about status he had the last laugh. The picture survives. It shows the trades in front of Holyrood Palace, with the tradesmen wearing appropriate working gear, caps and leather aprons. If they are seated, they are on three-legged stools, but the painter, no doubt Chalmers himself, is seated at an easel on a carved high-backed chair, wearing a full-bottomed wig and a velvet coat.

It is a trivial incident, but clearly reflects the determination of the painters, even though they made their living as decorators, to keep alive their claim to be considered artists. Nor were their aspirations vain. Not only did Allan Ramsay and Robert Adam, two of the most distinguished visual artists in the eighteenth century in Britain, come from this circle of Edinburgh tradesmen, but the apprenticeship system remained vital in Scotland right down to the end of the eighteenth century; through it, Alexander Runciman, Alexander Nasmyth, Jacob More and less directly even Raeburn, were all trained in the tradition that these men founded.

II

Empirical Portraiture

'We have no abstract idea of existence, distinguishable and
separable from the idea of particular objects.'
David Hume, A TREATISE OF HUMAN NATURE, 1739

The most remarkable thing about the early career of the younger Allan Ramsay is that he apparently knew very clearly what he wanted to learn when he went to Italy at the age of only twenty-three, and when he set up his practice in London three years later, too, he knew exactly how he wanted to paint.[1] It was in a manner quite distinct from that of any artist currently practising there. These facts are themselves among the strongest arguments for the case set out in the last chapter for the self-consciousness of the artistic community in Scotland in the two decades following the Union.

This community, in which Ramsay's father had a central role, is identified in the charter of the Academy of St Luke and could muster a considerable variety of skill and experience. In addition, the young Ramsay had access both to the collections and to the individual experience of members of such intellectual families as those of Clerk and Forbes. In later life he developed literary ambitions. These have been seen as a distraction from his main business as a painter—an exclusive one in the narrow twentieth-century view—but the breadth of his interests clearly reflects this early environment, which was one in which painting took its place as an equal and cooperating partner with the other branches of intellectual and imaginative endeavour and was not something to be set apart.

Aikman and Smibert, however, the two most distinguished of his father's painter friends and the ones on whom the younger Ramsay is most likely to have modelled his own career, both left Edinburgh while he was still a boy. Their work may have been an important example to him in forming his own aesthetic ideas, but neither could have played a direct part in his training, though Aikman did return to Scotland once, in the summer of 1730, and painted at least one picture during his stay. For all his difficulties, Aikman, enjoying royal patronage as he did at that time, had a good claim to be the leading portrait painter in London. Clever and likeable and among the senior Ramsay's oldest friends, he was equip-

ped to make a strong impression on the young painter, but there is no way of knowing, if Aikman had survived, whether he would have taken him on as a pupil. The painter William Mosman had spent a short time with Aikman in London, apparently on Baron Clerk's recommendation, but not much to the satisfaction of either master or pupil.[2] Even if Aikman had not been put off by this experience, by 1730 his health was so much shaken that he was probably not in a position to offer much more than advice, but it was conceivably on his recommendation that Ramsay spent some time only a year after Aikman's death, with the Swedish painter, Hans Hysing.

Hysing had worked in London for more than thirty years, beginning his career with his compatriot, Michael Dahl. Ramsay worked with Hysing during the year 1732–33, returning to set up his own practice in Edinburgh probably in the latter year. He worked in Edinburgh for nearly two years before he left again, this time for Italy, but only a small number of his portraits are certainly datable from this time. The receipt for the portrait *Kathleen Hall of Dunglass* is dated 31 May 1736.[3] A second portrait, *Mary Campbell of Lochlane*, is probably from the same year, but *Margaret Calderwood* (private collection, on loan to National Trust for Scotland) (plate 9), recently identified by Professor Alastair Smart, is dated by a letter of Ramsay's father to before 5 April 1735. On that day the elder Ramsay wrote in a letter to the Lord Provost of Edinburgh, Patrick Lindsay: 'Miss Peggy Stuart, Sir James's sister was married the other day to Mr. Calderwood of Polton, my son had made an excellent half-length picture of her, and I begin to think it not bad politick for young beautys to be seen in my sons painting room where so many of the Beau-Monde resort.'[4]

The poet's letter makes plain the Ramsays' own idea of their style, and the portrait now identified is very much in keeping. It is an elegant essay in Hysing's manner, the young Ramsay showing off with pardonable pride what he had learned in London. His own personality, however, shows through Hysing's rather flat and conventional style

in the hands and the face, but especially in the eyes. The gaiety of the young Mrs Calderwood's glance reveals very clearly her awareness of the interesting young painter and gives us a little glimpse of what the poet meant by the 'Beau-Monde'.

In the two pictures that survive from the following year Ramsay has thrown off the constraint of Hysing's stylization and has returned to Aikman's example. Margaret Calderwood is a real person looking out through a mask of convention, but Mary Campbell is a real person present to us. Already in this picture Ramsay takes pains by such details as the pearl earrings and the ribbons in her hair to establish the light, space and atmosphere in which she can take her place. These are the qualities that three years later immediately distinguished his painting from that of his contemporaries in the south. They indicate his intention from the very beginning to create a natural art based on observation. They are also paralleled in the best paintings of Ramsay's older but less gifted contemporary, Jeremiah Davison (c. 1695–1745), such as his portrait of *Duncan Forbes of Culloden*.

In the late summer of 1736 Ramsay set out for Italy. He travelled in the company of Alexander Cunynghame, later Sir Alexander Dick Cunynghame of Prestonfield. Cunynghame was a doctor, educated, lively and with

9. Allan Ramsay. *Margaret Calderwood*. 1735. Oil on canvas, 126 × 101 cm. Private collection on loan to the National Trust for Scotland

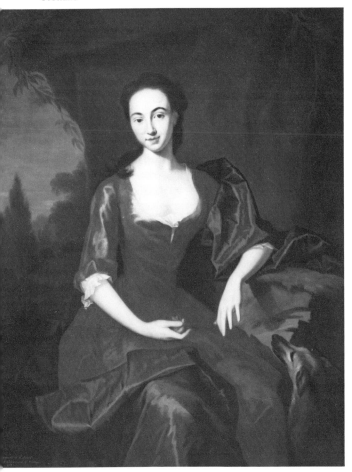

wide interests. He was a good companion and his diary is a valuable record of the adventures and amusements of their journey and their time in Italy till he returned to Britain in 1737, leaving Ramsay on his own.[5] For Ramsay the experience of moving easily in cosmopolitan circles in Rome, including the Stuart court, was an important education, but his main business was painting. From Scotland he had chosen Francesco Imperiali as his teacher. The choice probably reflects the Clerk influence, for James Clerk, later the third baronet, and his brother, Alexander Clerk, had recently spent time with Imperiali. A number of Imperiali's paintings are still at Penicuik. It is not clear what Ramsay learnt from Imperiali, unless it was the late Baroque orchestration of colour apparent in one or two of his post-Italian works, but he also spent time at the French Academy, introduced by a letter from the Parisian antiquarian Mariette to Watteau's friend Vleughels, who was master of the academy at that time. The original introduction to Mariette may have come from Clerk, himself a prominent antiquary, and was the beginning for Ramsay of a lifelong association with European antiquities and antiquarians. The French Academy was more stimulating than Imperiali's studio and from that time forward Ramsay maintained an interest in French painting.

In the summer of 1737 Ramsay moved from Rome to Naples to join the studio of Solimena. Although very old, Solimena was a much more interesting choice of master, for he was almost the last representative of the Italian academic tradition founded by the Carracci, in which the understanding of the human figure through drawing was the prerequisite of all art. The discipline of drawing remained one of the bases of Ramsay's own art throughout his life and his understanding of the Italian tradition through Solimena was an important part of this. Nevertheless, except for the figure drawings that he did at this time and during his second visit to Italy nearly twenty years later and the compositional sketches made in his later career (plate 12), his drawings are largely confined to the analysis of the expressive parts of the figure, and include a great many studies of the hands. 'Disegno', drawing in Vasari's sense, had only a discreet role in his art. From the beginning light, rather than line, was what unified his pictures.

We do not know on whose advice Ramsay decided to spend time with Solimena, but it may be significant that part of the qualification for which Aikman recommended a painter friend, Henry Trench, in a letter to Baron Clerk was that he had spent two years with Solimena.[6] Aikman certainly understood the problem that Ramsay also faced as a 'natural' portrait painter: how to reconcile individuality with grace without compromising the truth. Solimena was an inspired choice and Ramsay learnt what he needed, without however accepting the idealism that was the heart of the tradition that Solimena represented.

Only once was Ramsay clearly carried away by Italian style. This was in the picture (Earl of Haddington, Mellerstain) that he painted in Rome, at the end of 1738, of

his friend Samuel Torriano. Like the *Margaret Calder-wood*, though much more accomplished, the picture is a flourish, a demonstration of the sheer excitement of a new skill. But a year later, in his delightful *Agnes Murray Kynnynmond* (col. plate 1), the Baroque touch in the fluttering drapery is already no more than a charming aside. The sitter's own person, though only a child, takes complete command.

By the late summer of 1738 Ramsay had established himself in London and his success was so rapid that by 10 April 1740 he was able to write in a letter to Alexander Cunynghame the famous remark: 'I have put all your Vanloos, and Soldis and Roscos to flight and now play the first fiddle myself.'[7] He was in high spirits, for he was writing to tell his friend of the birth of his first child, but his remark must nevertheless reveal something of his perception of himself. The most interesting part of it is that he enumerates only his foreign rivals in London. In this his attitude seems to be identical to that of Hogarth, who, according to some authorities, took up portrait painting in response to the challenge of the same foreign painters, and especially of the Frenchman Vanloo, who had established himself in London with great success in 1737.[8]

Hogarth was the leading figure in English art when Ramsay settled in London. Earlier, Hogarth had dedicated his illustrations to *Hudibras* to Ramsay's father, and, given the probable mutual admiration between the two older men, it seems likely that the young painter arrived with a strong recommendation to Hogarth. In later life the two men clearly appreciated each other, in spite of occasional grumpy references by Hogarth to Ram's-eye and to Phizmongers, and at the beginning of his career Ramsay must have appreciated the affinity between Hogarth and his father. Both men believed passionately in a national art, saw that if they did not set about establishing one, no one else would, and saw, too, the necessary character of that art in a similar way. Ramsay had the advantage, as a poet, of a literary tradition on which to draw, but nevertheless the results that he and Hogarth produced were not dissimilar, an art with a degree of humour, of naturalism and immediate accessibility, but informed by a lively awareness of international and classical models. As will be seen, the younger Ramsay remained surprisingly faithful to the essentials of this aesthetic. Hogarth's example therefore may have been an important encouragement to him at the beginning of his career.

The stimulus between Hogarth and Ramsay may however also have been mutual, for it is striking that Hogarth seems to have taken up portrait painting at just the moment that Ramsay arrived in London. It is unlikely that he would have set himself up in deliberate rivalry to a young artist towards whom he had reason to be friendly and much more probable that what grew up between them was a kind of co-operative rivalry in the creation of a modern portraiture dedicated to the defeat of the Soldis and Vanloos.

Hogarth records one exchange between them that might suggest something of this kind. 'I exhorted the painters to oppose him [Vanloo] with spirit. But was answered, "You talk! Why don't you do it yourself?" Provoked by this I set about this mighty portrait [Thomas Coram] and found it more difficult than I thought it. One day at the Academy in St. Martin's Lane I put this question: "If anyone now was to paint a portrait as well as Van Dyke, would it be recognised and the person enjoy the benefit?" They knew I had said I believed I could. The answer was made by Mr. Ramsay and confirmed by the rest "Positively no." The reason was given very frankly by Mr. R: "It is our opinion must be consulted and we will never allow it."'[9]

Ramsay sounds bumptious, but not necessarily as hostile as Hogarth in his combativeness would like to represent him. Hogarth later referred to Ramsay as 'another face painter from abroad' and their relationship may well have been turbulent, but this did not need to conceal the community of purpose of which there is a clear indication in the conversations that Hogarth is recollecting. This not only embraced the desire to displace the foreigners. Fielding's defence of Hogarth in the introduction to *Joseph Andrews* could in one respect also apply to Ramsay: 'It has been thought a vast commendation of a painter to say his figures *seem to breathe*, but surely it is a much greater and nobler applause, that they *appear to think*.'[10] Both painters were dedicated to the creation of a natural art, but whether it was as friends or as rivals that they made common cause, the contrast between their paintings underlines Ramsay's independence from the start.

In 1739 Ramsay married Anne Bayne, the girl to whom he had been informally betrothed before he left Scotland for Italy. She died four years later and the portraits (plates 10, 11) that he painted of himself and his young wife are generally dated to the beginning of their brief marriage. Such intimate portraits as these may not be typical of the work of a busy professional portrait painter, but they reveal his central artistic convictions as well as his personal feelings. The two paintings are vividly contrasted between masculine and feminine, but the obvious delicacy of the one should not overshadow the equally delicate precision with which Ramsay records his own more rugged features and incipient beard. George Vertue recognized the distinctiveness of Ramsay's way of painting and condemned it as 'neither broad, grand nor free'.[11] Certainly compared to contemporary practice his handling of paint was unusually reticent, but it was in no way dry or pedantic. Light and atmosphere soften and humanize his touch.

In *Anne Bayne* the treatment of reflected light on the shadow of her cheek and on the dark edge of her sleeve reveals a fidelity to the phenomena of nature of a kind not seen before in British painting. Likewise the transition from the dark left-hand side of the background, which is in shadow according to the fall of the light, to the right-hand side, which is illuminated, is handled in such a way

that it suggests a real illuminated space into which the painted oval opens our view. Although Ramsay and Hogarth were at this moment joint champions of natural portraiture, there could not be a stronger contrast than that which exists between Ramsay's willingness to stand back and let light create his image, as here, and the way in which at the same date Hogarth by his florid and emphatic brushwork brings his sitters to life by his own compelling energy.

The portrait Ramsay painted of his young wife has no precedent in English painting, nor is it recognizably Italian. He has not flattered her by softening her appearance nor has he adorned her image with the conventional decorative devices of composition and execution. Instead he has paid her the much greater compliment of a loving delineation of her actual person. If this kind of frankness has an immediate precedent it is in the best portraits of Aikman and Smibert. Aikman in addition had also demonstrated the importance of a real light source.

Portrait painting is however the most social form of art and as such is bound equally by social and by artistic conventions. The kind of scrutiny to which Ramsay subjected himself and his wife would be as inappropriate in a more formal portrait as the detailed scrutiny of one's partner's face in a polite conversation. The problem that Ramsay faced was how to reconcile the fidelity of his vision with the social needs of portraiture. Given the difficulty of doing this, as well as the pressure on his time in a busy professional practice, it is not surprising that he withdrew to some extent from the immediate confrontation of this problem, using at times stock poses and frequently employing the services of the drapery painter, Joseph van Aken. Ramsay's production during the 1740s should not be dismissed, however. Especially in half-length portraits like *Lady Inglis* (Scottish National Gallery) and *Sir Peter Halkett Wedderburn* (1746; Scottish National Gallery) precise delineation of the sitter's features is brought to life by the life-giving envelope of light and air.

In full-length portraiture Ramsay faced a different kind of social expectation. The tradition of the full-length as a grand mode had never died out, but was on the face of it almost impossible to reconcile with the idea of the natural portrait in which the sitter's individuality was the dominant factor. This is the problem that Hogarth confronted in his painting of Thomas Coram. Before Hogarth, however, Aikman had successfully explored the possibility of preserving the inherent dignity of the grand style without sacrificing the sense of the sitter's presence, and it was from Aikman rather than from Hogarth that Ramsay took his cue.

Ramsay's *Anne Campbell, Countess of Strafford* (1743) can be compared to Aikman's *John, 2nd Earl of Stair* (1727; Mellerstain) in its attempt to reinvigorate the Van Dyck tradition. In the double portrait of the *Hon. Charles and the Hon. Rachel Hamilton* (1740; Mellerstain) Ramsay paid homage to Aikman's solution of the ultimate puzzle of the grand style, the full-length child portrait.

He took inspiration from Aikman's picture, also at Mellerstain, painted twelve years earlier, the *Hon. John and the Hon. Thomas Hamilton, with a negro slave*. In doing so he showed how far he had advanced beyond Aikman, coming down firmly on the side of the natural. Hogarth in turn picked up Ramsay's inspiration in his double portrait of the *MacKinnon Children* (National Gallery of Ireland).

Ramsay finally took up the challenge of Hogarth's *Coram* in 1747 with his own contribution to the Foundling Hospital collection, following the agreement in the previous year of a number of artists to present works to it. He painted for the hospital a full-length portrait of Dr Richard Mead, medical practitioner and antiquarian. Like Coram, Mead is shown seated with a still life at his elbow and a grand architectural back-drop. Compared to Hogarth, however, Ramsay has achieved a much more stable balance between the individuality of the sitter, which lacks nothing beside Hogarth's account of Coram, and the weight of the apparatus that supports him.

Two years later Ramsay returned to the theme of the grand portrait of a seated figure with his painting of the *3rd Duke of Argyll* (1749) (col. plate 3). The picture is a *tour de force* and a fitting culmination of the first decade of his full professional practice. In it he achieves the formality and impact of what is in effect a state portrait without sacrificing naturalness, not in the social sense of the word, which would be inappropriate, but in the sense of the convincing presence of a real person. The secret of the painting is in the light. The Duke is seated with a strong but cool light falling on his head and left side. He is well back in the space so that we sense the presence of air between us and him. His right hand is out of the direct light and rests on a book. In this half-shadow a soft grey light prevails. The blocks of type on the page of the book are simply rectangles of dove grey against the white page. Elsewhere warm and cool constantly play against each other, the white on his cuffs and stock against the cream of his ermine, for example, and this creates a feeling of atmosphere. The quality of the light is such that the head itself is much softened, and part of the picture's magic is that it succeeds in being deeply impressive while being wholly unemphatic.

To compare such a formal portrait of a great statesman to the portrait of a friend, Janet Dick, wife of Alexander Dick-Cunynghame, painted a year earlier, is to show Ramsay in complete command of the whole gamut of portraiture from the grandest to the most intimate. *Janet Dick* (col. plate 4) is as frank and friendly as the *Duke of Argyll* is formal and imposing, but there is no difference in kind between them. Both are equally human. Ramsay has only altered the degree of intimacy according to his intuitive sense of the social dimension of portraiture, reflecting in a way that is as naturalistic as his handling of light, the actual web of social relationships within which portrait painting must take its place.

If Ramsay's painting showed a very striking command by the end of the 1740s it was also beginning at that time

to shift towards a greater flexibility and informality. This is seen first of all in a softening of the brushwork to give a gentler touch and then by the use of less formal and more varied poses. The stimulus for the latter change was probably the less formal kind of painting evolving in France in the work of painters like Quentin de la Tour, whom both Ramsay and Hogarth admired. A portrait by la Tour is cited by Ramsay as an example of naturalness in his *Dialogue on Taste*.[12] But whatever the stimulus, Ramsay seems to have begun to rethink the whole nature of portraiture. It may be just a coincidence that his *Duke of Argyll* was painted in the year that the drapery painter, Joseph van Aken, died, but in that picture, even though it is on a large scale, unity depends on execution as well as conception. The accessories are much more than a foil for the head, and the manner in which they are painted is important for the whole. In 1753 in paintings like *Thomas Lamb of Rye* (private collection) and *Lady*

Walpole Wemyss (Earl of Wemyss), costume and accessories are the occasion for some vividly exquisite painting and brilliant colour, but are held together by the same atmospheric unity and presented with the same tact. The transfer of the elegance of costume to the elegance of portraiture is specifically French, and in these two pictures he is at his closest to la Tour, but in effect, what Ramsay is doing is bringing forward into his professional painting the qualities that had distinguished the early portrait of his wife. Now, however, the penetrating vision of that picture no longer presents a risk of impertinent intimacy because of Ramsay's command of the social dimension.

It has been argued that the new development in Ramsay's painting that can be seen in the mid-1750s was also stimulated by the appearance for the first time of a serious professional rival in the person of Joshua Reynolds, who returned from Italy early in 1753 and rapidly established a reputation for himself. It may have been that Ramsay

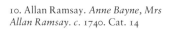

10. Allan Ramsay. *Anne Bayne, Mrs Allan Ramsay. c.* 1740. Cat. 14

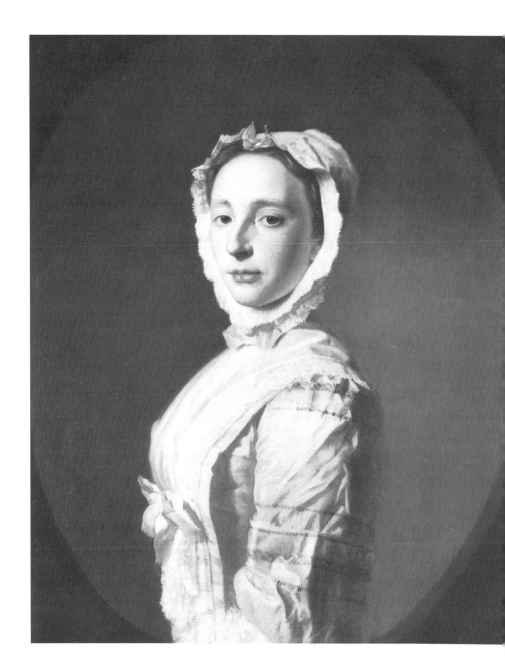

found competition stimulating, but if it made him at all anxious his reaction was a little odd. He absented himself from London late in 1753 for a period of four years, leaving Reynolds in command of the field.

Following a pattern of regular visits, though staying rather longer than usual, he was in Edinburgh from the latter part of 1753 to the middle of 1754 and then travelled to Italy, probably in the late summer of 1754. It was during this stay in Edinburgh that he made his most practical contribution to the intellectual life of the city by taking the initiative, ably supported by David Hume, in founding the Select Society. He also painted his first portrait of Hume at this time, but by far the most important picture that he painted was the three-quarter length *Sir Hew Dalrymple, Lord Drummore* (plates 12, 13), one of the finest of all his male portraits and a picture that seems more than any other to personify the early Scottish Enlightenment. Drummore is seated, full face and in an

easy posture, his left elbow on a table, his knees towards us. His hands catch the light and his head is thrown into strong relief against the sunlit wall behind. In place of the cool light of the Argyll portrait, the light here is warm and active, suggesting irresistibly the light of intellect. In painting the picture, Ramsay may have still had Hogarth's *Coram* in mind as well as Aikman's *Carstares*, but he surpasses any rival. Drummore typifies the Enlightenment. He is individual, intelligent, sociable and humane. The picture also typifies Ramsay's own balanced empiricism, social and sociable, qualities which characterize his friendship with Hume as based on real intellectual affinity. Ramsay himself may have seen this, for his second portrait of Hume (plate 17), painted twelve years later, is a half-length version of his *Lord Drummore*, the light altered so that Hume himself is a light figure emerging from darkness.

The creative excitement that is so apparent in Ramsay's

11. Allan Ramsay. *Self-Portrait. c.* 1740. Cat. 15

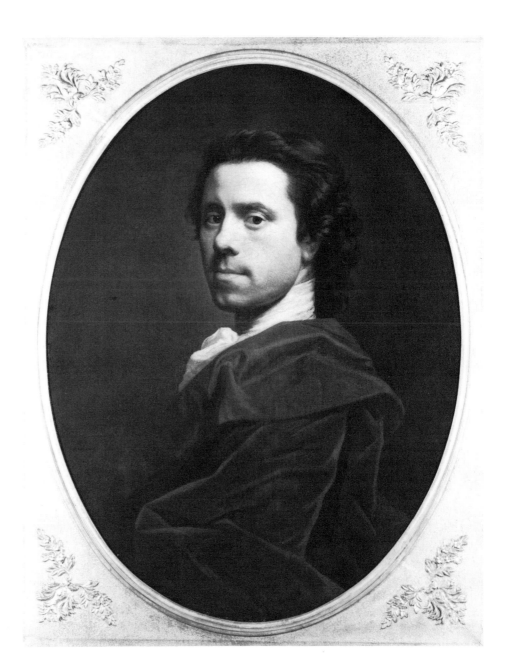

painting in the 1750s also bore a different fruit. The years 1753 and 1755 saw the publication of his first three efforts as an author. They throw a clear light on the intellectual convictions on which his painting is based and confirm the importance of his links with the Scottish Enlightenment and especially with Hume. The first of these essays was *A Letter to the Earl of—concerning the Affair of Elizabeth Canning*. This was a necessarily ephemeral but nonetheless effective intervention in a celebrated and disputed criminal case. Ramsay's balanced and rational assessment of the evidence changed the course of justice and earned the praise of Voltaire. This short essay set the tone for all his subsequent writings; rational, empirical and urbane, and inspired by the belief that truth can always be reached by the dedicated investigator. *The Investigator* was in fact the name that he gave to the imaginary journal of which a collection of his essays published in 1762 purported to be a number. Several of Ramsay's later essays were of the same type as the *Letter . . . concerning . . . Elizabeth Canning*, that is, intervention by the rational man to bring clarity to the tangled web of public affairs, but the essay *On Ridicule* (1753) and the *Dialogue on Taste* (1755) were of a more speculative kind.

On the subject of ridicule, Ramsay holds a position close to that of Fielding and of Hogarth, whom he praises warmly, and which derives from Shaftesbury. For him it is a weapon that depends on an essentially naturalistic vision and functions by bringing affectation and folly into confrontation with nature. It has a general bearing therefore on his own aesthetic ideas and illuminates his painting most directly when at one point he takes issue with Addison's view that the 'agreeable' and the 'exact' are alternatives in painting. It is a view that implies the idealist position in which nature is improved by art and Ramsay answers it: 'The agreeable cannot be separated from the exact; and a posture, in painting must be a just resemblance of what is graceful in nature, before it can hope to be esteemed graceful.'[13] One can see behind this the force of the conviction expressed by Hume, but equally fundamental to Ramsay: 'Everything in nature is individual.'[14] There is no better illustration of the artist seeking the point of perfect balance where the graceful and the exact coincide than in such drawings as the studies Ramsay made for the hands in his portrait of Queen Charlotte (plate 14).

By its subject, the *Dialogue on Taste* has an even closer bearing on Ramsay's own business as a painter, though he does not speak to us himself but through Colonel Freeman, whose principal interlocutor is Lord Modish. Ramsay's choice of the dialogue form may have been suggested by Filippo Baldinucci's dialogue, *La Veglia* (1684), which set out the principles of an empirical approach to art history. It was the only recent example of a dialogue used in this way to present an artistic topic and in general Ramsay would certainly have found sympathetic Baldinucci's rational anti-idealism.

Ramsay's own anti-idealism was fundamental and closely comparable to Hume's. 'No analysis can be made of abstract beauty, nor of any abstraction whatever,' he writes.[15] Beauty is relative and particular. Classical artists, for example, reached their ideal of feminine beauty 'on the cautious principle' of finding a compromise between all the infinite variety of individual preference.[16] The result, he says, was boring and lifeless. He disposes of the idea that society endorses the ideal by its habit of selecting a single fashionable individual as enshrining the ideal of feminine beauty by asking, 'What could be supposed more ridiculous, or even fatal, than for all the inhabitants of London and Westminster to be real, instead of pretended, admirers of one woman?'[17] He illustrates the relativity of beauty by turning upside down Hogarth's choice of the toad as an example of ugliness lacking the line of beauty and grace and pointing out that a she-toad may be the epitome of beauty in the eyes of her gentleman toad admirers. In this he is adapting a point made by Francis Hutcheson whom he admired and whose portrait

12. Allan Ramsay. *Study for Sir Hew Dalrymple, Lord Drummore*. 1754. Cat. 19

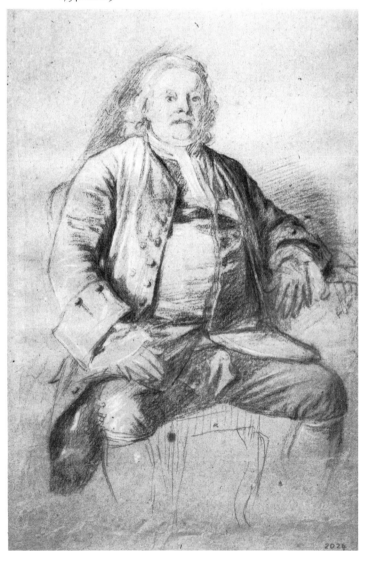

OPPOSITE 13. Allan Ramsay. *Sir Hew Dalrymple, Lord Drummore*. 1754. Cat. 18

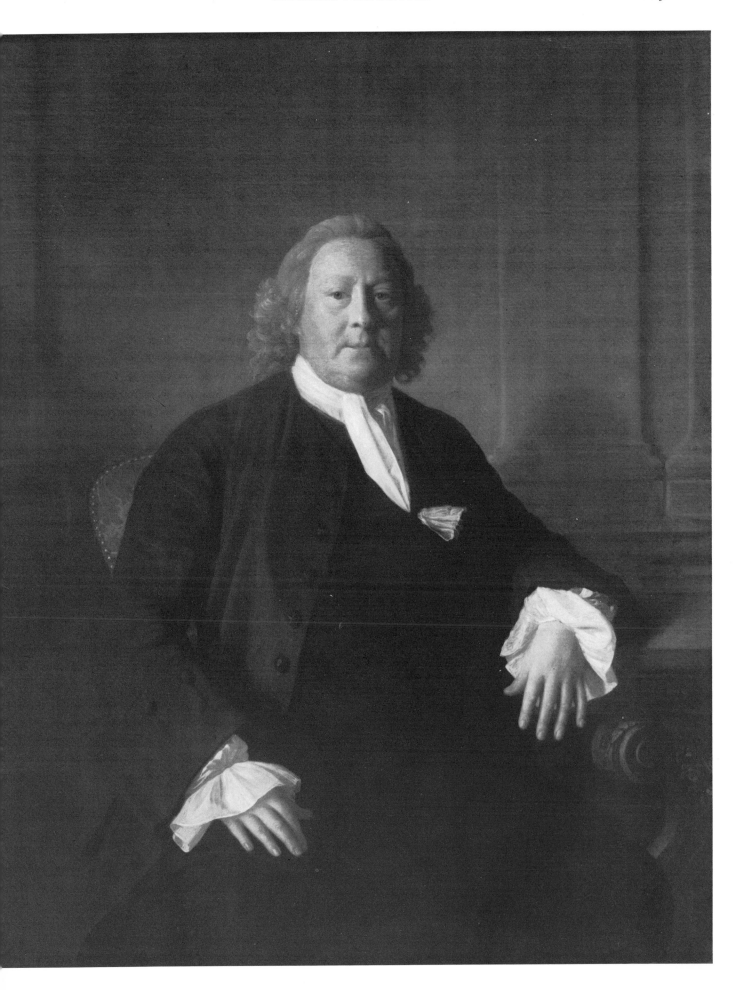

he painted in 1750, but he is especially close to Hume here too.[18] Compare his ideas of particularity and his rejection of abstraction with Hume's fundamental proposition: 'We have no abstract idea of existence, distinguishable and separable from the idea of particular objects.'[19]

For Ramsay truth is 'the leading and inseparable principle in all works of art'. In art beauty lies in naturalness, 'in the representation of truth, and the real existence of things'.[20] In consequence it is not abstruse but immediately accessible. 'Your lordship has only to hide yourself behind the screen in your drawing room, and order Mrs Hannah to bring in one of your tenants' daughters and I will venture to lay a wager that she shall be struck with your picture by la Tour, and no less with the view of your seat by Lambert, and shall fifty to one, express her approbation by saying, "They are vastly natural". When she has said this she has shewn that she knew the proper standard by which her approbation was to be directed, as much at least as she would have done, if she had got Aristotle by heart and all his commentators.'[21] Ramsay might well have added his own name to those of la Tour and Lambert, as indeed he added Hogarth's a few lines later, but he comes as close as he needs to declaring the aesthetic of his own painting.

Both the principles and the method of the *Dialogue on Taste* confirm the importance of Ramsay's friendship with Hume. We do not know when this friendship began. It is very likely that it predated 1754, the year in which we know that they were in particularly close touch. Both men were born in Edinburgh and within two years of each other. They both returned from abroad, Ramsay from Italy, Hume from France, to launch themselves on British public life in the same year, 1739, and with the same éclat. In that year, as Ramsay opened his practice in London, Hume began publication of his *Treatise of Human Nature*. Of him it has recently been said, 'He is best known as an empiricist and a sceptic, but his distinctive philosophy lies in his naturalism.'[22] Leaving aside for the moment the question of his scepticism and substituting painting for philosophy, this would serve very well as an account of Ramsay.

Finally and unexpectedly following George Turnbull, in his *Treatise on Ancient Painting* (1740), and ultimately Shaftesbury, Ramsay sees taste in terms of politics. Arguing in effect for the superiority of Gothic architecture he associates this superiority directly with political ideas: 'All the states of Europe, who at this day enjoy any of the blessings of good government, are ready to own that from this Gothic source these blessings were derived. But they [the Goths] were not like the Romans, a gang of meer [sic] plunderers, sprung from those who had been but a little while before ... naked thieves and runaway slaves.'[23] For this reason Gothic architecture was somehow quite separate from the Middle Ages. 'For many ages had bishops and barons, monks and knights errant, kept the people of Europe in slavery and dissention, sloth, ignorance and misery. ... At last about the fourteenth century, the cloud of ignorance began to disperse. The

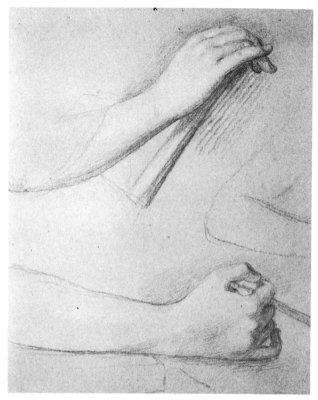

14. Allan Ramsay. *Two Studies of a Lady's Right Forearm and Hand Holding a Fan (Queen Charlotte). c. 1762–65.* Cat. 21

arrogance and avarice of the Church of Rome had stretched the cord till it cracked and brought on in several parts of Europe an inquiry into the spiritual rights of mankind which that corporation had so grossly invaded; and these having been so interwoven with their temporal rights, the enquiry always became the more extensive, the farther it proceeded.'[24] The revolutions of the seventeenth century were a continuation of this process, and that of 1688 its culmination, with the consequent development, by Pope and his contemporaries, clearly including Ramsay's own father (though he does not name him), of a poetry drawn like that of the great poets of the past directly 'from the pure fountain of nature'.[25] Incredulously Lord Modish sums up this part of Colonel Freeman's argument: 'So then, good taste in poetry proceeds from good poetry, good poetry from good philosophy, and good philosophy from good government. A very curious genealogy.'[26]

From Ramsay's two principal essays it is possible to see how very close he was to Hogarth as well as to Hume, but it is also possible to recognize some of his father's convictions underlying his own. The elder Ramsay's vision of the strength and simplicity of the art of his forefathers is surely recognizable in his son's vision of the Goths. Both men advocate a kind of naturalness in art which precludes the imitation of anything other than the world that the artist knows. With both father and son, 'We are not carried to Greece or Italy for a Shade, a Stream or a Breeze. The Groves rise in our own Valleys;

the Rivers flow from our own Fountains, and the Winds blow upon our own Hills.'[27] Finally, both associated these qualities in art with social and political good though they saw the circumstances differently.

The *Dialogue on Taste* is therefore a pointer to Ramsay's increasing self-awareness as a painter as well as to the complexity of his own view of his art. As such it is useful, but it is hardly indispensable. The evidence of his painting as it evolved during the 1750s is plain enough. His whole vision of the nature of portraiture is enlarged, not as it was for Reynolds, by the incorporation into his vocabulary of devices from elsewhere, but from within the resources of portraiture itself by the subtlety and completeness of the account that Ramsay is able to give of the sitter before him. As at the beginning of his career he showed his capacity to the full in his portrait of his first wife, so in the 1750s in the painting of Margaret Lindsay, his second wife, with whom he eloped in 1752, he demonstrated the extraordinary scope of his new style.

The exact date of *Margaret Lindsay, Mrs Allan Ramsay* (col. plate 6) is unknown. It is thought that it dates from immediately after the Ramsays' return from Italy in 1757.[28] It is certainly a summer picture because of the flowers, but it might date from an earlier summer in their marriage, from 1753 or 1754; the colour and even the 'touch' are reminiscent of French pastel painting in a way also apparent in pictures of that date, such as *Lady Walpole Wemyss*, but which was more fully digested by the end of the decade. Though the date is doubtful, there is a strong suggestion of place. Mrs Ramsay is undoubtedly in her own house. It could be Edinburgh, but is most likely to be London. Her activity, arranging a posy of garden flowers, identifies her as the mistress of the house. The hint of sunlight on the shutter behind her suggests an open window and the garden beyond from which the flowers have come.

The picture is a role portrait therefore, but Ramsay goes further than presenting his sitter as a wife and the creator of the domestic environment in which she is seen. He identifies her as his own wife. By exquisite subtlety of expression, gesture and movement, he has recorded her reaction, interrupted in an absorbing task, and turning with open features to respond to a familiar voice or step. Thus he records his own presence and her response to him. The intimacy of such a portrait or of the wonderful red-chalk drawing that he made of her (plate 15) was hardly appropriate to Ramsay's professional practice, but the delicacy of perception and execution on which it was based remained an integral feature of all his painting until he ceased to paint creatively. Even in the royal portraits, which increasingly absorbed his time, we are made aware of the person inhabiting the role. In the finest of these, for example *Queen Charlotte and her Children* (plate 16), as a consequence of the discrepancy between the person and her status as queen, there is a hint of pathos that might have intrigued Goya.

In the decade 1749–59 Ramsay's technique underwent a considerable change. He abandoned the red underpaint-ing universal in his earlier work and to which Vertue took exception. It had given warmth and solidity to the heads in his paintings, but now he adopted a much looser touch over a grey or light-toned ground. At the end of the decade, when he painted his friend William Hunter (col. plate 7), the surface of the flesh is broken into a multitude of tiny flecks of colour. But as before, there is nothing of the decorative surface of the rococo. There is no hint of bravura and his technique is still dictated by his perception of light, which is now much softer and so allows him to explore with ever greater subtlety the details of physiognomy. The portrait is quite at home with Hunter's three superb Chardins, and Chardin is the only one of Ramsay's contemporaries with whom he can be compared.

This delicacy of observation is not restricted to the head and hands. Even in a formal bust-length oval, like the lovely portrait *Anne Broun* (1763) (col. plate 9), costume is completely integrated into the painting by colour and light to endorse the unity of the image and so our sense of the sitter's presence. But there is nothing extraneous, nor does the artist intervene to remind us of his presence. He is there only as we are, as a party to the mutual awareness suggested by the sitter's glance. In a painting like this or in the pair of portraits of the *Earl of Elgin* and his wife, *Martha, Countess of Elgin* (1762) (col. plate 8) portrait painting is raised to the very highest level entirely within the terms of reference appropriate to it as a natural and social art.

Even by 1760 and in *William Hunter* (col. plate 7), the softening of Ramsay's technique begins to erode the solidity of the head, as though light can suggest but cannot fix the tangible world. By the mid-1760s this quality is at times so marked and the paint so thin that his sitters seem almost evanescent, fixed only by their clothes. Jean Jacques Rousseau, for example, whose portrait Ramsay painted for Hume, not only seems about to turn from us to vanish in the darkness, but, except for the luminous eyes, seems scarcely present as solid flesh. Such a mysterious, elusive quality is appropriate to the sitter in this case, and is brilliantly contrasted in Ramsay's portrait of *Hume* (plate 17), painted as a companion to it. In place of Rousseau's indefinable, exotic costume, Hume wears the resplendent red frogged coat that he adopted as appropriate to his status as secretary to the British ambassador in Paris. As Rousseau turns away, Hume turns towards us and fixes his clear grey eyes upon us. Ramsay's command is such that in each case we see the philosophy in the man, yet for all the contrast between them in characterization, Hume in the end is as little defined as Rousseau. The light can only fix a fragile image in the darkness which may at any moment reassert itself. The subtle use of shadow in both these pictures suggests that Ramsay was looking carefully at Rembrandt and with such complex and intimate portraits he could certainly approach the Dutch painter on common ground.

In some of the late female portraits the colour is exquisite, composed with the delicate interchange of a

marvellous piece of chamber music. It is difficult to imagine anything more delicately constructed than the colour of *Mrs Bruce of Arnot* (col. plate 10) for example, yet the effect is further than ever from being decorative; in fact in a strange way it is almost austere. In these late portraits, as the solidity of the head progressively diminishes, colour, orchestrated through the whole design, holds it and prevents it from becoming altogether recessive. Thus in *Mrs Bruce* the most delicate touches of pink and grey in the flesh tints gain substance by the way in which they echo the colours of her costume. The features are scarcely defined, yet are made legible by this subtle counterpoint.

From 1757, when he painted his first portrait of George III, then Prince of Wales, Ramsay was increasingly in demand as a provider of royal portraits. Although on George II's death in 1760 he did not succeed immediately to the office of king's painter, from that date he enjoyed a monopoly which by the end of the decade had become an industry. As this both absorbed much of his energy and provided a generous and steady income, it is understandable that the rest of his practice declined, until an accident to his arm in 1773 may have prevented him from painting altogether.[29] The twentieth century has been inclined to see this withdrawal from painting as backsliding. It demands absolute commitment from its artists; anything less invalidates their claim to be genuine. Whatever the reasons for Ramsay's withdrawal, however, a fundamental lack of interest in his art cannot have been one of them. The man who painted *Mrs Bruce of Arnot* in the late 1760s was not a man for whom painting had become merely a chore.

Ramsay was a leading disciple of Scottish eighteenth-century empiricism. He was, too, a close friend of Hume, extremely self-aware and noted by his contemporaries for his intellect. The disturbing consequences of the discovery of the limits of empirical knowledge applied to the human condition, so ably and with such consequence demonstrated by Hume, cannot have escaped his attention. As he worked out his own treatise of human nature in his painting, Ramsay shifted from a position of empirical certainty, seen in the portrait of Anne Bayne, to one in which perception can only suggest and knowledge is held together by the imagination alone, as it is seen in the portrait of Mrs Bruce. Here he parallels Hume very closely. For Hume it is the imagination that makes it possible for us, dependent as we are on perception, to cope with the limited nature of perceptual knowledge. But it is in the perpetually present mystery of our separation from the minds of those around us that we are most constantly reminded of the limitations of our own understanding. At this point portrait painting confronts one of the central mysteries in the nature of knowledge. Perhaps the next step from Ramsay's late portraits is towards the

shifting relative world presented by Degas in his portraits a hundred years later.

If at the end of his active career Ramsay was indeed confronting what might be called the sceptical dilemma of portraiture, it would not be surprising if he felt he could take the matter no further. Although he was very much at the centre of intellectual life in London during the last two decades of his life, he was artistically isolated after Hogarth's death in 1764. Reynolds, never charitable, is reputed to have said of him that he was a man 'of remarkable good sense, yet not a good painter', a remark that would suggest that as far as Reynolds was concerned—and he was a leader of taste—Ramsay was for the scrap heap.[30] Of his other contemporaries, Gainsborough saw the poetic quality in Ramsay's late style and exploited it to the full in his own painting of the 1770s. But Gainsborough's insubstantial and poetic painting, though derived from Ramsay, only underlines the irrelevance of

16. Allan Ramsay. *Queen Charlotte and her Children. c.* 1764. Oil on canvas, 208 × 137 cm. Her Majesty The Queen

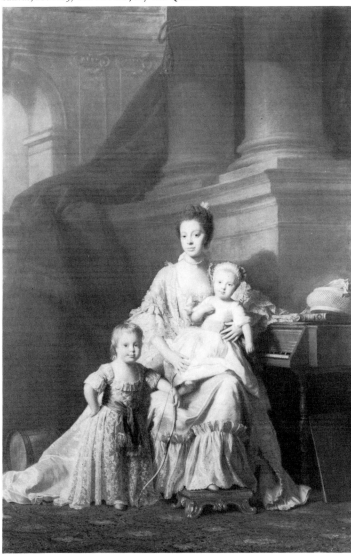

OPPOSITE 15. Allan Ramsay. *Margaret Lindsay. c.* 1757. Cat. 24

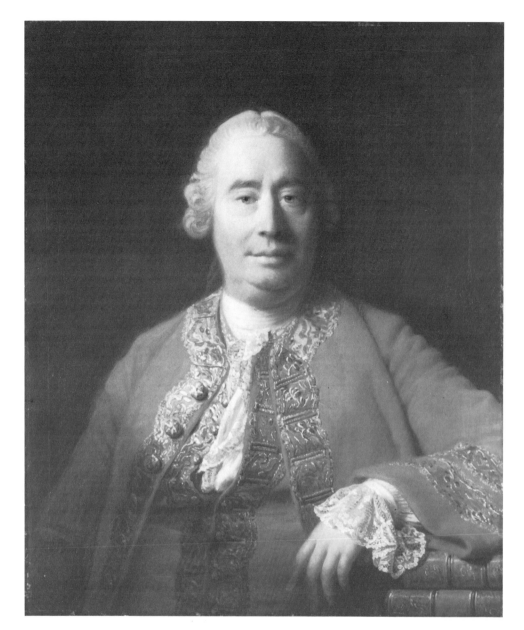

17. Allan Ramsay. *David Hume*. 1766.
Cat. 29

Ramsay's real convictions about the nature of perception to the way in which English painting was developing. That is ironic, for it is because of his ideas about perception that it is possible with Ramsay to speak for the first time in British art of painting as concerned with the nature of knowledge, with the relation between seeing and knowing, the preoccupation that we are taught to believe eventually shaped modern art. The conflict between English and Scottish taste later helped to bring about a crisis of self-doubt for Wilkie. It would not be improbable if something similar was a factor in Ramsay's withdrawal.

Ramsay's best paintings, particularly those of the last decade of his active life as a painter, will always be among the supreme achievements of British art. If his style was never naturalized in England, it did, however, bear fruit in Scotland. The relationship between his painting and Raeburn's is matter for a later chapter. For the moment it is sufficient to say that Raeburn's achievement would not have been the same if he had not had Ramsay's to build on. In perpetuating Ramsay's memory in Scotland there were two of his assistants who continued to play an active role in Scottish art. David Martin worked with Ramsay for twenty years from 1752 before establishing his own practice in Edinburgh, where he worked until his death in 1797. Alexander Nasmyth, who worked in Ramsay's studio from 1774 to 1778, lived on till 1840.

III

The Epic Style

'A Hero without Passion is, in Poetry, as absurd as a Hero
without Life or Action.'
The Earl of Shaftesbury, CHARACTERISTICKS, 1714

Allan Ramsay spent much of the last part of his life work-
ing on what was essentially an archaeological project, the
identification of the site of Horace's Sabine villa. His
interest in the subject dates from at least as early as his
second visit to Italy in 1755[1] and it was a major preoccu-
pation on his two subsequent visits in 1775–77 and in
1782–84. He died at Dover on the return journey from
his last visit. His careful assessment of the evidence, liter-
ary, topographical and archaeological, was set out in an
unpublished essay, 'An Enquiry into the Situation and
Circumstances of Horace's Sabine Villa', largely written
during these last two visits. His interest in Horace has
rightly been associated with his father's lifelong admira-
tion for the poet, expressed not only in his poetry, but
in his life style.[2] The house that father and son built,
known grandly as the House of the Muses, or less respect-
fully as 'Guse-Pie House', and which still stands on
Castlehill in Edinburgh, was conceived as a Horatian
villa, a suburban retreat for the poet from the noise of
the city.

The painter was loyal to his father's memory in the
character of his quest as well as in its subject, for it was
to be a practical demonstration of the truth of the elder
Ramsay's idea that true poety reflects a real landscape.
The main objective was to identify the landscape that
Horace knew and loved and to match it with his poetry
and thus to prove the poet's naturalism. As a literary exer-
cise Ramsay's work was preceded by a similar under-
taking drawn on a larger canvas, Robert Wood's *Essay
on the Original Genius of Homer*. This was published
in 1769, but was the result of two journeys that Wood
made to the Aegean in 1742–43 and 1750–52. His original
objective had been to prove that Homer likewise was a
naturalistic poet by matching his poetry to the actual
landscape that was the scene of the events that he des-
cribed. Wood's inspiration for this project was in turn
the *Inquiry into the Life, Times and Writings of Homer*
by Thomas Blackwell of Aberdeen, published in 1735. It
was in this very influential book that the idea of Homer,

the natural poet, first appeared and as such he is readily
recognizable as one of the elder Ramsay's 'good old
bards'. 'Here then was Homer's first happiness; he took
his plain natural images from life; he saw warriors and
shepherds and peasants such as he drew.'[3]

Corresponding to the links and analogies between
Wood and Blackwell, and between Blackwell and the
elder Ramsay, the younger Ramsay's own project may
have been quite closely linked with Wood's. The two men
were friends when they were both in Rome in 1754 and
1755 when Wood was acting as tutor to the Duke of
Bridgewater. Wood had recently published, with James
Dawkins, *The Ruins of Palmyra*, one of the first scholarly
publications on the antiquities of the eastern Mediter-
ranean, which, if nothing else had done, would have made
him an object of interest to Ramsay. In addition Wood
was formulating his ideas on Homer at the same time that
Ramsay was first becoming interested in his Horace proj-
ect. According to Wood, he first set out his ideas on
Homer in a letter to Henry Dawkins in 1757.[4]

The ideas of Wood and Blackwell were central in the
genesis of the pictures on which Gavin Hamilton's repu-
tation was built. So too was another antiquarian connec-
tion of Ramsay's, Blackwell's associate in Aberdeen,
George Turnbull, whose *Treatise on Ancient Painting*
was published in 1740. In Italy, in 1738 Ramsay had
assisted Turnbull with some negotiations over the plates.
Ramsay and Hamilton had considerable interests in com-
mon and it is not at all surprising that they should have
become good friends during Ramsay's last two visits to
Rome, where Hamilton had been a permanent resident
from 1756. There is no evidence for their earlier contact,
but it is very probable that their common interests had
brought them together when Hamilton was pursuing a
rather desultory career as a portrait painter in London
from 1751 to 1756, or in Rome, where he followed the
Ramsays in the latter year.

Gavin Hamilton (1723–98) (col. plate 11) was ten years
Ramsay's junior. He came from the west of Scotland, and

like Aikman he was a minor country gentleman turned professional. He studied at Glasgow University before going to Italy in the mid-1740s to join the studio of Agostino Masucci. At this early date he may have had some Jacobite connection. Masucci had worked for the Jacobite court and among Gavin Hamilton's early works are *William Hamilton of Bangour*, a portrait of the Jacobite poet, who was in exile in France from 1746 until his death in 1754, and the altarpiece of the Scottish church in Rome, S Andrea degli Scozzesi, which has a traditional attribution to him. Its subject is St Andrew led to martyrdom, a particularly appropriate choice in the Stuart church after the failure of the 'Forty-Five. If the picture is indeed by Hamilton, it suggests that he was more interested in the expressive traditions of the seventeenth century in Italian painting than in the decorative language of the late Baroque, and a similar taste for the dramatic continued to inform his painting during the first half of his career.

Hamilton's interest in Greece also dates from his first stay in Rome. He was friendly there with James Stuart and Nicholas Revett, who left in 1751 on an expedition to Greece, from which eventually resulted *The Antiquities of Athens*, one of the most important publications in the whole Greek revival. They were encouraged in their proj-

ect by Robert Wood in Rome in 1750. Hamilton may even have planned to go with them, but instead returned to London to try to make his living as a portrait painter. His heart does not seem to have been in it, however, and a friend reported to his father on 2 July 1751, defending Hamilton against a charge of indolence: 'I must own he very often requires a spur to industry, it often happens that he is not in the humour of painting and loves to indulge himself in thinking of fine pictures and fine compositions, but this sort of indulgence is very natural to a man who has been so long in Italy, and will wear off by degrees in England.'[5] Dreams of fine pictures got the upper hand, however, and five years later he returned to Italy to settle there permanently, though he seems to have visited Scotland at least once in later life.

In Italy two of his earliest commissions can be associated with Robert Wood. One is the lost *Anger of Achilles* for the Duke of Bridgewater, to whom Wood was tutor, and the other is a portrait of Wood himself, together with James Dawkins at the ruins of Palmyra. This was commissioned by Henry Dawkins in 1757 to commemorate James Dawkins's death in the same year. It is a truly enormous painting and belongs to Glasgow University. It was possibly the following year that Hamilton received the commission from Lord Compton for *Andromache*

18. Gavin Hamilton. *The Anger of Achilles for the Loss of Briseis*. 1769. Cat. 31

mourning *the Death of Hector*. It was completed in the summer of 1760,[6] though only the sketch survives. It was the first of a set of six monumental paintings from the *Iliad* which Hamilton painted over the next fifteen years or so (plates 18–23). Although they eventually formed a narrative series they were not painted in any particular order. The second to be painted was *Achilles mourning Patroclus*, commissioned by James Grant of Grant in 1760 and completed in the summer of 1763.[7] In that year Hamilton received the commission for *Achilles' Revenge upon the Body of Hector* from the Marquis of Tavistock. This was completed by 1766 by which date the fourth picture, *The Parting of Achilles and Briseis* had been commissioned by Viscount Palmerston, later Lord Shelburne.[8] Then Hamilton slowed down. *The Anger of Achilles for the Loss of Briseis* was engraved in 1769. *Priam pleading with Achilles for the Body of Hector*, for Lord Mountjoy, was engraved in 1775 while the last to be painted, *Hector's Farewell to Andromache*, may not have been commissioned by the Duke of Hamilton till 1777. It must however have existed as a sketch at least four years earlier, when this was the subject set for the prize competition, the Concorso Balestra, in the Accademia di San Luca, which was won by Hamilton's protégé, David Allan.[9] Not only was Allan's winning entry a version of

Hamilton's composition, but so too were at least two other entries which have by chance survived.[10] The picture must have been well known even as a sketch. The specification of the subject for the competition is preserved in the archive of the academy. It reads like a detailed description of Hamilton's picture.

The Abbé Peter Grant wrote of the first in the series that it was 'the best piece of modern painting I have ever seen'.[11] For the *Patroclus*, the second subject painted, Hamilton was paid the very large sum of £350 and was able thereafter to maintain his price of £50 a figure. By 1767 John Aikman of the Ross (of the same family as the painter Aikman) was able to write of him as follows: 'Mr Gavin Hamilton . . . is what the Italians call the Premiero, and we call the Principal, in the Academy of Painting at Rome, and all the young students apply to him for Direction and Instruction in their Studies. . . . He is a sweet blooded gentleman, and being the most renowned of all the History Painters of this age is highly respected at Rome.'[12] The occasion for this letter was the preparation for the journey to Rome of Anne Forbes to study painting. She was yet another artistic member of the Clerk connection and one of the few women artists in the eighteenth century to enjoy a full professional training. It was paid for by a subscription among her friends and relatives in

19. Gavin Hamilton. *Hector's Farewell to Andromache. c.* 1775. Oil on canvas, 315 × 395.6 cm. University of Glasgow

Edinburgh and she was chaperoned in Italy by her mother. She was just one of a large number of young Scottish artists who gathered round Hamilton in Rome in the 1760s and 1770s. Through him it became a second centre for Scottish painting, and, after the Italians, the Scots were the largest single group in the Accademia di San Luca in the time of his presidency.

When the Abbé Grant wrote about Hamilton's first *Iliad* picture as 'modern' he certainly only meant to distinguish the picture chronologically from the painting of the past. The word had none of the stylistic meaning that it now has, but in this case it could have done. In spite of their classical vocabulary Hamilton's pictures must have looked quite novel and their distinctive qualities are also self-conscious. First of all the paintings are enormous, averaging 9 by 13 feet. The figures too are large within the picture frame and, though not particularly refined in drawing, are solid and separate. They are not linked by the rhythms of the Baroque, but are held together by more stable compositional devices. They tend to be related visibly to the plane of the picture and this has been several times attributed to the influence of Poussin. Poussin was certainly in Hamilton's mind, at least incidentally, for Hamilton was advising the Abbé Grant on the purchase of prints after that artist for James Grant of Grant at the time that he himself was painting *Achilles*

mourning Patroclus for the same patron. Poussin's example may well have had something to do with what might be called the visible seriousness of his paintings, though he, like Poussin, also went directly to Roman relief sculpture for inspiration and to the Renaissance narrative art that was inspired by it. In the end, however, his use of overwhelming scale is completely at odds with Poussin's controlled classicism.

Following this connection with Poussin, it has been suggested more than once that the initial stimulus for Hamilton's Homer pictures was provided by the book, *Tableaux Tirés de l'Iliade ... de Homere*, published in 1757 by the Comte de Caylus.[13] Caylus was a leading French connoisseur and champion of the revival of interest in Poussin in France, which was part of the development of French neoclassicism. This would also link Hamilton with Winckelmann and the painter Anton Raphael Mengs in Rome, who were likewise pioneers of the new neoclassicism. Winckelmann's approval of the first of Hamilton's *Iliad* pictures is recorded,[14] but so too is Hamilton's awareness of his difference from Mengs. Mengs's sister specialized in miniature copies, and in 1760 Hamilton expressed extreme reservation about having one of his pictures copied by her as had been proposed: 'Hamilton ... shows great aversion to its going to Mengs house for he is persuaded that gentleman will criticise it

20. Gavin Hamilton. *Achilles mourning Patroclus*. 1760–63. Cat. 32

too much and that his criticisms will do him prejudice.'[15]

In later life Hamilton did move much closer to international neoclassicism, but at this date it is irrelevant; so too is Caylus's book. It is in the first place extremely patronizing towards painters. Caylus's avowed purpose in writing it was to compensate for 'un certain manque de sçavoir, dont on peut faire se réprocher aux peintres'.[16] This was hardly an opening to attract a painter as literate as Hamilton. Caylus then proceeds to divide Homer into 137 tableaux, including several subjects for continuity that he admits would be inappropriate as paintings. Even so he manages to miss out the subject that Hamilton chose to begin his six pictures, *Andromache mourning the Death of Hector.*

On two points in particular Hamilton and Caylus are completely at odds. The first is the supernatural. The gods play such an important part in Caylus's catalogue of compositions that he writes at one point, after introducing yet another god riding on a cloud: 'Au reste on ne doit pas critiquer la répètition des nuages que l'on voit dans le plus grand nombre de ces compositions: il faut les régarder comme la voiture générale des dieux.'[17] Hamilton has no gods in his paintings, in spite of the central role that they play in the *Iliad.* He shared a point of view with Ramsay, who was very severe in such matters, criticizing even Shakespeare for offending against the

natural order by introducing the supernatural.[18] He was at one with Courbet in his famous dictum: 'Show me an angel and I will paint you one.'

The attitude to the supernatural that Ramsay and Hamilton shared in this way probably also reflects a common interest in the writings of the Earl of Shaftesbury who was also very much against that kind of thing. In his celebrated essay on the Judgement of Hercules as a subject for painter or sculptor, Shaftesbury had written: 'That a historical and moral piece must of necessity lose much of its natural simplicity and grace, if anything of the emblematical or enigmatick kind be visibly intermingl'd.'[19] The link with Shaftesbury also provides a clue as to how Hamilton's art, although not naturalistic in the modern sense like Ramsay's, was so in its own terms. Human nature was its subject, not seen empirically but through the medium of the poetic imagination. It is a kind of moral naturalism where, in Shaftesbury's words, 'not only men but Manners and Human Passions are represented.'[20] Elsewhere, making specific reference to Homer and with an obvious bearing on Hamilton, Shaftesbury amplifies this to say, 'The able Designer who feigns in behalf of the Truth, and draws his characters from the Moral Rule, fails not to discover Nature's Propensity, and assigns to those high spirits (e.g. Achilles) their proper exorbitancy and inclination to exceed in that Tone or

21. Gavin Hamilton. *Achilles' Revenge upon the Body of Hector.* 1764. Cat. 33

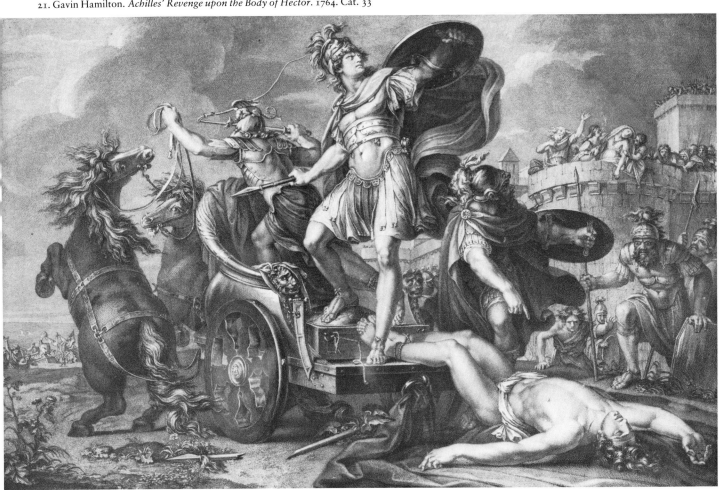

Species of Passion, which constitutes the eminent or shining part of each Poetical Character.'[21]

Shaftesbury's influence seems also to be apparent in the second point on which Hamilton is at variance with the Comte de Caylus, the matter of scale. Caylus recommends that the pictures he proposes should be Poussin-size, not more than 3 or 4 feet high. His reasons are partly practical, to make it possible to accommodate the vast number of canvases that he proposes, but they are also aesthetic. The pictures should be small because, he says, humanity derives pleasure from the feeling that it can dominate even inanimate objects. It is with the same understanding that Hamilton uses scale in precisely the opposite way. His pictures are gigantic in order to impress and overwhelm. Shaftesbury recommends that the figures in *The Judgement of Hercules* should be 'taken as big, or bigger than the common Life; the subject being of the Heroick kind, and requiring rather such figures as should appear above ordinary human stature'.[22] Elsewhere he gives Aristotle as the classical authority for this opinion and adds 'a small remark of my own which may perhaps be noticed by the Studiers of Statuary and Painting; that the greatest of the ancient as well as the modern artists were ever inclined to follow this rule of the philosopher; and when they err'd in their Designs or Draughts, it was on the side of the Great, as running into the unsizeable and gigantic, rather than into the minute and delicate. Of this Michelangelo, the great beginner and founder among the Moderns, and Zeuxis, the same among the Ancients may serve as instances.'[23]

Shaftesbury was really the founder of the British tradition of philhellenism. He saw Greece as the prototype of cultivated and liberal Whig democracy, in opposition to uncultivated Roman tyranny, a view clearly shaped by the events of 1688. Ramsay, as we have seen, adopted this idea in his *Dialogue on Taste*, replacing the Greeks with the Goths. Shaftesbury's ideas about the seriousness of art very likely underlay Hamilton's own approach to painting as they did Hogarth's, but Hamilton may have encountered such ideas more directly through the teaching of Francis Hutcheson at Glasgow, where he was professor of moral philosophy when Hamilton was a student. Hutcheson was himself an original thinker as well as an influential one (Hume's naturalism for example is attributed to his influence), but he was also profoundly influenced by Shaftesbury. Apart from any influence on his philosophy, his introduction of the study of Greek literature at Glasgow, which has an obvious bearing on Hamilton's career, was a characteristic response to Shaftesbury's philhellenism.

Hutcheson's idea of the equation of the moral and the aesthetic sense, and that both are rooted in experience,

22. Gavin Hamilton. *Priam pleading with Achilles for the Body of Hector. c.* 1775. Cat. 35

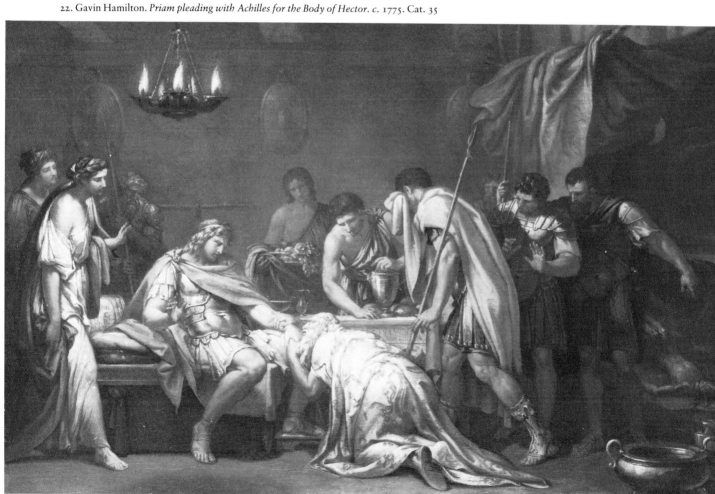

may also have been stimulated by Shaftesbury's attitude to art.[24] It was an idea that had something very real to offer to the self-respect of artists who may have come under his influence, while also encouraging naturalism, though this may not be of a kind that we would immediately recognize as such.

In turning to Homer, Hamilton was probably responding to all these influences, but also particularly to that of yet another Scottish follower of Shaftesbury, George Turnbull, whose *Treatise on Ancient Painting* (1740), was a very influential book. Hamilton may not have met him until 1765 when Turnbull passed through Rome on a journey to Greece, but considering Hamilton's career one might well suppose that the book, which was brand new when he was a student at Glasgow, had a decisive influence on him from that date. Turnbull took as his starting point Shaftesbury's view of Greece and of the importance of art. He argued that the encouragement of all the arts had a central role to play in the development of a nation. Not only did Greek art flourish because of Greek liberty, it was itself a contributory cause of that liberty. It did so by promoting 'Virtue and Public Spirit'. To establish this, Turnbull gave a very full and accessible narrative account of the history of Greek art, but it is especially important that he did so as an avowed champion of painting. The common view, reiterated by Caylus, was that painting was inferior to poetry because it could neither convey time nor any other abstract idea, except through the use of allegory and personification. Turnbull's declared purpose in writing his book was to demonstrate the specific importance of painting among the arts. By proving its importance in ancient Greece, 'The conclusion that is principally aimed at is the Connexion of Painting with Poetry and of both with Philosophy.'[25]

In Turnbull's account of the history of ancient painting Homer has a central place. He begins with the description of the shield of Achilles from the *Iliad* as proof that painting and poetry are at least coeval, but then proceeds to stress constantly the importance of Homer as the central inspiration for classical Greek art. 'For this we are sure of that the best ancient Statuaries and Painters studied Homer constantly: from his writings they took almost all their ideas and subjects; whatever Affections, Passions, Virtues, Vices, Manners, Habits, or Attitudes they drew: whatever Characters of Gods, Demi-Gods, or Men and Women they represented they had Homer always in their view as their best pattern to copy after. Zeuxis was considered by the Painters as their Legislator with respect to Divinities and Heroes because he had followed Homer as his.'[26]

One of the most important examples that Turnbull gives of Homeric painting is the paintings of Theodorus

23. Gavin Hamilton. *Andromache mourning the Death of Hector.* 1764. Cat. 36

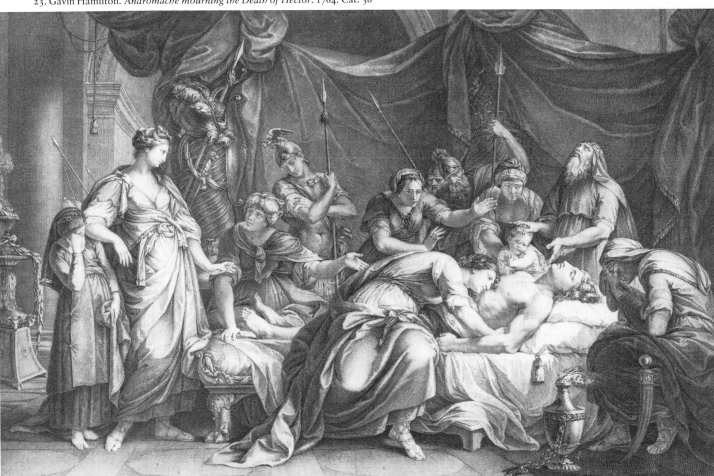

'who is said to have represented the whole war of Troy in several pieces'. He associates these paintings, in Rome in Pliny's time and so probably in Virgil's, with Virgil's description in the first book of the *Aeneid* of the paintings of the Trojan war that Aeneas saw in Dido's temple of Juno. This association, he says, shows 'how nearly allied painting and poetry are'. He then concludes: 'To these reflections it may be added that Painting plainly admits the same Variety as Poetry. . . . There is plainly the Epick, the Lyrick, the Tragick, the Comick, the Pastoral, the Elegiack, in the one art as well as the other. Those Pictures for instance, which described the Siege of Troy were as properly Heroick Pictures, as a poem having that for its subject is an Epick Poem.'[27] This is really the text for Hamilton's undertaking.

The information that Turnbull was presenting was of course not new. Classical authors' accounts of the paintings of ancient Greece had been a key inspiration in Renaissance painting. Homeric subject matter, however, was on the whole fairly rare. Theodorus' paintings of the Trojan war had probably been the inspiration for Giulio Romano's paintings of the same subject in the ducal palace at Mantua. Rubens had done a series of tapestry cartoons of the life of Achilles, and Pietro Testa had made several etchings of subjects from the Trojan war. There were also occasional pictures, such as Poussin's *Achilles among the Daughters of Lycomedes*. There had been illustrated editions of the *Iliad*, but Turnbull's stress on Homer was nevertheless a new emphasis in the long relationship of modern art to the antique. This was the result of the new attitude to Homer pioneered by Alexander Pope, whose translation, published from 1715 to 1726, was the standard English text in the eighteenth century, and by Thomas Blackwell, Turnbull's teacher in Aberdeen.

Hamilton's pictures are part of this new attitude to Homer. To see this, however, it is necessary to appreciate that the six pictures were a single work in Hamilton's mind. In a letter to the antiquarian Carlo Bianconi, written in 1768, when apparently only three of the pictures were complete, he mentions 'the three other subjects to be done to complete *the work*'.[28] There was, however, no question that they were ever thought of as a single commission. In 1765, the year after the first of his prints had been published, he wrote to Viscount Palmerston: 'I should be glad to know what your Lordship thinks of my print of Andromache bewailing the Death of Hector: it is the first of a set of six prints I intend to publish from Homer, and consequently I am anxious about the success of it.'[29] He refers several times in his letters to the prints and they were clearly of great importance to him. Sadly, however, no doubt because of the slow production of the paintings, the last, *Hector's Farewell to Andromache*, was apparently never engraved.

Hogarth may not seem an obvious source of inspiration for pictures with such classical subject matter, but it is quite clear from the history of the engraving of his own pictures, and its success, that Hamilton had fully understood the importance of Hogarth's enterprise in publishing his own works. In his Homer pictures he was endeavouring to do what Hogarth had tried to do with *Marriage à la Mode*: to give a life to the paintings and independently to the engravings, but to avoid the difficulty that Hogarth encountered in trying to dispose of six pictures at once. There are, in addition, several points of similarity between Hamilton's cycle and Hogarth's *Rake's Progress*, which are apparent if his pictures are looked at in the order of the narrative and not the order in which they were painted.

In the sequence of events in the poem the first scene is *The Anger of Achilles for the Loss of Briseis*. It matches the first scene in *The Rake's Progress*. The heartbroken girl and the expostulating figure of the rake are in the same dramatic relationship to each other as Achilles and Briseis, but in addition, Briseis is in precisely the pose of the girl's mother. The fourth of Hamilton's pictures, *Achilles' Revenge on the Body of Hector*, matches, in its position in the series, the sixth scene in *The Rake's Progress*, where the rake in a gaming house shakes his fist at the heavens. Achilles' pose, except for his left leg, is identical to that of the rake. Finally both series end in a scene of death and mourning and in addition to the general resemblance of the two scenes, Helen in Hamilton's picture looks on in a detached way that might have been suggested by the smart lady visitors in the background of Hogarth's scene, though she also has something in common with the girl in the funeral in *The Harlot's Progress* who peers into the harlot's coffin with chilling, remote curiosity.

The importance of establishing the link with Hogarth is that it suggests that Hamilton's pictures are an integrated cycle as Hogarth's are, rather than being six scenes from Homer chosen for their suitability as pictures and not otherwise linked. This is indeed the case. From all the diverse incident and material in Homer, Hamilton has created a remarkably unified, even symmetrical plot, a study in passion. His starting point was Pope, who in the preface to his translation identified the unity of the *Iliad*, 'the probable fable' as he calls it, as 'the Anger of Achilles the most short and single subject that ever was chosen by a poet'. This is Hamilton's subject too. To reach it, however, in a visually communicable form he has not only cut out all the divine intervention (and the Olympians are principal actors in Homer's poem), he has also cut out all the fighting which occupies four-fifths of it. The only violence in Hamilton's pictures is in the single scene of *Achilles' Revenge on the Body of Hector*. Instead Hamilton concentrates on feeling or passion.

He identifies three key moments in the story of Achilles, and to throw Achilles' anger into relief, he gives equal weight in his series to the story of Hector and Andromache, thus creating a series of parallels or contrasts by which he is able both to explore a whole range of feeling and to keep the drama within the bounds of human possibility. To do this he has also to humanize Achilles. He does this at the beginning, following a lead

suggested by Pope, by showing him in *The Anger of Achilles for the Loss of Briseis* as motivated not merely by injured pride but also by affection for the girl. While he swears revenge on the Greeks for the insulting loss of his prize, she is no mere passive chattel, but looks back with a sad glance as she is led away by the heralds of Agamemnon. Achilles' violent anger, prompted both by injured pride and by love, is contrasted to the gentle love and family pride of Hector in the second scene, *Hector's Farewell to Andromache*, where Hector meets his wife and son at the gate of the city on his way to battle.

On consequence of Hector's success in the absence of the Greek champion Achilles, Patroclus rejoins the battle and is killed by Hector. The third scene shows Achilles mourning his dead friend, his anger rekindled now by love and grief. He vows a new revenge, this time on Hector and the Trojans. The violence of his grief here is contrasted to the tragic sorrow of Andromache in the sixth and final scene where she mourns Hector. It also leads directly to the death of Hector and the terrible piety of Achilles' grief for Patroclus is contrasted to the violence of his desecration of Hector's corpse in the fourth picture. In the background of this Andromache, Hecuba and Priam stand on the battlements of Troy, distracted with sorrow. Achilles' ferocious revenge is in turn contrasted to Priam's humility as a supplicant in the fifth scene. At the same time in that picture the denouement begins as Achilles' anger begins to abate.

In Homer, Priam is miraculously transported into Achilles' tent. Achilles yields, not to his supplication, but to the pressure of the gods. There is no hint of this here. Instead there is a simple and moving confrontation. Pope puts a gloss upon Homer's account of Achilles here, which Hamilton follows: 'His anger abates very slowly; it is stubborn, yet still it remits: had the poet drawn him as never to be pacified he had outraged nature, and not represented his hero as a man but as a monster.'[30] Hamilton thus re-stresses Achilles' humanity. His anger is aroused by love, pride and grief and is abated by compassion. His feelings are no different from those of other men, though they are heroic in scale and catastrophic in their consequences.

Catharsis is reached in the final scene. The tragedy of the whole story is focused and completed and its humanity finally confirmed by the grief of Andromache for her beloved husband. In this the last scene again matches *The Rake's Progress*, where the grieving Sarah, by her feeling for the dying rake, affirms his humanity and brings the whole story back to the level of ordinary human experience.

Hamilton has therefore interpreted the *Iliad* to find in it a study in human nature, much as Blake did, a generation later, with *The Book of Job*. Homer is therefore seen as responding to actual experience much as Shakespeare was held to have done, and indeed Shakespeare may have provided models for Hamilton's view of tragedy as he did for Hogarth's. In interpreting Homer, however, Hamilton has preserved the rules of art as Ramsay saw them. He takes no poetic licence with his human subject matter but sticks to the constraints that govern human behaviour (in this he implicitly criticizes Homer as Ramsay did), and reveals the essential naturalism of his own position, on which his appreciation of Homer was based.

In formulating the idea of Homer as a natural poet Hamilton's connection with Robert Wood must have been important. Wood's *Essay on the Original Genius of Homer* has been seen as the most important contribution to Homeric criticism in the eighteenth century. His central conviction was that Homer's poetry was rooted in experience and he frequently refers to him as a painter, as one who records his experience directly. Wood, building on Blackwell, put Homer into a real world, both in terms of geography and of history, separating the poet entirely from classical times. 'The Poetic Age of Homer', he writes, 'differed as much from the age of his critic Longinus in all significant things as we do, in these respects, from our Gothic ancestors in the days of Chivalry and Romance.'[31] Homer, according to Wood, was composing in a language that was probably not written down and which lacked sophisticated critical and scientific terms. The whole critical apparatus that had been built upon Homer was therefore quite untrue to him and, as Wood puts it: 'That Homer should escape so entire out of the hands of the Lawyers and Grammarians is a piece of good fortune to Letters.'[32] A later critic wrote 'with Wood, we break away from the tradition of the elders . . . even if it be the monumental work of Alexandrian scholarship; at the touch of Homeric wind from North and West, blowing out of Thrace upon Greek lands and Greek seas, the sleeping beauty has awakened from her Egyptian sarcophagus; from dogmatic slumber to the renaissance of romance.'[33]

The freshness of Wood's vision of Homer was the result of his central conviction that as a poet Homer was describing the real world that he knew. This conviction Wood could have derived from Thomas Blackwell. Blackwell's own point of view, however, differs from Wood's in one important respect which also brings it very close to that of the elder Ramsay. He sees Homer as belonging to an ideal age in the evolution of human society, between barbarism and developed civilization. 'It may be said of Homer, and of every poet who has wrote [sic] well that what he felt and saw that he described: had he been born much sooner he would have seen nothing but nakedness and barbarity . . . later private passions are buried in the common order and established discipline.'[34] It is a view of the development of human society that became familiar a generation later through the writings of Rousseau, but it is used here to argue the poetic advantage that Homer enjoyed.

Our first business when we set down to poetise in high strains is to unlearn our daily way of life. . . . We are obliged to adopt a set of more natural manners which however are foreign to us and must be, like plants,

raised up in hotbeds or greenhouses in comparison to those which grow in soils fitted by nature to such productions. Nay, so far are we from enriching poetry with new images drawn from nature that we find it difficult to understand the old. We live within doors, covered, as it were, from nature's face: and passing our days supinely ignorant of her beauties. We are apt to find similies taken from her low and the ancient manners mean and absurd . . . the moderns can think nothing great or beautiful but what is the product of wealth. They exclude themselves from the pleasantest and most natural images that adorn the old poetry, wealth and luxury disguise nature.[35]

In this long quotation lies the germ of modern primitivism. It is not only concerned with the appreciation of Homer, but with an opposition, to our disadvantage, of the experience available to him with that which we know: 'The marvellous and wonderful is the nerve of the epic strain; but what marvellous things happen in a well ordered state?'[36] What is attractive to the artist is the implication that through Homer, or any other art that comes to us from these remote times, it is possible for the artist to recapture this freedom of sensibility in which

the imaginative fire can burn more brightly.

Blackwell anticipates Rousseau in many ways, but especially in an idea that seems to have been of key importance to Hamilton: that the quality of the epic stems from its reflection of a time when human feelings actually were more intense and more vivid. 'For so unaffected and simple were the manners of those times that the folds and windings of the human breast lay open to the eye: nor were people ashamed to avow passions and inclinations, which were entirely void of art and design.'[37] Hamilton's subject is therefore not only human nature, it is human nature in its natural condition; in the words of Hugh Blair, written on Ossian when Hamilton was engaged on his second Homer picture, it is 'That state in which human nature shoots wild and free' and 'encourages the high exertions of fancy and passion'.[38] Hamilton's paintings from Homer are epic in scale certainly, but, in addition, in them the word epic has a new connotation in the context of painting. We encounter for the first time the belief that the painter can draw a contrast between natural feeling as a feature of a remote and primitive condition of human nature (or later its apparent echo in modern primitive societies) and the stultified condition of the imagination in contemporary life.

24. Gavin Hamilton. *The Oath of Brutus.* 1766. Cat. 39

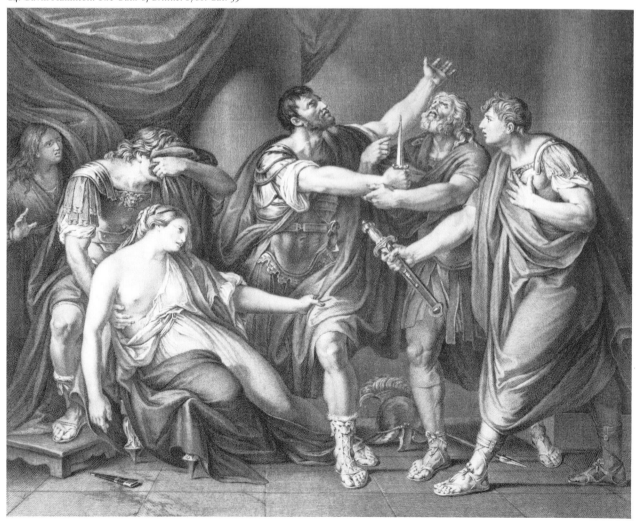

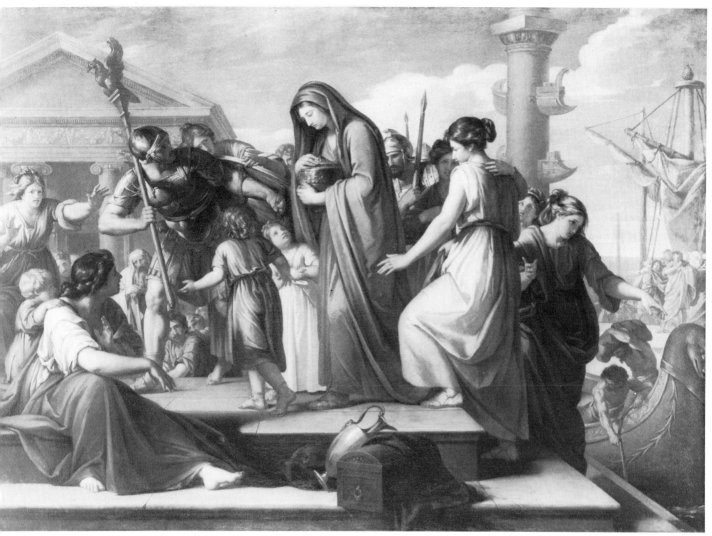

25. Gavin Hamilton. *Agrippina with the Ashes of Germanicus.* 1772. Cat. 38

Hamilton produced two other major canvases during the period that he was working on the Homer paintings: *The Oath of Brutus* (plate 24), which was commissioned for Lord Hope in the summer of 1763 and engraved in 1766, and *Agrippina with the Ashes of Germanicus* (plate 25), commissioned in 1765 by Earl Spencer and exhibited at the Royal Academy in 1772.[39]

Though smaller, the first of these is in the same style as the *Iliad* pictures. The composition is built around interlocking gestures, which are carefully differentiated, as are the expressions. This attention to dramatic clarity suggests Hamilton's continuing interest in Poussin, but equally part of Poussin's own inspiration, the study of classical rhetoric. In contrast to Poussin and to Hamilton's own later pictures, however, the composition is crowded and spaceless. The figures occupy almost the whole picture field in the manner of sarcophagus relief sculpture. They are so dominant that Hamilton's peculiar figure style is very apparent. The individual figures are large in the manner recommended by Shaftesbury, but

they are also massively built with enormous limbs. Brutus, towering above the others, has a huge barrel chest, but a relatively small head. For all their massiveness, however, they do not seem to have much volume. It is not that they are badly drawn, but they represent a kind of drawing in which there is not even a remote echo of the life class. The classical language of forms, originally sculptural, seems to have become an imaginative vocabulary in two dimensions on which the artist can draw without further reference to the real world. This is a point on which Hamilton differs fundamentally from French neoclassicism. David, whose early work was much indebted to Hamilton's Homer pictures, corrected his drawing and his treatment of space, but Runciman, Barry, Fuseli and eventually Blake all followed Hamilton's example, and it became a distinctive feature of British proto-Romantic painting. For Blake it was a way of preserving essential imaginative freedom. As the other painters seem to have derived the approach from Hamilton, it is reasonable to suppose that the idea began

with him and that he too sought to free himself from the limiting need to describe the actual in order to give expression to the natural imagination.

The subject of Junius Brutus swearing to avenge the suicide of Lucretia, ravished by Sextus Tarquinius, and foretelling the establishment of the republic was taken from the heroic age of Roman history. In the picture that followed, *Agrippina with the Ashes of Germanicus*, Hamilton chose a subject from Tacitus and the history of imperial Rome. In spite of this shift towards an apparently more conventionally classical subject the pictures do have a common theme. Brutus actively defied Tarquin and the tyrannical power of kingship. Agrippina passively defied the emperor Tiberius, whom she mutely accused of the murder of her noble husband. The political point of both pictures suggests that for Hamilton the idea of imaginative freedom was allied to that of political freedom as it was for Ramsay. If he had been, or remained a Jacobite, it was of the sentimental kind, and like Burns he felt able to reconcile his Jacobite feelings with a certain amount of radicalism.

Agrippina was a popular subject. It first appeared in a commission given in 1762 to James Nevay, a young Scottish painter in Hamilton's circle. (It took Nevay ten years to complete, perhaps because of the terms of the commission: Lord Strathmore had promised him £100 a year until this and another painting were finished.)[40] Benjamin West painted an *Agrippina* in 1768. Hamilton himself painted *Agrippina Weeping over the Ashes of Germanicus*, a single figure, and exhibited it at the Royal Academy in 1770. Alexander Runciman exhibited *Agrippina Landing at Brundisium* at the Royal Academy in 1781, but had begun to plan a similar subject in Rome in 1770. It is very likely that all this activity began with Hamilton himself as he was generous with his ideas. Certainly in scale and composition the *Agrippina* is comparable to his Homeric pictures, with whose planning it would be contemporary if it was a project going back to 1762, but its subject is sensibility rather than passion.

As early as 1763 Hamilton had begun to dig for antiquities and made increasing profits from this trade. According to the Abbé Grant, for example, he made £2,000 between 1771 and 1774 from the excavation of Hadrian's villa.[41] It is understandable that his output of pictures was not prolific while his trade as a dealer continued to increase. He remained committed to painting, however, and by 1770 he was planning a new series, 'the story of sweet Helen'. It is first mentioned in a letter of December 1771 to Lord Shelburne, but he had evidently discussed it with Shelburne in Rome a year earlier. He mentioned it again in a letter of 1777 to the same patron, writing that 'My great plan in life are those six small pictures representing the story of Paris and Helen.'[42] Hamilton described the pictures as small at this point as he was endeavouring to persuade Shelburne to take them to decorate his sculpture gallery as part of a deal the principal object of which, for Shelburne at least, was the purchase of antiquities. He remained unpersuaded. A few years later, however, Hamilton was given the opportunity to carry out his project in the Villa Borghese as a grand decorative scheme in the Renaissance manner. It seems that he planned it from the beginning as spatially unified. This was why it was so important for him to find a single patron to take it on, in contrast to the *Iliad* cycle with its several patrons. Its original conception around 1770 must have some bearing on the ambitions of Alexander Runciman, Fuseli and Barry to realize similar schemes, all apparently originating at much the same time.

The decoration of the Villa Borghese was one of the biggest projects in painting in Rome in the later eighteenth century. It is a comment on the status of the Scots that, among the various artists involved, the two most important parts of the commission went to Hamilton and Jacob More. More decorated the Apollo and Daphne room, and also laid out the ornamental garden. Hamilton was given the principal room for his *Paris and Helen* cycle. Unfortunately this room is now partially dismantled and the three principal canvases removed to the Museo di Roma.

In its original form the decoration consisted of five canvases on the ceiling, with a large rectangular painting of the *Death of Paris* at the centre and four smaller scenes from the life of Paris around it. Two of these are circular and two octagonal. On the walls were *The Meeting of Paris and Helen*, *The Rape of Helen* and *The Death of Achilles*. *The Rape of Helen* is the largest of these. In its general lines it is closest to Hamilton's earlier paintings, but like the other pictures it has a lightness of tone and daintiness of gesture quite unlike the melodrama of the *Iliad* pictures or *Brutus*. Throughout the series the figures are smaller and more in line with Renaissance models, especially Giulio Romano, than in his earlier work. There is also more landscape and the mood is elegiac. Hamilton even has Venus riding on a cloud to introduce Paris to Helen, as well as several putti, to testify how far he has moved from the strenuous poetic naturalism of his major works, though to be fair, these pictures, unlike any of his earlier works, were intended to be decorative and as decoration they worked very well. The *Sala di Elena e Paride* was one of the finest and most elaborate painted rooms of its time.

IV

An Ossian's Fancy
and a Fingal's Fire

'That state in which human nature shoots wild and free.'
Hugh Blair, ON THE POETRY OF OSSIAN, 1765

Gavin Hamilton's reputation may never again be what it was in his lifetime, yet his achievement can be measured by the fertility of his influence. This was spread through the engravings of his work, but it was equally the result of his own personality and the way he worked. An easy and approachable man, he seems to have kept an open studio and made his plans and projects readily available to the younger artists who surrounded him. Sketches of pictures were apparently visible in his studio sometimes years ahead of their actual execution. The case of *Hector's Farewell to Andromache* acting as inspiration to David Allan in 1773, four years before it was commissioned, has already been mentioned.[1] Copley reported in 1775 that the same subject was on Hamilton's easel and 'had been since I came to Rome'.[2] Alexander Runciman in 1770–71 shows a knowledge of some compositions that Hamilton did not finally execute in his *Paris and Helen* series till nearly fifteen years later.

Hamilton also seems to have been prepared to take an active interest in the welfare of younger artists when the occasion demanded. In the case of Anne Forbes we know from the Forbes correspondence that he willingly made himself available as adviser and overseer of her work, nor is it unkind to suppose that David Allan would not have won his gold medal in the Accademia di San Luca in 1773 without Hamilton's support. If only to oblige his friends at home, he probably took a similar interest in the progress of others among the numerous young Scots in Rome. Alexander Runciman's friend James Clark (not one of the Clerks of Penicuik) travelled to Rome with a recommendation to Gavin Hamilton from the Dalrymples and carried with him several items commissioned by Hamilton, including a smoked glass.[3] This was probably the standard form for all young Scots who travelled out to Rome in the 1760s and 1770s, and they were quite a crowd. James Nevay and Colin Morison were there from the beginning of the 1760s. They were joined in the middle of the decade by David Allan and John Baxter, son of the architect whom Sir James Clerk employed on his new

house at Penicuik. In 1767 and 1768 the Runciman brothers, James Clark, Anne Forbes and the sculptor William Jeans, also employed at Penicuik, all arrived in Rome. John Brown and Richard Cooper joined them at the beginning of the next decade. There were probably others, too, who are not recorded but from this casual academy the Runciman brothers and David Allan stand out.

The Runciman brothers came from the same background in Edinburgh as Allan Ramsay.[4] Alexander was born in 1736 and John in 1744, and many of the people who had transmitted their enthusiasms to the younger Ramsay were still alive during Alexander's youth. The elder Ramsay died in 1758. Alexander was apprenticed in 1750 to Robert Norie, eldest surviving son of James Norie, but James remained an active member of the firm he had founded till his death in 1757. Richard Cooper died in 1764. About that time his son, Richard Cooper junior, travelled to Paris to continue his training as an engraver there, following in the footsteps of his father's pupil, Robert Strange. Before he left for Paris the younger Cooper and Alexander Runciman had worked together in the spirit of friends and fellow students. It seems to have been the elder Cooper who taught the Runciman brothers to etch, a medium that was important for both of them.

Allan Ramsay's theatre had been short-lived, but from the early 1750s a lively theatre flourished in Edinburgh. It exploited a loophole in the law before finally being granted a royal licence in 1769. It may not have had quite as much impact as Ramsay felt his own project would have had, for he had hoped that it

. . . at small expense
had pleased without the least offence
advanced a great way to remove
that scarecrow of all social love
Enthousiastick vile delusion
which glories in stiff-rumpt confusion.[5]

26. James Norie. *Landscape with an Imaginary View of Linlithgow*. Cat. 9

Nevertheless, it provided a focus for a lively and Bohemian milieu. Part of this society was a club called the Cape Club, begun around 1764, of which Alexander was a founder member.[6] It met nightly in one or other of the Edinburgh taverns and for more than twenty years it provided a meeting place for a group of people beneath the rank of gentlemen—drinking porter not claret—but a lively and creative company including actors, painters, poets and musicians. They were united not just by revelry, but by real enthusiasms, especially for music, poetry, art and Scottish antiquities. No figure like the elder Ramsay emerged from among them, but this was perhaps in part because his ideas were by this time more widely accepted, and this group certainly carried on the tradition that he had founded. Their common objective and their community of purpose with the elder Ramsay can be summarized by the declaration of Walter Ruddiman, one of their number, in an editorial in the magazine that he founded, the *Caledonian Mercury*: 'We hope to render our publication not a flimsy retail shop of foreign articles, but a genuine Caledonian magazine.'[7]

Among Alexander Runciman's closest friends, and early members of the Cape Club, were James Cumming, a painter and fellow apprentice, who was from an early date an enthusiastic Scottish antiquarian, and David Herd, a writer's clerk, who collected ballads. He published his own collection in 1769, but also contributed significantly to the collections published by Bishop Percy and Joseph Ritson. It was Herd and Cumming in particular who encouraged Robert Fergusson, the first major vernacular poet after Allan Ramsay himself. It is not surprising therefore, given their interests, that members of the Cape Club formed an important part of the original membership of the Society of Antiquaries of Scotland, founded in 1781.

As well as the theatre, Edinburgh acquired in 1760 Scotland's first permanent art institution, the Trustees' Academy. The Trustees for the Board of Manufactures administered a fund set up after the Union, in lieu of Scottish income from taxation, to encourage Scottish industry. One of their special interests was the linen industry. As early as 1728 in a letter to Aikman, Sir John Clerk had commented on the need to keep up the quality of design in order to remain competitive.[8] In 1760 Lord Kames took the initiative to set up a school for this purpose. Its first teacher was the Frenchman, William Delacour, and though his duty was to teach pattern design to apprentices from the linen industry, he was also expected to teach drawing in the more conventional sense. The city took an interest in this side of the operation and shared the cost with the Trustees, as well as providing accommodation in the College (Edinburgh University) where the academy was housed till the end of the century.

Delacour had come to Edinburgh three years earlier to work for the theatre (including the theatres in Glasgow and Newcastle). He was a proficient decorative artist in the French manner and co-operated with the Adam brothers on at least three occasions, though only at Yester House does his decoration survive intact. His painting there shows him to have been a skilled rococo colourist and though there is nothing to connect the Runcimans with him directly, Alexander's command of colour, noted by Fuseli, is striking and may well derive from Delacour. The Runcimans may in fact have come into direct contact with him at the theatre. Alexander certainly worked there before he left for Rome and may even have supplanted

Delacour, who complained bitterly in the press in 1763 that he had been first underpaid and then replaced as scene painter by an unnamed artist.[9]

As an apprentice to the Nories, Alexander Runciman was trained in their manner of ornament painting (plate 26). This consisted mainly of very freely painted grisaille landscapes incorporated into decorative schemes. Of the various examples that survive, part of a scheme at Caroline Park in Granton, Edinburgh, seems to date from the years of his apprenticeship. The paintings there are vigorous but approximate interpretations of classical and Scottish motifs. The first important work that Alexander did in Rome was a set of drawings of actual classical ruins and though they are much more accomplished, they carry on directly from this kind of decorative painting (plate 27). When he announced his intention to travel to Rome in the newspaper in February 1767, he described himself as an 'ornament painter' and decorative landscape painting was at least part of what he meant by the term.[10] He was also experimenting in subject painting for decorative purposes, however, and he, or he and his brother together, painted a *Silenus* and a *Danae* (both now lost) for Lawers House, apparently as part of a larger painted scheme.

Alexander's professional practice, in which John had joined him, led to the commission from Sir James Clerk for the decoration of his new house at Penicuik in 1767.

Clerk's advance payment of £150 was the principal factor in the brothers' decision to go to Rome, but by that date both had developed a different side to their activities unrelated to decorative traditions.[11] Alexander had revealed his ambition to be seen as an artist rather than as a decorator in 1762 when he first exhibited in London, sending three landscapes to the Free Society. Sometime in the middle 1760s he also painted a large picture of *Jacob's Dream*, which is still at Penicuik. The landscape setting is in the Norie style, but otherwise the picture reveals a quite different inspiration. Though *Jacob's Dream* is not an uncommon subject, Runciman's interpretation seems to derive from a print now attributed to Aert de Gelder, and though the picture is immature he has made a fair attempt at capturing the Rembrandtesque chiaroscuro of his model. A painting by Rembrandt is also the model for a large drawing of *The Good Samaritan* (National Gallery of Scotland), which can be dated to around 1764 by comparison with John's dated etching of *The Taking down of the Netherbow Port* (plate 28). John also painted the earlier stage in the Samaritan story. The two pictures are linked by the figure of the Samaritan, who wears the same turban in both, and must be contemporary. John's likewise has a Rembrandtesque source for its composition.[12]

Technically, however, John Runciman's starting point seems to have been Teniers. In a painting of the *Temp-*

27. Alexander Runciman. *The Tomb of the Horatii*. Ink and wash, 22 × 31.1 cm. National Galleries of Scotland

tation of Christ (National Gallery of Scotland) he quotes directly from a painting at Hopetoun House attributed to Teniers, of the *Temptation of St Anthony*, and Teniers's handling of space and the contrast he uses between minute and open handling of paint characterize several of the dozen surviving small panels with religious subjects attributable to John, of which *Hagar in the Desert* is an example. These are on the whole the least accomplished of the group and so presumably the earliest in his short career. They lead on to two pictures, the *Journey to Emmaus* and the *Flight into Egypt* (plate 29), in which he comes close to Rembrandt in technique as well as in composition with quite remarkable results. Even more surprisingly, Rembrandt seems to have led to an interest in Dürer. There are three paintings with compositions derived from Dürer woodcuts. The best of these

is the *Adoration of the Shepherds* (col. plate 13), based on the same scene in the *Little Passion*. It captures and translates into paint the intense feeling of its model with astonishing fidelity.

Historical awareness was an element in the Runcimans' work at this time. The earliest datable work by either of the brothers is John's etching of *The Taking down of the Netherbow Port* (1764). It was matched by a drawing by Alexander of another lost historical monument, James IV's porch at Holyrood, taken down ten years earlier (National Gallery of Scotland). The contemporary antiquarian interest of these two works is recorded by George Paton, himself an antiquary, in a letter to James Cumming in 1766.[13] John's etching shows the demolition men at work dismantling the sixteenth-century spire of the port. Meanwhile life goes on in the city street below, but it is

28. John Runciman. *The Taking down of the Netherbow Port, Edinburgh.* 1764. Cat. 68

not simply incident added to enrich an architectural draw-ing. The picture is unified and brought to life by the presence of human activity. As a result the work conveys a unique sense of the building which is its subject, not set apart by its historic status, but as history integrated into the living fabric of the city. John Runciman's etching is matched by the broadside written by the patriotic poet James Wilson in 1764, *The Last Speech and Confession and Dying Words of the Netherbow Porch of Edinburgh which was exposed to roup and sale on Thursday 9th August, 1764.* Wilson had written a similar broadside on the demolition of the Holyrood porch. His views were echoed ten years later by Robert Fergusson musing in Holyrood's ruined chapel:

> For O, wae's me! the Thistle springs
> In *domicile* of ancient kings,
> Without a patriot to regret
> Our *palace* and our ancient *state*.[14]

These two small works therefore show the moment at which historical self-awareness, already present in Scot-tish poetry, entered Scottish art. It is impossible to say if the consistent focus of the brothers' other work before they left for Rome, in Rembrandt and northern European art of the sixteenth and early seventeenth centuries, sprang from a similar cause, but the religious character of these works is quite exceptional in the eighteenth century.

It is clear that John Runciman was trying to give to these small pictures the maximum expressive intensity and in this sense they develop towards his *King Lear* (col. plate 12) of 1767. It is his only dated painting and in style and content it is midway between the small religious pic-tures and what we know of his work during the short time he was in Italy before his death there in the winter of 1768–69.

Alexander did a drawing of *Lear on the Heath* (plate 30) contemporary with John's painting. It is a vigorous drawing and identifies the key moment in the play when Lear is moved to pity poor Tom's nakedness and tears off his clothes to cover him: 'Unaccommodated man is no more but such a poor, bare, forked animal as thou art. Off, off, you lendings! Come; unbutton here' (Act III, Scene iv). Alexander follows the stage directions closely, but though Lear had been performed in Edin-burgh in the 1760s, neither brother's picture has anything to do with the tradition of theatrical painting that had been growing up over the previous decades. Instead they seem to depend on a reading of Shakespeare's original text. John on this basis has produced what is in effect an epitome of the play, creating rather a pictorial equivalent than an illustration:

> Blow, winds, and crack your cheeks! rage! blow!
> You cataracts and hurricanoes, spout
> Till you have drench'd our steeples, drown'd the cocks!
> (Act III, Scene ii)

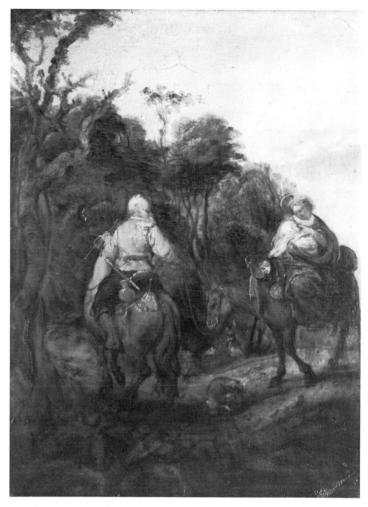

29. John Runciman. *The Flight into Egypt. c.* 1766. Cat. 70

is conveyed by a cataclysmic storm raging on land and sea and by a drowned corpse washed up in the right fore-ground. The setting seems to be suggested by the image of the sea in the lines;

> Thou'dst shun a bear;
> But if thy flight lay towards the roaring sea,
> Thou'dst meet the bear i' the mouth.
> (Act III, Scene iv)

John Runciman turned to Rubens for the way in which he conveys the energetic movement of sky and water. In the midst of this chaos Lear appears neither overwhelmed nor defiant, but as its still and stable centre. Those who support him in the play are gathered round him, but here he supports them, not they him. The painting seems to imply that far from raving, Lear has found his true strength in the storm, in union with nature. Alexander's drawing provides a gloss on this. It is Lear's own human-ity that he recovers with his compassion after his own exposure to nature and the elements.

30. Alexander Runciman. *King Lear on the Heath. c.* 1767. Cat. 44

Poor naked wretches, wheresoe'er you are,
That bide the pelting of this pitiless storm,
How shall your houseless heads and unfed sides
Your loop'd and window'd raggedness, defend you
From seasons such as these? O! I have ta'en
Too little care of this. Take physic pomp;
Expose thyself to feel what wretches feel,
That thou mayst shake the superflux to them,
And show the heavens more just. (Act III, Scene iv)

The expressive language of paint with which this pro-foundly romantic interpretation of Lear is conveyed in John's painting gives it a claim to be the first fully fledged Romantic painting.

John Runciman's remarkable paintings reveal intense creative excitement, an excitement shared with his brother. The painting of *King Lear* shows too that, in understanding what the poetic imagination had to offer the pictorial, they were already in tune with the ideas that Hamilton had been pioneering over the last decade in Rome, but when it came to realizing this visually they must have felt themselves isolated. It is clear why they wanted so urgently to travel to Rome. On 5 December 1767, six months after he arrived there, Alexander wrote to his friend James Cumming, 'I find since I came here I have been (on) a wrong plan of study for painting all my life but I have begun an intire new system of which I hope to show something if I come home, that is if God spares me ye ken.'[15] The evidence for this new system is not clear in his work till 1769, but it is very apparent in John's, seemingly from the moment that he arrived to join Alexander, some time shortly before that letter was written.

Alexander arrived in Italy on 25 May 1767. He had originally proposed to stay two and a half years. In the end he was away from Edinburgh for four and a half years, even though his funds were exhausted within a year and he had no guaranteed support. His friend Walter Ross, who was handling the brothers' affairs in Edin-burgh, was desperately trying to raise money for them by the summer of 1768.[16] In the end Sir James Clerk seems to have doubled the amount that he had originally con-tracted to pay and Robert Alexander seems also to have come to the brothers' aid. He was a merchant and banker and something of a Maecenas. He was a member of the Select Society, but eventually the source of his fortunes led him to join in the American War of Independence on the colonial side.

John Runciman spent some months in London before he joined his brother in Italy. In Rome the Runcimans were living under the same roof as Anne Forbes and her mother, where James Nevay was a regular visitor. In 1769 Mrs Forbes wrote to her son in Scotland hotly denying rumours of an engagement between Nevay and her daughter. These rumours having 'got among the artists have given the gumples to Mr Nevay who never now comes near us but when he is sent for'.[17] Intrigue among the artists may not have been purely artistic in its causes,

31. John Runciman. *Self-Portrait*. 1767–68. Cat. 74

but it was nonetheless disastrous for poor John Runci-man. He was consumptive and in a fit of nervous depres-sion brought about by attacks on his work, led by Nevay, he destroyed what he could lay his hands on and left Rome for Naples, where he died shortly after, his consumption apparently brought to a crisis by nervous distress and a chill.

John's *Self-Portrait* (plate 31) is the only painting by him that survives from this last year of his life. There are in addition a few drawings and an etching which can be dated to this year. The *Self-Portrait* shows him reflecting on Michelangelo. The figure of Day from the Medici tombs is visible behind him, identified with the blue sky and the bright daylight that falls on John's face, which is half in the shadow of the wide brim of his hat. The painting is larger than any of the others which survive and it has far less of that intense, minute handling which is their principal characteristic. To judge by the other Roman works, this broadening of his style was inspired by his admiration for Michelangelo, who is their con-sistent theme. One drawing is a rough sketch of the *Cruci-fixion of Haman* from the Sistine Chapel and on the other side of the same sheet is a composition of the *Fall of Phaeton* the principal source for which is a drawing in the Royal Collection, attributed to Michelangelo, of the

Labours of Hercules. John has turned the figure of Hercules upside down for the falling figure of Phaeton. The finest of all his drawings is a study of the Torso Belvedere, one of Michelangelo's own principal sources of inspiration, and specifically the inspiration of his figure of Day.

The only complete subject composition among these works is the etching (plate 32). It probably represents the *Return of the Prodigal Son.* The tonal structure still recalls Rembrandt, the dominant influence on his earlier work, but the main group derives from one of the subsidiary parts of the Sistine ceiling. The result of this combination of tonal subtlety with monumental grouping is striking and dramatic. It is a leading characteristic of Alexander's later work, but there are also similarities to Fuseli, whose first major exhibited work, the drawing of the *Death of Cardinal Beaufort* of 1772, shows a number of similarities to this composition, which Fuseli most probably knew.

In September 1769 Alexander wrote to James Cumming, 'Nevay has after a ten years siege finish'd a picture. Christ forbid I should make my large picture like it but mum for your life. I send whenever he sends his picture two of Jacky's to let Mr Alexander, Rynolds (Reynolds),

Burk(e) and (James) Stewart and some more friends of Jacky's see the difference there was between him and Nevay and it will open a scene of villainy that's been practis'd here for some time.'[18] Barry in a letter to Burke records his admiration for John who was beginning to enjoy some reputation.[19] Alexander may not have been disingenuous when he wrote to Sir James Clerk the next year, 'Had my poor brother been alive I probably never would have thought of Serious History, but the Debility of my living contemporaries more than any great Oppinion I had of my own Abilitys made me take this resolution of disputing the preheminence of Reputation with them.'[20]

The large picture he refers to in his letter to Cumming, his first attempt at 'Serious History', was a painting of *Ulysses and Nausicaa.* In a letter to Robert Alexander it may be this picture that he describes as a desperate undertaking, as well he might.[21] This is how he described it to Clerk: 'I have begun a picture and am a good way advanced in it. The Story is from the Odyssey of Homer when Ulysses meets Nausicaa. There is nine figures in the Picture the two principal being a little larger than life. I know it may be said I might have done it in Edinburgh as well but it is certainly necessary to bring something

32. John Runciman. *The Return of the Prodigal Son. c.* 1768. Cat. 75

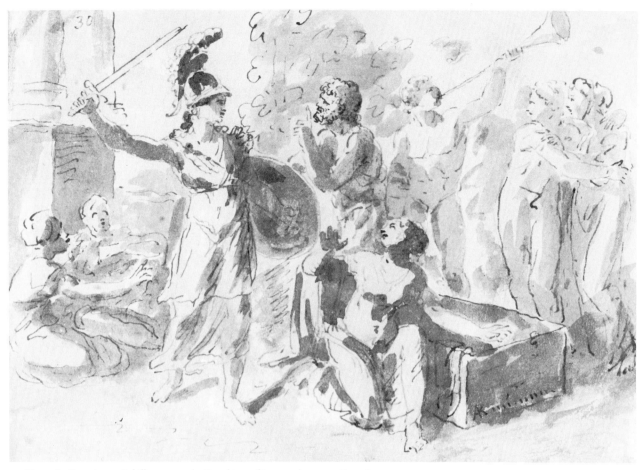

33. Alexander Runciman. *Achilles among the Daughters of Lycomedes*. 1770. Cat. 46.

home to convince you I have not misspent my time for what proof of ability is a parcel of drawings from statues etc. but another reason is that I may have the advantage of Exhibiting next May in London with Mr Hamilton.' He mentions Hamilton again in his letter and goes on to say, 'The reason I mention Mr Hamilton in particular is only in consequence of his being our first character here.' He did eventually exhibit his picture alongside Hamilton's *Agrippina* in 1772. Since then his painting has been lost.

Runciman did not need to mention Hamilton for it to be clear that he was the inspiration of this massive project. The subject was probably chosen from Turnbull, who writes, 'Ulysses surprising Nausicaa and her Damsels, . . . was painted in the various Gallery at Athens by Polygnotus, who it seems had done all the more pic-toresque parts of Homer. So Pausanias tells us in his Atticks. And what a charming Subject it is for a Master of Expression and Grace.'[22] Perhaps Runciman was presenting himself as Polygnotus to Hamilton's Zeuxis.

Hamilton's influence is also apparent in the rest of the same long letter which Runciman wrote to Sir James in May 1770 and in which he described his new proposals for the decoration of Penicuik House, of which the principal part was to be the *Life of Achilles*. The original

idea had been that the main room should be decorated with a mixture of landscapes and classical scenes. Runci-man did a large drawing of *Bacchus and Ariadne* early in his stay in Rome which would have fitted such a scheme, but the new proposals suggest that he knew something of Hamilton's projected 'story of Paris and Helen', as well as the *Iliad* pictures.

More than a dozen drawings survive from this Achilles project. The largest group are lively and fairly free com-positional studies that were originally consecutive pages in a sketchbook which can, on the evidence of the letter, be dated to 1770 (plate 33). In addition, there are three more elaborate drawings, two of which can also be dated by the letter. The first is 'a pretty large drawing' that he mentions as 'the commencement of the Iliad where Achilles going to draw on Agammemnon is stopt by Pal-las' (plate 34). The second seems likely to be identical with a 'more correct' drawing of the *Wedding of Peleus and Thetis* that he proposed to do when he had finished his large painting. (It also bears a striking resemblance to Hamilton's *Meeting of Paris and Helen* for the Villa Borghese.) The third is a large wash drawing of *Achilles and Scamander* (National Gallery of Scotland).

The most striking feature of the first two drawings is that they are in fine, rather painstaking outline, very much

in contrast to his usual ebullient handling and without any of the tonal quality that is a normal feature of his drawing. In the first there is no significant shading at all and in the second it has been introduced in part of the drawing as a simple dark background to the light figures. In both drawings he seems to be exploring an idea that became conventional later in the century: that the primitive, original form of visual art, appropriate to the age of Homer, was pure outline, and that other conventions of pictorial representation were later accretions that obscured the purity and imaginative simplicity of the original artistic idea. Vase painting which seemed as old as Homer provided support for this view. It had become a subject of special interest because of Sir William Hamilton's collection of vases in Naples, which had been published in a magnificent edition in 1767. The collection was subsequently purchased by the British Museum. Vase painting was even more clearly the inspiration in a series of oval drawings with classical subjects that Runciman did in 1772.

The same preoccupations were given a more metaphorical expression in a drawing which was on the page in Runciman's Roman sketchbook that followed the last of the Achilles drawings. The subject is the *Origin of Paint-*

34. Alexander Runciman. *Achilles and Pallas.* 1769–70. Cat. 47

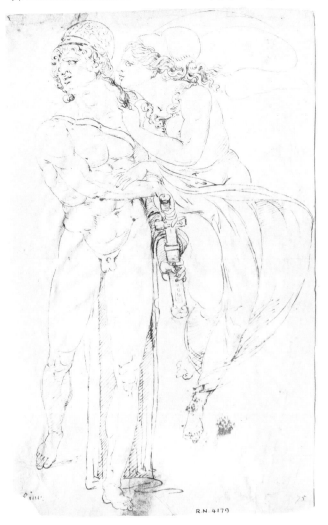

ing. It follows the story of Debutades' daughter as told by Pliny. The girl, her hand guided by Cupid, traces the outline of her sleeping lover's shadow on the wall. There is nothing austere about this drawing, however, and it gave rise to Runciman's most beautiful surviving easel painting (col. plate 16) two years later.

Runciman's inclinations were always painterly, favouring the expressive and colourful rather than the austere and theoretical. Even the two Roman drawings which use outline in such a precocious way are far from severe. The outline is open and lightly handled, and the most remarkable of all his Roman drawings shows an interpretation of the primitive style much more in keeping with this free and expressive side to his art. It shows a bard sitting among the trees (plate 35). The drawing is in pen, and the rhythm and energy of the line evokes the wind as it blows through the foliage and flutters his cloak and beard. The wind in nature is also the wind of inspiration in the strings of his harp. The bard must be Ossian, seen as the speaking voice of nature, the personification of the natural epic, completely at one with the energy that moves in the landscape. This is how Runciman presented Ossian in the Penicuik ceiling two years later, but he also picks up the idea of man in nature that John Runciman had presented in his *King Lear.* In doing so he takes Hamilton's approach to the inspiration of the primitive epic a stage further, recognizing the stylistic questions that it posed for the artist in a way that Hamilton never did, and resolving it, not in terms of formal, primitive simplicity, but of spontaneous expression and energy. In this he was probably encouraged but certainly not led, by Fuseli, with whom he was on friendly terms in 1770 and 1771. Fuseli recorded his admiration for the older painter in a letter that he wrote to introduce him to Mary Moser on his return to London. In it he described Runciman as 'the best painter among us here in Rome'. Certainly Fuseli's enthusiasm could have encouraged him to return to the expressive style of his own earlier work and to abandon the more formal style that may have owed something to his friendship with James Barry in 1769 and 1770.

Ossian in Runciman's drawing is the bard as Hugh Blair, professor in Edinburgh and champion of Ossian, saw him in the famous essay that he wrote as introduction to the collected edition of James Macpherson's translations from Ossian:

In the infancy of societies, men live scattered and dispersed in the midst of solitary rural scenes, where the beauties of nature are their chief entertainment. They meet with many objects to them new and strange; their wonder and surprise are frequently excited; and by the sudden changes of fortune occurring in their unsettled state of life, their passions are raised to the utmost; their passions have nothing to restrain them, their imagination has nothing to check it. They display themselves to one another without disguise, and converse and act in the uncovered simplicity of nature. As

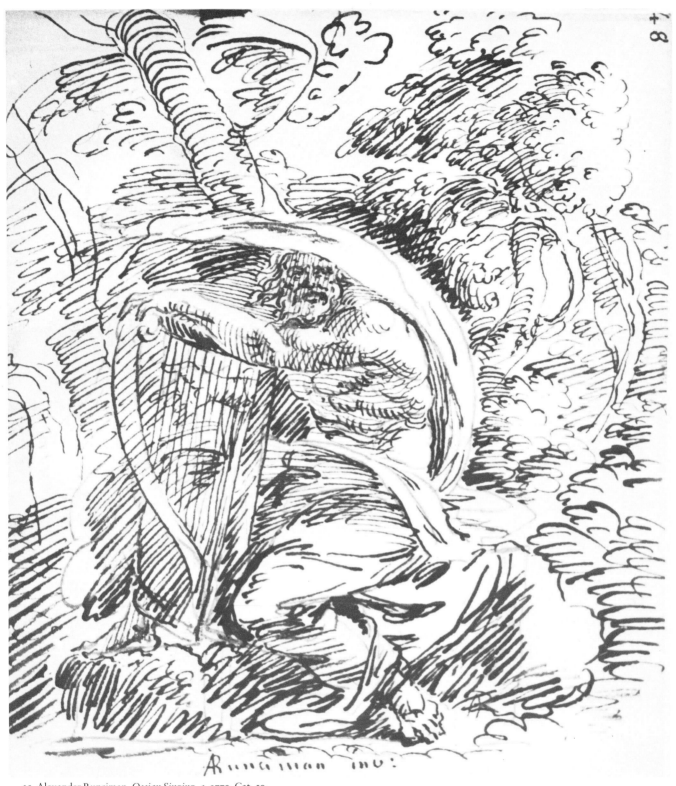

35. Alexander Runciman. *Ossian Singing. c.* 1770. Cat. 50

their feelings are strong, so their language of itself assumes a poetical turn. Prone to exaggerate, they describe everything in the strongest colours; which of course renders their speech picturesque and figurative.[23]

This compares very closely with the passage from Thomas Blackwell quoted above,[24] and Blair's Ossian relates to Blackwell's Homer much as Runciman's art relates to that of Hamilton. There is a shift in emphasis towards the expressive quality of primitive poetry, but the basic thesis is the same. The character of the poetry is a result of its historical circumstances. The poet reflects his own actuality, both social and physical, in a manner that is itself conditioned by the particular moment in the development of human society in which he lived. In the case of Ossian, however, there was in addition the claim that his poetry represented a still living tradition, untouched by alien values. Macpherson himself wrote:

If tradition could be depended upon, it is only among a people from all time free from intermixture with foreigners. We are to look for these among the mountains and inaccessible parts of a country; places, on account of their barrenness, uninviting to an enemy, or whose natural strength enabled the natives to repel invasions. Such are the inhabitants of the mountains of Scotland. We accordingly find that they differ materially from those who possess the low and more fertile parts of the kingdom. Their language is pure and original, and their manners are those of an ancient and unmixed race of men . . . It is no wonder, therefore, that there are more remains of antiquity among them than among any other people in Europe.[25]

Alexander Runciman left Rome in the summer of 1771. In October he was in London and met up with Walter Ross, who lent him money for the return journey to Edinburgh, which they undertook together.[26] He may have returned to London the following spring to exhibit his large painting, *Ulysses and Nausicaa*, at the Academy, but he was back in Edinburgh in June, and in July began work on the decoration at Penicuik in fulfilment of his contract to Sir James Clerk signed five years before.[27] By the end of November, when he took the post of master of the Trustees' Academy, he had completed the painting of what came to be called Ossian's Hall and in addition had painted three and probably all four of the scenes from the life of St Margaret of Scotland, which decorated one of the two oval staircases in the house.[28] For some unknown reason the second staircase was painted several years later, not by Runciman, but by another decorative painter, John Bonnar.

It was an astonishing season of work. The two ceilings together added up to twenty-one large compositions. The largest, the central oval in Ossian's Hall, was 24 feet on its long axis. The subsidiary pictures there ranged from 4 by 5 feet to 4 by 10 feet, and the St Margaret paintings were apparently similar in scale. It is almost as though

in his execution Runciman was consciously emulating Pope's image of Homer, whose fancy 'grows in the Progress (of the poem) both on himself and on others, and becomes on Fire like a Chariot-Wheel, by its own rapidity'.[29] The result, in Runciman's case, was very closely comparable to what Blair said of primitive poetry: 'Irregular and unpolished we may expect the productions of uncultivated ages to be; but abounding, at the same time with that enthusiasm, that vehemence and fire, which are the soul of poetry.'[30]

Runciman's most important work was destroyed in the fire that burnt down Penicuik House in 1899. Its appearance is recorded in a rather poor set of photographs of Ossian's Hall, which do not include the paintings over the windows, by a very detailed watercolour of the same room made in the late nineteenth century (col. plate 14) and by two written descriptions, one of them by Runciman's friend Walter Ross, published anonymously in January 1773. Unfortunately neither the photographs nor Walter Ross's description include the St Margaret pictures, but they are described in some detail in a *Description of the Paintings at Penicuik*, written by John Gray at the end of the nineteenth century. In addition there are an oil sketch and a number of drawings for parts of both ceilings, and four of the compositions are recorded in etchings by Runciman himself (plates 36, 38, 39).

The decision to make the themes at Penicuik Scottish rather than classical may not have been taken till Runciman returned to Scotland. The initiative seems to have come from Runciman himself, but the whole character of the enterprise suggests that he was aided and abetted by his friends in the Cape Club. The St Margaret pictures for example were based on a reading of the medieval Latin chronicle of John of Fordun, *The Scotichronicon*, a book mentioned several times in the correspondence of James Cumming and George Paton. Cumming's enthusiasm for Ossian is apparent in his letters, and if Runciman himself did not know Hugh Blair, George Paton certainly did. There would have been plenty of advice and encouragement available to Runciman once he had embarked on a national theme.

Unlike the planned story of Achilles, Runciman's Ossian paintings did not follow a single narrative. Macpherson's *Ossian* is a series of self-contained tales and so Runciman organized the space of the room rather as a metaphor of the poet's imagination than as a strict narrative cycle. Ossian himself appears in the centre in the large oval singing on the seashore and playing his harp (col. plate 15). He is surrounded by an audience, and facing him is his principal listener, Malvina, the betrothed of his dead son Oscar. In the sky behind him the clouds assume the fantastic shapes of the ghosts of the departed heroes conjured by his song: 'The awful faces of other times look from the clouds of Crona.'[31] In the four corners of the ceiling around the oval appeared four gigantic river gods, the Clyde, the Tay, the Tweed and the Spey, each set in a characteristic landscape. These were massive Michelangelesque figures. Such a dramatic use of

Michelangelo is anyway exceptional at the time, but it is made even more remarkable by the way that Runciman set them in atmospheric landscapes, which in the case of the Tay and Clyde seem to have represented actual scenery.

The idea of the river gods appeared first in the drawing of *Peleus and Thetis*. There they were conventional classical figures representing the world's rivers and were suggested by the figure of a river god on the Roman sarcophagus that was the starting point of the composition.[32] As they were executed, they were very different, and their development can be traced in a series of drawings (plate 37), more than exist for the whole of the rest of the ceiling. They show the gradual blending of the Michelangelesque figures with a romantic rendering of the actual landscape of Scotland. In the end they were perhaps Runciman's greatest invention and they are still the key to his identification of poetry and history with landscape as an embodiment of the liberated imagination.

The twelve pictures in the cove of the ceiling represented the subjects of Ossian's song. Ten of them were scenes from the poems, but two were invented scenes, *Scandinavian Wizards saying their Incantations* and the *Building of a Monument to the Poet*. These, representing the era of Ossian, stressed the historical character of the whole scheme, even though it is not history as the twentieth century would recognize it. They point to the continuity of inspiration between the Ossian pictures and those that represent the story of St Margaret, who as a real historical figure seems to us to belong to a quite different order of reality from the age of Ossian. In style Runciman's approach was consistent in the two cycles. In at least one of the St Margaret pictures he included a very precise representation of a particular scene, with St Margaret rising into heaven from Edinburgh Castle against the background of a panoramic view of Edinburgh and the Firth of Forth. Two of the St Margaret compositions are recorded in large etchings. One, the *Landing of St Margaret*, has a vivid dramatic sweep, closely comparable in feeling to that in some of the Ossian scenes (plate 38).

There are also three etched versions of one of the subjects from Ossian's Hall, *Fingal and Conban Carglâ* (plate 39). They show the same vigorous figure style as the St Margaret pictures. Two of them enlarge on the original painting and they do so in a way that suggests

36. Alexander Runciman. *The Death of Oscar*. 1772. Cat. 53

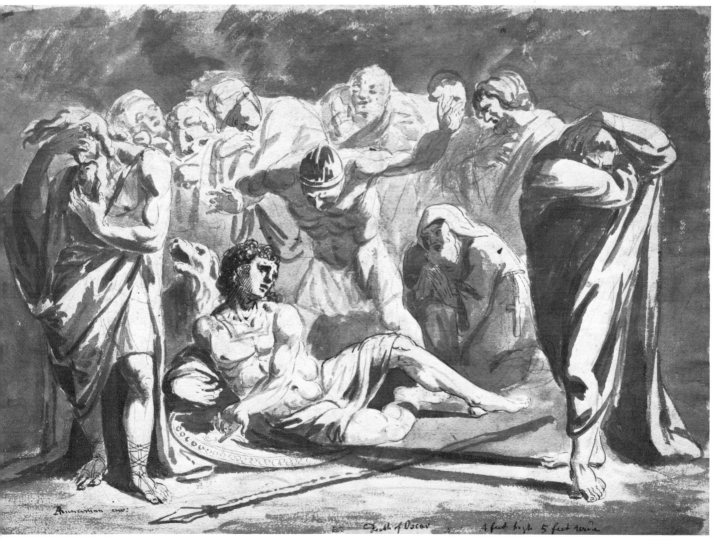

that the openness in the figure drawing is related to land-scape and atmospheric unity. The scene is moonlit and the light plays over landscape and figures, uniting them and creating an analogy between the human figure of Fingal and the form of a mighty tree, possibly the subject of a separate drawing (plate 40). Thus light and drawing stress the union of the hero with the natural world that he inhabited.

Colour played a vital part in the decorations. John Gray describes the *Landing of St Margaret* as follows: 'Its background is a rich blue sky, and a distance of stormy sea. In the centre King Malcolm, clad in a broad Scottish bonnet with a little white plume, red knee-breeches, white hose and white shoes, with ample rosettes, and with a red cloak flapping round him in voluminous folds. With one hand he leads the lady, robed in a yellow mantle and a white dress, her long yellow hair tossed by the wind, and with the other points energetically towards the church before them, where white robed monks, with clasped hands are awaiting their arrival.'[33] There are unfortunately not such detailed colour notes on the Ossian pictures, but the nineteenth-century watercolour gives some idea of the general brilliance, while in Runci-man's own sketch for the central oval the principal group has been coloured in oil, revealing the same kind of high-keyed colours that Gray described.

Something of the colour as well as the execution of the Penicuik paintings can be deduced from the remains of a smaller scheme that Runciman painted the following year for the new Episcopal church in the Cowgate, Edinburgh. These consisted of a half dome, elliptical in shape and 24 feet across on its long axis. In a letter to George Paton, Runciman guessed at the dimensions as 'Thirteen

feet high and thirty broad'.[34] He went on, 'The subject painted in it is the Ascension of Jesus Christ, Luke the 24th cap. verse the 51 and 52 (and he was taken up into heaven and they worshipped him). The figures nearest the eye are something larger below.'

This part of the decoration was painted out early in the last century, but there are four subsidiary panels that are still visible. They are *Moses* (plate 41) and *Elijah*, life-size in oval panels, and the *Return of the Prodigal Son* and *Christ and the Woman of Samaria*, in rectangular panels 3 foot 6 inches by 5 foot 6 inches. These paintings were executed the same way as those at Penicuik, in oil directly onto white-primed plaster. In the Cowgate chapel this plaster has a rough surface. The paint is often transparent and the brush strokes are broad and sweeping. Though these pictures are badly in need of cleaning, enough is visible to suggest that the colour handled in this way must have been quite dazzling. Indeed Walter Ross in his *Description* remarked of the painting in Ossian's Hall that the gaiety and brilliance of the colour was such that it might almost seem inappropriate to the solemnity of the subject.

Everything about Runciman's Penicuik paintings seems to have been calculated to make a dramatic impact. Expression was their keynote, emulating the spontaneous, primitive freedom that it was felt could be recognized in the poetry of Ossian, a natural epic. In spite of this style of interpretation, however, the formal language of Runciman's painting was still derived from the High Renaissance. The composition of the central oval of Ossian's Hall was derived from the engraving of Raphael's *Judgement of Paris* by Marcantonio. Michelangelo was a dominant influence throughout the ceiling and Giulio Romano was also a possible inspiration in several places. Although the inspiration of the paintings was so closely linked to poetic ideas, their formal language, with its roots still in a classical tradition, puts them in a similar stylistic position to Robert Adam's castle-style buildings which are closely contemporary. In fact among Adam's clients was James Macpherson, for whom he built a house near Aviemore, not indeed in a castle style, but in a style that is explicitly 'natural'. Like Runciman, Adam sought an expressive style in a historical vocabulary, one which could emulate the strength and freedom from constraint of an imagined earlier time.

Rather than use an engraver, as Hamilton had done, Runciman chose to etch his own designs. Aesthetically he was right to do so. His etchings are brilliant and capture exactly the free and open quality of his paintings in a way that an engraver probably could not have done, but he only etched four of the compositions, so their total impact was limited, except for those who could actually visit them. Nevertheless, there is some evidence of their reputation having an influence outside Scotland. Barry undertook a programme of national designs in *The Progress of Human Culture* for the Society of Arts which, although it was entirely different in character, had the bard, Orpheus, at the start of the scheme, as Runciman

37. Alexander Runciman. *River God (The Tay)*. 1772. Cat. 59

38. Alexander Runciman. *St Margaret landing at Dunfermline. c.* 1772. Cat. 57

39. Alexander Runciman. *Fingal and Conban Carglâ. c.* 1772–74. Cat. 54

had Ossian at the centre of his. More tellingly, one of the oddest features of Barry's series, the *Triumph of the Thames*, seems to be directly inspired by Runciman's river gods. Later, one of Barry's finest paintings, his large version of *Lear and Cordelia* (Tate Gallery), seems to attempt to identify primitive history, poetry and specific landscape, in this case the white cliffs of Dover, in a way that is uncharacteristic of Barry, but is the principal characteristic of Runciman's painting at Penicuik. Barry's King Lear, too, bears a detailed similarity to Runciman's figure of Fingal in the *Death of Oscar*. Fuseli, in trying out the idea of a Shakespearean Sistine Chapel in a series of drawings in the mid-1770s (British Museum), was attempting something with an obvious similarity to Ossian's Hall and in doing so he dropped back into the style of rather loose drawing that reflected his familiarity with Runciman's work in 1770. Both Fuseli's *Milton Gallery* and Boydell's *Shakespeare Gallery*, in the conception of which Fuseli played a key role, take up the idea which, wherever it originated, had its first expression in Ossian's Hall.

On his return to Edinburgh Runciman had set up in partnership again with his former apprentice, Dugald MacLaurie, to whom he had assigned the business when he left for Rome. Runciman's ambitions were however fixed on higher things. He had made his reputation as a history painter and he worked hard to maintain it.

Indeed when he took the post as master of the Trustees' Academy it was originally expected to be only temporary because, according to the minutes of the Trustees, he expected more important business to call him away from Edinburgh. It is not recorded what this business might have been. Perhaps Barry was holding out some hope of involving him in one of the collaborative schemes that he was trying to promote in London at this time. Whatever it was, it never materialized and Runciman spent the rest of his life in Edinburgh.

He did not, however, give up his grand projects. As well as the Cowgate chapel, on which he must have worked in 1773–74, he proposed in December of that year to paint the ceiling of the Trustees' boardroom in the Royal Exchange.[35] They voted to accept the proposal, but there is no further evidence regarding it. There are suggestions among his drawings of similar proposals; most clearly identifiable is a frieze of the Muses for an unknown destination. He is also recorded as painting an *Adoration of the Magi* on the wall or panelling of a house belonging to the notorious murderer, Deacon Brodie, who was also a member of the Cape Club.[36] He painted scenery for the theatre, and he also seems to have painted permanent decoration for it. Captain Edward Topham, who published his *Letters from Edinburgh* in 1776, described the theatre in a letter of 10 March 1775: 'over the boxes were the illuminated heads of the poets after whose names the

boxes were denominated and over the stage boxes land-scapes done in the same form by Runciman, the Sir Joshua Reynolds of this country, and whose invention is perhaps equal to that of any painter in Europe.'

Topham, an English visitor, was clearly impressed by Runciman's reputation and the painter himself en-deavoured to maintain it beyond merely local bounds by exhibiting regularly in London. In 1774, for example, he showed two subjects from Ossian, one of which, *Gelchosa Mourning Lamderg* (now lost), he had treated in the Peni-cuik ceiling. Such pictures must have made an impact, but the only critical response came in 1781 and was not very flattering. *The Earwig* described his *Parting of the Lord and Lady Russel* (now lost), one of three pictures that he exhibited that year, as a 'sturdy, raw-boned, Caledonian picture, all brick dust and Scotch snuff'.[37] His unconventional drawing and high colouring may have justified such a comment in the context of the contempor-ary Academy, but the drawing for the picture (National Gallery of Scotland) suggests that it was lively and well composed. A more flattering commentary may be implied in the fact that his painting of the *Death of Dido* (private collection) of 1778 bears a striking similarity to Reynolds's painting of the same subject exhibited at the Academy in 1781.

The *Death of Dido* was a subject that Runciman may originally have proposed for one of the staircases at Peni-cuik.[38] On other occasions too he returned to the inspi-ration of his Roman years. His *Aeneas at the Court of Dido* was 8 feet along its largest axis, and so clearly an important picture. In 1781 he exhibited *Achilles and Agamemnon* and *Agrippina with the Ashes of German-icus* (col. plate 17). The latter was the subject Hamilton painted while Runciman was in Rome and it was also painted by his enemy James Nevay. Runciman tried several variations on the theme and also made an etching of *Agrippina Mourning over the Ashes of Germanicus* (plate 43), a subject that Hamilton had painted as well. The painting that Runciman finally exhibited, however, is among the most accomplished of his surviving easel pic-tures. It bears a general resemblance to Hamilton's pic-ture, but is light and airy in execution. The colourful costumes are seen against a background of sails and open sea, and it may be that it gives some idea of what the *Landing of St Margaret* was like. Runciman's pupil George Walker, who owned the picture, thought highly of it, but Lord Gray, who bought Walker's collection, after some rather disparaging remarks, comments 'Upon the whole this picture, . . . possesses sufficient merit to hang in any collection, and it will always be considered

40. Alexander Runciman. *Study of a Tree. c.* 1772. Cat. 56.

41. Alexander Runciman. *Moses.* Cat. 60

as an effort of much natural genius considering the few opportunities for improvement which Alexander Runciman enjoyed in early life. It must also be interesting as a principal work of an artist who was the father of the Scottish School of Painting which we have every reason to hope will one day assume a place in the history of art.'[39]

This comment, like Topham's, confirms the importance of Runciman's reputation as a history painter in establishing the self-respect of the Scottish artistic community. As a teacher, he may not have been well qualified by temperament for the more mundane side of the business of the Trustee's Academy, the teaching of pattern drawing; yet it was perhaps in response to the demands of pattern drawing that he developed in later life a naturalistic style of draughtsmanship for which there is no precedent in his earlier work. He was qualified to inspire his pupils with higher artistic ambitions however, and, though among his immediate pupils only John Graham seems to have gone on to become a history painter, his influence ramifies throughout Scottish painting. In the nineteenth century David Scott (1806–49) was profoundly influenced by Runciman's subject painting. Scott's largest picture, *Vasco de Gama rounding Cape Horn* (Trinity House), is a development of Runciman's *Fingal and the Spirit of Loda* at Penicuik, and the little composition of *Lear and Cordelia* shown here (plate 42) is a variation

on Runciman's *Fingal and Conban Carglâ* in the small etched version. It was as a landscape painter that Runciman's influence was most immediate however. He continued to paint landscapes throughout his life. Some were in response to decorative commissions, like the paintings in the theatre and paintings recorded in the Royal Infirmary, Edinburgh. Others were straightforward topographical commissions like a series of views of Fort George commissioned by its builder, General Skinner.[40] There are also landscapes recorded with poetic subjects and from their number these seem to have been an important part of his output. Only a small group of paintings are known. The most important of these is the *Allegro with a Distant View of Perth* (col. plate 18) and together with that picture our assessment of his landscape painting must be based on two small, freely painted Scottish scenes and a considerable number of drawings, including a series of very beautiful watercolours of the countryside near Edinburgh (plate 44). Their quality lends significance to the fact that both Jacob More and Alexander Nasmyth, the two principal landscape painters in the younger generation, were his pupils.

Runciman was also an inventive portrait painter. Though he seems never to have worked as a professional, a number of portraits by him are recorded and three survive. The small portrait of Robert Fergusson (Scottish

42. David Scott. *Lear and Cordelia.* Cat. 76

43. Alexander Runciman. *Agrippina mourning over the Ashes of Germanicus. c.* 1772. Cat. 63

44. Alexander Runciman. *East Lothian Landscape*. Pen and watercolour, 19.1 × 32.4 cm. National Galleries of Scotland, Edinburgh

National Portrait Gallery) is an extraordinary visionary head. It is hardly a portrait at all in the accepted sense, but more like an icon. The portrait of the *Earl of Buchan* (Perth Museum), painted in 1784 and presented to the Society of Antiquaries of Perth, is so badly overcleaned in the head that it is only partly legible, but the painting of the accessories is rich and lively. The double portrait of the painter with John Brown (col. plate 19) was also painted for the Earl of Buchan. It is the only one of the three on which a proper assessment of his portrait painting could be based. It is highly eccentric. Instead of the mirror, usual in self-portraits, the painter is looking at a picture on the easel which is the subject of discussion between himself and Brown and into which, by its position, we are put. The subject identified by the book over which Brown is gesticulating is a scene from *The Tempest*. The drawing is erratic but the colour and handling are very lively. They give force and presence to the animated expressions and gestures of the two artists. Brown wrote to Buchan in August 1784 about the portrait: 'I was yesterday with Runciman and sat for my portrait which he has done a first sitting of on the same canvas on which he has already done his own. The piece is for your lordship and I think will be an admirable one. . . . he has represented himself sitting at his work, his pallet and pencils in one hand, a portcrayon in the other. I, behind, am seeing to point at, and find fault with some part of the work, at which, as being rather irascible, and impatient of reproof, he is making a damnable face, as he himself expresses it.'[41]

In the nineteenth century J. H. Benton commented: 'High indeed in the great republic of genius was the ill-starred Runciman. He was one of those who had not the

good fortune, or the skill, as it may be, to make their light shine before men: and it is in obscure corners that people stumble on his best works, wondering whence came the deep artistic power, and the noble simplicity of pictures so unknown to fame. I have seen portraits of his own esteemed friends—of some of those for instance who made his student circle at Rome—which I question if even Raeburn—who took his tone from Runciman, and is generally reputed to have much improved on it—could have excelled in truth and dignified simplicity.'[42]

The feeling expressed by Benton that fate had been unkind to Runciman was already apparent in an obituary of the artist written by his pupil George Walker: 'On Friday last (21 November 1785) died here, Mr Alexander Runciman, historical painter;—An artist, who, had his situation been uniformly favourable to the cultivation and exercise of his talents, was, by nature eminently formed to excel in all those nobler parts of the art, the attainment of which depends on the highest powers of the mind.— Though unassisted by his situation, and even, for a long period of years, labouring under every possible disadvantage, he completed works, which, upon the whole, are equal to the best of those of his contemporaries; and, in some respects, it may be asserted, that they are superior.'[43]

The double portrait of Runciman and Brown is testimony to the friendship between the two painters. Brown (1749–87) had attended the Trustees' Academy in Edinburgh before travelling to Italy in 1769 where he joined Runciman. The influence of the older painter is apparent in the peculiar pen technique of an Italian drawing *A Farm House with an Ionic Column in the foreground* (National Gallery of Scotland) and also in the much more accomplished *Basilica of Constantine and*

Maxentius with a scene of Murder, a startling drawing which testifies to undoubted talent and also to the community of interest between him and his mutual friend with Runciman, Henry Fuseli. Brown and Fuseli seem to have remained on intimate terms after Runciman had returned to Scotland and until Fuseli too finally left Rome in 1778.

Fuseli's influence is clearly apparent in his drawings at times, but Brown's own artistic personality was not subordinated to that of Fuseli. Among his most remarkable works are a small number of strange and sinister genre scenes such as *Two Men in Conversation* (plate 45) or *The Stiletto Merchant* (Pierpoint Morgan Library), which are halfway between Fuseli and Goya.

Though it is said that he did paint, Brown's surviving works are exclusively drawings and in his later career this was a matter of principle. According to Lord Monboddo, he held drawing to be the only important part of visual art. As a draughtsman he found employment from William Townley and Sir William Young in making drawings after the antique both in Italy and at the very end of his life in London. Latterly his main creative endeavour was restricted to portrait drawings of which he may have made a great number. Among the most important was a series of the founder members of the Society of Antiquaries of Scotland (Scottish National Portrait Gallery), a commission undertaken for Lord Buchan, founder of the society; this has given us a record of the appearance of many members of the circle to which Brown and Runciman belonged, men like James Cumming, David Deuchar and George Paton. Runciman was 'Historical Painter' to the society and his portrait was added posthumously by Brown to this collection.

Brown himself was evidently a man of considerable learning. He assisted Lord Monboddo with his book *The Origin and Progress of Language*, in which Monboddo produced his hypothesis that men were descended from apes, and Monboddo was in turn the recipient of Brown's *Letters on the Italian Opera*, published posthumously. Monboddo wrote of Brown in the introduction to the second edition of this work: '(He) was not only known

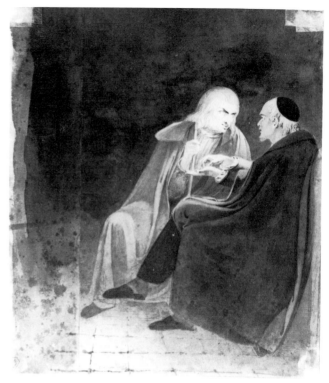

45. John Brown. *Two Men in Conversation*. c. 1775–80. Cat. 41

as an exquisite draughtsman, he was also a good philosopher, a sound scholar and endowed with a just and refined taste in all the liberal and polite arts and a man of consummate worth and integrity.'[44] Ten years later Alexander Campbell wrote in equally glowing terms about him in his *Introduction to the History of Poetry in Scotland*, a work which he dedicated to Fuseli but says he would have dedicated to Brown had he been still alive. Brown clearly enjoyed a high reputation among his contemporaries and typified the range of interests that find such vivid reflection in his own art and that of his contemporaries.

V

A Vision of
Pastoral Simplicity

*'My muse will no gang far frae hame
Or scour a' airths to hound for fame.'*
Robert Fergusson, CALLER WATER

David Laing, the nineteenth-century antiquarian, described Runciman's paintings at Penicuik as 'truly national designs'.[1] Runciman himself would not have quarrelled with this view. Among his Edinburgh friends was a poet, Thomas Mercer, and in 1772 Runciman made a frontispiece for Mercer's poem, *The Sentimental Sailor*, which incidentally included an account of the *Origin of Painting* and was dedicated to Rousseau. Shortly after this Mercer had to flee Edinburgh for his debts, but his next poem, *Arthur's Seat*, published in 1774 seems very close in spirit to Runciman's Ossian pictures. Contemplating the historic landscape of Edinburgh and regretting its lost glory, the poet calls a roll of the poets as witnesses to the traditions of Scotland, of which they are also the principal guardians. The roll call begins with Ossian, who flourished

> While slept the nations round
> In darkest ignorance profound.[2]

Ossian is thus seen as the very root of a still living tradition. Our present perception of historical time, and indeed of historical truth, has changed so much that it is difficult to recognize just how potent this claim was. A generation conditioned by Blackwell and Wood to see true poetry as a product of the earliest state of human society suddenly found poetry with apparently just these credentials in a living, but literally aboriginal condition in Scotland itself.

Although Macpherson's *Ossian* was not entirely spurious, his purported translations were so widely discredited that it calls for a considerable effort of the imagination to see Ossian in the character of one of Allan Ramsay's 'good old Bards' and thus to see the close links between the enthusiasm for *Ossian* in Scotland and the renewed interest in Scottish vernacular poetry—to see the singleness of the Scottish tradition as it is implicit in Mercer's poem. It is personified in James Cumming's portrait of William Macgregor, an Edinburgh porter but presumably one of the many Gaelic singers and poets among the city's porters and chairmen. Cumming sees him as a modern Ossian following Runciman's imagery of the bard. Much of what Blair and Macpherson said about Ossian was held to be equally applicable to poetry in Scots. The two languages of old Scotland could both be seen as natural and uncorrupted. Gaelic, it was argued in 1751, was 'the natural and uncorrupt speech of men', but Allan Ramsay had already made similar, if less direct claims, for old Scots.[3] Both poetic traditions were seen as dependent on the landscape and way of life of the inhabitants. Runciman's friend David Herd surmised in the preface to his first collection of *Scots Songs* (1769), much as Macpherson did, that the tradition of popular song in Scotland derived its special distinction from 'the romantic face of the country and the pastoral life of the great part of the inhabitants'. The song and the ballad were seen as a kind of natural growth, an efflorescence of a settled way of life in which man and nature lived in mutual and poetic harmony. The classic statement of this view, extended in a sociological and even economic direction, was Robert Fergusson's poem, 'The Farmer's Ingle'.

Robert Fergusson was sponsored for membership of the Cape Club in October 1772 by Runciman's two closest friends, James Cumming and David Herd, together with the musician, Cornforth Gilson. He thus joined Runciman's immediate circle and he recorded his admiration for Runciman's painting in verse, wishing that his own muse,

> Like thee could make the awe-struck world admire
> An Ossian's fancy, and a Fingal's fire.[4]

Admiration for Runciman's painting may also be the inspiration of Fergusson's 'Ode on the Rivers of Scotland', but he offered a more extended commentary on the ideas that they shared in 'Hame Content', written in the summer of 1773. This poem is closely parallelled in Runci-

man's painting, *The Allegro with a Distant View of Perth* (col. plate 18), a summer landscape painted in the same year. Fergusson's poem paraphrases Milton's 'Allegro' in its opening lines. In doing so the poet sets up the opposition of town and country, which is the theme that Runciman takes from Milton's poem. Runciman contrasts the rural peace of the rustic cottage scene in the foreground to the view of Scone Palace in the middle ground, and of Perth in the distance.

'Hame Content' is, however, much more than a paraphrase of Milton. It starts from the Horatian opposition of the strife, din and materialism of the city to the health and peace of the country. He then goes on to contrast the natural way of life, 'Mang herds and honest cottar folk', with the unnatural, 'Steekit frae Nature's beauties a'.[5] In this last phrase he is paraphrasing Blackwell, not Milton (cf. Blackwell 'we live within doors, covered as it were from nature's face' etc.).[6] Developing Blackwell, he then goes on to draw a distinction between a natural, native art, simple and unadorned, and one that is artificial and dependent on foreign models. He ends up with a poetic expansion of Allan Ramsay's view of traditional poetry without 'imported trimmings' or 'foreign embroidery'.

Blackwell, like Ramsay, laid stress on landscape and it plays an important role in Fergusson's argument:

> The Arno and the Tibur lang
> Hae run fell clear in Roman sang;
> But, save the reverence of schools!
> They're baith but dowy lifeless pools.
> Dought they compare wi' bonny Tweed,
> As clear as ony lammer-bead?
> Or are their shores mair sweet and gay
> Than Fortha's haughs or banks o' Tay?

These lines recall the gigantic river gods in Ossian's Hall, whose function in the ceiling is to set Ossian in the real landscape of Scotland and to make his poetry specific to Scotland, not general, the point that Fergusson is making in this poem. He continues:

> Come, FANCY, come, and let us tread
> The simmer's flowr'y velvet bed,
> . . .
> That tae'n wi' thy inchanting sang,
> Our Scottish lads may round thee thrang,
> Sae pleased they'll never fash again
> To court you on Italian plain;
> Soon they will guess ye only wear
> The simple garb o' NATURE here;
> Mair comely far and fair to sight
> Whan in her easy cleething dight,
> Than in disguise ye was before
> On Tibur's or on Arno's shore.

Fergusson and Runciman therefore had a great deal in common, but Fergusson's poetry had an immediacy and a social dimension which apart from the one picture, *The Allegro*, Runciman does not seem to have followed. One reason for this may have been Fergusson's tragic early death. He died insane on 16 October 1774, just five weeks after his twenty-fourth birthday. It was left to Runciman's contemporary, David Allan, to develop the relationship between painting and Scots poetry embarked on by Runciman and Fergusson.

Allan (1744–96) was a product of the Foulis Academy in Glasgow, the institution founded for the teaching of art by the publishers Robert and Andrew Foulis in 1754. Like the two Edinburgh academies, the Foulis Academy was housed in the university in Glasgow and it functioned for a little more than twenty years. Allan joined the academy at the age of eleven in 1755 and studied there till 1764. Then, backed by the Cathcarts and the Erskines, two families from the region of his native Alloa, he travelled to Italy, probably in 1767. He spent ten years there, possibly interrupted by at least one visit home, then, after two years in London, finally settled in Edinburgh in 1780.

Like Runciman, his ambitions were formed by his association with Gavin Hamilton in Italy. In 1788, dedicating to Hamilton his illustrations to Allan Ramsay's *The Gentle Shepherd*, he acknowledged 'a grateful recollection of those advices with which you honoured me while I was studying painting at Rome'. The circumstances in which he won the gold medal of the Accademia di San Luca in Rome in 1773 have already been alluded to. He was clearly one of Hamilton's principal protégés. His history painting is, however, tame and rather feeble. His best history picture in the classical mould is his small *Origin of Painting* (1775; National Gallery of Scotland), but this is as close as he came to rivalling Runcimam.

He was more gifted as a portrait painter, and on his return to Britain portraiture was his principal livelihood. His large, open-air family portraits have a great deal of charm and they obviously had considerable popularity, too, for there are quite a few of them; the Erskine family, the Cathcart family, the Duke of Atholl and his family, are examples. This last was seen and admired by Burns. Allan's debt to Zoffany is clear, though he introduces a certain neoclassical formality to the composition which is elegantly turned to the charm of simplicity by the informality of the subject matter.

The charm of Allan's group portraits can accommodate but not disguise the weakness of his draughtsmanship. It was only in genre that he found a way of turning this to advantage, as Runciman did in a similar way in his treatment of imaginative subject matter and it was in genre that Allan made his most original contribution. His interest in subject matter in the Dutch tradition began early. Two genre pictures, *A Cottage Interior* and the *Muzzling Fair*, date from before his departure for Rome, and there, at the same time as he was pursuing laurels as a history painter, he continued to draw and also to etch scenes from common life. He was not motivated by idle curiosity, however, nor, though there is humour in his drawings, are they simply comic. There is a definite

documentary purpose in much of his work of this kind. Its subject matter belongs under that very eighteenth-century heading of 'manners', that is, social customs, especially dances, games and public amusements. The drawing, *Neapolitan Dance* (Dunimarle), is an example, a subject that he drew, engraved and painted. His most ambitious work during these years was a series of large drawings of the *Roman Carnival* (plate 46) which he exhibited in 1778 and subsequently sold to Paul Sandby in London, who published four of them. The rites of the Catholic Church came into this category of manners too. They were clearly an object of interest to a Protestant. Runciman in his letters comments on the spectacle. They were still sufficiently unfamiliar for Wilkie to be impressed by his first sight of Catholic ritual in France more than fifty years later. Allan made a series of the *Seven Sacraments* as well as recording less formal manifestations of popular belief, such as *Two Zampanieri Playing before the Virgin*. The drawings that resulted from all this were not unduly solemn. Allan it seems was moved by the spectacle of popular belief, so different from the Protestant experience, much as Gauguin was in Brittany a century later. Piety is represented as simple and unassuming, much as the good humour of social festivity is represented with lively characterization, but little obvious satire.

This aspect of Allan's work was not separate from his interest in history painting, a kind of relaxing sideline. It was a product of the same interests, and an ingenious extension of the new aesthetic of history painting as proposed by Hamilton and developed by Runciman. Allan delighted in identifying the natural grace of a country dancer, as in the *Neapolitan Dance*, with a classic form, not in order to 'correct' it according to an artificial aesthetic norm, nor as though it was a folk memory of a lost civilization, like a ruin in the landscape, but to suggest that a certain kind of movement or gesture was inherently graceful in the life of simple, unspoilt people. He was on friendly terms with Sir William Hamilton and so knew his collection of vases. They provided an example of an apparently natural style, capturing with sympathetic simplicity the life of a primitive people. Allan did not take their inspiration as literally as Runciman and Fuseli did, but his lightly drawn figures are often set unemphatically in profile. They have little volume and the lines of the compositions flow through graceful movements of arm and head. His approach has something in common with Winckelmann's theory of Greek classicism as an inherent product of climate and life style, but Allan's interest lies in the 'folk'. Grace, is a natural feature of a simple culture, not the product of a complex civilization.

46. David Allan. *The Victor conducted in Triumph (from the Roman Carnival)*. c. 1775. Cat. 79

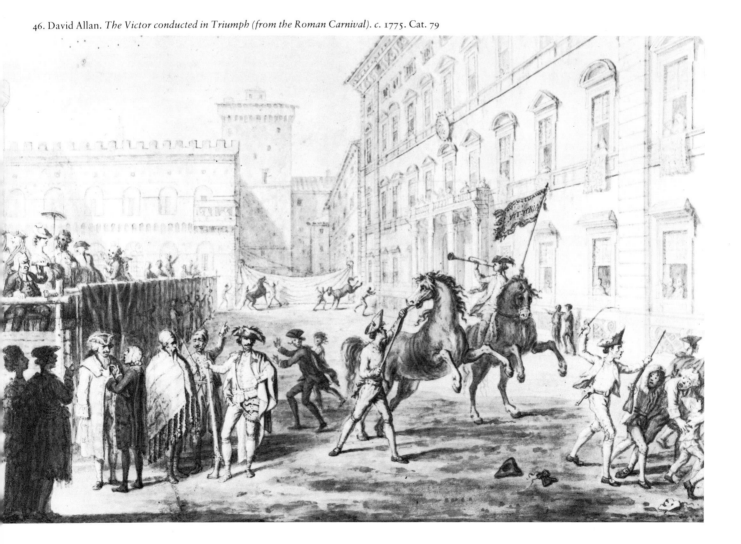

Allan seems to have had a particular interest in cos-
tume, one of the most visible manifestations of a distinc-
tive folk culture, and the costume studies among his
drawings cover not only the Italian mainland but also the
islands of the Bay of Naples and Minorca (plate 47). The
latter island may have been a port of call between England
and Italy, but even so, as the only evidence that we have
of these visits is in the surviving costume studies, it would
seem they were an important part of his traveller's record,
almost in the nature of ethnographic field work. Islands,
like remote mountain regions in Macpherson's view,[7]
could justifiably claim to present particularly favourable
conditions for the undisturbed preservation of ancient
cultures. Indeed James Byers, who was interested in
geology, argued that the islands of the Mediterranean had
been a refuge for survivors of the Flood and so had con-
tinuity with the antediluvian world.[8] Byers was a Scot
resident in Rome, and Allan would certainly have been
familiar with his views. Allan's own interest in costume
was not in itself original, but his motivation in recording

costume perhaps was, if he was indeed searching for evi-
dence of the survival of antediluvian Mediterranean
culture.

Like Runciman, Allan saw no difficulty in transferring
his interest from a Mediterranean to a Scottish context.
There was as good a claim to be made for the ancient
and natural character of Scottish culture as for Mediter-
ranean according to Macpherson's ideas. On 6 November
1780 Allan wrote to Sir William Hamilton in Naples de-
scribing the transfer of his interest: 'I did at Rome a set
of Drawings in Bister representing the amusements of the
Carnival at Rome in 8 Drawings, which Sandby bought
from me in London and he has executed them charmingly
in aquatint prints at a guinea the sett If I have health
and time I intend to do groups of the manners in Scotland,
which would be new and entertaining and good for
engraving. I have painted at Athole for myself a Highland
Dance as a companion to the Neapolitan, but the High-
land is the most picturesque and curious.'[9]

'Picturesque' and 'curious' are words that in this con-
text in the eighteenth century denote a serious interest
rather than one that was merely superficial, as the same
words at a later date might have implied. The *Highland
Dance* (col. plate 20), was the first in a long series of pic-
tures of 'manners in Scotland' that Allan made. These
range from the record of social customs in the *Highland
Wedding* (private collection), through prints from con-
temporary life like the *Stool of Repentance* (plate 48),
down to single figures, studies of types and costumes like
those that he made in Italy and the Mediterranean. His
scenes and characterizations are frequently humorous
and he quotes at times from Hogarth. In the *Stool of
Repentance*, for example, the seduced girl and her mother
echo *The Rake's Progress*, but there is no satirical inten-
tion. Things are recorded for their own sake.

Allan's works have real value as social documentation,
but he is not simply a recorder of visual fact. Style for
him is in certain circumstances part of the process of
recording. The naive grace or unconscious awkwardness
of a gesture or the humour in a scene are part of the
naturalness of the way of life which is his subject and
which can only be matched qualitatively in an appropriate
style. At this point he comes very close to the kind of ideas
which are explored by Robert Fergusson in 'Hame Con-
tent', and it is through his response to Scottish literature
that his own aesthetic ideas can be most clearly identified.

Allan's first illustrations of a Scottish literary text were
four that he did when he was in London in 1778 for an
edition of Thomson's *Seasons* published by Murray.
Thomson, who had died in 1748, was very much a Scot-
tish literary hero in Allan's time. Indeed the Cape Club
celebrated his birthday, as later generations celebrate that
of Burns. Later, too, Allan produced an illustrated *Ossian*,
though not in a manner that challenged Runciman's inter-
pretation.[10] These book illustrations were, however,
minor projects compared to the illustrations to Allan
Ramsay's *The Gentle Shepherd*, which was an enterprise
of quite a different kind. The edition was published by

47. David Allan. *The Procidan Girl*. 1776. Cat. 82

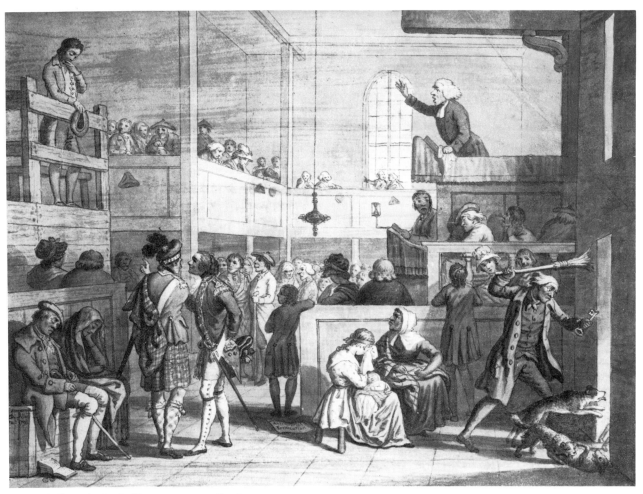

48. David Allan. *The Stool of Repentance*. 1795. Cat. 84

the Foulis Press in Glasgow in 1788, and by its exceptional typography it clearly fulfils the younger Ramsay's declared but unfulfilled ambition to produce a typographically worthy edition of his father's masterpiece. There is no direct evidence to associate the younger Ramsay with the Foulis project, which did not bear fruit till four years after his death, but David Allan was in a position both in Rome, where their mutual friend was Gavin Hamilton, and subsequently in London, to have got to know him.

The Gentle Shepherd was Allan's own project. It was the edition itself that he dedicated to Gavin Hamilton, not just the illustrations. There is every likelihood therefore that the idea of the magnificent edition originated with Allan Ramsay and that David Allan took it up with the Foulis Press, adding at the same time the proposal to embellish it with his own designs. This connection with Allan Ramsay would explain how David Allan had access for the title page to an otherwise unknown drawing by Ramsay of his father.

The twelve full-page illustrations in etching and aquatint are of equal weight to the text (plate 49). As a set of pictures therefore they relate to Hamilton's *Homer*

illustrations or Runciman's *Ossian*. They are not ancillary to the text but an independent complement to it. This implies a view of *The Gentle Shepherd* that may seem exaggerated to modern eyes, but was widely accepted in the eighteenth century. Henry Mackenzie described the play as the finest modern pastoral.[11] An even more interesting authority, Burns, commented on the play and David Allan's edition of it in a letter to Alexander Cunningham: 'Do you know Allan? He must be a man of very great genius. Why is he not more known? Has he no Patrons; or do "Poverty's cold wind and crushing rain beat keen and heavy" on him? I once and but once got a glance of that noble edition of the noblest Pastoral in the world, & dear as it was; I mean dear as to my pocket, I would have bought it; but I was told that it was printed and engraved for Subscribers only. He is the *only* artist who has hit *genuine* Pastoral costume.'[12]

Allan chose a key work in the history of 'natural' verse for what was in effect a visual manifesto. He backed it up with his dedication to Gavin Hamilton, where he spelt out the principles on which his art was based. Clearly he did not see the dedication to Hamilton as incongruous. On the contrary, the choice is a demonstration of his

belief that his aims were wholly compatible with those of history painting and he justifies himself in those terms first of all. After a rather nominal declaration of his regret for the lack of encouragement for 'public and great works in the historical line', he goes on to propose his own art as a satisfactory substitute: 'In the humbler walk of Painting, which consists in the just representation of ordinary Life (by which, it is believed, the best moral effects may be often produced), there can be no better models than what Nature, in this country, daily presents to our view. Without descending to mean and low objects, it is possible, by a strict adherence to truth and nature, to produce compositions which, though not so striking as the sublimer efforts of the pencil, are yet capable of pleasing and instructing in the highest degree.'

At this point there is an echo of Hogarth's justification of comic history painting as it was presented by Fielding in the introduction to *Joseph Andrews*, but the essential difference is clear. As Ramsay the painter, too, defined ridicule, Hogarth held a mirror to life; his intention was to show how far customary behaviour and the standards to which it conforms fall short of nature. Allan intends to find actual models of undistorted simplicity which nature herself presents. He clearly proposes, as Burns, for one, equally clearly accepted, that his pastoral world is real, not ideal. To this end he continues:

49. David Allan. *Glaud and Peggy* (*from* The Gentle Shepherd). 1789. Cat. 87

This consideration has incited me to present the public with a series of designs illustrating the different scenes of a justly admired Pastoral, the 'Gentle Shepherd' of Allan Ramsay. This piece it is well known, he composed in the neighbourhood of the Pentland Hills, a few miles from Edinburgh, where the shepherds to this day sing his songs, and the old people remember him reciting his own verses. I have studied the same characters on the same spot, from Nature. This, likewise, has been my model of imitation, and while I attempted in these sketches to express the ideas of the poet, I have endeavoured to preserve the costume as nearly as possible, by an exact delineation of such scenes and persons as he actually had in his eye.'

At a single stroke Allan Ramsay has joined Ossian and Blackwell's Homer as the inspired recorder of an unspoilt natural world. Allan's claim that he has checked the poet against nature, as it were, is identical to Robert Wood's approach to Homer, but like Macpherson, Allan has the advantage that the social world his poet is illustrating, and not just the landscape, does, in his belief, survive in the present. Nor is he alone in the claims that he makes for Ramsay. In a vignette designed by Richard Cooper, on the title-page of the two earliest editions of *The Gentle Shepherd*, those of 1729 and 1734, the poet appears in full pastoral rig. Robert Fergusson, too, in 'A Drink Eclogue' makes the same claim as David Allan that Ramsay's songs have passed into pastoral use. The poem is a dispute between Whisky, the natural drink of the people, and Brandy, the imported foreign drink that satisfies the artificial taste of the rich and affected:

BRANDY : Frae some poor poet, o'er as poor a pot
 Ye've learnt to crack sae crouse, ye haveril
 Scot!

WHISKY : Troth I ha'e been 'ere now the poet's flame
 And heez'd his sangs to mony blythsome theme.
 Wha was't gar'd ALLIE's *chanter* chirm
 fu'clear,
 Life to the saul, and music to the ear:
 Nae stream but kens, and can repeat the lay
 To shepherds streekit on the simmer brae,
 Wha to their *whistle* wi' the lav'rock bang,
 To wauken flocks their rural fields amang.[13]

Allan had aligned himself with the vernacular poets from the time of his return to Scotland. Burns in 'The Vision' argues the claims of the rustic muse against the grander muse of history, much as Allan did in his Dedication. In 'The Vision' Coila, the rustic muse, claims him for her own in words that would equally fit Allan:

 I taught thy manners-painting strains,
 The *loves*, the *ways* of simple swains . . .[14]

Fergusson in 'Caller Water', reflecting the same sentiment that he did in 'Hame Content', wrote:

My muse will no gang far frae hame,
Or scour a' airths to hound for fame:
 In troth, the jillet ye might blame
 For thinking on 't,
When eithly she can find the theme
 Of *aqua font*.[15]

The poem is an elegant metaphoric plea for the virtues of simplicity and naturalness in life and art, as symbolized in the purity of water.

Allan concludes his Dedication by remarking, 'I have engraved these designs in the manner called aqua-tinta, a late invention which has been brought to much perfection by Mr Paul Sandby of London. A painter finds his advantage in this method, in which the pencil may be associated with the graver. It will be easily seen that I am not a master in the mechanical part of this art; but my chief intention was not to offer expensive smooth engravings, but expressive and characteristic designs.' Simplicity here takes on a startling new guise. Hogarth provides a precedent for the deliberate imitation of unsophisticated styles in, for example, the woodcut version of *The Four Stages of Cruelty*, but whereas Hogarth was adopting an unsophisticated style to reach an unsophisticated audience, Allan was presenting lack of sophistication as desirable to a sophisticated audience because it was more expressive. This is surely the first time in the history of art that an artist claims that the authenticity of his expression lies in his *lack* of mechanic skill. It is possible to compare this in later generations to Courbet's claim to be untaught, or even Miró's claim that he became an artist, not because he could draw, but because he could not, but it is not easy to find precedents in earlier art, unless it is in Runciman's deliberate neglect of finish and formal drawing, seeking expressive spontaneity where Allan sought simplicity.[16] To use a later term, both were seeking to capture the qualities of naivety.

In *The Gentle Shepherd* illustrations Allan sought naivety of effect by adopting a light and open composition, lacking movement in depth or strong chiaroscuro. There are no strong diagonals, nor are there sinuous lines except where they characterize the grace of an individual figure. In spite of superficial echoes of rococo pastoral imagery therefore, the compositions really have no rococo qualities. The figures are clearly differentiated into youthful and aged, graceful or awkward, before they are distinguished as individuals. Details of costume, furniture, etc., are included, but very sparely, and Allan's 'exact delineation' seems to refer to a manner of life captured aesthetically rather than to a catalogue of its details.

Before David Allan, Sandby had made five etchings illustrating Ramsay's play. Allan clearly knew these, but the comparison of them with his own underlines the stylistic novelty of what he was doing. Sandby's small figures are set in sophisticated picturesque landscapes. Their poses are complex and they and the compositions as a whole are enlivened by rich patterns of chiaroscuro.

Inevitably perhaps, in his own time, Allan's designs were also compared to Teniers and Ostade, but there is no simple relationship between his images and seventeenth-century art. David Deuchar, his contemporary in Edinburgh, a seal engraver and amateur etcher, began to produce his large collection of etchings in or before 1784. These are predominantly genre scenes, some to his own design, one or two after Allan himself, but principally after seventeenth-century Dutch models, especially Ostade and Rembrandt. They are sometimes pretty villainous, though occasionally powerful and certainly influential, but their appearance and the time and place of their production does underline the extent to which Allan's interpretation of the pastoral turns away from the convention of the Dutch or Flemish boor. His pastoral world is innocent, not ignorant.

Allan Cunningham remarked of Allan: 'On the antiquities and literary history of the country he had employed much of his leisure time and delighted to discourse.'[17] His interest in antiquities brought him, like Runciman, Brown and also Deuchar, into the circle of the Earl of Buchan. Though, unlike the other artists, he was not directly associated with the Society of Antiquaries, he seems in fact to have been particularly closely associated with Buchan. He co-operated with him on a variety of antiquarian projects, especially Buchan's *Temple of Caledonian Fame*, his collection of historic portraits for which Allan both copied and actively sought out pictures. For example, he wrote to Buchan on 8 September 1789: 'I have been in pursuit of your picture of King James V, an excellent one Busto I have found according to order at Pitfirrane ... I found likewise an excellent picture size Busto of Ludovic, 2 Duke of Lennox the date on it is 1623 with order of the Thistle with a brown beaver. I thought it necessary to inform your Ldp. that in case you wanted this likewise ... Begs your Lordship will inform me if you wish only James V or both, shall then write & get them over & do them soon. I like the business well as I love the Erskines and Stuarts & particularly the latter, For whom I have been exercising my brush and brains for some time.' Allan then continues, shifting without pause from Buchan's interest in portraits, to his own interest in the drama of history: 'If your Lordship had done me the honour when last in town to have seen my poor study would have seen two large historical pieces from the life of the unfortunate Queen Mary. My mind is upon this history and intends doing several pieces. I have with some difficulty found out many of the old Scottish dresses. I shall aim at character and costume.'[18] The pictures that he mentions were probably two of the three that he exhibited at the Royal Academy in 1791. They were *The Murder of Rizzio*, *The Abdication of Queen Mary* and *Queen Mary hears the Warrant for her Execution*. None of the paintings is now known, though several drawings for these and other subjects from the life of Mary do survive. The documentary approach to history, with its special interest in details of costume as well as physiognomy through portraiture that Allan describes, was continued by Wilkie in the next generation.

Allan's interest in the imaginative reconstruction of history also has an obvious parallel in the Waverley novels.

Like Scott, too, Allan's interest in history was matched by his interest in literary history. In his view his *Gentle Shepherd* illustrations would have been historical to the extent that they purported to be an accurate record of an actual pastoral life. It was on this literary context and the accuracy of costume too that Burns especially commented. After the success of *The Gentle Shepherd*, Allan's next major project was the illustration of Scots songs. It linked him even more closely with Burns. As a projected publication it took various forms, none of which seems to have been realized in Allan's lifetime, but he produced around a hundred drawings, all in the same oval format and illustrating seventy-five songs (plate 51).

Allan's interest in songs is attested in an anecdote written down more than sixty years after his death. A party of Italians had performed the 'finest airs' to a large but unimpressed audience at Hopetoun House. 'A splendid entertainment followed of good cheer. As the exhilarating glass went round, the Earl said "Mr Allan, we have heard much of the finest Italian music; will you be so good as to give us a specimen of one of your best Scotch songs, such as I have often heard you sing?" This request was most readily complied with, and while Allan proceeded the guests, who were truly Scotch, were, as it were, electrified. The scene turned the tables on the Italians who became as solemnly grave as their auditors were formerly, for of melody they heard not an air, and they understood not one word of the song.'[19] It seems hardly necessary to add that the song in question was a 'primitive' one. It was even grotesque in its simplicity and it was this which amazed the Italians.

This story is so neat that it suggests that, either in the acting or in the telling, life is imitating art. Compare for example Fergusson in 'Daft Days':

> *Fidlers*, your pins in temper fix
> And roset weel your fiddle-sticks,
> But banish vile Italian tricks
> From out your quorum:
> Nor *fortes* wi' *pianos* mix,
> Gie's *Tulloch Gorum*.[20]

But even if all the circumstances are apocryphal, the central point must be true. Given so many other candidates for the task better qualified, there would be no reason arbitrarily to appoint Allan champion of Scottish song.

The great majority of the songs that Allan illustrated were contained in the collections of David Herd, published in 1769 and 1776. In his preface to the 1776 collection Herd described the 'sentimental, pastoral and love songs' as characterized by 'Forcible and pathetic simplicity', and the other class, 'the humorous and comic as no less admirable for sprightly naiveté, picturesque language, and striking paintings of low life and comic charac-

ters'. Given such opinions, it is very possible that some kind of illustrated collection was projected between Herd and Allan. It was in a publication of Joseph Ritson's, however, that Allan's illustrations were first used. Five of them were published in his *Scottish Songs* in 1794, but by that time Allan had already begun to collaborate with George Thomson on a project in which it was proposed to publish a considerable number of his illustrations. Such as Thomson did in the end publish did not, however, appear till after Allan's death.[21] Allan himself planned to publish a collection of twenty-five etched illustrations to Scots songs, but this project too was cut short by the painter's death. An etched title-page and the posthumously published *Songs of the Lowlands of Scotland* (1798) are the surviving evidence for this project.

Thomson was clerk to the Trustees for the Board of Manufactures. In that position he had oversight of their academy, where Allan succeeded Runciman as master in 1786. Thomson's great enthusiasm was for Scots music and poetry and perhaps guided by Allan he seems to have seen the possibility of linking them with painting. He remained in his post as clerk to the Trustees till his death in 1851 and so his enthusiasm remained a stimulus to young Scottish painters from the time of Runciman and Allan into the beginning of the second half of the nineteenth century. In the publication of his *Scots Songs*, at the same time as he enrolled the assistance of Allan, he also enrolled Robert Burns to write words for the songs, and their three-way collaboration is recorded in the correspondence between Thomson and the poet.[22]

Allan first appears in this correspondence when Thomson wrote to Burns in August 1793. 'Mr Allan has made an inimitable drawing from your "John Anderson, my Joe", which I am to have engraved as a frontispiece to the humorous class of songs.' By 17 April 1794 Burns had seen some of Allan's drawings, for Thomson wrote: 'Allan is much gratified by your good opinion of his talents. He has just begun a sketch from your 'Cotter's Saturday Night', and, if it pleases himself in the design, he will probably etch or engrave it.' Burns replied the following month: 'I return you the plates with which I am highly pleased . . . A friend of mine who is positively the ablest judge on the subject . . . is quite charmed with Allan's manner. I got him a peep of *The Gentle Shepherd* and he pronounces Allan a most original artist of great excellence.' And he went on: 'For my part I look on Mr Allan's choosing my favourite poem for his subject, to be one of the highest compliments I have ever received.'

There then followed an exchange through Thomson about that essential of primitive music, a primitive musical instrument, the stock and horn; this was a topic of mutual interest, for Burns had already commented to Alexander Cunningham on Allan's representation of one in the engraved portrait of Ramsay in *The Gentle Shepherd*.[23] Burns, suggesting a correction to Allan, describes to Thomson one in his possession. It was made of the thigh bone of a sheep, a cow's horn and an oaten reed 'by a man from the braes of Athol and is exactly what

the shepherds were wont to use in that country. . . . However, either it is not quite properly bored in the holes, or else we have not the art of blowing it rightly; for we can make little of it. If Mr Allan chooses I will send him a sight of mine; as I look on myself to be a kind of brother brush with him. "Pride in poets is nae sin"; and I will say it, that I look on Mr Allan and Mr Burns to be the only genuine and real painters of Scottish costume in the world.'

When Allan had completed his *Cotter's Saturday Night*, introducing the figure of Burns in the title role, Thomson sent it as a present to the poet in May the following year. This painting is now lost, but there is a drawing of the subject in the National Gallery of Scotland. Burns's response was enthusiastic: 'Ten thousand thanks for your elegant present . . . I have shown it to two or three judges of the first abilities here, and they all agree with me in classing it as a first rate production. My phiz is sae kenspeckle, that the very joiner's apprentice whom Mrs Burns employed to break up the parcel (I was out of town that day) knew it at once. My most grateful compliments to Mr Allan, who has honoured my rustic muse so much with his masterly pencil.'

In April 1796 Burns's enthusiasm for Allan's designs continued: 'I am highly delighted with Mr Allan's etchings, "Woo'd and married and a'", is admirable. The grouping beyond all praise. The expression of the figures, conformable to the story of the ballad, is absolutely faultless perfection etc.' Thomson by this time was planning a more elaborate use of the illustrations, for he wrote: 'I am happy to find you approve of my proposed octavo edition. Allan has designed and etched about twenty plates, and I am to have my choice of them for that work. Independently of the Hogarthian humour in which they abound, they exhibit the character and costume of the Scottish peasantry with inimitable felicity.'

This correspondence is worth examining in some detail for although Burns does not offer any complex critical opinion, his sense of the appropriateness of Allan's art to what he himself was trying to do is clearly quite genuine, as is his recognition of their common interest. At the beginning of their co-operation Burns wrote to Thomson on the subject of Scottish song: 'In the sentiment and style of our Scottish airs, there is a pastoral simplicity, a something that one may call the Doric style and dialect of vocal music.' Allan's illustrations seem to reflect an attempt on his part to match this view and to find a visual equivalent for the small scale and simplicity of song. Though the formal language is similar to that of *The Gentle Shepherd* illustrations, it is even more reduced. He includes the necessary minimum for his setting and such details of costume as are appropriate, but generally seems very conscious that song and even ballad is not burdened with descriptive detail. Within the narrow compass of the oval format, he modulates his designs with considerable success to convey the essential feeling of the song—pathos, humour, or what David Herd called 'sprightliness'. 'Maggie Lauder', for example, is the epit-

ome of sprightliness, the 'Gaberlunzie Man' of humour, 'Barbara Allan' of pathos.

Allan's intention in the song illustrations, to which he devoted so much time, is illuminated by comparing it with the documentation of Scottish life and manners in his other works. These range from types—coalmen, city guards and such like, a development of his Mediterranean single figure studies, but principally urban—through scenes from daily life such as *The Lawnmarket, Edinburgh*, the *Stool of Repentance*, *Leith Races*, *Coal Miners' Celebration*, etc. Again these are principally urban and the style is elaborate, for example, in the print that records the *Laying of the Foundation Stone of the new building of Edinburgh University* in 1789 there is a wealth of circumstantial detail, appropriate to the occasion but clearly quite inappropriate to his interpretation of pastoral poetry and song.

In his treatment of urban scenes Allan had an important precedent in Sandby, who had produced a variety of scenes in the streets of Edinburgh during his stay in the city betwen 1746 and 1752. Robert Fergusson was, however, an equally important precedent. He was the supreme poet of Edinburgh street life. Both in subject, as in *Leith Races*, and in characterization, as in the *City Guard*, Fergusson's 'black banditti', Allan comes very close to Fergusson, and it was the poet and the painter between them who created the iconography of the street life of Edinburgh as it was developed in the next generation, particularly by Walter Geikie.

Allan's last dated work was *The Penny Wedding* of 1795, his best known and most influential single work (plate 50). As a subject it belongs with his studies of Scottish manners, *Highland Dance*, *Highland Wedding*, *Catechising in a Scottish Church*, etc. Compositionally and thematically it is particularly close to the first of these which in turn evolved out of the theme of the *Neapolitan Dance*, but by rendering it in the idiom of pastoral genre that he had developed he was perhaps essaying a more universal theme. The iconography has the precedent of Jacob de Wet's late seventeenth-century *Highland Wedding* at Penicuik House. Before that it derives ultimately from Pieter Breugel's engraving of the *Peasant Wedding*, which is actually shown as a penny wedding. The bride is seated at a table in the background, receiving coins given by the guests (hence the name of the occasion); this detail is missing from Allan's picture. More recently Hogarth had treated the *Wedding Dance* in the composition that he used to illustrate the *Analysis of Beauty*.

In the genesis of the image there are also important literary precedents. George Thomson suggested the subject to Wilkie in 1807 in a letter and quoted the last stanza of 'Muirland Willie':[24]

> Sic hirdum dirdum and sic din
> Sic laughter, quaffing, and sic fun,
> The minstrels they did never blin
> Wi' meikle drink and glee,
> And aye they bobbit and aye they beckit.

50. David Allan. *The Penny Wedding.* 1795. Cat. 96

He then went on: 'The bride and bridegroom, the brides-maid and her sweetheart and the convivial old folks might be seated in the foreground and behind them the dancing group and the fiddlers might appear.' Thomson was plainly quoting Allan's picture as a model to Wilkie, but he was in a position also to have been party to its original conception. It obviously reflects the interest in music and song that he and Allan shared. Cunningham, in describing the picture that Wilkie eventually painted, cites the poem 'Christ's Kirk on the Green', together with Allan's pic-ture.[25] The first canto of the poem is attributed to James I of Scotland. It is a famous account of a popular gathering degenerating into anarchy. Allan Ramsay added two fur-ther cantos when he published it in the 1721 edition of his poems. In the first of them the shattered peace is restored by a wedding dance. Ramsay also celebrates the therapeutic power of dance in another poem, 'The Fair Assembly':

And, when the Fates unkind
Cloud with a blate and aukard air
A genius right refined,
The sprightly art helps to repair
The Blemish on the Mind.

He quotes Locke in a footnote for his authority in setting out this principle in the first part of the poem, then pro-ceeds to introduce an account of a dance, the fair assem-bly, as follows:

Hell's Doctrine's dung, when equal Pairs
Together join their Hands,
And vow to soothe ilk other's cares
In haly Wedlock Bands:
Sae when to dance the Maid prepares,
And flush'd with Sweetness stands,
At her the wounded Lover stares,
And yields to Heaven's Commands.[26]

The idea of the dance as a symbol of order in society was not new. Ambrogio Lorenzetti had used it as the central image in his fresco of *Good Government* more than four hundred years earlier, but in recent theoretical writing, music and the dance together had been given a new priority in the evolution of social order. John Brown of Newcastle in his elaborately named *Dissertation on the Rise, Union and Power, the Progressions, Separations, and Corruptions of Poetry and Music*, published in London in 1763, described the progression from brute chaos to human society: 'Thus chaos of Gesture, Voice and Speech rise into an agreeable order and proportion. The natural love of a measured melody . . . throws the voice into Music, the Gesture into Dance, the Speech into Verse or Numbers.'[27] James Barry adopted this view in his *Progress of Human Culture*, the opening scenes of which are *Orpheus* and the *Dance in a Grecian Harvest Home*. Allan's two principal figures seem to be identical to Barry's in the *Harvest Home*, except that they have exchanged positions as they now face each other and have also altered the direction of their glances. Barry's prints after his *Progress* had been published in 1792, so Allan would certainly have known the composition even if he had not had opportunity to see it in the course of its painting when he was in London at the end of the 1770s.

Allan's picture therefore seems to be a celebration of music and dance as the essential expression of social harmony. The only discord in the picture is provided by two dogs quarrelling over a bone, brutes unresponsive to the power of music. The title, costume and setting identify the occasion with popular custom in opposition to urban bourgeois conventions associated with property and the display of wealth, just as the music of the fiddlers is traditional, or natural, folk music. The natural grace of the dancers is prominently displayed as a function of their youth. They are not rustic clowns. Nor is there any authority alluded to in the picture except that of the musicians. The unconvincing snowy-haired old patriarchs who dominate Greuze's view of rural simplicity are absent. (Their humbug was memorably exposed by Dickens's Mr Pank in *Little Dorrit* when he cut the hair of the preposterous old patriarch, Mr Casby.) There is no reference, either, to the laird or even to the more prosperous kind of farmer. Allan's social view must have been touched by Rousseau, but it is loyal, too, to *The Gentle Shepherd*. There it is *because* Patie is a shepherd and *in spite* of his gentle birth that he is both morally and musically exceptional. As soon as his gentle origins are revealed, Glaud warns Peggy against her love for him in no uncertain terms:

> Before he, as a shepherd, sought a wife,
> With her to live a chaste and rural life;
> But now grown gentle, soon he will forsake
> Sic godly thoughts, and brag of being a rake.[28]

Loyal to this tradition, therefore, Allan's pastoral vision is neither morally nor politically neutral.

51. David Allan. *The Gaberlunzie Man. c.* 1794. Cat. 95

VI

The Portraiture
of Common Sense

*'The rank is but the guinea's stamp
the man's the gowd for a' that.'*
Robert Burns, FOR A' THAT AND A' THAT

Popular music and musicians are an unusual subject in the art of the late eighteenth century, though they had been common enough in the seventeenth, especially in Holland. The direct comparison of the aesthetics of such music to the aesthetics of the visual arts, and so the connection of painting with popular culture, as it is suggested by David Allan, seems to be unique before Courbet, though other artists in Scotland besides Allan were exploring the same subject matter. The amateur etcher, David Deuchar (1745–1808) produced in the 1780s and 1790s a large number of copies of Ostade and other seventeenth-century Dutch masters as well as compositions of his own and after Allan and including various scenes of music making. William Weir (d. 1816) not only illustrated *The Gentle Shepherd*, he also produced his own version of *The Penny Wedding*, but of all the pictures to emerge from this dialogue of art and music, at least before Wilkie, the most memorable is Raeburn's portrait of the fiddle player, *Neil Gow* (col. plate 21). Allan painted Gow in the *Highland Dance* with his brother, Nathaniel, who was also a gifted musician, but Raeburn's portrait is life-sized and far surpasses Allan's in its quiet monumentality. It is, nevertheless, close to Allan's approach to his musical subject matter, for it derives its strength as an image first of all from its simplicity. The musician is quite alone against a plain background. His costume is simple and there is nothing demonstrative in pose or gesture. His expression is withdrawn as he is absorbed in his music. It is a natural portrait of an unselfconscious artist, but the qualities of natural simplicity and strength apply to the music as well as to the man. He becomes therefore the personification of popular music as it is presented in Allan's pictures at much the same time—Gow's portrait was probably painted no later than 1793. It is a reminder therefore, that although Raeburn was unchallenged as the supreme painter in his generation in Scotland, his art did not flourish in isolation.

In spite of his status, Raeburn's career is surprisingly little documented. Such correspondence as survives is largely about business. Though it helps in dating some works, which he hardly ever did on the canvas, it tells us very little about him or his art. There is no adequate catalogue of his work, and his first biographer, Allan Cunningham, though he knew Raeburn, was inclined to invent when he lacked information.[1] The early part of his career is particularly problematic, though we know the main facts. He was born in 1756, was orphaned, educated at Heriot's Hospital in Edinburgh, and brought up under the general supervision of his elder brother, William. In 1772 he was apprenticed to James Gilliland, an Edinburgh goldsmith. While he was still an apprentice he began to paint miniatures, a natural extension of the goldsmith's business. Among the miniatures that survive there is one of David Deuchar (National Gallery of Scotland) and according to what may be a family tradition, recorded late but nevertheless convincing, it was Deuchar who first encouraged him to develop his artistic ambitions.[2] Traditionally, he was also helped and encouraged by David Martin, who returned to Edinburgh in the late 1770s. In 1780 Raeburn married Anne Leslie, a widow of some private means who was twelve years his senior and the mother of three children. In 1782 he joined with William Weir and the miniature painter, Archibald Robertson, in a regular life class under the supervision of Alexander Runciman.[3] It was Robertson who, after emigrating to America, was responsible for Raeburn's early reputation there. In April 1784 Raeburn left Edinburgh for Italy, apparently leaving his family behind and relying to some extent at least in his family arrangements on Walter Ross, his neighbour in Stockbridge, who had acted in the same capacity in the same circumstances for the Runciman brothers seventeen years before.

Raeburn's earliest dated work has always been accepted as the portrait of *George Chalmers of Pittencrieff* in the City Chambers, Dunfermline.[4] It is dated 1776 on the frame. This date is not corroborated by any documentary evidence however, nor is it consistent with the rest of the inscription on the label, which is com-

memorative and therefore postdates Chalmers's death in 1797. The painting clearly shows the characteristics of Raeburn's style as it can be identified in pictures datable around 1790 and there are no similar pictures that can be dated for any reason before 1787.

The sitter's costume, a brown worsted three-piece suit with broad flat metal buttons, is also typical of the early 1790s and appears on a number of Raeburn's male sitters from that time. Such homely garb would have been quite out of place in such a grand portrait at an earlier date. Even the frame, which has been the source of such confusion, is of neoclassical type, typical of the end of the century and perhaps to clinch the matter, Raeburn's picture bears a striking resemblance to Reynolds's portrait of Dr John Ash, painted in 1788 and engraved in 1791.

The Chalmers painting is an ambitious, full-length portrait. He is seated beneath a red curtain with a view of Dunfermline Abbey behind on the left. It is spatially accomplished and has the kind of carefully orchestrated colour that characterizes Raeburn's work between 1787 and 1792. It is inconceivable that it could predate such a plainly immature work as the portrait of the geologist *James Hutton* (private collection) (plate 52), which is nevertheless clearly attributable to Raeburn. Hutton died in 1797 aged seventy-one. In this portrait he is considerably younger and certainly of an age compatible with a date in the early 1780s. The picture is awkward in draw-

52. Sir Henry Raeburn. *James Hutton. c.* 1783. Canvas. 127 × 101 cm. Scottish National Portrait Gallery, Edinburgh

ing and in the handling of space. The strange, abstracted gaze of the sitter shows that the artist was still unable to handle the social and psychological refinements of large-scale portraiture. It is nevertheless a remarkable painting. The head and the still-life are painted with a bold bluntness that expresses a very strong feeling for substance. The only portraits at all comparable are *Lord President Dundas* (1787) and *James Veitch, Lord Eliock.* The Dundas portrait has a little of the same awkwardness, though this is less pronounced, and it has the same rather leathery impasto. None of these pictures shows much affinity with David Martin, however, so it seems Raeburn must have sought his early experience elsewhere than in Martin's painting room. Of the other artists resident in Edinburgh the only two that we know he was associated with were Deuchar and Runciman.

Deuchar was very much an amateur, yet there is considerable evidence of his influence on Raeburn's early work. Hutton's pose, with its uncanny abstracted gaze, is very like that of the female figure in an etching that Deuchar made after Ostade, an etching which was also the basis of Wilkie's portrait of his parents thirty years later. The bluntness and lack of social grace in the portrait of Hutton is also as typical of Deuchar and the kind of Dutch prints for which he had a taste, as it is remote from Martin. Raeburn certainly quickly overcame the limitations of such a style, but even in a work of the early 1790s like *John Tait and his Grandchild* (National Gallery, Washington), Raeburn echoes the formula that Deuchar derived from Ostade of a large and strongly characterized head set on a body so simplified in its anatomy as to be rudimentary.[5] In other works of the early 1790s too, there seem to be direct echoes of Deuchar. The idea of *Neil Gow* as a single figure against a neutral background has its equivalent in a very striking etching by Deuchar of a fiddle player seated alone, one of several treatments of the theme. There is also an etching of a solitary skater balanced on one skate against an open landscape (plate 53). Though he is seen from behind and not in profile, it has an obvious similarity in idea to Raeburn's famous painting of the *Revd Thomas Walker skating on Duddingston Loch* (National Gallery of Scotland). It seems that Raeburn's connection with Deuchar was close and left a distinct mark on his style, linking the beginning of his career directly to seventeenth-century Holland.

Through Runciman, Raeburn could have learned an unconventional and painterly approach to portraiture, characterized by a high colour key. Benton's opinion of Runciman's portraits and of their importance to Raeburn has already been quoted. To it may be added David Laing's account of a lost painting of a negro's head that served as a tobacconist's sign: 'It was painted in oil on paper with amazing force and depth of colours, more like some bold design of Tintoretto or Titian than some degenerate modern work.'[6] This could almost be an account of a painting by Raeburn and from the two survivors it is possible to see how animated Runciman's portraits were, liveliness of execution and colour endors-

ing liveliness of expression. He painted directly, apparently without formal drawing and with a very casual approach to structure. In addition he seems never to have used any dead colour. All these characteristics remained typical of Raeburn, too, throughout his life.

The features of Raeburn's style that appear to reflect the example of Deuchar and Runciman were deeply ingrained therefore and provide further reason for doubting that he was closely associated with Martin in his formative years. As Ramsay's longest serving assistant and perpetuator of his methods, Martin was a draughtsman. His art was based on correct drawing, close organization and a fairly high degree of finish. If the Chalmers portrait loses its claim to an early date, Raeburn's earliest dated work is in fact a miniature that he painted in Rome in 1786 of the 2nd Earl Spencer.[7] Its completion is recorded in a letter of James Byers written in January of that year. If Raeburn was still in the market for such an important commission for a miniature so late, he surely continued to practise professionally as a miniature painter till at least that date. With Martin dominating the portrait market in Edinburgh, he may well not have felt able to challenge him until he was very confident of his own powers in full-scale portraiture, in other words not until after his return from Italy.

The Spencer miniature itself may provide a further piece of evidence for this view of Raeburn's early career. His ambitions to paint on the scale of life must have been formed in an awareness of the success of the new English portrait style formed under Reynolds's leadership. Traditionally, Raeburn was helped and encouraged by Reynolds with whom he had contact during the brief period that he spent in London on his way to Italy.[8] That there was some contact between the young Scot and the leader of English art is corroborated by James Northcote who much later recalled dining with Raeburn at Reynolds's house.[9] But the most significant evidence is the first-hand knowledge of Reynolds's late work that seems to be apparent in Raeburn's painting, especially the link between his *Neil Gow* and Reynolds's *Joshua Sharpe*, discussed below. If Reynolds himself had any opportunity to form an opinion of Raeburn's work, it must have been on the strength of his miniatures, which were all that he could have carried to London to show him. The Spencers of Althorp were Reynolds's most loyal and constant patrons, building up the unique collection of his finest portraits which still hangs at Althorp. Reynolds's recommendation of Raeburn as a miniature painter is the most likely explanation of the 2nd Earl's commission of his miniature from an unknown Scottish painter in Rome.

Apart from this commission we do not know how Raeburn spent his time in Italy. He later expressed his indebtedness to James Byers and Gavin Hamilton, so he clearly took his place among the Scottish colony.[10] He may even have met Ramsay there, for the two were together in Rome for a short period in the summer of 1784, the last year of Ramsay's life. To judge by his later work, he seems to have restricted his study to portraiture.

The histrionic figure style of Renaissance and classical art, the basis of the Grand Manner in portraiture, never played any part in his painting, but he seems to have paid very close attention to two of the greatest portraits of the sixteenth and seventeenth centuries available in Italy, Raphael's *Julius II* (then in the Galleria Borghese), and Velasquez's *Pope Innocent X*. The memory of these two pictures stayed with him for the rest of his life. They underlie the great series of seated male half-length portraits that he began immediately on his return to Edinburgh with his portrait of *Lord President Dundas* (Arniston House), dated 1787, though in this his most immediate debt is to Reynolds's *Lord Chancellor Thurlow* (1781). The three-quarter view of *Julius II*, elbows on the arms of his chair, one hand holding the chair arm, the other free across his body, recurs throughout his career, in *Adam Ferguson* (c. 1792; University of Edinburgh) and in *John Playfair* (c. 1819; University of Edinburgh), but it is never repetitive. With true genius, Raeburn, in understanding a great pictorial invention, gives it new life.

The comparison of Raeburn to Velasquez was first noted by Wilkie when he was in Spain and has often been made since. It is a matter of a deep affinity, especially in Raeburn's later work, rather than the abiding influence

53. David Deuchar. *Skating Figure from A Collection of Etchings After the Most Eminent Masters*. 1803. Cat. 98

of one picture seen and studied at the beginning of his career, but his awareness of this model is nevertheless clearly apparent in the Dundas portrait mentioned above. Another memento of the Velasquez may be seen in Raeburn's use of a chair for his sitter like the one depicted by Velasquez: broad and square with a high back and wooden uprights, but upholstered seat and arms and a rectangular backrest.

From 1787 Raeburn's development was rapid and can be fairly easily charted. His relationship with Reynolds is worked out in a series of paintings using landscape backgrounds that begins with the portrait of *Cornet Lyon* (Scottish National Portrait Gallery), datable by the uniform to 1788. This shows an unusually painstaking treatment of the uniform and solid local colour. The pose is ambitious but a little theatrical. A similar painting of *Rear-Admiral Charles Inglis* (Scottish National Portrait Gallery), has an equally theatrical pose, but the painter has made more attempt to orchestrate the colour, picking up the tints in the face and figure in the background as strongly stated, separate passages of colour. This becomes a feature of Raeburn's painting into the early 1790s and identifies a distinctive characteristic of his technique. He describes tone using colour directly without any separate chiaroscuro structure. This gives his painting a high colour key of purply reds, blues and yellows and may derive from Runciman's practice.

In 1790 a pair of portraits from Fyvie Castle (National Trust for Scotland), *Charles Gordon* and his wife *Christian Forbes*, dated by an inscription on the former, show that Raeburn was still feeling his way. Both pictures are freely painted. That of Christian Forbes is also very loosely constructed. Charles Gordon is set against a landscape in which the pattern of the trees and foliage pick up the patterns of the brushwork as well as the colours of the figure, but he is awkwardly set in the canvas. The shape of his head is described by a rather insistent oval contour, reminiscent of Martin, and in spite of the light in the background the figure is lit from the front, his eyes catching sharp points of light in a way that is also typical of Martin.

The Gordon portraits relate to a whole series of similar paintings using the same kind of setting and colour key. A beautiful example is *Janet Dundas* (col. plate 23) from Arniston House. Among the most ambitious is *Mrs Ferguson of Raith with her children* (Raith House). The group is set in a richly painted landscape and makes a daring essay in the new broad and grand style of English portraiture. Francina Irwin has shown that the composition bears a specific relationship to Reynolds's painting of the *Duchess of Buccleuch and her children* at Bowhill, particularly in the way that the mother and one of her children clasp hands across her knee, but the link only underlines the difference.[11] In spite of her romantic setting Mrs Ferguson is an ordinary mother, tangible and homely, where Reynolds's Duchess belongs to a different order of reality. With Raeburn the graceful detail of the clasped hands is not a mattter of elegance. It expresses the gentle restraint of a mother afraid that her child may not behave. For Raeburn as for Ramsay the 'agreeable' is necessarily dependent on the 'exact'.

Raeburn's first dated full-length is the portrait of *Dr Nathaniel Spens* (plate 54), commissioned by the Royal Company of Archers in 1791. It shows the features of the other early works, but with an increased colour range because of the elaborate costume. The patchy patterns created by the broad brushwork and the way colour describes tone are carried on in the background. Together they create a colourful and immediate presence. This is backed up by a matter-of-factness in the actual portrayal of the individual which disarms any accusation of grandiloquence. An equally impressive and probably contemporary picture is the full-length of *Sir John Sinclair of Ulbster* (National Gallery of Scotland) but in neither picture are the problems of lighting and space fully resolved. This was finally and triumphantly achieved in 1792 in the double portrait of *Sir John and Lady Clerk of Penicuik* (col. plate 22).

The idea for this picture derives from an early painting by Reynolds which was engraved, but the feeling is entirely Raeburn's. The figures are three-quarter length. The light is directly behind them. With his right arm Sir John Clerk points out across the landscape of their Penicuik estate. His left arm is around his wife's waist as she leans on his shoulder. He is looking at her, while her glance follows the direction in which he is pointing. The three-quarter length brings us close to the couple to share their easy intimacy with each other. This is reinforced by the naturalness of the lighting and the way it encloses them. With the light behind them they are in partial shadow. The further side of her face catches the light of the setting sun, but he is lit by its reflection from the sleeve and shoulder of her white dress. Their unity as a couple is thus subtly reinforced.

The Clerk portrait blends visual and psychological unity so that they become inseparable. In achieving such a natural effect, light is of paramount importance. As he came of age as a painter, Raeburn takes up this crucial point from Ramsay. Although the two painters are superficially so different, an increasing appreciation of Ramsay's naturalism as much as of Reynolds's informal portraiture may have underlain the rapid maturing of Raeburn's art in the early 1790s. Already in 1789, in the portrait of *Lord Abercromby* (Faculty of Advocates), he had shown his command of Ramsay's lighting in a simply lit figure against a dark ground. The lighting of the Clerk portrait has a certain amount in common with Ramsay's full-length of the boy, *Lord Mountstuart* (Marquis of Bute), of 1759. In it, out of respect for the actual light, the boy's face and figure are partly in deep shadow.

The portrait of *Neil Gow* illustrates this point. On grounds of its colour and handling, as well as of the sitter's age, this can be dated to around 1793. It is three-quarter length. The seated pose is identical to that of Ramsay's classic male portrait, *Sir Hew Dalrymple*, though the intense absorption of the sitter follows

Reynolds in his variation of Ramsay's invention, the remarkable portrait of Joshua Sharpe. This was painted in 1785–6 at just the moment that Raeburn might have seen it if he had visited Reynolds on his way home from Italy. Raeburn however remained loyal to Ramsay. The only variations in his *Neil Gow* from Ramsay's *Sir Hew Dalrymple*, in the angle of the head, the position of the right forearm and the rotation of the left hand, are dictated by the change of action. Otherwise the angles and the silhouette are identical, as are the position and fall of the light.

The point on which Raeburn and Ramsay agree, when two such portraits are compared, is that the sitter's presence should be evoked directly, without gloss or flourish. The difference between them is however also very significant. It can be identified in their handling of paint, but it is much deeper than a matter of painterly preference. Ramsay builds up an image on the basis of a careful analysis, and at least in his middle career, light clearly integrates form. Raeburn's approach, particularly in the early 1790s, is akin to Hals's, excepting his use of colour. Brushstrokes are not fully blended and, particularly in describing costume, they are frequently open-ended in a way that ignores contour. We are given a surface pattern in which structure is left to look after itself. The fact that Raeburn never drew, whereas Ramsay drew constantly, is a significant pointer to the character of these differences, but their implications become clearer when they are seen against the background of the shift in Scottish thought in the generation after Hume.

Raeburn was not obviously an intellectual as Ramsay was. He belonged in the same empirical tradition, however, though his empiricism was of a more practical turn. Its quality is conveyed in one of the most vivid sketches that we have of him: 'He had considerable skill in gardening; he was a learned and enthusiastic florist. His love for maritime architecture led him to make many models with his own hands—neat, clean built things, about three feet long in the keel—and it was his pleasure to try their merits in Warriston Pond, (on occasion falling in) He was a scientific and skilful angler. . . . His large figure was encased in capacious upper garments; he wore, in addition, knee breeches, black leggings, and a broad brimmed hat. Apart from his genius there was something massive in the man himself.'[12]

It is an account in which the man fits the character of his painting, and seems a typical figure of the Scottish Enlightenment, in which, characteristically, speculative and practical thought went hand in hand. His place in the history of the Enlightenment would be assured, if for no other reason, by the series of portraits of its leading figures that he painted. This began with *James Hutton*, but the earliest dated commission for a portrait of this kind was in 1792 for *William Robertson* (University of Edinburgh), delivered in 1794, which established the type

that, with variations, Raeburn continued to use to represent the scholar in his study right down to the end of his life.

Among these portraits of scholars and intellectuals *Thomas Reid* (col. plate 24) stands out. Reid was recognized as the leading philosopher of his generation and was, incidentally, a pupil of George Turnbull. He lived in Glasgow, but this portrait was painted in 1796 in Edinburgh, shortly before his death, and was done at the suggestion of Dr James Gregory, a kinsman with whom Reid was staying. Dugald Stewart, Reid's pupil, interpreter and biographer, said of it that it was 'generally and justly ranked among the happiest performances of that excellent artist [Raeburn].'[13] He also said of Reid that no man ever maintained more 'worthily or more uniformly the dignity of philosophy' and it is in character therefore that it should be an unusually austere portrait. Reid wears a red turban and is lit from in front in such a way that his head is in a pool of light surrounded by darkness. In this it recalls Ramsay's *Rousseau* and *Hume* portraits, and there may be a conscious link.

It is a striking portrait, but it is also important as a substantial link between Raeburn and Reid, for there are remarkable analogies between his painting and certain of Reid's ideas. Apart from this one contact, and of course the availability of Reid's books, there was an essential intermediary between the two men in Dugald Stewart. The relationship between Raeburn and Stewart was recorded after Raeburn's death by Stewart's wife, writing to the Pennsylvania Academy of Arts about a portrait of Stewart commissioned by them: 'The countenance is much younger than you would have expected and I sometimes think that Raeburn who had known Mr. Stewart all his life and had the most enthusiastic admiration for him, painted from remembrance as well as present sight, though he sat to him oftener than almost anybody ever did.'[14]

Thomas Reid's achievement, as mediated by Stewart, was to build a philosophic system which, while it accepted the basic principles of Hume's naturalism and empiricism, appeared to avoid the scepticism of his conclusions in the name of common sense. He did this largely by restoring the role of intuition in perception. In his view, perception is an act of the mind but our conviction and belief (in the thing perceived) are immediate and not the effect of reasoning. 'Sensation suggests the notion of present existence and the belief that what we perceive or feel does now exist.'[15] In this account of our immediate and intuitive, rather than analytical, apprehension of reality, sight plays a crucial role and Reid's account of sight, which he regards as the highest of the senses, is one of the most original features of his thought. From the point of view of the visual arts he makes a most important distinction between the appearance of things and our knowledge of them. 'The visible appearance of an object is extremely different from the notion of it which experience teaches us to form by sight.' Giving an example of this he writes: 'The visible appearance of things in my

room varies almost every hour, according as the day is clear or cloudy, as the sun is in the east, or south, or west, and as my eye is in one part of the room or another: but I never think of these variations, otherwise than as signs of morning, noon or night, of a clear or a cloudy sky. A book or a chair has a different appearance to the eye, in every different distance and position; yet we conceive it to be still the same; and overlooking the appearance, we immediately conceive the real figure, distance and position of the body, of which its visible or perspective appearance is a sign and indication.' The appearance, as distinct from 'the notion', of an object is exclusively the business of the painter, though even he must struggle to separate the seen from the known, the sign from the signified. 'If he could fix the visible appearance of objects without confounding it with the thing signified by that appearance it would be as easy for him to paint from the life . . . as it is to paint from a copy.' The signs by which we apprehend the world are a language of which, excepting the painter, we are no more conscious than we are of the language that we speak. 'To a man newly made to see . . . it is an unknown language: and therefore he would attend only to the signs without knowing the signification of them, whereas to us it is a language perfectly familiar: and therefore we take no notice of the signs, but attend only to the thing signified by them.'[16] The signs themselves can be vague and imprecise but this does not prevent our being able to interpret them.

In his interpretation of Reid's philosophy Dugald Stewart is quite clear about the importance that he attaches to his ideas on perception. The first chapter of the first volume of his monumental *Elements of the Human Mind* (1792) is devoted to a discussion of Reid's theory of perception, which Stewart considers to be 'the most important accession which the philosophy of the human mind has received since the time of Mr. Locke'.[17] The key to its importance in Stewart's view was that, contrary to all previous theories of perception, in it no idea intervenes between an object and our perception of it. All philosophers, from Plato to Locke, 'suppose that we do not perceive external objects immediately; and that the immediate objects of perception, are only certain shadows of the external objects (ideas).'[18] He concludes 'the ideal system may now appear to many readers unphilosophical and puerile: yet the case was very different when this author entered upon his inquiries and I may venture to add, that few positive discoveries, in the whole history of science, can be mentioned, which found a juster claim to literary reputation, than to have detected, so clearly and unanswerably, the fallacy of an hypothesis, which has descended to us from the earliest ages of philosophy.'[19]

As so often, it is in his theory of perception rather than in his aesthetics that a philosopher deals with matters of central importance to the visual arts. Reid's aesthetics are conventional enough, but in their view of perception he and Stewart do more together to demolish the idealist theory of aesthetics than anyone before them, for its effect is to argue that the image that the artist creates is not a reflection of his idea of the thing perceived. Rather he translates into paint the raw material of perception. The result may bear no formal relationship to our conceived idea of the thing represented, but within it we can read intuitively its presence, exactly as we do in our perception of the actual three-dimensional world. This theoretical view of perception provides an essential background to the technique that Raeburn developed during the middle 1790s as his aesthetic ideas clarified. These ideas also suggest such obvious analogies with later developments in French painting that it is worth remarking that through the work of Stewart, and after him of Sir William Hamilton (the philosopher, to be distinguished from the British envoy at Naples, his earlier namesake) and their French followers, they did in fact have a wide currency in France during the early and middle years of the nineteenth century. Victor Cousin's important book *La Philosophie Ecossaise* ran to a third edition as late as 1857.

By 1798 Raeburn was painting in a way that is clearly freed from any burden of describing the known rather than the perceived. He does not infer structures that are not visible. Contour is a function of light alone. The painter records patterns of tone and colour and pays no respect to continuities of surface or form as conceptually, but not perceptually present. We are left to respond intuitively to the signs that he sets down and which are themselves abstract. They 'bear no more resemblance to the qualities of matter than the words of a language have to the things they denote.'[20]

The special importance of 1798 was that it was the year in which Raeburn realized an ambition, first formulated by Aikman seventy years earlier, to build his own painting room in which he could control the light. The room survives unchanged in the house that he built himself in York Place. It is on the north side at the back of the building and is square in plan, with double doors leading to the saloon that runs across the front of the house. It is on the first floor, but because of the slope of the ground the painting room looks out from a considerable height with a magnificent view over the Firth of Forth. The light is from a single north window, centrally placed, $13\frac{1}{2}$ feet high by $6\frac{1}{2}$ feet wide. The embrasure actually extends above the level of the ceiling, the thickness of which is cut away at an angle to allow for the additional height. This angle is continued in the lintel of the window outside, further to maximize the fall of light. An ingenious arrangement of shutters allows the light to be varied through a series of intermediate stages from the 90 square feet of the whole window down to a single opening at the top of the window no more than a foot square. The creation of this magnificent and very practical painting room gave Raeburn an essential tool in the fulfilment of his ambitions as a painter and it was perhaps in excited response to the new possibilities it offered that he painted in 1798 two of the finest portraits of his middle career, those of *Dr James Gregory* (National Trust for Scotland) and of his wife *Isabella McLeod* (col. plate 25), who, before she married Gregory, inspired a romantic address by Burns,

AGNES MURRAY KYNNYNMOND.
Daughter of Hugh Dalrymple Murray Kynnynmond
WIFE OF THE RIGHT HON. SIR GILBERT ELLIOT OF MINTO
Bart. M.P.

1. Allan Ramsay. *Agnes Murray Kynnynmond.* 1739. Cat. 13

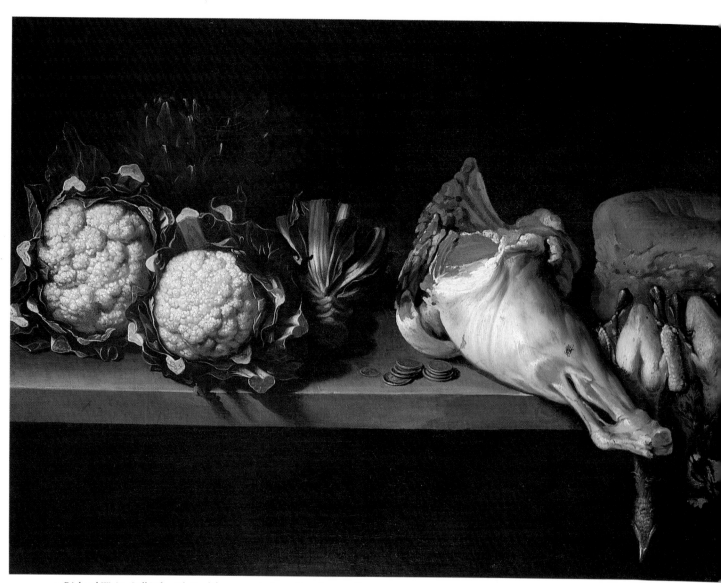

2. Richard Waitt. *Still Life with Cauliflowers and a Leg of Lamb*. 1724. Cat. 11

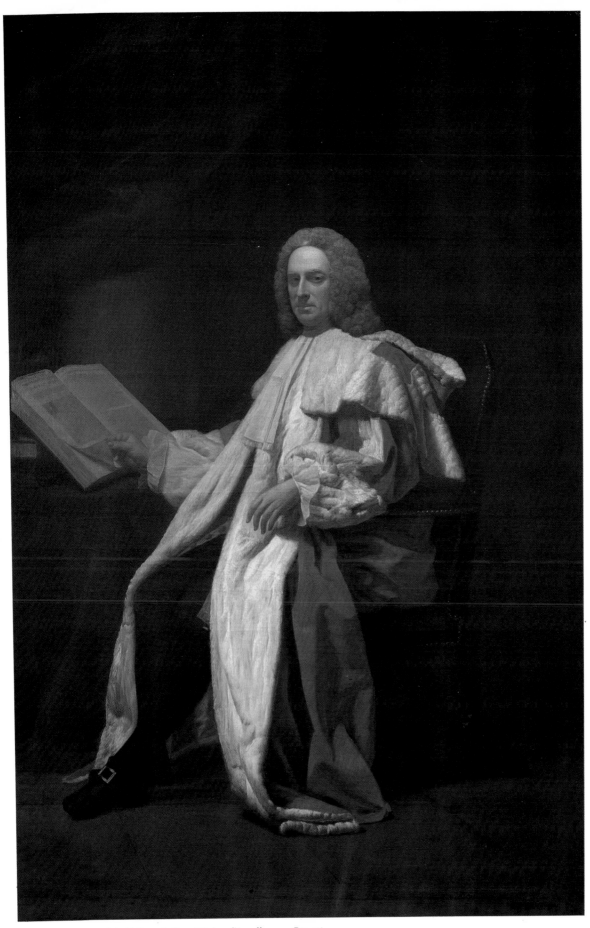

3. Allan Ramsay. *Archibald Campbell, 3rd Duke of Argyll*. 1749. Cat. 16

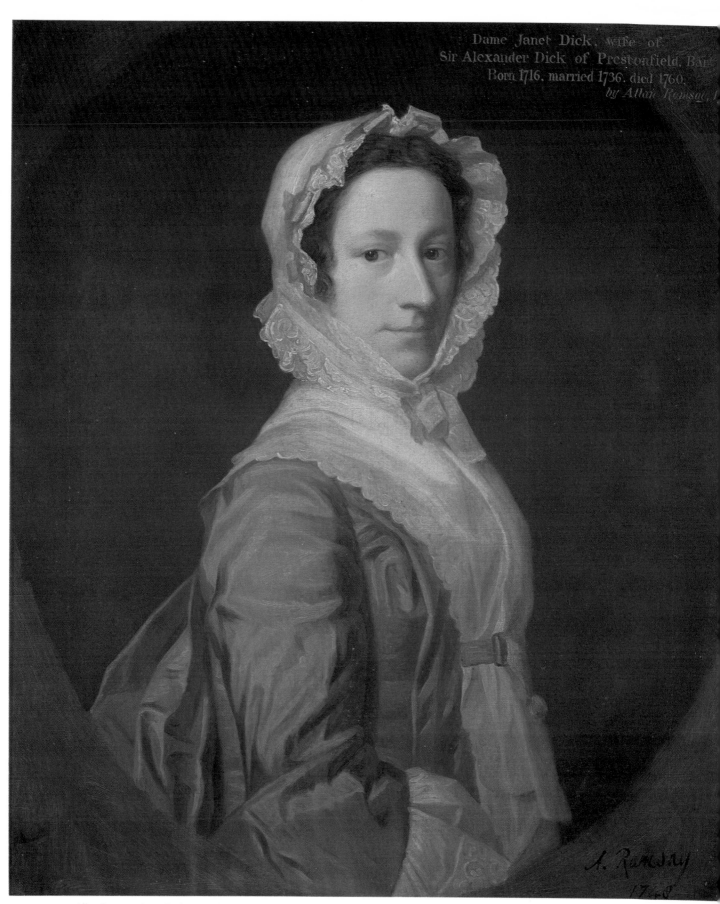

Dame Janet Dick, wife of
Sir Alexander Dick of Prestonfield, Bar
Born 1716. married 1736. died 1760.
by Allan Ramsay, 1

A. Ramsay
1748

4. Allan Ramsay. *Janet Dick*. 1748. Cat. 17

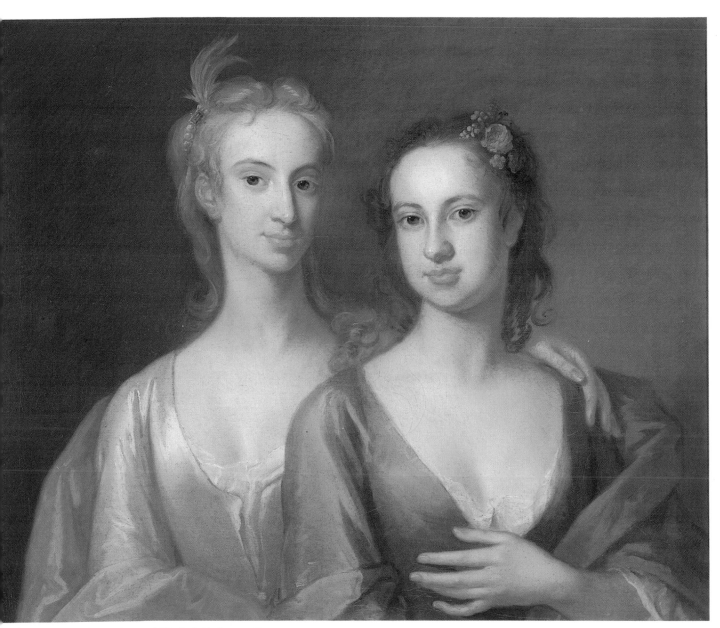

5. William Aikman. *Anne and Elizabeth Clerk*. 1730. Cat. 5

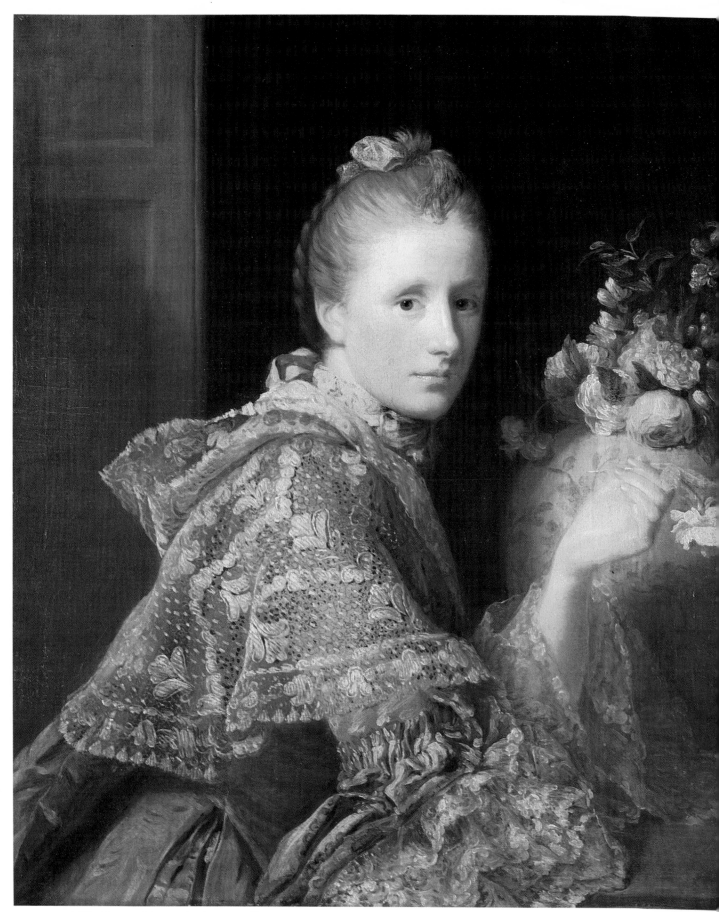

6. Allan Ramsay. *Margaret Lindsay, Mrs Allan Ramsay. c.* 1757. Cat. 22

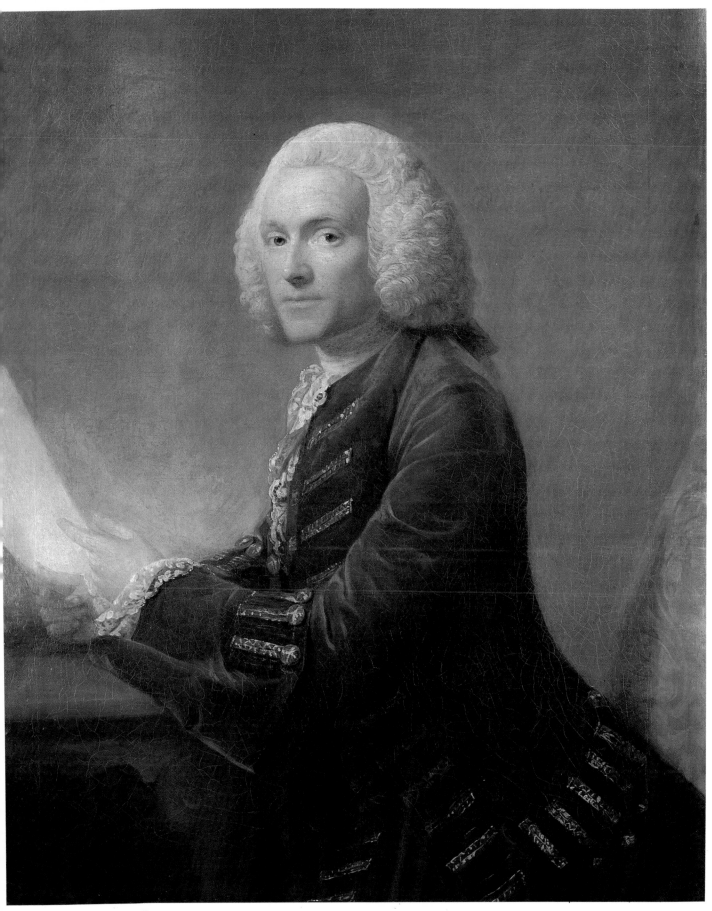

7. Allan Ramsay. *Dr William Hunter. c.* 1760. Cat. 25

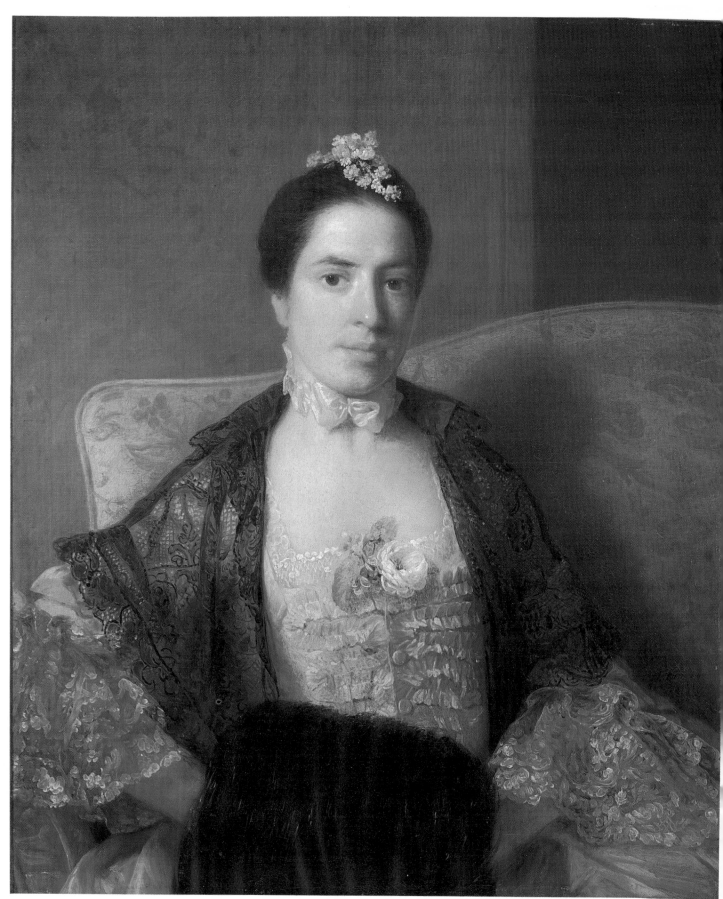

8. Allan Ramsay. *Martha, Countess of Elgin.* 1762. Cat. 27

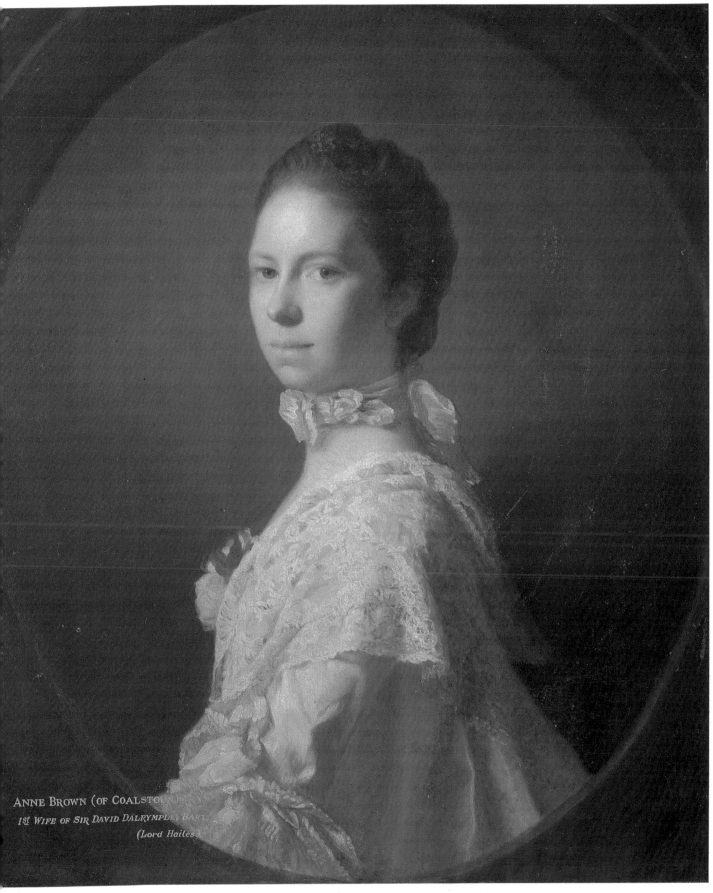

ANNE BROWN (OF COALSTOUN)
1st WIFE OF SIR DAVID DALRYMPLE, BART.
(Lord Hailes)

9. Allan Ramsay. *Anne Broun*. 1763. Cat. 26

10. Allan Ramsay. *Anne Bruce, Mrs Bruce of Arnot. c.* 1765. Cat. 30

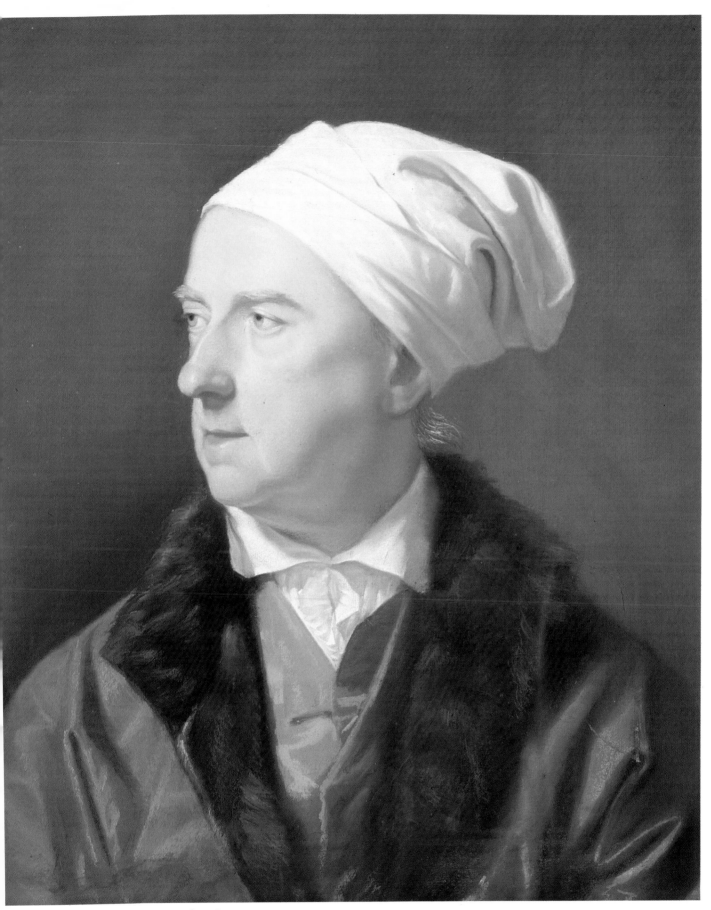

11. Archibald Skirving. *Gavin Hamilton*. Cat. 119

12. John Runciman. *King Lear in the Storm*. 1767. Cat. 72

13. John Runciman. *Adoration of the Shepherds. c.* 1766. Original size. Cat. 71

14. Alexander Runciman (after). *Ossian's Hall*. Cat. 51

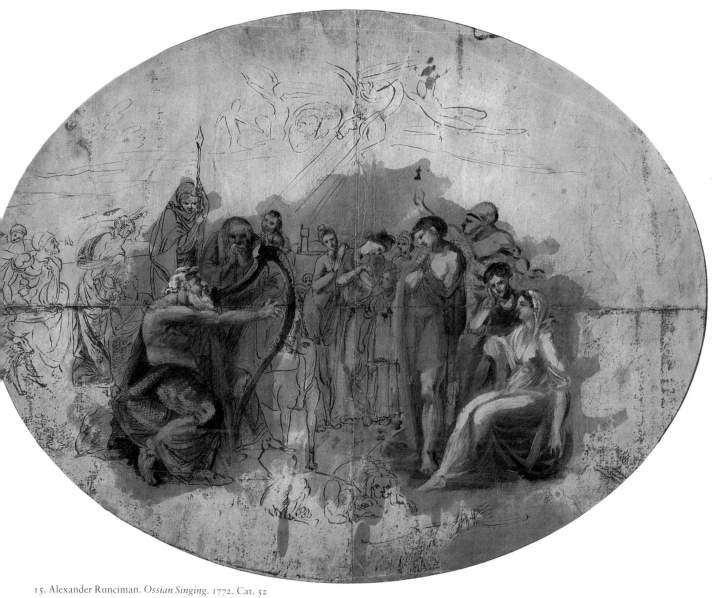

15. Alexander Runciman. *Ossian Singing*. 1772. Cat. 52

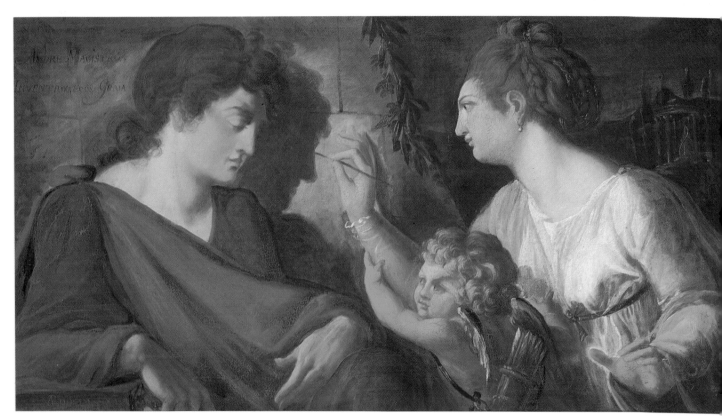

16. Alexander Runciman. *The Origin of Painting*. 1773. Cat. 49

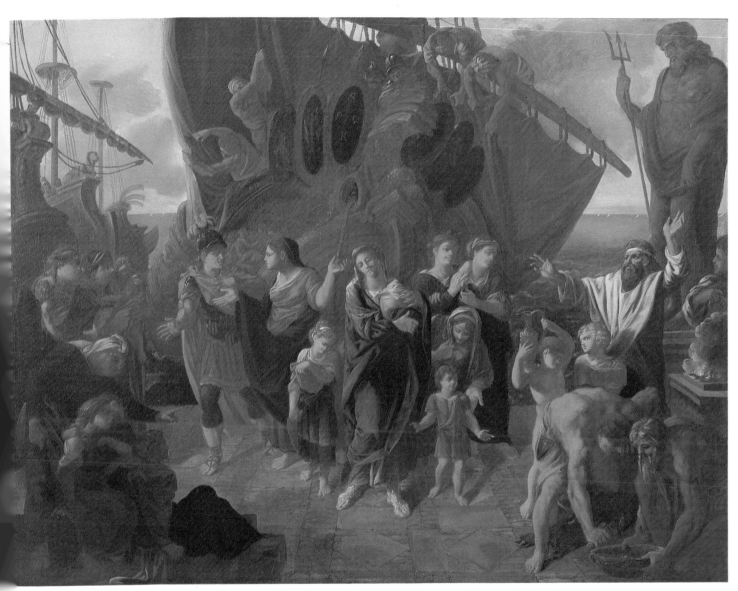

17. Alexander Runciman. *Agrippina with the Ashes of Germanicus*. 1780. Cat. 61

18. Alexander Runciman. *The Allegro with a Distant View of Perth*. 1773. Cat. 65

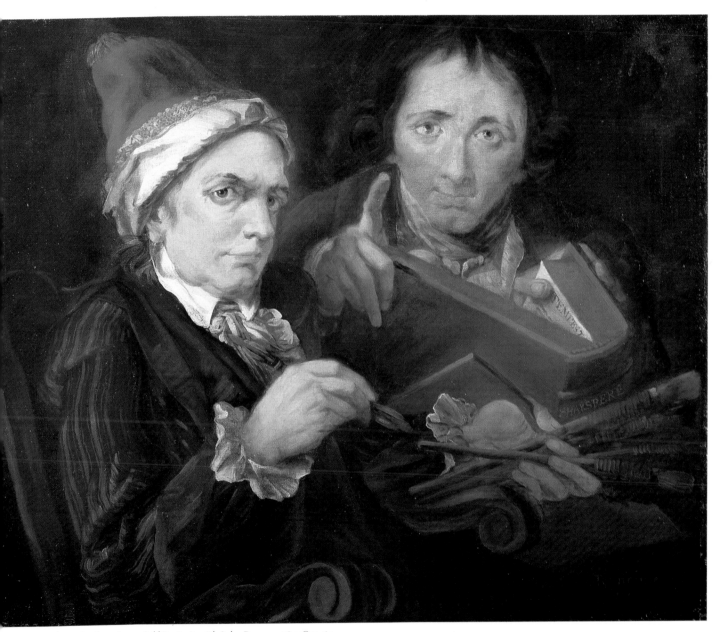

19. Alexander Runciman. *Self-Portrait with John Brown*. 1784. Cat. 64

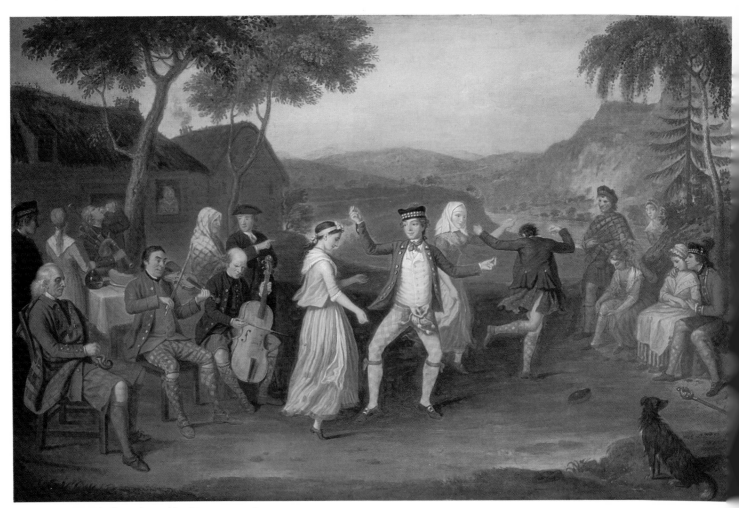

20. David Allan. *The Highland Dance*. 1780. Cat. 83

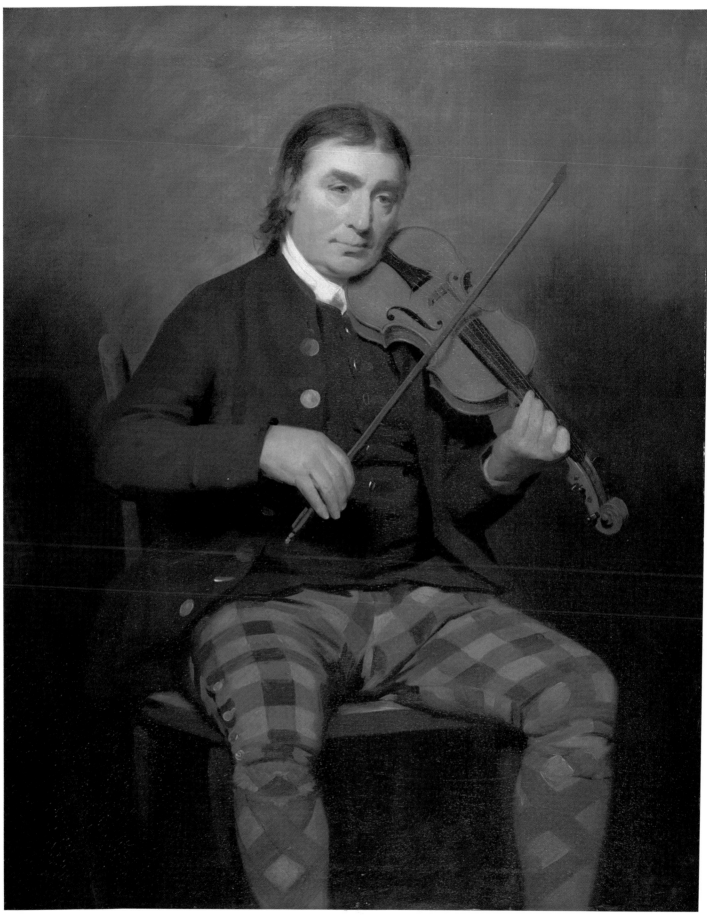

21. Sir Henry Raeburn. *Neil Gow. c.* 1793. Cat. 102

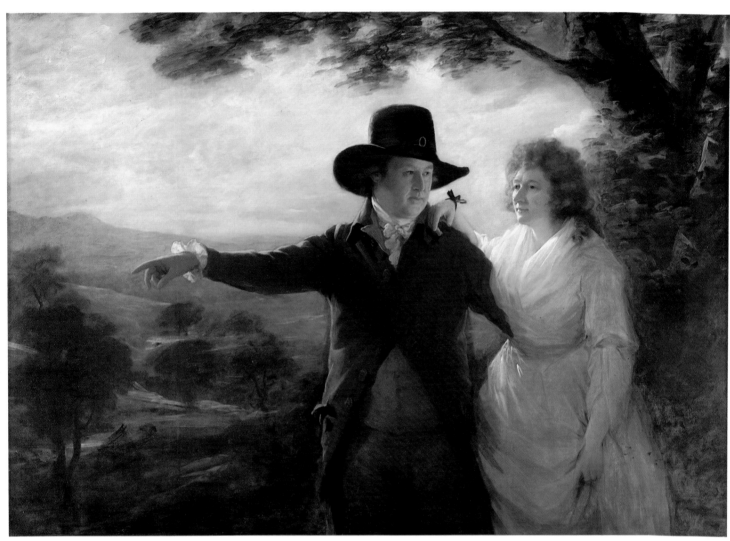

22. Sir Henry Raeburn. *Sir John and Lady Clerk of Penicuik*. 1792. Cat. 105

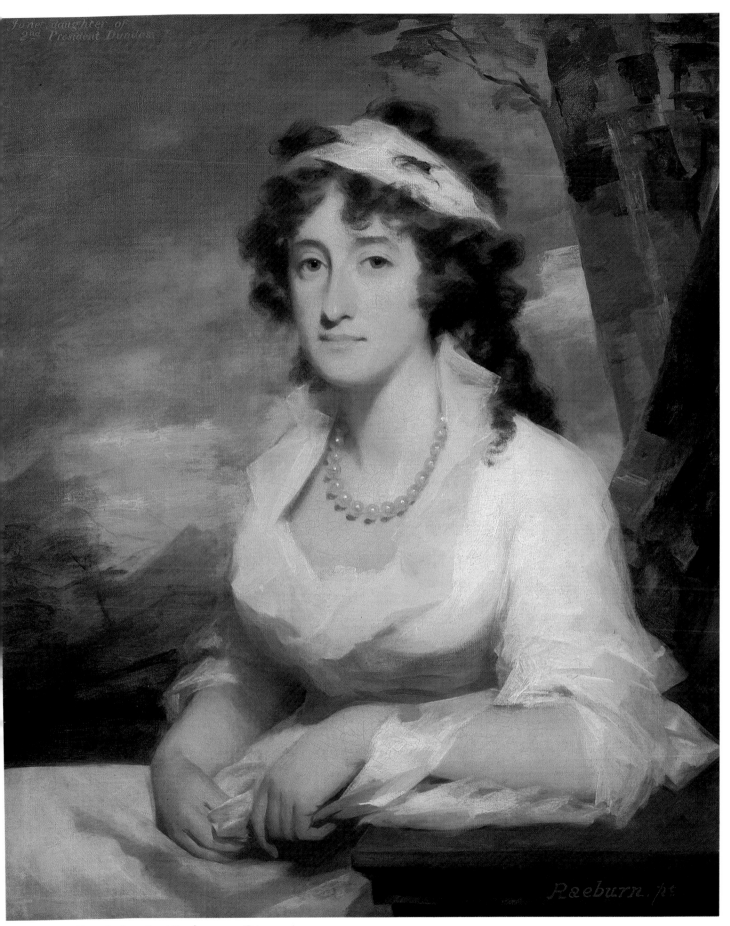

Janet, daughter of
2nd President Dundas ?

Raeburn. p.

23. Sir Henry Raeburn. *Janet Dundas. c.* 1790. Cat. 103

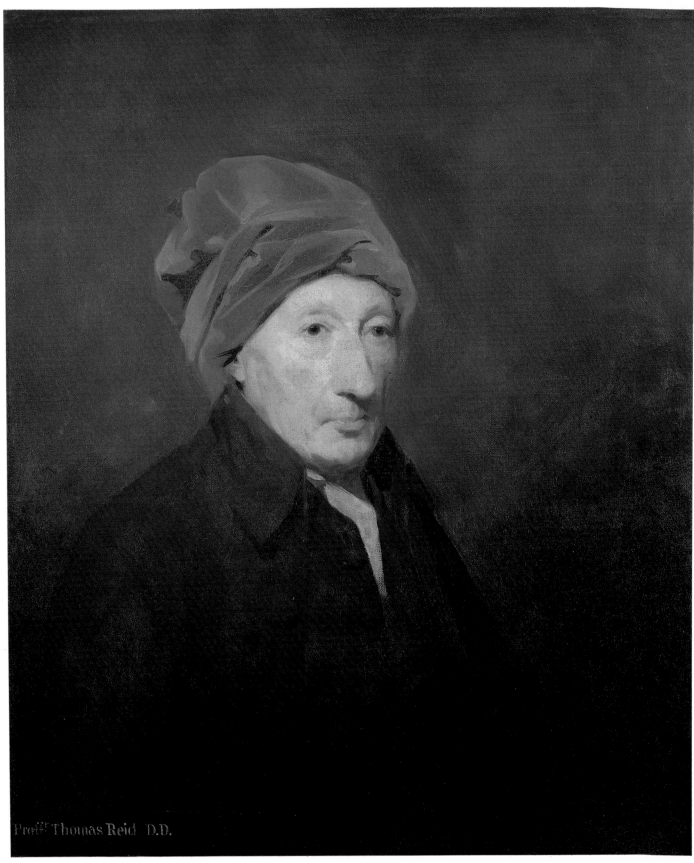

Prof.^r Thomas Reid D.D.

24. Sir Henry Raeburn. *Thomas Reid*. 1796. Canvas, 101 × 76 cm. National Trust for Scotland, Fyvie Castle

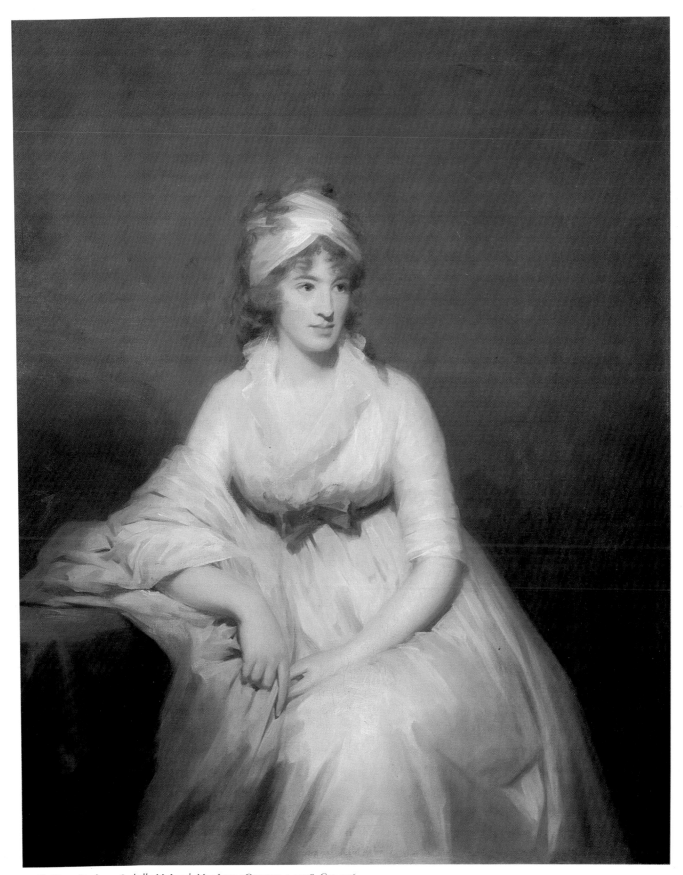

25. Sir Henry Raeburn. *Isabella McLeod, Mrs James Gregory. c.* 1798. Cat. 106

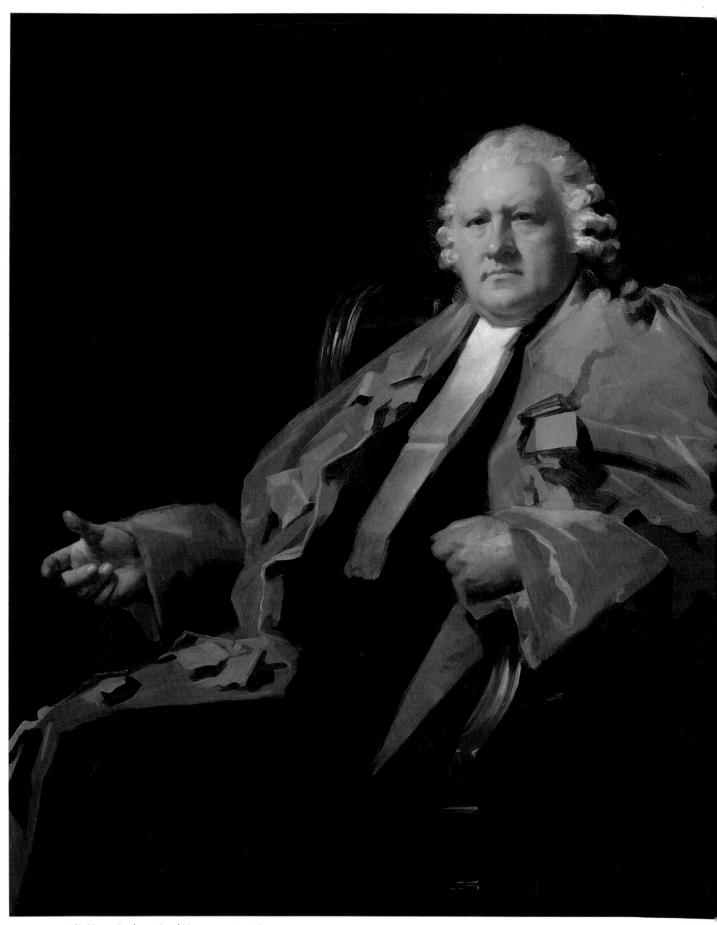

26. Sir Henry Raeburn. *Lord Newton. c.* 1806. Cat. 109

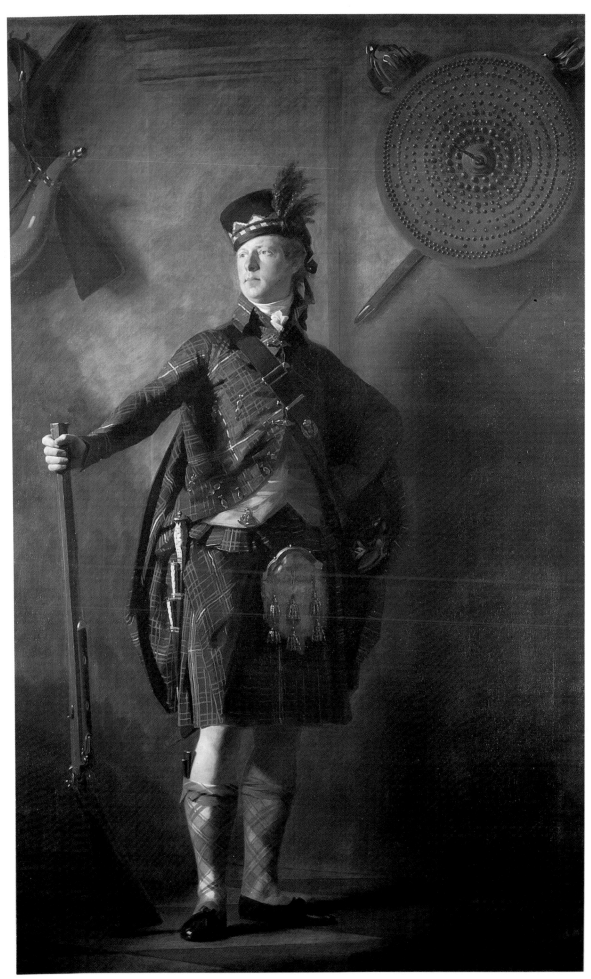

27. Sir Henry Raeburn. *Colonel Alasdair Mcdonnell of Glengarry.* 1812. Cat. 111

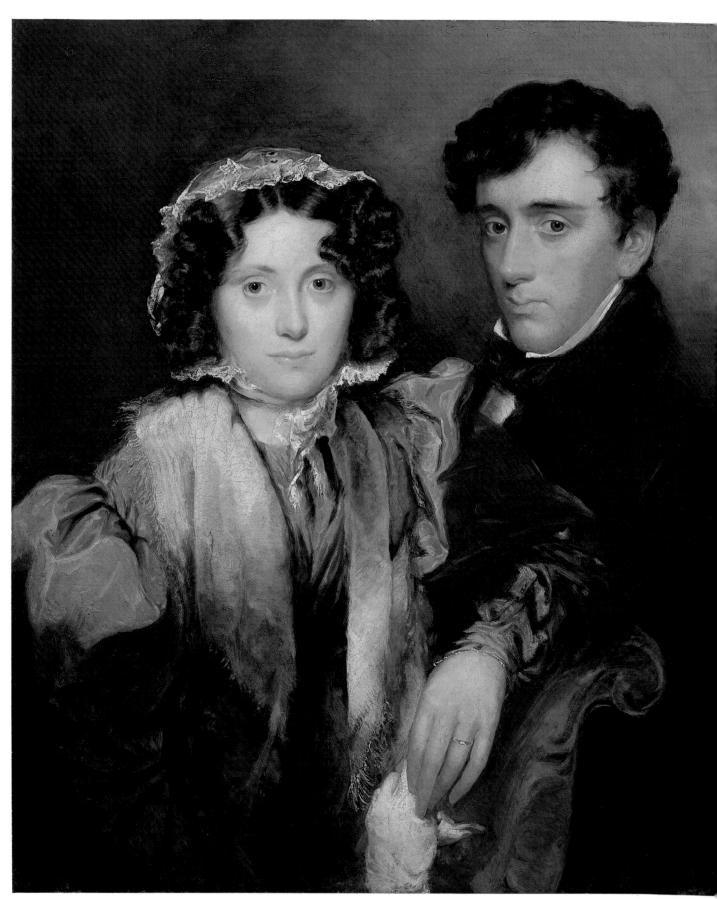

28. Robert Scott Lauder. *John Gibson Lockhart and his Wife, Charlotte Sophia Scott. c.*1844. Cat. 100

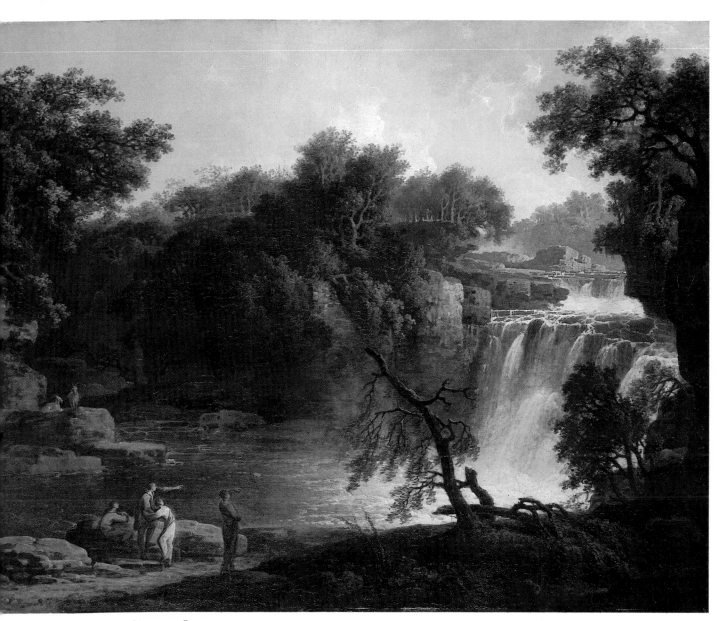

29. Jacob More. *Cora Linn*. 1771. Cat. 129

30. Jacob More. *Morning*. 1785. Cat. 132

31. Alexander Nasmyth. *Inveraray from the Sea. c.* 1801. Cat. 145

32. Alexander Nasmyth. *West Loch Tarbert looking South*. *c*. 1802. Cat. 138

33. Alexander Nasmyth. *West Loch Tarbert looking North*. 1802. Cat. 139

34. Alexander Nasmyth. *Princes Street with the Royal Institution Building under Construction*. 1825. Cat. 143

35. Alexander Nasmyth. *Edinburgh from the Calton Hill.* 1825. Cat. 144

36. Robert Scott Lauder. *A Border Keep. c.* 1831. Cat. 126

37. John Thomson of Duddingston. *Fast Castle on a Calm Day*. Cat. 148

38. Sir David Wilkie. *The Blind Fiddler*. 1806. Cat. 177

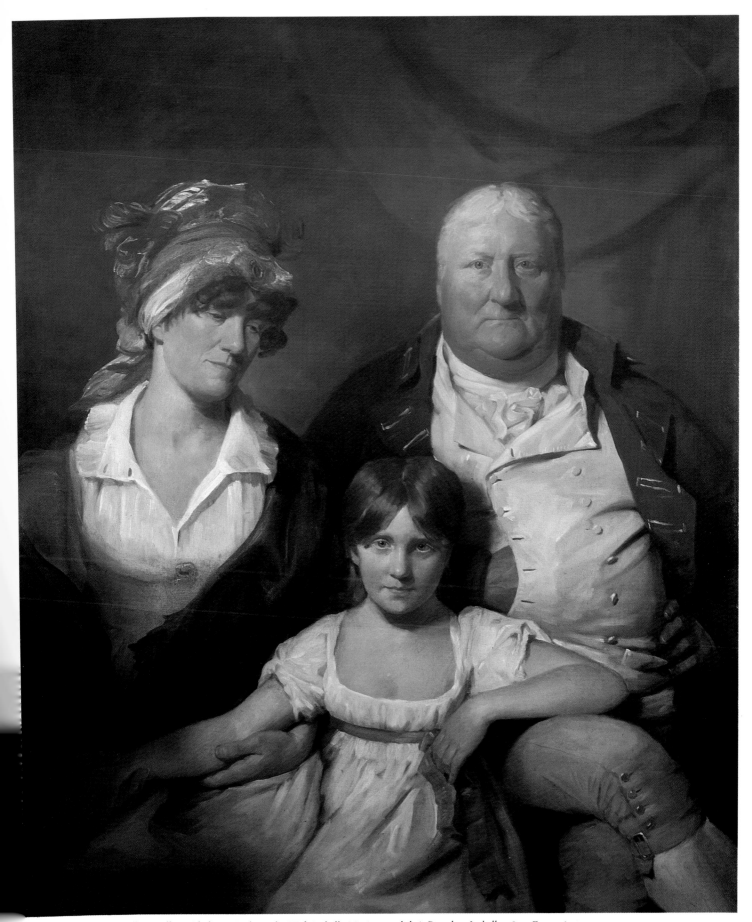

39. Sir David Wilkie. *William Chalmers-Bethune, his Wife Isabella Morison and their Daughter Isabella.* 1804. Cat. 176

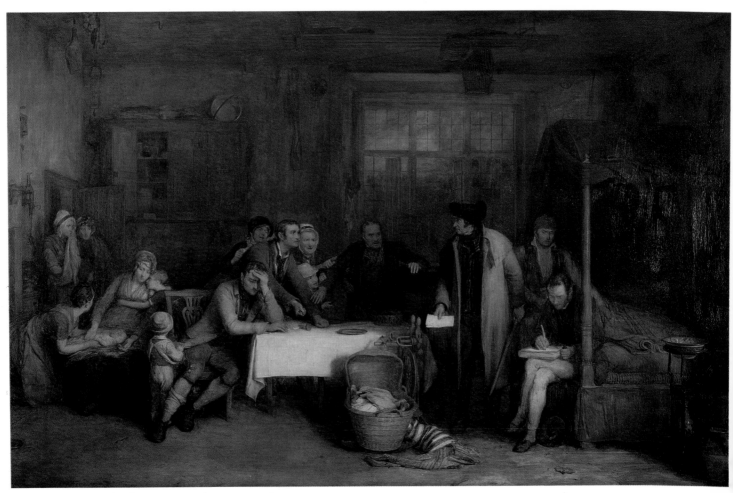

40. Sir David Wilkie. *Distraining for Rent*. 1815. Cat. 182

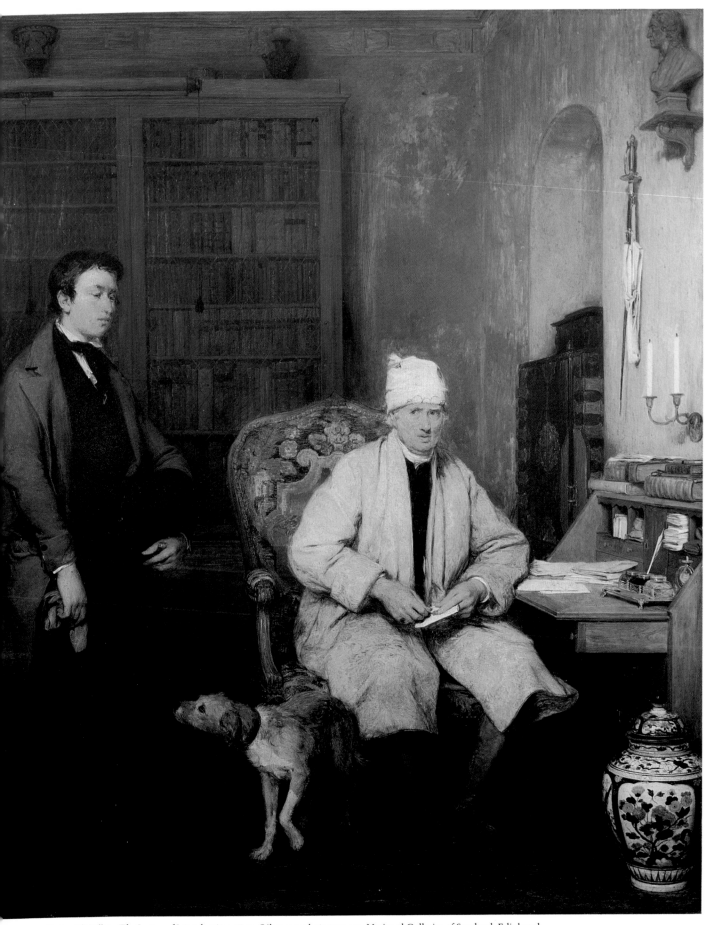

41. Sir David Wilkie. *The Letter of Introduction*. 1813. Oil on panel, 61 × 50 cm. National Galleries of Scotland, Edinburgh

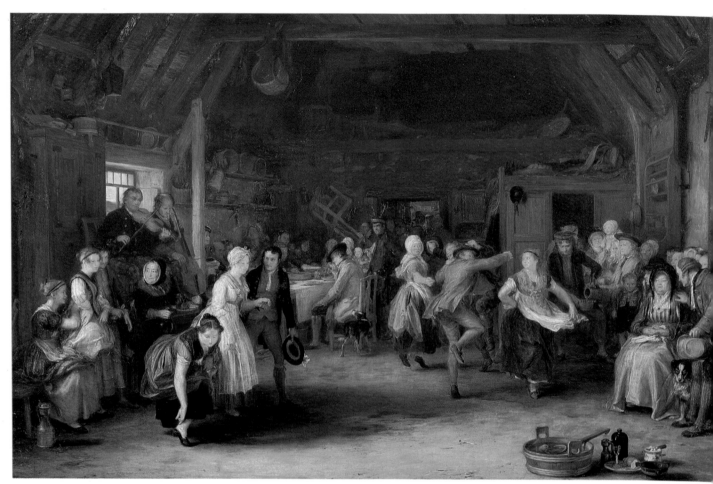

42. Sir David Wilkie. *The Penny Wedding*. 1818. Cat. 183

43. Walter Geikie. *The Drunk Man. c.* 1830. Cat. 164

44. Alexander Carse. *The Return from the Hunt.* Cat. 160

45. Sir David Wilkie. *The Cotter's Saturday Night*. 1837. Cat. 204

46. Sir David Wilkie. *The Preaching of John Knox before the Lords of Congregation, 10 June 1559 (Sketch)*. Cat. 201

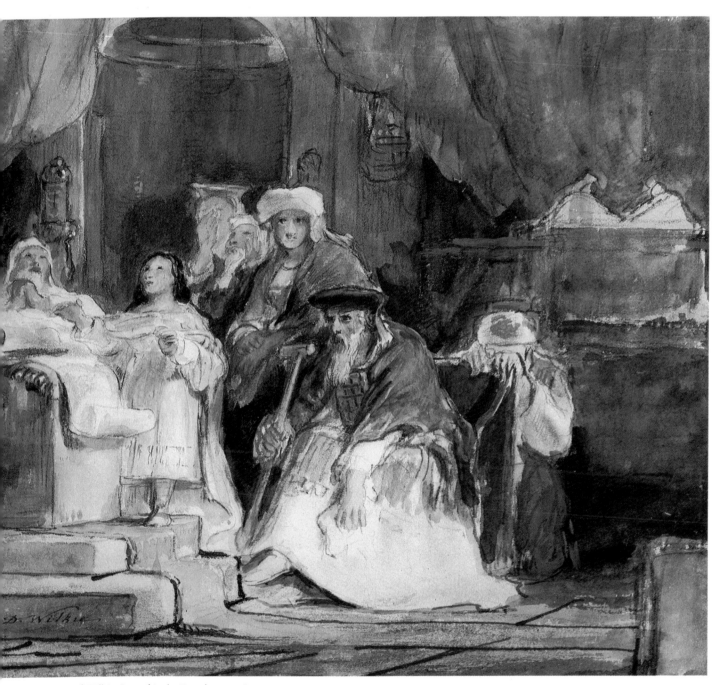

47. Sir David Wilkie. *Samuel in the Temple*. 1839. Cat. 205

48. Sir David Wilkie. *Seated Lady of Constantinople*. 1840. Cat. 206

'To Miss Isabella McLeod'. The daylight quality in the pictures is immediately apparent in comparison to his earlier work.

It was Dr Gregory who, as Thomas Reid's host, had commissioned Raeburn to paint his portrait and there may be something exemplary about these two pictures. Gregory was deeply involved in Reid's philosophy and conducted a long correspondence with him. Reid dedicated his *Essay on the Intellectual Powers of Man* (Edinburgh, 1785) to Stewart and Gregory together, and it is the work in which he elaborates most fully his ideas on perception. Certainly Raeburn has created classics of male and female portraiture; Gregory, tall, handsome and intelligent and Mrs Gregory, fresh, lovely and animated, her beauty a function of a lively personality. The direction of their glances and the lighting are such that if the two paintings were hung across the corner of a room they would be looking at each other, lit from a single source.

The pictures illustrate very clearly the relationship between Raeburn's painting and the ideas of Thomas Reid as they are outlined in the previous discussion. Throughout, tone is described in terms of colour. In Gregory's right eye, for example, the structure consists of a broad stroke of red brown in the angle of nose and eye. A darker brown runs around the eye socket, blends with the hair and cuts into the cheek. This is broken by a single stroke of pink laid directly over the brown to indicate the eyelid. The colours are not blended and there is no indication of form at all. That is left to the eye of the spectator.

One aspect of the philosophy of common sense could have been expressly intended as an answer to the dilemma faced by Ramsay in his late portraits, the impossibility of establishing on an analytical basis the real presence of other people. One of Reid's principles of common sense was 'There is life and intelligence in our fellow men with whom we can converse.' Raeburn on a number of occasions, very unconventionally, attempted to describe active animation directly. He painted the Whig advocate Henry Erskine as though he were speaking, and, even more strikingly, he painted James Balfour in the act of singing a ballad (identified as 'Toddlin' hame'). It is dated by the receipt to May 1793. More generally, Raeburn's creation of a convincing, living, human presence depends, like Hals's, on lively execution, but also on his use of colour. In the earlier paintings, though the colour is carefully orchestrated overall, warm and cool are sometimes left to work against each other. Thus in a passage across a cheek for example there may be quite an abrupt transition from a warm red to a cooler yellow. By the later 1790s the colour is very carefully harmonized so that warmth is always the dominant key. Thus in *James Gregory* the tints in the head are all warm. Even the white of the eye is softened to a creamy grey. The only cold tint is the light caught in the pupil of the left eye. In *Isabella McLeod, Mrs Gregory* the tints are lighter and cooler throughout, but they are not cold. The white of her dress supports the suggestion of cool tints in her face, which

are actually only hinted at in the white of her eye and the merest shadow of blue in the eye socket by her nose and in the shadow of her neck. Even the whites in her dress are softened by grey shadows. The overall effect of coolness is endorsed by the lovely green of her sash, picked up in the tablecloth and the cool colours in the ground, but warmth dominates in the end as a flash of red in the ground to the left echoes the coral of her lips and cheeks.

It is the sense of the living warmth of a real presence within the cool beauty of the painting that makes *Mrs Gregory* one of the loveliest of all female portraits. It serves to demonstrate the re-establishment of a structure of human values through intuition within the general framework of empiricism, which was the achievement of Thomas Reid and the common sense school of philosophy, as triumphantly as Ramsay's *Sir Hew Dalrymple* had demonstrated the brilliant analytical clarity of the earlier stage of Scottish Empiricism. In addition Mrs Gregory's portrait admirably demonstrates the theory of beauty as relative and individual, a necessary corollary of the anti-ideal portraiture of both Ramsay and Raeburn, and evolved by Archibald Alison, a mutual friend of Raeburn and Dugald Stewart. In his *Essays on the Nature and Principles of Taste* (1790), summing up the arguments against beauty as an ideal form, he wrote in words that echo Ramsay's views in his *Dialogue on Taste*:

If . . . in the human countenance and form, there were only *certain* colours, or forms, or proportions, that were essentially beautiful, how imperious a check would have been given, not only to human happiness, but to the most important affections and sensibilities of our nature! The influence of beauty would then have operated, in a thousand cases, in opposition to the principles of duty: whenever it was wanting in those with whom we were connected, some obstacle at least would be imposed to the freedom or the warmth of our regard; and wherever it was present, an irresistible and fatal preference would be given to those in whom it was found. . . . The regards of general society would fall but too exclusively upon those who were casually in possession of these external advantages; and an Aristocracy would be established even by Nature itself, more irresistible, and more independent either of talents or of virtue, than any that the influence of property or of ancestry has ever yet created among mankind.[21]

In keeping with this view and loyal to Ramsay's memory, Raeburn has ignored the convention of 'Beauty' painting begun by Reynolds and carried on by Romney and Lawrence, a convention of which he was certainly sensible as a later painting, *Mrs Scott Moncrieff* (National Gallery of Scotland), shows. Instead he has treated the beautiful Mrs Gregory with the same frankness as a little later he treated the plain Elizabeth Sheldon (Arniston House) and the homely Mrs James Campbell (plate 55).

In 1801 Joseph Farington visited Raeburn's studio,

while the artist himself was not there. He was struck by the naturalness of his painting and commented: 'Some of Raeburn's portraits have an uncommonly true appearance of nature and are painted with much firmness—but there is much inequality in his work—that which strikes the eye is a kind of camera obscura effect and from those pictures which seem to be his best, I should conclude he has looked very much at nature reflected in a camera'.[22] There is no evidence that Raeburn did use a camera. In fact his working method seems to have been very uncomplicated. Cunningham, without naming his source, describes how Raeburn stood back at the far end of his room to contemplate his model before attacking his canvas. It is an account which sounds so like that given by Lady Burlington of Reynolds's method that there might be some embroidery, though Cunningham's account is circumstantial.[23] The account given by Cumberland Hill is more matter of fact: 'Sir Henry painted standing. Having his palette set he began at once to a portrait without previous chalking out. He generally painted upon strongly twilled canvas. There was nothing elaborate about his best portraits, particularly those he painted late in life. By a few bold and skillfully managed touches he produced striking effects. From the manner in which he made the light strike upon the face of his sitter, the shadows were in general broad and massive.'[24]

Farington and Cumberland Hill were agreed, however, on the great importance of light. Like Ramsay, from whom he surely learnt, Raeburn as an empirical painter relied on natural light, consistently described. For most of his career Ramsay used light from well in front of the canvas, giving maximum clarity. In his later work, as in the second portrait of Hume, the light is moved round to the side, increasing the air of mystery. Nevertheless the light is always so placed that it catches the sitter's eyes. We never lose touch with that essential focus of identity. Raeburn certainly looked very closely at this kind of painting, but whereas in Ramsay's late work shadow suggests the mystery at the limits of our ascertainable knowledge, Raeburn uses it to engage our intuitive awareness

55. Sir Henry Raeburn. *Mrs James Campbell. c.* 1805. Cat. 108

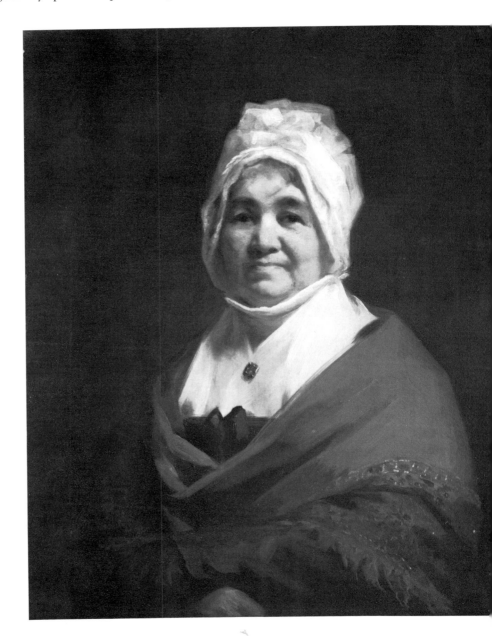

and so reinforce the sitter's presence. In Reid's view of perception, 'the notion which our senses give of the object may be more or less clear, more or less distinct in all possible degrees,' without the immediacy of our recognition or knowledge being impaired.[25] Taking this as his cue, Raeburn became increasingly adventurous in his use of light and shadow. He was particularly fond of using a high light source which cast the eyes in full or partial shadow. For example, in *Baillie William Galloway* of 1798 (plate 56), although the light is frontal, it is at such an angle that the eyelids cast a line of shadow across the pupils. Professor John Robison, whose portrait (University of Edinburgh) was engraved in 1805, is characteristically represented as turning away from the light so that his eyes are shadowed. The effect is of course to give emphasis to the eyes, and as his confidence advanced, Raeburn frequently used very rich dark tones around the eye, as in such portraits as *George Smith* (Trinity House) of 1807.

Half-length male portraits like these or *George Bell* (*c.* 1801; Fyvie Castle) from the first ten years or so of the nineteenth century, simple, forceful and direct, represent Raeburn at his most reliable and familiar. He was never an artist of limited range, however. Indeed the variety of his responses to his sitters is astonishing. Between 1808 and 1810, to give just three examples, he painted the iconographically ambitious portrait of the young *Walter Scott* (Bowhill) seated on a ruin, a book of verse in his hand, very much the Romantic poet; the extraordinarily direct and emphatic *Lord Newton* (col. plate 26); and the eloquent *Alexander Adam* (Scottish National Portrait Gallery), teacher of Dugald Stewart and many others at the Royal High School, seen as the venerable pedagogue he was.

In 1808 Raeburn suffered bankruptcy as a result of his involvement in his son's affairs, but this does not seem to have curtailed his ambitions, nor does he seem to have lost control of his business, as has sometimes been suggested. He seems to have recovered his financial stability fairly quickly, but it may have been these difficulties that

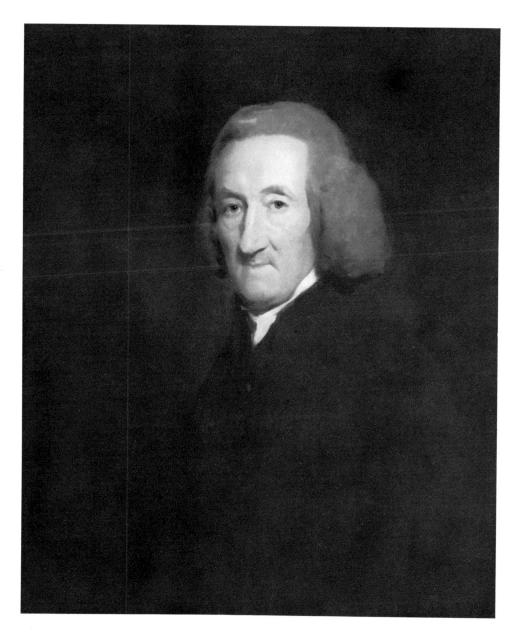

56. Sir Henry Raeburn. *Baillie William Galloway*. 1798. Cat. 107

57. Sir Henry Raeburn. *General Francis Dundas and his Wife (Eliza Cumming). c.* 1812. Cat. 110

prompted him to consider moving to London in 1810. It is a measure of his modest opinion of himself that it was the opportunity created by Hoppner's death that was the occasion for this contemplated move.[26] In the end nothing came of it beyond a congenial visit to London, where he confirmed his friendship with Wilkie, familiarized himself at first hand with Lawrence's work and perhaps got a clearer idea of his own qualities from the comparisons that he was enabled to make.

The stimulus of rivalry with Lawrence may have played a part in the series of ambitious pictures that Raeburn painted immediately after his return from London. In 1812, for example, he painted two very large, seated male portraits: *Daniel Stewart* for the Edinburgh Merchant Company and *Sir Frederick Campbell*, Clerk Register, for Register House, Edinburgh. In both of these the scale, and the strong, dark colouring—deep, contrasting, blacks and reds—recall Lawrence.

Other equally ambitious pictures were very much in an idiom of Raeburn's own. In 1812 he exhibited the full-length *Colonel Alasdair Mcdonnell of Glengarry* (col. plate 27), one of the series of full-lengths of Highland gentlemen that had begun with *Sir John Sinclair* twenty years before. Lawrence praised the picture although it is, in a way, an answer to his own extension of the grand

manner. Perhaps he saw this, for what he is actually reported as saying is that it was the 'finest representation of a human being that he had ever seen', a remark that is not wholly unambiguous as praise, though appropriate as description.[27] What is striking about the picture is the way that, for all the evocative costume and the setting suggesting ancestral halls, the sitter is not subordinated to his role. Indeed there is a certain poignancy in the way the pensive, averted gaze and half-shadowed figure are contrasted with the warlike history invoked by the other aspects of the painting. This was after all the age of the Clearances and the disintegration of Highland society. Raeburn was far too subtle and realistic a painter to ignore the tension between this and the sitter's pretended role to create a simple-minded romantic image at such a moment. The picture's psychological complexity is such that it may well have stimulated Scott, as it is said to have done, in the creation of Fergus MacIvor, the doomed chieftain in *Waverley*, at once a sophisticated European gentleman and leader of a primitive and warlike people.[28]

In a very different mood, the same psychological quality informs the double portrait *General Francis Dundas and his Wife* (plate 57), which may be identical with an unidentified double portrait exhibited in 1812. At first sight this is a half-length double portrait in the

grand manner, but it soon reveals a subtlety in the internal relationships which is quite foreign to the grand style. Raeburn had painted several memorable portraits of husband and wife, including those of the Clerks of Penicuik and the Campbells of Kailzie (Glasgow). But here he shifts from the representation of mutual aware-ness to show the wife observing her husband, who ponders the next move in the game of chess that they are playing. We see him very much as she does, not in any analytical detail, but vividly and with such openness that we have to go back to Ramsay's portrait of Margaret Lindsay to find an equal, though that was a private picture and this is a public one. Its character may reflect the stimulus of Wilkie. *The Letter of Introduction*, for exam-ple, is a closely contemporary picture, though in fact painted a little later, and it shows a similar, apparently passive scene, which is in fact psychologically complex.

Another factor that may play a part in the increasing

depth of Raeburn's painting after 1810 is the influence of Rembrandt, though his example may underlie aspects of Raeburn's work before this and in his interest in Rem-brandt he was preceded by both Ramsay and Reynolds. In his adoption of a range of colours balanced in favour of warmth in the later 1790s, he was doing what Rem-brandt had done before him. In his exploration of the use of indirect lighting and the significance of shadow, Rem-brandt also provided a precedent, but in neither case is there explicit reference to models provided by the Dutch painter. Raeburn's general interest in old masters is clear enough. On one occasion, for example, he undertook to value a collection.[29] In 1819 he lent his painting rooms to the Institution for the Encouragement of the Fine Arts in Scotland (later the Royal Institution) to hold their first exhibition, principally of old masters. In 1810 in London, Wilkie, if not Lawrence himself, was well placed to secure access for him to the principal collections and, with

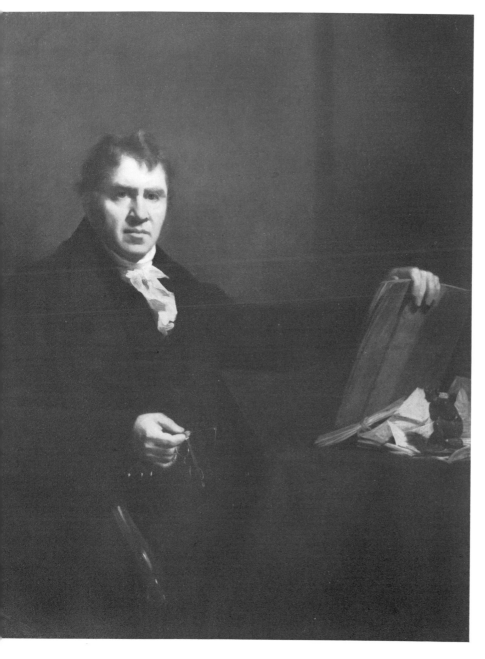

58. Sir Henry Raeburn. *John Clerk, Lord Eldin*. 1820. Cat. 115

Wilkie's own interests to guide him, Raeburn could renew or enlarge his acquaintance with Dutch painting, including a significant number of pictures by Rembrandt.

In 1814 Raeburn painted a highly unusual picture for him, a character study known simply as *Portrait of a Jew* (National Gallery of Scotland). The patron was once again Dr Gregory. The picture is explicitly an essay in Rembrandt's manner, dark and dramatic in chiaroscuro with richly impasted colour in the costume. This interest in Rembrandt did not divert Raeburn, however, but rather confirmed the direction of his development. Three years before the *Portrait of a Jew*, *Walter Lothian* (1811; Merchant Company of Edinburgh) shows the same approach to structure in the head as earlier pictures, but the colour is richer, especially in the shadows. His shadowed right temple, for example, is represented by a single stroke of rich brown with cream dragged over it to indicate the arch of the eye. Other areas in the head are rich red, for example, an area of red freely overlaps the right eyelid. The nose is hatched in red, brown and pink. The full-length *John Stirling of Kippendavie with his Daughter* (*c.* 1813; National Trust for Scotland) shows the same subtlety in the treatment of relationships as is seen in the Dundas portrait, but with even greater freedom of handling. Perhaps in a full-length portrait this kind of freedom is even more possible because of the distance of the spectator, but in the painting of John Stirling's head it is markedly more pronounced than even in the portrait of Walter Lothian. The head is composed of

59. Sir Henry Raeburn. *John Pitcairn of Pitcairn. c.* 1820. Cat. 117

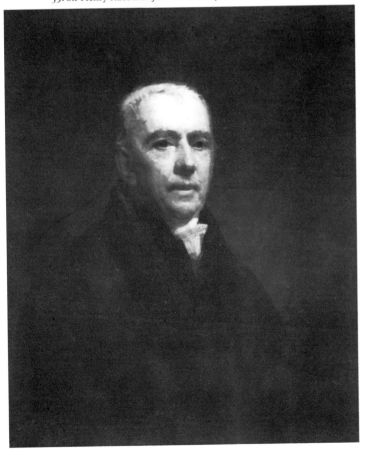

very open brush strokes in colours close to Rembrandt: carmines, strong reds and yellows.

The Stirling portrait is undated. The half-length *Francis Horner* can have been painted no later than 1817, the year the sitter died. It could be compared quite closely to such a picture as the Rembrandt *Self-Portrait* of 1654, then in the Bridgewater collection and now in the Sutherland. Both painters set the eyes in deep shadow enlivened with flashes of strong colour. In Raeburn's portrait this is red, streaked against black. Elsewhere in the head there are small dashes of strong broken colour, constantly enlivening the surface, but also giving a new quality of tangible, physical presence to the head. This, especially, seems to be what Raeburn learnt from Rembrandt in forming his late style. In portraits like those of David Hume, Baron of Exchequer, John Playfair, professor of mathematics, the magnificent portrait of Raeburn's friend, John Clerk of Eldin (plate 58), John Pitcairn of Pitcairn (plate 59) and Mrs Jameson (plate 60), all datable between 1815 and 1823, the typical flow of the brush in his earlier work is broken up in the head into small dabs of paint. This gives a new tactile quality to the image and so reinforces the effect of the sitter's presence.

It is reasonable to compare Raeburn's earlier work to Hals's. Lively brushwork and summary description create an image close to our ordinary social perception of others. Already in the later 1790s it is apparent that he is trying to capture something of the warmth of a living person. In the spectacular *Sir Duncan Campbell of Barcaldine* (San Francisco), dated by a receipt to 1812, he succeeds in doing this and in adding a sense of space and volume. During the last ten years of his life he built on this, enriching the image without elaborating it; conveying increasingly his sense of the variety and complexity of the human image without pausing to enumerate details. If he turned to Rembrandt for inspiration in this, it is hardly surprising. Few painters were better equipped to learn from Rembrandt and his own art was linked by an unbroken intellectual tradition to the humane empiricism of the seventeenth century, of which Rembrandt was the greatest exponent.

Raeburn was elected R.A. in 1815. He was knighted by George IV in 1822 and appointed King's Limner for Scotland, though sadly he did not live to paint the portrait of the King that he proposed in response to his appointment to this office.[30] These honours confirmed Raeburn's reputation not only in Scotland, but also beyond, in England and America. He thus became the first Scottish artist to establish such a reputation though working all his life in his native country. His achievement was important for the confidence and self-respect of Scottish artists generally, much encouraged as they were at the same time by Wilkie's success in London.

Raeburn generously put his reputation and his resources at the disposal of his brother artists in their efforts to establish a permanent professional art institution in Scotland. Though he had worked to promote it, he was absent from the first exhibition to result from these

efforts, that of the Society of Artists in 1808, the year of his financial troubles, but in the following years the exhibition took place in his painting room. He offered the same service to the successor organization, the Institution for the Encouragement of the Fine Arts in Scotland. Acting as their spokesman, he supported the artists' cause in their quarrel with that institution over how they should be represented, which eventually resulted three years after his death in the foundation of the Scottish Academy, which became the Royal Scottish Academy ten years later.

In his own generation Raeburn had no rivals. George Watson (1767–1837), who was a competent though not gifted painter, set himself up in opposition to Raeburn in the Society of Artists, but when Raeburn withdrew in protest, Watson was immediately ousted. Archibald Skirving (1749–1819) was by far the most interesting portrait artist of his contemporaries. He was seven years

Raeburn's senior, but did not turn to art till around 1777.[31] Like Raeburn, he worked principally as a miniature painter before travelling to Italy in 1786, where he remained till 1794. His mature work is principally in chalk. He perfected a delicate and refined type of neo-classical portrait, often using pure profile. Latterly, perhaps under the influence of his friendship with Raeburn, he developed a more relaxed and natural style. His *John Clerk of Eldin* (plate 61) is the finest portrait by any of Raeburn's immediate contemporaries before Wilkie.

Professionally, Raeburn encouraged younger artists. As early as 1792 the miniature painter, Andrew Robertson, enjoyed freely given help and advice.[32] Among others who followed, John Watson (1788–1864), who became John Watson Gordon, worked with Raeburn for a time around the turn of the century and carried the high stan-

60. Sir Henry Raeburn. *Mrs Jameson (née Haig). c.* 1822. Cat. 112

dard of his portraiture into the second half of the nine-teenth century. The landscape painter, John Thomson of Duddingston, too, seems to have begun his career on the basis of help and advice given by Raeburn. John Syme (1795–1861) worked as his assistant towards the end of Raeburn's life and completed several of his paintings after his death, continuing to work thereafter in a style closely modelled on that of his master. Others less close to him, too, were inevitably influenced by his style: Colvin Smith (1795–1875), William Nicholson (1781–1844) and William Yellowlees (1796–1859). Even William Dyce (1806–64) shows an unexpected appreciation of Raeburn's understanding of Rembrandt in *John Small and his son*, a portrait painted in Edinburgh ten years after Raeburn's death. Such a picture and the even more remarkable paint-ing of J. G. Lockhart with a posthumous portrait of his wife by Robert Scott Lauder (1803–69) (col. plate 28), painted a decade after the Dyce portrait, show that Raeburn's influence was by no means crushing, and perhaps the most striking testimony to its continuing fer-tility is to be seen in the calotypes of D. O. Hill, twenty years after his death. It is not a coincidence that the finest early portrait photographs resemble in so many ways Raeburn's paintings and were made within sight of his studio. It is entirely consistent with the empirical and intellectual character of his painting and the character of the intellectual tradition in which it belongs.

In spite of his reputation Raeburn sometimes showed signs of insecurity. Curiously, on two occasions where his opinion of any of his own paintings is recorded, he speaks warmly of pictures that are unusually close to Lawrence.[33] It was perhaps a reflection of his awareness of his isolation in terms of British art as a whole, an isolation to which he referred directly in a famous letter to Wilkie, written in 1819, and in which he describes himself as if living at the Cape of Good Hope.[34] The letter should perhaps be taken as an expression of concern for his reputation in England as much as of his actually being forlorn in Scot-land, where he was certainly not isolated in any literal sense. Such a reading would also be consistent with a plan apparently referred to in a fragmentary letter to Wilkie to hold a one-man exhibition in London.[35]

Even in Scotland his reputation was not beyond ques-tion, however. The public subscription set up in 1814 for a formal portrait of Lord Hopetoun resulted in a consider-able disagreement between those who supported Raeburn as the artist, and those who would have preferred Lawrence. Though Raeburn eventually won, it was true that he was at his best in informal portraiture. A rare fully formal portrait, like the *Earl of Rosebery* (Dalmeny) paint-ed in 1812, is not his most successful kind of painting. In fact formal portraiture inevitably requires some sacri-fice of the exact to the agreeable, something of which Raeburn was not readily capable.

61. Archibald Skirving. *John Clerk of Eldin. c.* 1795. Cat. 118

A similar feeling may lie behind Scott's rather ambivalent attitude to Raeburn. His Whig individualism was perhaps at variance with Scott's more Tory vision, but the relationship between the two men got off to rather a bad start with Scott's dislike of Raeburn's first portrait of him, painted for Constable, Scott's publisher, in 1808. At the very end of the painter's life, however, they estab-lished a closer and more cordial relationship. Scott sat to Raeburn for a portrait which, according to John Mor-rison, who arranged the sitting, was for Raeburn's private gallery.[36] This was a gallery of fifty or sixty portraits of his friends and distinguished contemporaries, a remark-able collection, sadly dispersed, which provided the bulk of the posthumous exhibition held in Raeburn's studio. It was unique testimony to the vitality of Raeburn's inter-est in his subject matter. Portrait painting was for him a branch of the study of human nature. The portrait was an appropriate occasion for Raeburn and Scott to come together and recognize in this their common pursuit.

VII

The Landscape Painters

'Their images are native and their landskips domestick:
copied from the Fields and Meadows we every Day behold.'
Allan Ramsay, preface to THE EVERGREEN, 1724

'Other artists', said one who knew him, 'talked meat and drink, but Runciman talked landscape.'[1] Unfortunately this contemporary witness to Runciman's preoccupation with landscape is not supported by enough surviving paintings to enable us to say how far he developed the idea of landscape as a kind of stage for the interaction of history, poetry and nature that is seen in his Ossian paintings. The two principal landscape painters in the next generation, however, Jacob More and Alexander Nasmyth, were both his pupils and to a greater or lesser degree carried on these preoccupations. Nasmyth, indeed, kept them alive to transmit them to the generation that succeeded him in the nineteenth century. The close relationship between landscape, poetry and history that is reflected in Runciman's friendships is carried on, too, in the younger generation. Burns and Nasmyth were close friends, for example, and so were Walter Scott and John Thomson of Duddingston. Landscape was an important inspiration for Burns and was central to the writing of

Scott, while Nasmyth continued to paint antiquities and the etchings of John Clerk of Eldin (1728–1812) are devoted almost entirely to recording historical views and buildings (plate 62). With the increasing importance of science in Scottish intellectual circles these relationships are also given a new dimension, reflected in Nasmyth's scientific interests or John Clerk of Eldin's collaboration with the geologist James Hutton for whom he made the drawings for his revolutionary *Theory of the Earth* (1795).

The story of Scottish landscape begins with the Norie firm of painters, built on the practice of James Norie, who specialized in landscape.[2] They used a classical idiom, but Scottish features frequently appear in their pictures, painted with a great deal of freedom. Jacob More (1740–97) joined the Norie firm as an apprentice in 1764, when he was already twenty-four years old. Runciman was then a partner and Robert Norie was still alive.[3] Like Raeburn, More had started his career as an apprentice goldsmith.

62. John Clerk of Eldin. *View of Edinburgh with Salisbury Crags and the Wrytes Houses. c.* 1775. Cat. 124

He was evidently treated as an equal by Runciman, for he became a member of his Club, the Cape, when it was still a small informal group. During Runciman's absence in Rome, More painted scenery for the new Edinburgh theatre, which opened in 1769 with a production of *Artaxerxes, or the Royal Shepherd*, to which Robert Fergusson also contributed by writing several songs. As well as his training in the Norie firm, therefore, he was an accepted member of the Bohemian circles of the Cape Club and the Edinburgh theatre, which played such an important part in Runciman's own inspiration. In response to this stimulus More produced a small number of very original works at the beginning of his career; these he never again equalled, even though after he settled in Rome in 1773 he became one of the most successful and celebrated landscape painters of his time.

The most important of More's surviving Scottish landscapes are his paintings of the three Falls of Clyde, *Bonnington Linn* (plate 63), *Cora Linn* (col. plate 29) and *Stonebyres Linn* (frontispiece), of which he painted two

sets. The first set was painted in Scotland before he left for London, where he exhibited them in 1771, and the second set was probably painted during the two years that he spent in London before moving to Rome in 1773.[4] Like the smaller painting of *Roslyn Castle,* (Earl of Wemyss and March), these pictures start from the Norie landscape style. More's use of a cool palette dominated by greys and greens, the way he builds up his composition from simplified, block-like masses and his free, rhythmic handling of the brush, all relate to the Norie practice. He leaves the Nories, however, where he combines a much greater degree of topographical particularity with grandeur of effect. Runciman's surviving Roman landscapes provide a parallel, but do not detract from the originality of More's achievement. His waterfall paintings are self-sufficient landscapes, painted to celebrate the magnificance of a natural phenomenon.

The Falls of Clyde were not only to be celebrated for their beauty, however. A natural wonder on one of the great rivers of Scotland, as Runciman characterized them

63. Jacob More. *Bonnington Linn.* 1771–73. Cat. 131

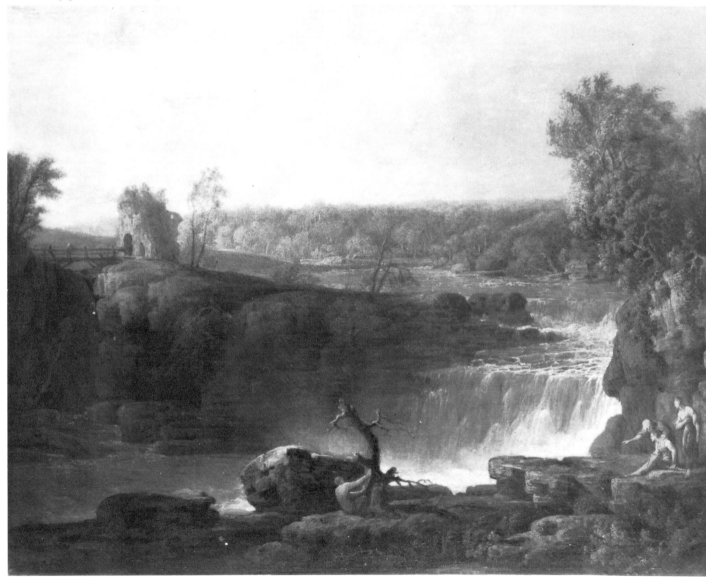

in 1772, they had a special national status. This was enhanced by a traditional association with William Wallace. More than fifty years later Christopher North (John Wilson) must have had this in mind when he made the Ettrick Shepherd, James Hogg, in the *Noctes Ambrosianae* remark, not of More, but of Thomson of Duddingston, 'I never look at his roarin' rivers, wi' a' their precipices, without thinkin', some hoo or ither, o' Sir William Wallace! They seem to belang to an unconquerable country.' North begins his reply 'Yes, James, he is a patriotic painter.'[5] It is in keeping with such a view that George Walker describes *Corra Linn* as 'a national work'.[6]

When More painted the Falls, their reputation as a kind of natural national monument was already established. Once again Sandby had been there before him, though his pictures were very different from More's. The Falls' literary reputation, however, was more important than any earlier pictorial treatment. James Thomson, though he did not name it, described Corra Linn in *Summer*. The fall was on the estate of one of his intimate friends, Dr William Cranstoun, who had been a fellow student with him at Edinburgh University, and in a letter to Cranstoun, written when he was still working on *Winter*, the first of his *Seasons*, he wrote to his friend, 'I see you in the well known Cleugh, beneath the solemn Arch of tall, thick, embowering trees, listening to the amusing lull of the many steep, moss grown cascades; while deep, divine contemplation, the genius of the place, prompts such awful swelling thought.'[7]

Thomson's reputation amongst More's generation, and particularly among the Cape Club circle, was as a national poet, and he certainly played a part in the inspiration for More's paintings. His approach to landscape in the *Seasons*, though his canvas is British rather than Scottish, was to move discursively from the account of a particular natural phenomenon into some wider field of speculation. Following this procedure the association of the Falls with Wallace would indeed have been the key to a whole series of patriotic thoughts for the Scottish spectator of More's paintings.

As well as Thomson, and of course Robert Fergusson in his own time, More's paintings suggest an analogy with another poetic voice, that of James Beattie, the first part of whose poem, *The Minstrel*, was published in 1771. It was an immediate success, being an object of interest not only in itself but also because it followed the author's celebrated refutation of Hume, his *Essay on Truth* published the previous year. Beattie has a claim to be the first writer to recommend the contemplation of nature as an end in itself. In *The Minstrel* he wrote of:

... the boundless store
Of charms, which Nature to her votary yields!
The warbling woodland, the resounding shore
The pomp of groves and garniture of fields;
...
These charms shall work thy soul's eternal health,
And love and joy and gentleness impart.[8]

Beattie's poem may not have influenced More in his paintings of 1771, the year it was published, but it may have had a bearing on the way in which his work developed thereafter, for it changed significantly after he left Scotland.

When Alexander Runciman returned to Scotland from Italy, his art shifted from classical to national preoccupations. More seems to have undergone the same shift of interest in reverse. In the second set of paintings of the Falls of Clyde, the figures have changed into classical garb, the scale of the scene has been enlarged to move the Falls back and increase their grandeur. The details of the painting are more generalized and in *Stonebyres*, at least, the fresh immediacy of the first version has been veiled over with the conventions of the 'savage' landscape. This shift may have been caused by a number of factors, but if it was at all rooted in More's Scottish background, it was only Beattie among the Scottish intellectuals who, in spite of writing some good passages of nature poetry in *The Minstrel*, subscribed to an explicitly idealist aesthetic. A little later, in his *Essay on Poetry and Music* (1776), he took the position of Reynolds, arguing that poetry must generalize from nature and even that in portraiture costume should be timeless to have dignity.[9] Reynolds admired Beattie and painted his portrait putting Hume to flight in *The Triumph of Truth* (University of Aberdeen), in 1773. Reynolds also seems to have thought highly of More to the extent that he bought several paintings from him. More's later painting belongs wholly to the ideal approach to landscape and it may well be that Beattie and Reynolds together had something to do with this. The Beattie-Reynolds connection may also be reflected in the way that More failed to make common cause with Richard Wilson as he might have been expected to do. From the mid-1760s Wilson, in respect of Welsh landscape, had been pursuing ideas very similar to those apparent in More's Scottish paintings, but in so far as More shows the influence of Wilson at all it is the academic, Claudian side of his painting that he seems to admire. By the time he settled in Rome he was committed to this kind of painting, in which Claude was his dominant model. In his watercolours and sketches something of the fresh naturalism of his earlier painting survived, but where it is still present in his more formal works, the actual, perceived world is firmly subordinated to a single overall poetic effect, both in the description of the topography, as in *A View of Rome* (Adelaide), and of the detail of nature. The pair of paintings, *Morning* and *Evening* in Glasgow, painted in 1785, are good examples of this kind of painting in his mature work. Mood is conveyed by colour key; in *Morning* (col. plate 30) cool greens are set off by blue and gold, in *Evening* the balance is reversed, warm pinks and golds are set off by silvery blues. In both pictures the place and time evoked are a remote, indefinite, Claudian Arcadia.

George Walker who was also a landscape painter and a pupil of Runciman, commented on More's career that it was to be regretted that he should have 'suffered his

genius to evaporate by imitating while in Italy, the aerial perspective and pearly tints of other masters.'[10] It was only in his celebrated paintings of the eruption of Vesuvius that More showed a continuing interest in more speculative ideas. It was an interest he shared with his friend Wright of Derby and also with James Byers, who had advanced ideas about geology and was particularly interested in volcanoes.[11]

As a leading member of the Scots community in Rome, More's status was important to his compatriots. He was employed as draughtsman by Ramsay in his search for Horace's villa during his visit to Rome in 1775, though it is perhaps significant that Ramsay did not turn to him again on his last visit. Like Gavin Hamilton, to whose later career his own is rather similar, More was given a room in the Villa Borghese to decorate. He painted a large *Landscape with Apollo and Daphne* for the room there that houses Bernini's famous sculpture. This painting is now lost. More importantly for posterity, he also laid out the English garden which still survives in the Borghese Gardens, though much altered. Such recognition was clearly important in encouraging younger painters. Alexander Nasmyth, for example, certainly learnt from More, though he was a very different artist.

Like More, Nasmyth (1758–1840) began his career as apprentice to an Edinburgh housepainter, Runciman's friend and fellow apprentice of the Nories, James Cumming.[12] During his apprenticeship he also attended classes with Runciman at the Trustees' Academy. Among his earliest datable drawings is a fine study of Paisley Abbey done when he was sixteen years old (National Gallery of Scotland). It is remarkably similar to Runciman's earliest dated drawing, his study of the porch of Holyrood, and shows that Nasmyth had absorbed at the very beginning of his career the scholarly interest in antiquities which he retained all his life.

Before he could complete his apprenticeship with Cumming, however, Nasmyth was taken on as a studio assistant by Ramsay. He spent four years with him in London, from 1774 to 1778, though for part of this time Ramsay himself was away in Rome. During his master's absence Nasmyth presumably worked turning out royal portraits in the company of Philip Reinagle, Ramsay's principal assistant after Martin's departure. Ramsay was evidently kind to Nasmyth, who, according to his son, retained his friendship, and Ramsay's influence as a man as well as an artist seems to have been central to Nasmyth's formation as a painter.

Nasmyth's debt to Ramsay can be most clearly seen in his use and advocacy of drawing. He drew constantly, not as Runciman did, as an imaginative exercise, but as an instrument of intellectual analysis. Nasmyth's son

64. Alexander Nasmyth. *A Farmyard Gate*. 1807. Cat. 140

65. Alexander Nasmyth. *Castle Huntly and the Tay. c.* 1800. Cat. 135

James in his autobiography is emphatic about this and about how Nasmyth stressed the importance of drawing to his own pupils: 'There was one point that my father diligently impressed upon his pupils, and that was the felicity and happiness attendant upon pencil drawing. He was master of the pencil. . . . It was his Graphic Language. My father was an enthusiast in praise of this Graphic Language. . . . It educates the eye and hand and enables (the artist) to cultivate the faculty of definite observation.'[13] Only Ramsay could have impressed upon the young artist such an enduring sense of the importance of drawing as an instrument of empirical analysis. It was something that Nasmyth in his turn, passed on to the younger generation of Scottish draughtsmen, David Wilkie, David Roberts, Walker Geikie and others. As a result it was still a feature of Scottish art in the generation of Orchardson and Pettie.

Though he had almost ceased to paint when Nasmyth knew him, Ramsay was at the height of his reputation as a man of intellect. Dr Johnson said of him at this time, 'You will not find a man in whose conversation there is more instruction, more information, and more elegance than in Ramsay's.'[14] Such a man cannot have failed to

leave a lasting impression on the young Nasmyth and he remained throughout his life loyal to Ramsay's conception of art as a branch of human understanding and one that might well lead its practitioner into other fields of enquiry without inconsistency. Ramsay was not himself a landscape painter, but landscape was an essential part of the search for Horace's villa with which he was so preoccupied at the time that Nasmyth knew him. This search involved a theory of natural poetry, but it also involved Ramsay in detailed analysis of an actual landscape in terms of the siting of buildings and land use as well as more subtle considerations of the impact on its appearance of centuries of human occupation and its consequent status as a witness of the past.

These things remained part of Nasmyth's own approach to landscape throughout his life. His paintings are always of actual places and the great majority have architecture as their principal focus. Even though this is set in the middle or even the far distance, its siting within the landscape as a whole is always the basis of his composition. *Castle Huntly and the Tay* (plate 65) is a beautiful example of this. The result is that his painting is human-centred, based on a practical analysis of the scene

that he is recording. This led naturally to his practice as a landscape consultant and some of his finest paintings are in fact not representations of existing buildings, but painted to show the siting and effect of buildings that he himself had proposed.

After he left Ramsay, Nasmyth practised for a period as a portrait painter. A small number of portraits in Ramsay's style survives, but from an early date he specialized in open-air conversation pieces, and a commission for a picture of this kind seems to have been the occasion that brought him under the wing of Patrick Miller. Like Robert Alexander, who had been the Runcimans' patron, Miller was an Edinburgh banker. He advanced Nasmyth £500 to enable him to go to Rome, whither he set out in 1782. He returned to Scotland in 1785.

Nasmyth coincided in Rome with his old master, Ramsay, and it is likely that his friendship with Raeburn dates from this time, for the two were together in Italy for a year or more. According to James Byers, landscape was his main preoccupation in Rome.[15] Byers records that he copied a Claude, and looking at his later work, what he derived from Claude in terms of mood, composition and general effect suggests that Jacob More may have been an intermediary between him and the language of classical landscape painting.

After his return to Scotland, Nasmyth continued for a while to practise as a painter of conversation portraits. He also remained closely associated with Patrick Miller. Miller was a typical practical man of the Enlightenment, with a wide diversity of interests. In 1785 he took over

the neglected estate of Dalswinton in Ayrshire and spent time and energy improving it, experimenting with the latest agricultural ideas. He took an equally committed interest in naval engineering. John Clerk of Eldin's *Naval Tactics* and his idea of breaking the line of ships in battle led Miller to experiment with paddle-driven, two- and three-hulled ships. Nasmyth did the drawings for these and probably contributed to their design. In the first boats the paddles were driven by manpower. It was a small step to replace the men with a pair of William Symington's steam engines, and so on 14 October 1788 the world's first successful steamship sailed on Dalswinton Loch with Nasmyth on board; it was also incidentally the first ship built of iron (plate 66).[16]

According to James Nasmyth, Robert Burns was also part of the crew on this remarkable voyage. Patrick Miller had taken Burns under his wing as he took Nasmyth. Later he set him up on his farm at Ellisland, unhappily as it turned out. It was presumably Miller who introduced Nasmyth to Burns and the two became close friends. The lasting testimony of their friendship is in the two portraits of Burns that Nasmyth painted, one in 1787 (Scottish National Portrait Gallery) and the other, a full-length, cabinet-sized, of the poet in his native landscape, many years posthumously (also Scottish National Portrait Gallery). The two men shared a passionate interest in landscape.

Although Burns is not in any simple sense a landscape poet as Thomson was or Wordsworth, landscape permeates his poetry. When in his commonplace book in

66. J. C. Bourne after Alexander Nasmyth. *Patrick Miller's First Steamship on Dalswinton Loch, 1788*. Published 1848. Lithograph. Science Museum, London

August 1784 he wrote of his ambitions as a poet he did so in terms of the landscape of his native part of Scotland, not just as a background but as somehow incorporating the history to which it has been witness:

> I am hurt to see other places of Scotland, their towns, rivers, woods, haughs etc, immortalized . . . while my dear native country, the ancient bailleries of Carrick, Kyle, and Cunningham, famous both in ancient and modern times for a gallant and warlike race of inhabitants; a country where civil, and particularly religious liberty have ever found their first support, and their last asylum; a country the birthplace of many famous philosophers, soldiers, and statesmen, and the scene of many important events recorded in Scottish history, particularly a great many of the actions of the glorious Wallace, the Saviour of his country; yet we have never had a Scottish poet of any eminence, to make the fertile banks of Irvine, the romantic woodlands and sequestered scenes on Ayr, and the heathy mountainous source and winding sweep of Doun, emulate Tay, Forth, Ettrick, Tweed, etc.[17]

What the poet describes is a landscape of association, a landscape whose natural beauty is made significant by the poet's own relation to it and by the scenes and deeds to which it has been witness.

At the time this was written, Burns and Nasmyth cannot have known each other, yet the poet's approach is already very close to the painter's, and once they had met they seem to have spent time together exploring landscape. The earliest record of their acquaintance is a drawing of a mill on the Nith in Dumfriesshire inscribed, 'Done in company with Robert Burns, 1786' (National Gallery of Scotland). Both James Nasmyth and J. G. Lockhart in his *Life of Burns* record the two men enjoying country walks together. The younger Nasmyth describes how on one occasion a night's drinking was followed by a dawn walk to Roslyn, where the painter made a drawing of the castle with Burns standing under the bridge.[18]

Much of our knowledge of Nasmyth's work in these years comes from another member of the circle of Burns and Patrick Miller, Robert Riddell, the antiquary for whom Burns prepared the Glenriddel manuscript, a manuscript collection of songs. Riddell made a list of works by Nasmyth to add to Richard Gough's *British Topography*.[19] It is a list of over fifty works and shows Nasmyth taking an active part in the enthusiasms of this group. The works recorded include several views of Edinburgh, three versions of the Falls of Clyde, views of Loch Lomond, Dumbarton Rock, various other antiquities and also a number of country houses including Dalswinton and Arniston.

Surviving pictures by Nasmyth datable to before 1790 are however comparatively few. Those that can be identified seem already typical of his mature style, for example, *Crosby Castle* (1789) and *Loch Ness with Dochfour House* from the same year. The influence of More may be apparent in these in the choice of light, for both pic-

tures have a beautiful Claudian glow. The composition is also classical in form, but in neither is a real place subordinated to a borrowed vision. It is rather that the language of classical landscape allows him to describe the real breadth and tranquillity in the scene before him. From the same year a lovely watercolour, one of several views of Edinburgh, shows very clearly the balance between topographical precision and a sense of light and atmosphere that was to be the principal characteristic of his work over the next twenty years (plate 67).

During this period Nasmyth was still working as a portrait painter. He may have benefited from Allan's appointment as master of the Trustees' Academy in 1786, taking up the portrait practice that he left vacant, but he stopped painting portraits apparently quite abruptly in 1792. According to James Nasmyth this was because 'My father's frank opinions on political subjects began to be known. He attended Fox dinners. He was intimate with men of known reforming views. All this was made the subject of general talk. Accordingly my father received many hints from aristocratic and wealthy personages, that "if this went on any longer they would withdraw from him their employment". My father did not alter his course; it was right and honest but he suffered nevertheless. His income from portrait painting fell off rapidly.'[20] Elsewhere James Nasmyth remarks how Burns and Nasmyth warmly sympathized in their political views and there seems no reason to doubt this story of the impact of the painter's radical sympathies on his career as a portrait painter.[21] The pressure may not have come only from his patrons, however. The feeling that such service to the vanity of the upper classes was incompatible with his other beliefs must be the explanation of Burns's facetious remark in a letter to John Beugo, the engraver, that he wished Nasmyth would pay less attention to 'the carcass of greatness'.[22]

1792 saw the height of radical agitation in Scotland, followed in 1793 by the trial and deportation of Thomas Muir, which inspired Burns to write 'Scots wa' hae', a song that was banned as inflammatory. In this atmosphere it is not surprising that Nasmyth had to withdraw from the service of the ruling class, whether voluntarily or otherwise. This, it seems, affected him both as a landscape painter and as a portraitist, as from the date that his portraits ceased until the end of the decade, and his landscapes are also very rare. He turned instead to stage painting. His earliest dated work for the theatre was in October 1792 for the Dumfries theatre, in which Patrick Miller had an interest. A surviving drawing also records in an inscription Burns's involvement (National Gallery of Scotland). At the same time he began to work for the Edinburgh theatre and he continued to do so for the next thirty years. It was a branch of his activity that he himself greatly valued and by which he earned considerable reputation. The sets that he painted for Glasgow, for example, had great celebrity and were in use for many years. David Roberts testified to their influence on is own career, telling James Nasmyth that the sight of the drop scene, a mag-

67. Alexander Nasmyth. *Edinburgh from St Anthony's Chapel*. 1789. Cat. 134

nificent view of the Clyde, 'determined him to strive to attain excellence in that branch of fine art'. Elsewhere Roberts confirmed this and added that he studied these scenes incessantly 'and on them my style, if I have any, was originally formed.'[23]

Nasmyth also set up a drawing school, which played an important role in the later development of Scottish art. He painted a panorama[24] in 1796, following the example of Robert Barker who had painted the first panorama in 1788, *A View from the top of Calton Hill, Edinburgh*, and who invented the word 'panorama'. Nasmyth does not seem to have returned fully to his practice as a landscape painter till just before 1800, when he also began his very successful career as a landscape consultant. The radical crisis had passed, and the same patrons who had found his views obnoxious eight years before were apparently happy to employ him to advise on landscape and to design buildings for the improvements they were carrying out on their estates. His finest landscapes date from this decade. *Castle Huntly* mentioned above (p. 141), is typical of their form. On a large canvas a wide sweep

of view opens from the shade of trees. The tall castle is in the middle distance, the silver Tay and the blue hills of Fife beyond. The formality of the composition gives harmony and stability to a real view. He was prepared to edit but not to depart from the essentials of the scene in front of him. James Hogg, the Ettrick Shepherd, in a short story, 'The Scottish Haymakers', quotes Nasmyth's own comment on the simplicity that he aimed for in his pictures: 'It is amazing how little makes a good picture: and frequently the less that is taken in the better.' The qualities that result can be seen in a beautiful group of four paintings of *East* and *West Loch Tarbert* (col. plates 32, 33). These at first sight belong to the class of country-house pictures, but they do not include a country house, nor is one implied, for the different viewpoints of the pictures are several miles apart. They seemed to represent the landscape to which the family belonged who commissioned them, the Campbells of Stonefield, rather than the more normal convention of such pictures where the relationship is the other way round and the landscape belongs to the patron, not he to it. Perhaps therefore they

celebrate the old Highland relationship to the land just at the moment that it was vanishing under the onslaught of modern ideas of property. Whatever their origin, the finest of them, *West Loch Tarbert looking North*, is the ancestor of countless views of the spacious beauty of the west Highlands, but it has not been often surpasssed.

The careful analysis and assessment of landscape on which such a painting is based can be seen very clearly in the various pictures that Nasmyth painted to illustrate the effect of proposed buildings on an actual landscape. One of the most beautiful of these is *Inveraray from the Sea* (col. plate 31), painted for the Duke of Argyll to illustrate the effect of a planned lighthouse. The picture, painted in 1801, is a wonderful study of sky and water, but also of civilization and wilderness, seen in harmony with each other. The landscape contains not only Nasmyth's proposed improvements, but the new, planned town of Inveraray, a jewel of eighteenth-century town planning seen by the painter as at one with its natural environment.

Nasmyth's renewal of relations with his former patrons does not therefore necessarily imply a surrender of principle on his part. His painting is not significantly different in 1800 to what it was a decade before. At neither date is it possible to identify in it anything overtly social or political as it is in some of Burns's poetry. Nevertheless, seen apart from the social expectations of later political criticism, his painting does reveal a consistent view of the human condition.

There is a strong element of incipient Utopianism in the painting of Runciman and Allan. Ancient poetry for Runciman, the pastoral life for Allan, were witnesses to a heroic or a more innocent age, providing the model for a freer, a happier or a better state to be achieved by bringing man back into harmony with his nature. These ideas were not of course unique to Scotland, but they were given a special immediacy because consciously or unconsciously the implicit fall from grace could be identified with the Union. In addition, pre-Union history contained in Wallace, in the 1320 Declaration of Independence, in the Scottish Reformation and in the history of the Covenanters, notable examples of resistance to tyranny that assumed a striking contemporary relevance in the context of the American War of Independence and the French Revolution. All of this is present in Burns's approach to landscape as it is set out in the quotation given earlier (p. 143).

Nasmyth's vision is much more stable and harmonious than Runciman's but, like Burns, he had the events in America and France to give reality to his ideas. He also had in the writings of Thomas Reid a practical vision of Utopia. Reid, who influenced Marx, summarized his vision of progress: 'The extent of human power is perfectly suited to the state of man, as a state of improvement and discipline. It is sufficient to animate us to the noblest exertions. By the proper exercise of this gift of God, human nature, in individuals and in societies, may be exalted to a high degree of dignity and felicity, and the earth become a paradise. On the contrary, its perversion

and abuse is the cause of most of the evils that afflict human life.' The means by which this paradise is to be reached are the proper realization and employment of human gifts.

> Upon his own mind (a man) may make great improvement, in acquiring the treasures of useful knowledge, the habits of skill in arts, the habits of wisdom, prudence, self-command, and every other virtue. It is the constitution of nature, that such qualities as exalt and dignify human nature are to be acquired by proper exertions; and by a contrary conduct such qualities as debase it below the condition of brutes.
>
> Even upon the minds of others, great effects may be produced by means within the compass of human power; by means of good education, of proper instruction etc . . .
>
> That these have often had great and good effects on the civilisation and improvement of individuals and of nations cannot be doubted. But what happy effects they might have if applied universally . . . is not easily conceived.'[25]

Human fulfilment is to be achieved through knowledge. The impact of Reid's vision was such, however, that in 1794, though at an advanced age, he was either compelled, or felt obliged, to recant and to publish a warning against too radical an interpretation of his Utopian ideas. Reid's interpreter, Dugald Stewart, was an even closer associate of Nasmyth than he was of Raeburn. The two men were members of the same masonic lodge.[26] Burns, too, was both a friend and a great admirer of Stewart. Within Burns's Ayrshire circle Reid's ideas provided the stimulus for such enterprises as the circulating library started in Ayrshire by Robert Riddell with Burns's participation. For Nasmyth they provided a vision of landscape in which man and nature coexist in a harmony in which improvement has a place.

Reid's ideas also created a context in which the aims of science and the arts were accommodated to each other in a common pursuit. Nasmyth reflected this accommodation in his own life. His talent for applied science was not limited to the contribution that he may have made to the design of Patrick Miller's steamship. His drawings contain numerous ingenious mechanical ideas, some of them quite substantial. For example, he invented the bow and string bridge that was used with much success in some of the greatest constructions of the Victorian engineers, both for bridges and for roofing wide spaces. He was the first to propose and design a practical means of implementing the axial arrangement of engine and propeller from which all subsequent ship design evolved. He also invented the compression rivet, though he apparently failed to patent this or indeed any of his ideas. James Nasmyth was clear that it was his father who made him an engineer.

Nasmyth's interest in science was not only practical, but also speculative. His son records walks with his father in the company of such men of science as Sir David Brewster and Sir John Leslie, discussing on site the latest ideas

in geology.[27] These conversations were many years later than any that may have taken place between Nasmyth and Burns, but just such a conversation on the temporal implications of Hutton's geology may underlie two of Burns's most memorable lines: 'Till a' the seas gang dry, my Dear,/And the rocks melt wi' the sun.'[28] Burns's interest in science was not practical like Nasmyth's, but it was real. Furthermore, he made a direct association between progress in human knowledge and progress in human liberty. In 1788 he wrote publicly of the 'contest between prince and people, the consequence of that light of science which had lately dawned over Europe'.[29]

Nasmyth's relationship with Burns allows us to see therefore how his political attitudes, his belief in science and his painting of the historical landscape of Scotland were all part of an integrated vision. It is a vision into which the kind of improvements to which he lent his aid, like those at Inveraray for example, fitted naturally, and whose balance and coherence is reflected in the very structure of his painting.

Typically Nasmyth's pictures incorporate one of the peculiar charms of the Scottish landscape, the presence in a single view of cultivation and the habitation of man, together with an expanse of water and wild hills, the domain of untamed nature. In the serene light in which he presents them, these two things are in harmony. Even where he is proposing a new building, the picture is painted to show how it can be incorporated without disturbing that harmony, and in a rural setting he always favoured the Gothic style. Man is at the centre of his landscape, but nature is not subservient. The paradise that he describes is to be realized in the spirit of Thomas Reid, by man fulfilling the potential given him within nature.

This vision of human order within nature found practical social expression on a more dramatic scale than at Inveraray in the extension of Edinburgh's New Town to the north and east. While Raeburn was expanding the city to the northwest on a private enterprise basis, Nasmyth was one of those invited to submit proposals in 1815 for the eastern extension as a public undertaking. The presence of the Calton Hill in the middle of the site meant that nature had to be accommodated within the pattern of social order willy-nilly. In Nasmyth's plan nature and society would have complemented each other.[30]

His vision of the city was also given pictorial expression in a set of four paintings that he painted in 1824 and 1825. The stimulus for these may have been partly the artistic activity surrounding George IV's visit to Edinburgh in 1822. Turner and Wilkie were both there to record the event, and there was an enormous amount of creative activity surrounding it. Nasmyth's interest in the social view of townscape, may however already have been stimulated by work that he did for the theatre. In 1820 he painted scenery for a dramatic adaptation of *The Heart of Midlothian*, Scott's novel of town and country. He had watched the demolition of the old Tolbooth, the sight that stimulated Scott to complete the novel, in the company of the author and in the sets that he painted he seems to have responded himself in a new way to the historical texture of the living city, so important in the novel.

The paintings of Edinburgh that followed are of unique importance as urban landscapes. Turner had painted views of London and Alexander Carse painted a panoramic *View of Leith with the Landing of George IV*, but no one else had attempted to describe the city as a living organism in the way that Nasmyth now did, and on a scale fitting the importance of the subject. In 1824 he painted *Shipping at Leith* and a *View of the High Street*, and in 1825 *Princes Street with the Royal Institution Building under Construction* (col. plate 34) and the largest of the four, *Edinburgh from the Calton Hill* (col. plate 35). The four pictures together constitute a striking record of the city at the height of its fame as the home of the Scottish Enlightenment. Its setting is a magnificent landscape, but within this framework, provided by nature, it is richly endowed by the work of man. It is all fuelled by commerce, epitomized by the *Shipping at Leith*, but the whole machine is not driven by the great and powerful, but by ordinary folk, shown in such detail, pursuing their daily business in the co-operative life of the city or enjoying well-earned relaxation watching the midsummer sunset from the Calton Hill, prefiguring the theme of Seurat's *La Grande Jatte* (even to the detail of the monkey). Nasmyth's paintings of Edinburgh inspired John Knox to undertake a similar account of Glasgow in such pictures as the *Trongate, Glasgow* (1826) (plate 68).

1825 was perhaps the latest date that Nasmyth could have painted the city as so stable and integrated. This was the year of Wilkie's breakdown. Raeburn had died two years before. Profound aesthetic change was under way in Scotland in response to deeper currents. Nasmyth himself had already shown signs of responding to these changes in his own work more than ten years earlier. In 1813, for example, he painted *A Distant View of Barnbogle* (Dalmeny) in which there are signs of a new and less fastidious appreciation of the old masters. In 1816 he painted a pair of magnificent views of *Culzean Castle* (National Trust for Scotland) which are nevertheless distinctly mannered. He worked extensively for Scott, as an illustrator but his benign vision did not really match Scott's romantic needs. It is as though the stable clarity of his earlier work was no longer adequate to the demands put upon landscape. On occasion, he attempted a more explicitly romantic image, but he was ill at ease and on the whole the best work of his later life is a less confident rendering of his earlier imagery.

Wilkie described Nasmyth in a touching letter of condolence to his widow as 'one of my earliest professional friends, whose art I at all times admired, and whose society and conversation were perhaps the most agreeable of any friend I ever met with. He was the founder of the landscape painting of Scotland, and by his taste and talents took the lead for many years in the patriotic aim of enriching his native land with the representations of her romantic scenery.'[31] David Roberts's testimony was

equally warm. He wrote to James Nasmyth: 'I used to feel gratified when in after times your father claimed me as a pupil, which, strictly speaking, was scarcely correct; but if love and admiration for his works, unwearied industry in copying them and afterwards doing my best to imitate them, could make me a pupil, I was one in the best sense of the word.'[32]

Thus Wilkie and Roberts record their affection for Nasmyth, his approachability and the advice and encouragement that he freely gave to young artists. These qualities played at least as important a part in the transmission of his influence as his formal teaching, though that too was important. James Nasmyth lists David Wilkie, David Roberts, Francis Grant, Clarkson Stanfield, William Allan, Andrew Geddes, Hugh William Williams, William Lizars, Andrew Wilson and John Thomson of Duddingston among his pupils, and though not mentioned John Knox probably also belonged to this group, as did D. O. Hill and indeed Ruskin's father.[33] Among these Andrew Wilson, himself a distinguished landscape painter, and William Allan, as teacher in the Trustees' Academy, passed on Nasmyth's ideas to a younger generation. Cer-

tainly some, like Roberts and Wilkie, were not formally his pupils. Nevertheless, this list (to which other names can be added, such as those of John Ewbank and Patrick Nasmyth, the most gifted artist among Alexander's numerous children), provides a fair measure of the extent of his influence, which was not restricted to landscape painters but also affected crucially the development of Wilkie's art and so that of Scottish genre.

David Roberts (1796–1864) was the outstanding landscape painter in the generation that Nasmyth influenced. He took Nasmyth's interest in architecture and his understanding of its siting in landscape (plate 69) and applied it to buildings in Spain and the Near East (plate 70). Hugh William Williams (1773–1829) known as Grecian Williams, who was closer in age to Nasmyth, anticipated Roberts to a certain extent with his views of Greece and these created great excitement when they were exhibited in Edinburgh in 1822.

Williams began his training as a private pupil of David Allan before 1790, but his earliest dated works, such as the drawing *Glasgow Cathedral* (private collection; version in National Gallery of Scotland) of 1794 or *Dun-*

68. John Knox. *The Trongate, Glasgow. c.* 1826. Cat. 125

fermline Abbey (plate 71) suggest that Nasmyth played a significant part in his decision to become a landscape painter. For more than twenty years he continued to work as a topographical artist very much in the Nasmyth orbit, though in the later part of this period he began to paint in a more ambitious and dramatic way when using oil, in contrast to the continuing coolness and precision of his watercolour drawings. The ambition may be explained by the success of Turner, but Williams's own approach in turning to oil paint seems old-fashioned. In the *Falls of Braan*, for example, he uses strong and rather simplified chiaroscuro to create drama at the expense of detail and subtlety.

Between 1816 and 1818 Williams travelled through Italy to Greece and the Ionian islands. The pictorial results of this journey were first seen in the exhibition of his sketches in 1819, followed in 1820 by the publication of the two volumes of *Travels to Italy, Greece and the Ionian Islands*. It was only in 1822 that Williams exhibited the finished work on the basis of the sketches that made his reputation (plate 72). A critic writing about the first volume of the *Travels* remarked, 'these classical scenes, more interesting even from their historical associations than from their unequalled beauty, have inspired him with higher conceptions of art than even the delicacy and beauty of his pencil could have lead us to anticipate.'[34]

69. David Roberts. *Melrose Abbey.* 1830. Cat. 147

70. David Roberts. *Church of the Nativity, Bethlehem.* 1840. Cat. 146

The idea of association that the critic invokes is an echo of the theoretical writing of Archibald Alison, whose *Essays on Taste* was first published in 1790. Alison was a friend of Dugald Stewart and with him a pupil and follower of Thomas Reid. He was also a close friend of Scott and Raeburn. He met Burns in 1789 and sent him a copy of his book, of which Burns thought highly.[35] The impact of his ideas was greatly increased when in 1811 the second edition was published to an enthusiastic response from Francis Jeffrey on the *Edinburgh Review*. In the intervening time Alison's own personal impact on the Edinburgh art world had been limited by his absence in England where, as an Episcopalian clergyman, he had a living in the diocese of Salisbury between 1790 and 1800. He only returned in the latter year to the Cowgate chapel, at that time still the leading Episcopalian congregation in Edinburgh.

Alison's starting point, following Hume and Reid (and Ramsay), was that there could be no such thing as an idea of beauty existing apart from our experience of beauty. He then follows the same authorities in the alternative mechanism he proposes, the association of ideas. We find beauty in things according to the associations that they hold for us. One effect of this, as Burns very quickly observed in a letter to Alison, was to place everything on an equal footing as a candidate for our appreciation.[36] In place of the tyranny of abstract taste therefore, 'Instead of a few forms which the superstition of early taste had canonised, every variety, and every possible combination of forms is thus brought within the pale of cultivated taste.'[37] As might be expected from a follower of Reid, Alison's position is profoundly anti-ideal. He limits its implications by concentrating on the works of nature, but even here for landscape they are far-reaching. Echoing closely the quotation from Burns's commonplace book given above (p. 143), he writes, 'Objects which have been devoted to religion, to patriotism, or to honour, affect us with all the emotions of the qualities of which they became significant; that the beauty of natural scenery is often exalted by the events it has witnessed; and that in every country the scenes which have the deepest effect upon the admiration of the people are those which have become sacred by the memory of ancient virtue or ancient glory.'[38]

A point on which Alison departed from Burns and certainly from Nasmyth, but which appealed very strongly to the next generation, was the ultimate justification of his system in terms of religion. He was an admirer of Beattie as well as of Reid and even at one point asked Beattie to write a reference for him.[39] In his view, in which both Constable and Ruskin followed him, our appreciation of the beauty of nature is ultimately a response to our recognition of the working of the divine mind. 'Wherever we observe the workings of the human mind, whether in its rudest or its most improved appearances, we everywhere see the union of devotional sentiment with sensibility to the expressions of natural scenery. It calls forth the hymn of the infant bard, as well as the anthem of the poet of classic times.'[40]

71. Hugh William Williams. *View of Dunfermline Abbey. c.* 1795. Cat. 153

Alison therefore christianized Hume's idea of association. The effect of this was to open up for the artist a new field of subjective response. He could devote as much energy to describing his feelings as to describing whatever was their occasion. Ironically, therefore, here as elsewhere, the analytical process begun by Hume opens the way to full-blooded subjectivity, justified by religion. To return to Hugh William Williams, this approach seems to be illustrated closely in the painting that resulted from his Greek sketches. In them feeling prevails over description. The best known, *View of the Temple of Poseidon, Cape Sunium, Attica* (plate 73), seems to be an essay in Alison's aesthetic. The grandeur of the temple is shown as deriving from its associations with ancient Greece, but also from the way it reflects the works of God, as its columns echo the columns of light in the sky and of basalt in the cliff on which it stands.

Williams dedicated the first volume of his *Travels* to

his friend the Revd John Thomson of Duddingston. As a fellow cleric, though in a different denomination, and one who was also a landscape painter, Thomson was uniquely placed to appreciate Alison's justification of landscape as being to the greater glory of God. Even more than Williams, by whom he was much influenced, he treated landscape as an opportunity to attempt to convey a subjective state. A contemporary wrote of him: 'His landscapes are intensely Scotch in their character, and yet scarcely one of them approaches to a facsimile of any known locality. He has left views of particular places; but they are all representations of the scenes under the influence of accidents and as the momentary mood of his own mind apprehended them.'[41]

Thomson (1778–1840), a minister of the Kirk, was scrupulous in preserving his amateur status out of deference for the feelings of his parishioners in the parish of Duddingston, on the outskirts of Edinburgh, of which

he was minister from 1805 until his death in 1840. However, he was to all intents and purposes a professional landscape painter, and from 1808 he exhibited regularly. At the height of his fame he is reputed to have made between £1,800 and £2,000 annually from his painting, but in the absence of an up-to-date catalogue of his considerable output, it is impossible to form a clear picture of his development. He evidently formed his interest in painting early enough for it to have been his own preferred alternative to the ministry, into which he followed his father. While still a student at Edinburgh University he studied briefly with Nasmyth, but his friendship with Raeburn seems to have been the main formative influence on him as a painter. Raeburn's freely painted backgrounds provide the starting point for the freedom of his own paintings and perhaps, too, Raeburn's ideas on perception may have something to do with the extraordinary summariness apparent in such sketch-like works as *Landscape Composition* (Scottish National Gallery) (plate 74).

Of equal importance to Thomson's connections with

the painters who were his contemporaries was his friendship with Walter Scott, which began when he was still a student in the 1790s. Of all the Scottish painters, Thomson was closest to the novelist, who both admired and promoted his work, and in their approach to landscape they had much in common. Scott did more than anyone else to replace the eighteenth-century view of landscape with the landscape of association, giving substance to the theories of Alison and creating a situation in which the wild, the bleak and the barren could be preferred to the cultivated or the picturesque. Wilkie summarized the new trend in 1817 after returning from a visit to Scotland: 'Scotland is the most remarkable as a volume of history. It is the land of tradition and of poetry, every district has some scene in it of real or fictitious events, treasured with a sort of religious care in the minds of the inhabitants and giving dignity to places that in every other respect would, to the man of the world, be considered barren and unprofitable.'[42]

Thomson provides a perfect example of this in one of his most celebrated compositions, *The Martyrs' Tombs*

72. Hugh William Williams. *The Ancient Temple at Corinth*. 1820. Cat. 154

OPPOSITE, TOP 73. Hugh William Williams. *View of the Temple of Poseidon, Cape Sunium, Attica*. Pen and watercolour, 61.75 × 97.15 cm.
National Galleries of Scotland

OPPOSITE, BOTTOM 74. John Thomson of Duddingston. *Landscape Composition*. Cat. 150

ABOVE 75. John Thomson of Duddingston. *Fast Castle from Below, St Abb's Head in the Distance*. Cat. 152

in the Bog of Loch-in-Kett (whereabouts unknown). The darkness and wilderness in the painting appear as an expressive comment on the historical presence in the land-scape evoked by the tombs of the murdered Covenanters. Thomson himself commented to Scott on the importance of the *associations* of the subject.[43]

Turner, whom Thomson knew and admired, was by far the greatest interpreter of Scott's vision of Scotland. Nevertheless the affinity between Thomson and Scott was very close. One of Thomson's favourite subjects was *Fast Castle* (plate 75, col. plate 37), one version of which he presented to the author. The same castle is reputed to have been the model for Wolf's Crag Castle in *The Bride of Lammermoor*, but Scott's description is closer to one of Thomson's paintings than either is to the actual place:

The castle perched on the cliffs like the nest of some sea eagle . . . a solitary and naked tower situated on a projecting cliff that belted on the German Ocean. Tall and narrow it stood, glimmering in the moonlight like the sheeted spectre of some huge giant. A wilder or more disconsolate dwelling, it was perhaps difficult to conceive. The sombrous and heavy sound of the bil-lows, successively dashing against the rocky beach at a profound distance beneath, was to the ear what the landscape was to the eye—a symbol of unvaried and monotonous melancholy, not unmingled with horror.[44]

Concentration on mood leads both Scott and Thomson into exaggeration and such exaggeration of tone and scale characterizes most of Thomson's larger works after about

76. John Thomson of Duddingston. *Urquhart Castle and Loch Ness*. Cat. 151
77. Robert Scott Lauder. *View in the Campagna. c.* 1833. Cat. 127

1820. He was probably following the example of his friend Williams, whose *Cape Sunium* is quite similar to his *Fast Castle*. He was certainly also much influenced by Turner, as can be seen in a painting such as *Urquhart Castle* (plate 76), and some of these large-scale works seem rhetorical and overblown. Nevertheless his expressive use of paint is genuinely original and in his smaller works it is not merely self-indulgent display. It manages to describe successfully both the thing seen and the feeling that it evokes. His intuitive apprehension of the physical world is inevitably coloured by feeling, but is not obscured by it.

In the younger generation, Horatio McCulloch (1805–67), though originally a pupil of John Knox in Glasgow, was much influenced by Thomson who befriended him when the younger artist first moved to Edinburgh in the late 1820s. McCulloch's main achievement belongs to the 1840s and 1850s, and so falls outside this study, but already in the 1830s, particularly in the paintings that he did in Cadzow Forest, he already showed considerable originality. Thomson's son-in-law, Robert Scott Lauder, a many-sided artist and a key figure in Scottish painting in the mid-nineteenth century, was also much influenced by him in his landscape painting[45] (plate 77, col. plate 36). Through Lauder, Thomson's approach to landscape was transmitted to Lauder's pupils, the dominant painters of the second half of the century, and especially to William MacTaggart.

VIII

Scenes of Scottish Life and Character

*'An excellent painter or statuary can tell, not only what are
the proportions of a good face, but what changes every
passion makes in it.'*
Thomas Reid, AN INQUIRY INTO THE HUMAN MIND, 1785

'Tis evident, that all the sciences have a relation, greater or less to human nature; and that however wide any of them may seem to run from it, they still return back by one passage or another.'[1] Hume's words identify the central characteristic of Scottish Enlightenment thought, in which no sharp demarcation existed between science on the one hand and art on the other. They both have a common object and so are responsive to the same methods of analysis. In a continuous spectrum of knowledge they can also inform each other. This was the position of Nasmyth. He was not an artist with a technological hobby, but a man for whom art and technology shared both ends and means.

In the generation after Nasmyth, a similar figure, though with his intellectual centre of gravity in the scientific rather than the artistic end of the intellectual spectrum, was Charles Bell. The place in history of Sir Charles Bell, as he became, is secure because of his fundamental discoveries about the nature of the nervous system. In medicine he was a pupil of Alexander Monro, Secundus, the greatest of the Monro dynasty of medical professors in Edinburgh. He was also a pupil and collaborator of his own brother, John Bell, who was 'an expert dissecting anatomist' and of whom it has been said by one authority, 'The subject of surgical anatomy seems to have been given birth by him.'[2] As well as this medical pedigree, Bell was a pupil at Edinburgh of Dugald Stewart, was an intimate member of the Edinburgh circle formed by Stewart's most brilliant pupils and was much influenced by his ideas and through him by those of Thomas Reid. In addition to all this Bell was a gifted draughtsman. He was a pupil of David Allan when he was a boy and remembered him kindly. The way he used drawing and also model-making as instruments of analysis of equal importance to the scalpel suggests that he also learned from Alexander Nasmyth. Not only was drawing an essential intellectual tool to Nasmyth, he was also a skilful model-maker. It is certainly intrinsically likely that Bell knew Nasmyth. He was very much part of the intellectual society of Edin-

burgh even when he was young, and his brother, George Joseph Bell, professor of law at Edinburgh University, was a close friend of Raeburn and the subject of a memorable portrait.

Bell's life's work as a neurologist had its starting point in the philosophy of Thomas Reid. Reid saw that the demolition of the idealist view of perception left speculative philosophy no way of explaining our apprehension of the physical world other than through the mechanics of our physiology, but to do so presented an apparently insoluble mystery. 'But how are the sensations of the mind produced by impressions upon the body? Of this we are absolutely ignorant, having no means of knowing how the body acts upon the mind, or the mind upon the body. There is a deep and dark gulf between them, which our understanding cannot pass.'[3] Dugald Stewart, while recognizing this mystery, also speculated that it might succumb to the tools of modern scientific inquiry.

The discoveries made by the microscope have laid open to our senses a world of wonders the existence of which hardly any man would have admitted upon inferior evidence; and have gradually prepared the way for those physical speculations, which explain some of the most extraordinary phenomena of nature, by means of modifications of matter far too subtle for the examination of our organs. Why then should it be considered unphilosophical, after having demonstrated the existence of various intellectual processes which escape our attention in consequence of their rapidity, to carry the supposition a little farther, in order to bring under the known laws of the human constitution, a class of mental operations, which must otherwise remain perfectly inexplicable?[4]

Bell, who was fiercely ambitious, could not ignore such a challenge. He set out to meet it armed with the dual weapons of visual and surgical analysis.

The first step that Bell took revealed the duality of his approach and eventually led to his revolutionary dis-

SCENES OF SCOTTISH LIFE AND CHARACTER

covery of the real nature and function of the nervous system. This was the publication in 1806 of his first major work, *Essays on the Anatomy of Expression in Painting*. Bell's point of departure is in Reid's discussion of perception. In his account of the difference between the sign and the thing that it signifies, which has already been invoked with reference to Raeburn, Reid says of expression:

> There are other external things which nature intended for signs; and we find this common to them all, that the mind is disposed to overlook them, and to attend only to the thing signified by them. Thus there are certain modifications of the human face, which are natural signs of the dispositions of the mind. Every man understands the meaning of these signs, but not one of a hundred ever attended to the signs themselves, or knows anything about them . . .
>
> An excellent painter or statuary can tell, not only what are the proportions of a good face, but what changes every passion makes in it. This, however, is one of the chief mysteries of his art, to the acquisition of which infinite labour and attention, as well as a happy genius, are required. But when he puts his art in practice, and happily expresses a passion by its proper signs, everyone understands the meaning of these signs, without art, and without reflection.[5]

Reid therefore places expression at the centre of his discussion of the processes of mediation between the mind and the external world, while making it the special province of the painter. Bell's intention was 'to lay a foundation for the study of the influence of the mind on the body',[6] but for him the province of genius in painting too, lay 'with invention and deep observation of human character . . . in order to make the mind apparent in the body'.[7] In expression the mind manifests its 'disposition' in a way that is directly physical, frequently involuntary, therefore without the intervention of ideas, or even actually physiological. At this point therefore the aims of art and science are identical.

Bell's early links with David Wilkie were recorded later by Bell himself in the third edition of his *Anatomy of Expression*, and also at the time by Wilkie's friend and fellow student, B. R. Haydon.[8] The occasion that both refer to is the series of lectures that Bell began in London at the end of 1805. He had arrived in London the previous year. He was young and quite unknown there and in desperate need of cash. Wilkie, who had himself only arrived in London in 1805, rallied a group of Academy students to attend Bell's lectures on anatomy for artists. (They were not exclusively on expression.)[9] It was a gesture of support and even of financial commitment that Wilkie would have been unlikely to make for a stranger. According to Haydon, Wilkie also contributed at least one of the illustrations to Bell's book, though it is not acknowledged.

The manuscript of Bell's book was complete before he left Edinburgh, and there is clear evidence in Wilkie's work that he shared ideas with Bell at that early date.

Sir William Allan, a friend and fellow student at the Trustees' Academy, recorded later how in one of Wilkie's first paintings, *Diana and Callisto*, a prescribed subject, 'Callisto was made to blush with so deep a colour in the ear and upper part of the neck as gave Graham [John Graham, master of the Academy] an opportunity for descanting on the difficulties of introducing the peculiarities of familiar life into the higher branches of the art.'[10] The blush, as a specific example of the involuntary and physiological nature of expression, was of especial interest to Bell, just as Wilkie's interest in it was clearly at variance with the tenets of high art as they were expounded by his teacher.

Wilkie's first two major works, *Pitlessie Fair* (plate 78) and the *Chalmers-Bethune* family portrait (col. plate 39), were both painted in 1804 when he was nineteen, immediately after he had finished at the Trustees' Academy. In both pictures he reveals the same preoccupation with expression at the expense of decorum. The *Chalmers-Bethune* portrait reveals quite clearly the painter's debt to Raeburn, as does his self-portrait of the same date (National Gallery of Scotland), but the portrayal of the fat, red-faced father is startling in its frankness even beside Raeburn, and the impact of the picture as a whole reveals a subtle departure from Raeburn's practice. It is in fact a study in expression. Wilkie makes us aware of the father's suspicious hostility to the young artist, of the mother's tender pride in her pretty young daughter and concern for her good behaviour, and above all of the little girl's frank and disarming curiosity about what the painter himself is up to. All this is achieved by an extraordinarily subtle account of expression and posture. To achieve such a result, Wilkie must have been looking as carefully at Ramsay as he was at Raeburn, but the effect is quite his own; it records through expression the different reactions of the sitters to the experience of being painted.

Pitlessie Fair is likewise a social picture, though in more obvious ways. Allan Cunningham described it as 'the portrait of a village', and Wilkie himself confirmed this in the catalogue of the one-man exhibition that he held in London in 1812, writing in a note, 'most of the figures . . . are portraits of the inhabitants of a small village in Scotland, where the Fair is annually held, and near to which the picture was painted.'[11] Cults, where Wilkie was born and brought up and where his father was minister, is the Kirktown of Pitlessie, and the picture, which includes portraits of Wilkie's father and several members of his family, was a portrait of his own community, studied from life. Its subject is therefore precisely 'the peculiarities of familiar life', in John Graham's phrase. Wilkie and Graham held each other in mutual respect and Wilkie acknowledged his debt to the older man, but it is almost as though Pitlessie Fair was painted in direct defiance of his values.

Wilkie's view of familiar life had precedents in David Allan, and especially also in Alexander Carse's *Oldhamstocks Fair* (1795) (plate 80), and ultimately in Hogarth,

78. Sir David Wilkie. *Pitlessie Fair*. 1804. Cat. 174

but he has presented the sounds and smells as well as the sights and he has concentrated on the currency of social exchange, expression. The liveliness of the whole scene is not just a sum of the multiplicity of incidents that it contains. It is the result of the vividness with which the expression of each individual is captured, even when they have their backs to us and we can only read the way they are standing.

Bell could have had Wilkie's painting in mind when, describing the advantages of painting over sculpture, he wrote: '(in painting), a stronger expression, or closer imitation of natural character may be adopted . . . a painting, with high finishing and bright colouring, demands minute expression.' He continued: 'the painter must study . . . the traits of human expression. The noblest aim of painting unquestionably is to reach the mind, which can be accomplished only by the representation of sentiment and passion: of the emotions of the mind, as indicated by the figure and in the countenance.'[12] It was a year or two before Wilkie caught up with the high-mindedness of Bell's sentiment, but there is no doubt that he was already with him on his ideas of the role of expression in painting before either man left Edinburgh.

The importance of the relationship between Bell and Wilkie was not however limited to the practical lessons that the anatomist could offer to the painter. In a letter to his brother George, written in July 1805, Bell wrote,

'The subject everywhere admits and requires theory and reasoning, for our ideas are only obscured by use and wont. The book (Alison's *Essays on Taste*) wanted theory and it will now have it: it was insulated remarks. We shall be able to combine it in system.'[13] The subject was evidently the common subject of his own and Alison's books, so his letter clearly reveals his intention to write more than a practical treatise, and in the introductory essay, which he later rewrote on much less radical lines, he did indeed outline very forcefully an empirical and anit-ideal aesthetic.

He opened his argument by defining anatomy:

By Anatomy . . . I understand not merely the study of the individual and dissected muscles of the face, body, or limbs; I consider it as including a knowledge of all the peculiarities and characteristic differences which mark and distinguish the countenance, and the general appearance of the body . . . The anatomy of painting, taken according to this comprehensive description, forms not only a science of great interest, but that from which alone the artist can derive the spirit of observation; learn to distinguish what is essential to just expression; and be enabled to direct his attention to appearances which might otherwise escape his notice (see Reid, above p. 80), but on which the effect and force, and much even of the delicacy of his delineations

will be found to depend . . . In this difficult study the painter must have recourse to nature, that he may have her habits and genuine language, rules and descriptions can do little for him.'

Nor indeed, in Bell's view, can either the antique or the academy model be of much use. He continues 'If an artist should make the imitation of the antique the beginning and end of his studies . . . he will be apt to degenerate into a tame and lifeless style; he will be in danger of renouncing in pursuit of ideal beauty, the truth of expression and character.'[14] Even Winckelmann's ideal tranquillity can only be reached by an artist 'who is also capable of producing all the violence and agitation of passion'.[15] The academy figure is equally unnatural because 'the display of muscular action in the human figure is but momentary'. Anticipating Degas, the artist has therefore to direct his model and 'catch, as it were intuitively, what is natural'.[16]

Bell's ideas continued to have a discernible echo in Wilkie's painting for the first ten years of his career. His

first important commission after he moved to London, the *Village Politicians* (Earl of Mansfield), based on a lost picture that he had painted in Edinburgh, is a study in the expressions appropriate to impassioned debate, and still in 1811 in *Blindman's Buff* (plate 81) he seems to be responding specifically to what Bell says about composing with the figure in action.

The ideas that Bell and Wilkie shared were complementary to the ideas on perception that are apparent in Raeburn's painting, with a common origin in the philosophy of Thomas Reid. Artistically, too, Wilkie was very close to Raeburn, whose influence is so clearly apparent in his early portraits. He shared with Raeburn an admiration for David Deuchar, whose collected etchings were published in 1803, and drew on Deuchar's compositions directly for his own painting of *The Cut Finger*, painted in 1808, and for the portrait of his parents (1808; National Gallery of Scotland). His relationship with Nasmyth was also important. If he was not actually his pupil, as James Nasmyth stated, he was very close to him; his expressed regard for the older painter makes this quite clear.[17] The

79. Sir David Wilkie. *Study of a Cow and other Studies for Pitlessie Fair. c.* 1804. Cat. 175

visible evidence for the relationship is in the drawings that Wilkie made for *Pitlessie Fair* (plate 79), which are very close to Nasmyth's own drawings in both character and function, and it seems legitimate to deduce that his lifelong habit of drawing began under the guidance of Nasmyth, who thus provided a vital link between Wilkie and Ramsay.

Nasmyth through his friendship with Burns was also an important link to the Scottish poetry that was another primary inspiration for Wilkie. Another such link was George Thomson, secretary to the Trustees. His brother was a fellow student with Wilkie at the Trustees' Academy. Although Thomson is reputed to have turned down Wilkie's application when he first applied to the academy, Wilkie remained on friendly terms with him and, according to Cunningham, used to speak of him with affection and respect. Thomson's possible importance to Wilkie is illuminated by a remark made by John Burnet, another fellow pupil: 'Next to nature he [Wilkie] loved David Allan.'[18] Thomson's enthusiasm for Scottish poetry and song and their relationship to the visual arts, which found expression in Wilkie's own relationship with David Allan, certainly would have found in him a sympathetic listener. Wilkie was himself an accomplished performer on the fiddle. All his earliest independent compositions have their inspiration in Scottish poetry, while David Allan's influ-

ence is apparent both in the style and the subject of his earliest surviving composition, an illustration to *The Gentle Shepherd* (Kirkcaldy Art Gallery). He returned to *The Gentle Shepherd* many years later and even planned at one stage his own illustrated edition of the play, wishing to update rather than to replace Allan's version.[19] *The Penny Wedding* (1818) and even *The Cotter's Saturday Night* (1837) (col. plate 45) show his continuing loyalty to Allan's memory. The first is linked to a specific suggestion of Thomson's and the second pays homage to the relationship of Burns and Allan as Thomson would certainly have described it to him.

Wilkie's first major surviving genre painting, *Pitlessie Fair*, is also linked to a literary inspiration. Cunningham mentions Burns's 'Holy Fair', in this connection, and Arthur Marks has pointed out that the poem by Fergusson which inspired that of Burns, 'Hallow Fair', is closely echoed in the picture.[20] Burns's inspiration is directly apparent too in the most interesting choice of subject among Wilkie's other recorded early compositions, *The Vision*, from Burns's poem of the same name.[21]

The poem is very close in spirit to the quotation given in the previous chapter (p. 143) from Burns's commonplace book. In a vision Burns sees the muse of his own locality, Coila, the ancient name for his part of Ayrshire. She has depicted on her mantle the rivers Doon, Irvine

80. Alexander Carse, *Oldhamstocks Fair*. 1795. Cat. 158

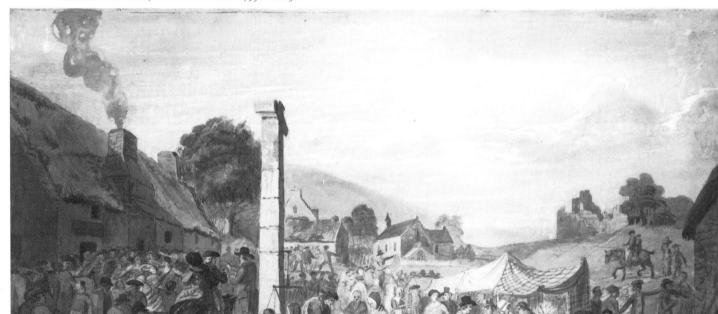

and Ayre, and, as in the commonplace book, the countryside is identified with the deeds of Wallace and other historical heroes. In the second part of the poem the Muse addresses him, reassuring him of the validity of his poetic ambitions.

> I taught thy manners-painting strains,
> The loves, the ways of simple swains,
> Till now, o'er all my wide domains,
> Thy fame extends;
> And some, the pride of Coila's plains,
> Become thy friends.
>
> Thou canst not learn, nor I can show,
> To paint with Thomson's landscape glow;
> Or wake the bosom melting throe,
> With Shenstone's art;
> Or pour, with Gray, the moving flow,
> Warm on the heart.
>
> Yet all beneath th'unrivall'd Rose,
> The lowly Daisy sweetly blows;
> Tho' large the forest's Monarch throws
> His army shade,
> Yet green the juicy Hawthorn grows,
> Adown the glade.

> Then never murmur nor repine;
> Strive in thy humble sphere to shine;
> And trust me, not Potosi's mine,
> Nor King's regard
> Can give a bliss o'ermatching thine,
> A rustic Bard.[22]

Whatever subject Wilkie derived from Burns's poem in his own lost painting, clearly in *Pitlessie Fair* he saw himself, as Burns did, as the pictorial equivalent of the rustic bard and, equally explicitly, as the artist of his own locality.

In *Pitlessie Fair* a further light on Wilkie's aesthetic position is provided by the group of boys in the left foreground. One boy is playing the jew's-harp, the others, indifferent to the surrounding din, are listening with rapt attention, except for one, who, seeking to compete on a tin trumpet, is energetically hushed by a companion. The group, from which Wilkie later made a separate composition, *The Jew's-Harp* (Liverpool), is a kind of musical equivalent to the *Origin of Painting*. The jew's-harp, the most primitive of instruments, engages the pure sensibility of children in contrast to the other musical episodes in the picture, the blind fiddler, whose contribution to the general clamour is ignored, and the Highland soldier who, loudly blowing his nose and not his pipes,

81. Sir David Wilkie. *Blind Man's Buff; Sketch*. 1811 Cat. 179

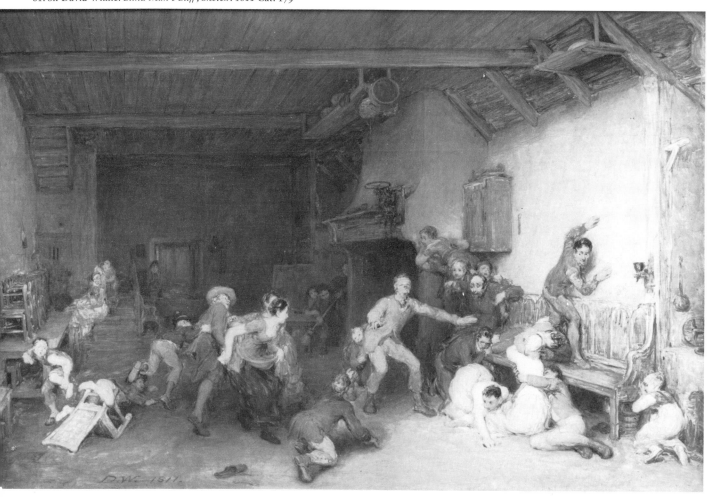

suggests an unkind analogy between them. Thus Wilkie introduces the idea of simplicity of style and sensibility, a commonplace in music, and familiar in painting from the work of David Allan. It is conceivable, therefore, that this also has a bearing on the style that Wilkie himself adopts with its echoes of Teniers. Comparison with the *Chalmers-Bethune* portrait makes it clear that he was self-conscious in the matter of style and not simply constrained by immaturity.

Although years later in *The Village School*, a painting that was begun in 1815 but never finished, he is said to have returned to the inspiration of Pitlessie, and in 1824 when he visited his birthplace he made a drawing of his grandfather's mill, perhaps with a view to a painting (plate 86), Wilkie ceased to paint his own locality when he left Scotland. In other respects he carried on, both in style and in content, from his first major painting for several years after he had moved to London. In *The Blind Fiddler* (col. plate 38), for example, painted for Sir George Beaumont and exhibited in 1807, he takes an incident from *Pitlessie Fair* and enlarges on the musical theme. He combines vivid expression with simplicity of style in a way that is clearly analogous to the music. The mimicry of the child imitating the musician and the child's drawing on the wall also evoke the primitive origins of the art that Wilkie himself practises, likening it, and also the breadth of its appeal, to folk music. The lively humour which was such an important part of that appeal is, like the humour of Fergusson or Burns, not an end in itself but an aspect of the essential humanity of their art.

In *The Blind Fiddler* there is also a serious note. The fiddler's poor wife and child huddle to the fire, indifferent to the appeal of art in their basic need for warmth. The picture that preceded *The Blind Fiddler* was the *Village Politicians* (Scone Palace). Wilkie painted it for the Earl of Mansfield, whose mother, the Dowager Countess, brought Wilkie's *Pitlessie Fair* to his attention. She was one of the Cathcart family who had been the patrons of David Allan. It was the success of this picture at the Academy in 1806, that launched Wilkie on his career. Its appeal lay in the lively humour of the artist's observation of character and expression, but it also had a certain seriousness and topicality. The inspiration for the scene was in a poem by Hector MacNeill, *Scotland's Skaith or the History of Will and Jean*, first published in 1795 with illustrations by David Allan. It tells the story of a happy marriage ruined by the distractions of whisky and enthusiastic politics—by 'news and whisky'. In the picture Will is seen in 'Maggie's club', the public house that has recently come to the district, inflamed by whisky and engaged in passionate discussion of a radical newspaper, bought by subscription.

Cunningham commented, 'To those who are old enough to remember those times when the yeast of the French Revolution was working in almost every mind . . . no explanation of the picture need by offered.'[23] MacNeill's account of his own purpose is summarized in his preface as follows: 'It was conceived . . . that a natural

pathetic story, in verse, calculated to enforce moral truths, in the language of simplicity and passion, might probably interest the uncorrupted.' Wilkie probably shared MacNeill's purpose. In *The Village Festival* (1812) he commented again on the evils of drink. It would, however, be a mistake to see his political views as identical with MacNeill's, for in the *The Rent Day*, the conception of which followed directly on the success of *Village Politicians*, he expressly took the position of Burns on the question of social injustice.

The Rent Day (private collection), exhibited in 1809, was commissioned by Lord Mulgrave, the subject being left to Wilkie's choice. Cunningham identifies the picture with Burns's poem, 'The Twa Dogs'.[24] He quotes the verse:

> I've noticed on our laird's court day.
> And monie a time my heart's been wae,
> Poor tenant bodies scant o' cash,
> How they maun thole a factor's snash;
> He'll stamp and threaten, curse and swear,
> He'll apprehend them, poind their gear,
> While they maun stan' wi' aspect humble,
> An' bear it a', and fear and tremble!

The poem is a conversation between a laird's dog, of foreign breed, called Caesar, and a ploughman's collie, Luath, called 'After some dog in Highlan' Sang/Was made lang syne, lord knows how lang' (i.e. Ossian). Following a now familiar theme, Caesar comments at first hand on the dissipation, immorality and lack of any real pleasure in the life of the rich, lived on the backs of the poor. Even at their pleasures, 'There's sic parade, sic pomp an' art/ The joy can scarcely reach the heart.' To this Luath contrasts the simple joy in human warmth open to the poor in spite of the hardship and constant insecurity that he acknowledges:

> When rural life, of every station,
> Unite in common recreation;
> Love blinks, Wit slaps, an' social Mirth
> Forgets there's care upon the earth.

Wilkie himself confirms the identification with Burns's poem by introducing two dogs into his picture, a well-fed pug lying in comfort by the fire and a hungry collie sitting and watching the tenants eating at table. All the details in the picture reflect in different ways the greed and inhumanity of the steward and by inference, the landlord, and the struggle and hardship of the tenantry in the face of oppression and injustice. Cunningham describes all this in detail and the chief group as follows: 'With the back of his chair to the fire, the steward is seated; his official papers displayed at his feet, his right hand spread anxiously over a quantity of gold, his lips apart, and his eyes flashing in contradiction to a young husbandman who is pleading the cause of a very old man, who stands a figure of silence and of patience, and endeavours to reclaim

some of his rent as due to him in both justice and mercy.'[25] When it was exhibited in 1809 the point of the picture was not missed. It had a mixed reception and was seen by some, according to Cunningham again, as 'a distinct image of the oppression which the aristocracy exercises over the children of the clouted shoe'.[26] Wilkie himself must have appreciated the irony that members of the Mulgrave family sat for several of the figures in the picture.

The highly characterized but rather blunt figure style that Wilkie used in his genre painting from *Pitlessie Fair* to *The Rent Day* seems to be a more expressive equivalent of David Allan's simplicity. If he saw its use in *The Rent Day* as appropriate to the close identification both of subject and purpose with Burns, then it was also perhaps a kind of pictorial equivalent to Burns's use of the expressive vernacular, in which humour takes its place without his art being lowered to the merely comic. In England, however, although Wilkie was widely acclaimed, the public failed to see him as anything other than a comic artist. He must have felt this misunderstanding all the more acutely in the light of his close friendship with Benjamin Robert Haydon, who was from the beginning a passionate champion of the high seriousness of art; yet it presented him with a dilemma, for he could not ignore the part the comic side of his paintings played in his success. The resulting tension may have contributed to his illness in 1810, which prevented him painting and was at least partly nervous in origin, prefiguring the nervous breakdown that disrupted his career fifteen years later. Despite such setbacks, however, he also sought to find a solution within his art. This is first apparent in the much more straightforward figure style of *The Village Festival*, and the next major composition that followed it, *Blindman's Buff* (H.M. The Queen). *The Village Festival* (Tate Gallery), originally called *The Alehouse Door*, was begun immediately after the exhibition of *The Rent Day* in 1809, and *Blindman's Buff* in 1811 after the completion of *The Village Festival* which was exhibited in the one-man exhibition that he held in 1812.

Various factors must have contributed to the new and more sophisticated naturalism of these pictures. The rivalry of Turner and the friendship of Constable are an indication of the close links between Wilkie's art and the development of English natural landscape painting. Wilkie himself regularly mentions painting landscape in the open air about this time.[27] The patronage of men like Sir George Beaumont and the Earl of Mulgrave had also given him much more opportunity to see Dutch painting and to understand its sophistication. Charles Bell's influence is still apparent too, for whereas in the earlier pictures Wilkie clearly shares Bell's theoretical ideas about the role of expression, now he seems to pay much closer attention to what Bell has to say about anatomy and especially about movement in respect of composition. Bell comments at one point, for example, 'I have seen paintings where the grouping was excellent, and the proportions exact, yet the figures stood in attitudes when they were meant to be in action: they were fixed as statues,

and communicated to the spectator no idea of exertion or motion.' Elsewhere he remarks, 'But it is in composing . . . that the knowledge of anatomy is truly useful. Without such knowledge, all the original exertions of genius are repressed. Every alteration of posture is accompanied with muscular exertion and change of form, and in proportion to the painter's ignorance of these changes are all his designs cramped and restrained.'[28] In the drawings for both compositions it is possible to see very clearly Wilkie working out the implications of such ideas and trying to construct compositions on the basis of the interaction of figures in natural movement.

In *The Village Festival*, Wilkie took up the theme of *Pitlessie Fair*, but translated it into a general context. It lacks therefore the specific qualities of locality and characterization that give the earlier picture such pithiness. Onto this scene he has also grafted part of the theme of *Village Politicians*, describing the picture in the catalogue of his exhibition as follows: 'In the principal group of his Picture, a Man is represented hesitating whether to go home with his Wife, or remain with his Companions in the Public-House.'[29] He then adds a quotation from *Will and Jean*. The central group therefore is a choice between virtue and vice, iconographically a choice of Hercules, taking us right back to Shaftesbury. Already Wilkie was thinking, as he was to do later, of resolving his dilemma by shifting towards more academic norms, and as a consequence there is a lack of spontaneity in the picture.

Blindman's Buff and *Boys digging for a Rat* on the other hand seem both to be intended as a conscious *tour de force* of anatomical naturalism as defined by Charles Bell. Between these two extremes, however, Wilkie evidently remained determined to vindicate his own original position and he sought to do so in two pictures, *The Letter of Introduction* and *Distraining for Rent*, which represent the culmination of his early career and the high point of his naturalism.

The Letter of Introduction (plate 85, col. plate 41), exhibited at the Royal Academy in 1814, is a low-key picture. It has none of the humour and broad characterization that Wilkie's public had come to expect of him. Instead, like the *Chalmers-Bethune* portrait nearly ten years before, it relies on capturing the finest nuances of attitude and expression to create the atmosphere of a particular social situation. The picture was painted in 1813 when Wilkie, after his father's death, had just been joined in London by his mother and sister. These events, and installing his mother in a new and alien environment, seem to have provoked Wilkie, who was always thoughtful, to reflect unusually deeply on Scotland and his own career as a Scottish artist.

At a superficial level the picture is clearly autobiographical. In his correspondence, both at the time and later, he refers on numerous occasions to the uselessness of the letters of introduction with which he came furnished to London. This must have compounded his sense of strangeness for he wrote to Tom Macdonald in

1805: 'I assure you that a stranger must feel very awkward on his first coming to London, unless he has some person to acquaint him with the manners and customs of the people.'[30] With different colouring the youth in the picture could bear a general likeness to the young artist and it is fair to see the picture as containing some reflections on the experience of the transition from his native land to London.

It has been pointed out by Arthur Marks that, as well as a painting by Ter Borch identified by John Burnet as the inspiration for this composition, it bears a striking similarity to an illustration in William Wilkie's *Fables* of 1768.[31] Dr William Wilkie, professor at St Andrew's University, had aided his kinsman, Wilkie's father, on a number of occasions, most significantly in securing him the living of Cults. Wilkie acknowledged his indebtedness by mentioning him warmly in a fragment of autobiography which Cunningham quotes, including there a reference to his *Fables*.[32] The illustration that underlies Wilkie's picture is in fact the frontispiece to 'A Dialogue' in which the poet (with some bearing on MacNeill) and in rather bad verse, justifies his use of the fable as a poetic form peculiarly suited to teaching because it has its origins in the earliest state of human society when:

With property, injustice soon began,
And they that prey'd on beasts, now prey'd on man,
Communities were fram'd, and laws to bind

In social intercourse the human kind.
These things were new, they had not got their names,
And right and wrong were yet uncommon themes:
The rustic senator, untaught to draw
Conclusions in morality and law,
Of every term of art and science bare,
Wanted plain words his sentence to declare;
Fable was then found out, 'tis worth your heeding,
And answer'd all the purposes of pleading.
It won the head with unsuspected art,
And touched the secret springs that move the heart.[33]

The argument continues however with doubt expressed that such a form—'Wisdom's first dress to court the op'ning mind'—could be effective in society as it has evolved.

Are natural pleasures suited to a taste,
Where nature's laws are alter'd and defac'd?
The healthful swain who treads the dewy mead,
Enjoys the music warbl'd o'er his head;
Feels gladness at his heart while he inhales
The fragrance wafted in the balmy gales.
Not so SILENUS from his night's debauch,
Fatigu'd and sick, he looks upon his watch
With rheumy eyes and forehead aching sore,
And staggers home to bed to belch and snore;
For such a wretch in vain the morning glows,
For him in vain the vernal zephyr blows.

82. Sir David Wilkie. *The Penny Wedding*. 1818. Cat. 183. (colour plate 42)

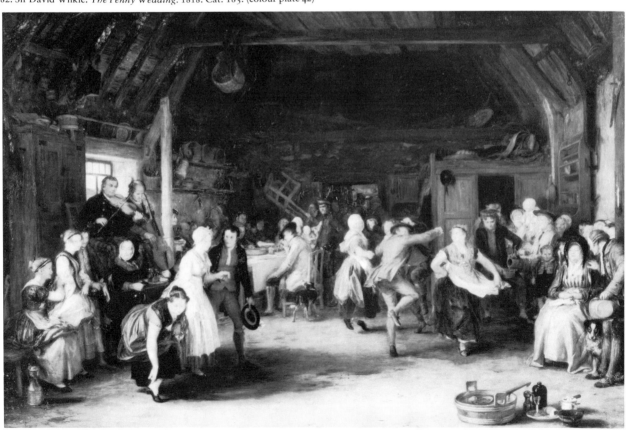

As David Wilkie was certainly aware, William Wilkie had also played an important role in the brief life of Robert Fergusson, taking him under his wing when he was a student at St Andrews. Fergusson had mourned his death in 'An Eclogue to the memory of Dr William Wilkie, late Professor of Natural Philosophy in the University of St Andrews'. In the poem discussed in chapter V, 'Hame Content', with its link to Thomas Blackwell, Fergusson further acknowledges his debt to William Wilkie by paraphrasing this latter passage from his *Fables*:

> Now when the Dog Days begin
> To birsel and to peel the skin,
> May I lie streekit at my ease,
> Beneath the caller shady trees . . .
> 'Mang herds, an' honest cottar fock,
> That till the farm and feed the flock;
> Careless o' mair, wha never fash
> To lade their KIST wi' useless Cash,
> But thank the GODS for what they've sent
> O' health eneugh, and blyth content . . .
> Unkend to a' the weary granes
> That aft arise frae gentler banes,
> On easy chair that pamper'd lie,
> Wi' banefu' viands gustit high,
> And turn and fald their weary clay,
> To rax and gaunt the livelong day.

> Ye sages, tell, was man e'er made
> To dree this hatefu' sluggard trade?
> Steekit frae Nature's beauties a'
> That daily on his presence ca';
> At hame to girn, and whinge, and pine
> For fav'rite dishes, fav'rite wine.[34]

Although he is less vehement, the situation in Wilkie's picture is that suggested by William Wilkie and elaborated by Fergusson. The boy is fresh-faced and vigorous. He is ill at ease in his city clothes and does not know how to hold his hat and gloves. The dog can smell on him the unfamiliar scents of the country. The old man in contrast is decrepit. He is dressed in indoor clothes, slippers, dressing-gown and turban. There is neither door nor window visible in the picture, so his environment is seemingly cut off from the outside. Wilkie is echoing Fergusson, and beyond him Blackwell, and the old man is 'steekit frae Nature'. As a witness to his artificial taste (a point made by Fergusson elsewhere in the poem) he has an exotic Japanese jar prominently displayed in the foreground, and in contrast to his visitor's obvious ingenuousness, he is suspicious and calculating. Perhaps where his visitor looks for kindness, he considers cash.

The number of working drawings (plate 84) and especially the sheer beauty of the finished painting testify to the depth of Wilkie's reflection on this picture. Its literary

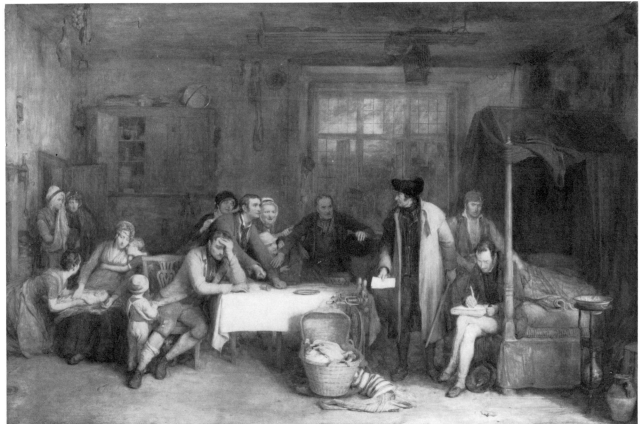

83. Sir David Wilkie. *Distraining for Rent*. 1815. Cat. 182. (colour plate 40)

links and analogies allow us to see that this was because in it he was reflecting on his whole career, not only on his experience as a stranger arriving in London, but on the reception of his art in an alien community. Instead of 'winning the head with unsuspected art', his naturalism, in spite of his success, was too often seen as merely artless.

In *Distraining for Rent* (plate 83, col. plate 40), he carried on the same argument, though in a way in which the moral and social aspects are even more clearly expressed. The picture carries on the theme of Wilkie's earlier painting, *The Rent Day*, and like it, echoes Burns's poem, *The Twa Dogs*. It is a measure of the continuity of Wilkie's thought that Burns's poem also echoes very closely in theme and language the passage in Fergusson's 'Hame Content' quoted above in connection with *The Letter of Introduction*. Burns develops the theme of social injustice from Fergusson's opposition of two ways of life and Wilkie follows him even more openly than he had done in *The Rent Day*. In the passage from that poem quoted in connection with the earlier picture is the line: 'He'll apprehend them, poind their gear.' 'Poind' is the Scots word for distraint of goods. In the poem Luath responds to this remark of Caesar's:

> Still it's owre true that ye have said
> Sic game is now owre aften play'd;
> There's monie a creditable stock
> O' decent, honest, fawsont folk,
> Are riven out baith root an' branch,
> Some rascal's pridefu' greed to quench.[35]

84. Sir David Wilkie. *Head of a Boy (Study for The Letter of Introduction)*. 1813. Cat. 181

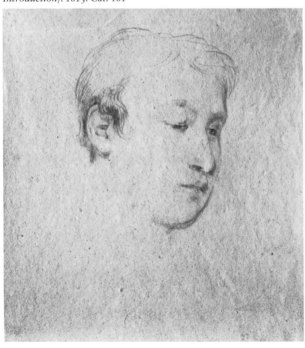

This is the scene in the picture. A small farmer who, by the size and furnishing of his kitchen, has evidently prospered by his hard work, is the victim of the injustice that Burns describes, an injustice to which the indignation of the farmer's neighbours, gathered in his defence, bears witness.

The scene in the picture is, however, not a simple illustration of the collision of unscrupulous greed and honest thrift. Wilkie as a countryman had been brought up against the background of accelerating change in the agricultural revolution in Scotland. As a member of Nasmyth's circle in Enlightenment Edinburgh, he would have been well aware of the advantages of improvement, but from the beginning of the agricultural revolution voices had been raised against the social and human consequences of disrupting traditional, and valued, patterns of life in the countryside in the interest of gain. Robert Fergusson had been foremost among such voices. This had been a constant theme for him, and in his eclogue in memory of William Wilkie he praised him especially as an improver of his farm near St Andrews, but one who preserved the harmony between nature and the pastoral way of life. In 'The Farmer's Ingle', Fergusson painted the classic portrait of the Scots gudeman, the pillar of this natural order in the countryside. In contrast to this may be set the view of Thomas Robertson in an *Outline upon the general size of Farms* (1796). According to Robertson, no efficient farmer should have to get his hands dirty; 'the poor farmer is always a bad one,' fit only for eviction.[36] The consequences of such attitudes, severe though they may have been in the Lowlands, were catastrophic in the Highlands. Hector MacNeill, who was in touch with Wilkie, commented at length in *Bygane Times and Late come Changes* on social dislocation due to the weakening of traditional values.[37] On the clearances of the Highland people he wrote:

> They're now nae langer in affection
> Screened by their Laird's ance warm protection
> But driven out helpless, naked, bare,
> To meet cold poortith's nipping blast
> And on the wide world houseless cast
> To beg for help . . .

The instrument of this profit-led improvement was the law, again most conspicuously in the Highlands, but everywhere seeming to replace customary relationships with paper ones in which there was no appeal from abstract to ordinary human justice. Elsewhere in the poem MacNeill comments on the fashion for law. The villain in Scott's *Guy Mannering* is Glossin, the lawyer, and John Galt, who made common cause with Wilkie,[38] in the *Last of the Lairds*, has Jock, the servant, exclaim at the latest manoeuvre of Caption, the wicked, chiselling lawyer: 'It was a better world when gentlemen were na fash'd wi' law . . . I'm sure the ten commandments are worth a' the King's statutes, and ye'll no find a word in them about payin' o' debts . . . I'm just wud to think o' the mischief

85. Sir David Wilkie. *The Letter of Introduction*. 1813. (colour plate 41) National Galleries of Scotland

that this law ... law ... law has brocht upon poor Scotland.'[39] In Wilkie's picture, the bailiff, the personification of this alien and inhuman principle, has entered into the farmer's simple life, a life of honest labour, supported by a close-knit community of equals. He is prepared to deprive the family even of the essential human warmth of bedclothes and cradle; one of his men is removing the bedclothes from the bed, and an empty cradle is prominent in the foreground.

Distraining for Rent was exhibited in 1815. It had by then assumed fresh topicality as the ending of hostilities in the French wars had brought a crash in agricultural prices. Rents had risen steadily with prices over the preceding twenty years, but did not fall when they did. It was reported from Wilkie's native Fife in 1816, for example, that 'the sudden fall in prices has had this effect that the produce of the ground falls short of the rent agreed by almost one fourth,' and from prosperous East Lothian, home of the agricultural revolution in Scotland, in the

same report it was recorded that 'several farmers have recently been sequestrated for arrears.' Even the champion of agricultural improvement, Sir John Sinclair (whom Wilkie met in Scotland in 1824), was moved to write in 1816: 'It is a maxim in common law, that all bargains between man and man shall be founded on just and equitable principles: it is not to be expected, therefore, that a tenant is to pay rent when he receives no return, especially if no blame be imputable to his conduct.'[40]

In this climate it is not surprising that Wilkie's picture had a mixed reception. It was eventually bought by the British Institution through Sir George Beaumont's intervention, but after considerable delay, and once bought it was discreetly removed from public view. Abraham Raimbach, who later owned the picture, commented on its reception: 'The objection was to the subject; as too sadly real, in one point of consideration, and as being liable to a political interpretation in others. Some persons,

ABOVE 86. Sir David Wilkie. *Pitlessie Mill.* 1824. Cat. 185

it is said, spoke of it as a *factitious* subject.' Wilkie himself, however, according to Raimbach, 'expressed satisfaction at having made the experiment and thereby proved that he was not to be estimated merely as a painter of *comic* scenes which he felt was doing him less than justice.'[41]

Wilkie's view of his picture is consistent with his continuing solidarity with the social ideas of Burns and Nasmyth, but also with the rather different ideas of Charles Bell. Bell laid down a challenge when he wrote: 'It is only when the enthusiasm of an artist is strong enough to counteract his repugnance to scenes in themselves harsh and unpleasant, when he is careful to seek all occasions of storing his mind with images of human passion and suffering, when he philosophically studies the mind and affections as well as the body and features of man, that he can truly deserve the name of a painter. I should otherwise be inclined to class him with those physicians who, being educated to a profession the most interesting, turn aside to grasp emoluments by gaudy accomplishments rather than by the severe and unpleasant prosecution of science.'[42] Answering this challenge, the supreme naturalism of Wilkie's picture is based on precise observation of both the human and the material world. It surely ranks him with (Bell's words

again) 'Those poets who have excelled in describing human emotion, and have been able to convey a forcible and vivid idea, by attending to the working of the impassioned countenance (and) have spoken with uniform effect to all ages.'[43]

Amongst such poets Wilkie himself would certainly have placed Allan Ramsay and at the end of this discussion it is not surprising to find that the subject of his picture seems to have its ultimate inspiration in *The Gentle Shepherd*, in lines that are invoked by both Burns and MacNeill in the passages quoted:

But Poortith, Peggy, is the warst of a' . . .
With glooman Brow the Laird seeks in his Rent:
'Tis no to gi'e; your Merchant's to the bent;
His Honour mauna want, he poinds your Gear:
Syne, driven frae House and Hauld, where will ye
 steer?[44]

In this picture, therefore, and in *The Letter of Introduction* which is so closely related to it, Wilkie knits together in a single image all the different threads in this long story. Of his contemporaries, only Walter Scott had such a comprehensive grasp of the pattern that they formed. This is nowhere clearer than in Scott's *Heart of Midlothian*,

OPPOSITE, BELOW 87. Alexander Carse. *The Arrival of the Country Relations. c.* 1812. Cat. 159

BELOW 88. Sir William Allan. *Christmas Eve.* Cat. 156

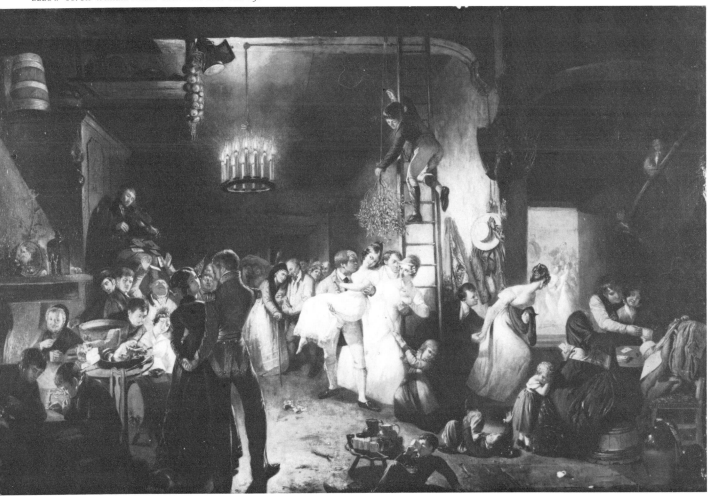

which he had begun to write by January 1817 and had been contemplating for a year before that date. Scott had passed through London in 1815 on his way home from a visit to Brussels in the aftermath of Waterloo, a visit prompted by a letter written from Brussels by Charles Bell to his brother George and passed on by him to Scott. In the autumn of 1817, before the novel was complete, Wilkie, whom he had first met in 1809,[45] visited him at Abbotsford.[46]

These circumstances are not enough to suggest that Wilkie influenced Scott in this novel, but they are coincidences that help to illuminate the common interest with Wilkie that Scott demonstrates. In *Guy Mannering* and *The Antiquary*, Scott acknowledges very frankly his admiration for Wilkie, but *The Heart of Midlothian* shows a deeper affinity. First of all, it raises to the level of tragedy the theme of *The Letter of Introduction*. Jeanie Deans, the heroine, has no extraordinary gifts, only the strength of her common humanity, which has its roots in her pastoral life. Her sister, Effie, is seduced away from this simple pastoral life by the corrupt and artificial attractions of the neighbouring city. As its victim she is incarcerated for a crime she has not committed in Edinburgh's Tolbooth, a prison notorious for its darkness. She is literally 'steekit frae Nature'. In the plot Scott develops

this simple opposition as Wilkie does in *Distraining for Rent*; it becomes an active confrontation between the virtues of simple human honesty and warmth, and the law, alien and inhuman working in the service of expediency. The conflict is only resolved when Jeanie, with only the strength of her simplicity to sustain her, survives a pilgrim's progress from Edinburgh to London and succeeds in appealing above the law to the individual in whose name it is administered. She saves her sister's life by re-establishing the claims of human feeling above the inhumanity of the law.

The community of purpose that this comparison reveals is perhaps reflected in the intimate informality of the portrait that Wilkie painted of Scott and his family in 1817 (Scottish National Portrait Gallery). It shows the family at Abbotsford in the guise of ordinary country people. In Scotland the idea that a poet could belong in such a mundane and practical relationship to the land as that in which Wilkie represented Scott was perfectly acceptable and the picture was admired, but in the south, the picture which was exhibited there in 1818, provoked a violent reaction quite out of proportion to its modest pretension.[47] It was accused of 'violating decency and good taste'. Rather than 'the elegant poet and his family', the public had been presented with 'a common clodpole

89. Sir George Harvey. *Study of a Man with an Arm Outstretched. c.* 1831. Cat. 191

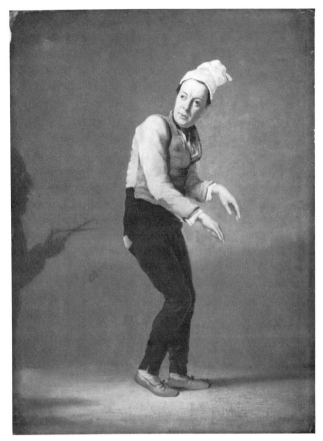

90. William Kidd. *John Toole the Actor in a Character Part*. Cat. 169

result had an enormous influence. It was the prototype of countless costume genre paintings throughout nineteenth-century European art.

The effect of setting the scene back in time was to change Allan's optimistic pastoral vision into a nostalgic glimpse of lost innocence. Absent from Allan's picture, the laird and his lady, or at least members of the gentry, are present in Wilkie's to the right of the scene, but shown as completely at one with the rest of the community. There is no social distance between them and their tenants. This is the old homogeneous world. All dance to the same music. *Distraining for Rent* is the new world of alienation. The pictures are the light and the dark, innocence and experience.

In *The Annals of the Parish*, published two years after *The Penny Wedding* was exhibited, John Galt traced in microcosm the disintegration, over a period of fifty years, of the old rural Scotland. Galt included a penny wedding in his narrative, and he may himself have helped Wilkie to focus his own ideas. He had already made some sketches for his book when he first contacted the painter in 1807. The two men had more in common perhaps even than Wilkie and Scott. In *The Annals of the Parish* and *The Provost* especially, Galt observes with a subtlety that equals Wilkie's the minute nuances of human behaviour and expression and then, like Wilkie too, elevates these into great art without any need for high drama or heroic scale. Wilkie's vision of Scotland in these two pictures before and after half a century of dramatic change is more pointed than Galt's but it is recognizably akin.

91. William Bonnar. *The Daughters of Thomas Chalmers. c.* 1840. Cat. 157

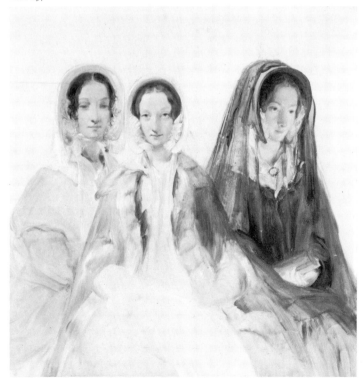

and his rude associates'.[48] Such a reception cannot have pleased poor Scott, whose portrait by Raeburn had been badly received eight years earlier. By using Reynolds's portrait of Goldsmith as a model, Wilkie made sure that his next portrait of Scott (Faculty of Advocates) in 1824 was unmistakably that of an 'elegant poet', but the reception of the earlier portrait must have hurt him, already bruised as he was by the failure of *Distraining for Rent*.

It was hard for Wilkie and Scott that their light-hearted image of Scott as a farmer, to match Ramsay as shepherd and Burns as ploughman, misfired so badly, but the experience does not seem to have affected their relationship. If Wilkie's example is apparent in *The Heart of Midlothian*, Scott's is equally apparent in *The Penny Wedding* (plate 82, col. plate 42), the picture that Wilkie was preparing during his visit to Scotland in 1817 and which he completed the following year. The subject was suggested to him by George Thomson in 1807.[49] In the picture Wilkie pays homage to David Allan, whom Thomson certainly had in mind, and whose composition of *The Penny Wedding* is reflected in Wilkie's own. He also pays homage to Raeburn by including the figure of Neil Gow taken from Raeburn's famous portrait. He is reaffirming his Scottish roots. He also sets his picture in the past. It is not a history picture, but a genre painting in period costume. There can be no doubt that the inspiration for doing this came from the Waverley novels. The

Wilkie's mastery in *The Penny Wedding* is unchallengable. There is summariness in his execution which, especially in such details as the still-life or the figures glimpsed in the shadow, is still miraculously wedded to precise observation and gives extraordinary liveliness to the picture. In the small painting of *The Pedlar* (private collection), which was contemporary with *Distraining for Rent*, Wilkie paid direct homage to Ostade, as in *The Letter of Introduction* he had done to Ter Borch. In this picture he turns away from the Dutch painters who followed Rembrandt to look closely at the master himself.

His interest in Rembrandt remained for the rest of his life. It is next seen in the first major Scottish picture on which he embarked after *The Penny Wedding*, *John Knox Preaching*, which he began in 1822. In that picture, however, his determination to create a serious art out of the preoccupations that he shared with men like Galt found a different expression and with it a different chapter is opened, reflecting the religious revival in Scotland, the subject of the closing chapter of this book. Meanwhile following the success of *The Penny Wedding*, which was bought by the Prince Regent, Wilkie was preoccupied with completing first *The Reading of the Will* (exhibited

at the Royal Academy in 1820) for King Ludwig I of Bavaria and then *The Chelsea Pensioners reading the Despatch from Waterloo* (Royal Academy 1822) for the Duke of Wellington. With such patrons and the extraordinary experience of having to arbitrate between the competing claims of his sovereign, George IV, who wanted to buy *The Reading of the Will*, and King Ludwig, who had commissioned it, Wilkie's career reached astonishing heights. His success seemed consolidated when the Duke of Wellington agreed to pay the very large sum of 1,200 guineas for *The Chelsea Pensioners*. Wilkie confided to Perry Nursey that he would have asked 2,000 guineas if the purchaser had been an institution but he was satisfied that the price he received was the most ever paid by a private individual for a modern picture.[50]

In spite of such seeming confidence, the pressure upon Wilkie is apparent in *The Chelsea Pensioners*. Although a huge success, it seems forced and artificial. The sympathy between the artist and his subject that gives such life to *The Penny Wedding* is absent. The tension between Wilkie's artistic inclinations and the expectations of his English public, which he had tried to resolve in *Distraining for Rent* and which had surfaced so unexpectedly in

92. Walter Geikie. *May Rennie peeling Potatoes*. 1830. Cat. 162

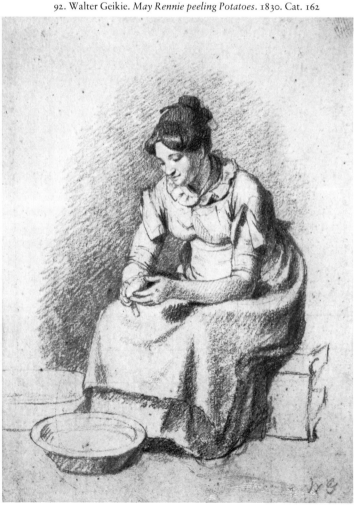

93. Walter Geikie. *Girl scouring a Pot Lid*. c. 1830. Cat. 161

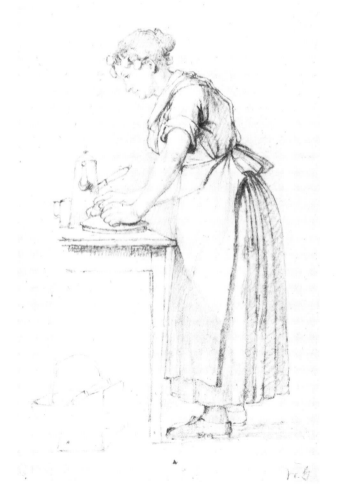

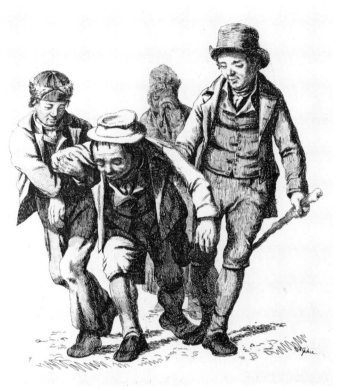

94. Walter Geikie. *Our gudeman's a drucken carle*. 1830. Cat. 165

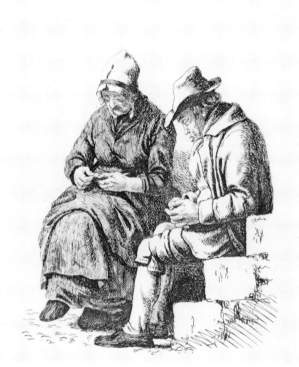

95. Walter Geikie. *They are real comfortable*. 1830. Cat. 167

the little picture of Scott and his family, is present here too. Although *The Chelsea Pensioners* contains much fine painting, the slightly manic expressions and strained postures of a number of the figures suggest the artist's insecurity. Wilkie, whose touch is elsewhere so sure, seems to be seeking effect rather than painting from conviction. The breakdown that he suffered early in 1825 was precipitated by a series of family tragedies, the death in quick succession of his mother, of a brother and of his sister's intended husband, but its most stubborn symptom was his inability to paint. For fully two years, though otherwise quite recovered, he was unable to paint at all. Whatever other causes that contributed to his breakdown, the tensions in his art were certainly part of the anxiety that overwhelmed him.

Among the numerous artists who followed the model that Wilkie's genre painting provided were Alexander Carse (d. *c*. 1838) who had himself earlier influenced Wilkie, John Burnet (1784–1863), Alexander Fraser (1785–1865), William Lizars (1788–1859), Sir George Harvey (1806–76), William Kidd (1796–1863) (plate 90), William Bonnar (1800–53) (plate 91) and Walter Geikie (1745–1837). Even William Allan tried his hand at Wilkie's kind of genre in *Christmas Eve* (plate 88). Of these, Alexander Carse, who anticipated Wilkie in his earlier works, occasionally produced paintings of real interest, such as *The Arrival of the Country Relations* (plate 87) and *The Return from the Hunt* (col. plate 44), but he was very uneven. Burnet and Fraser were both very

close to Wilkie personally. Burnet engraved a number of his pictures and Fraser worked for a while as his assistant. Their painting on occasion has charm but little individuality. Lizars was a more distinct artistic personality. Occasional paintings like *The Reading of the Will* (1811; National Gallery of Scotland), the unfinished *Interior of a Church* and his very fine drawings suggest that he might have been a rival to Wilkie, but he concentrated his energy on the business of engraving. George Harvey went on to become President of the Royal Scottish Academy and was a successful popularizer of Wilkie's style. His best work, however, is in the frank and forceful oil sketches (plate 89) that he made for the pictures that made his reputation like *The Covenanter's Baptism*, exhibited in 1831. The quality of these sketches is not maintained in the finished pictures and his later work falls disappointingly short of their promise. Of this group of artists the most interesting was Walter Geikie.

One or two of Geikie's paintings are very striking, but it was really as a draughtsman and etcher that he excelled.[51] He is best known for a collection of etchings published posthumously under the title *Sketches of Scottish Life and Character*. Some of his images derived from the humorous side of Wilkie's work show little advance on it, but others, particularly a collection of etchings that he published in 1831 and the drawings related to them, show a quite remarkably informal naturalism (plate 93). On occasion this approaches monumentality as, for example, in the drawing for an etching in this series of

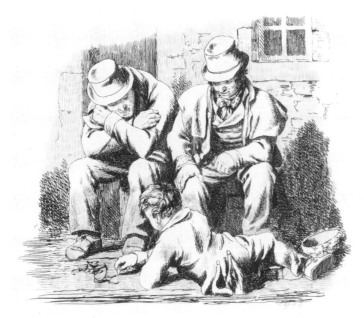

96. Walter Geikie. *The Young Artist. c.* 1829. Etching. Private collection

May Rennie peeling Potatoes (plate 92), or the etching, *They are real comfortable* (plate 95). These etchings have idiomatic titles that link them to the poetry that Geikie evidently admired, of Burns and especially of Fergusson, to whose poetry of city life he comes closest; his urban imagery and his way of drawing also link him closely to Nasmyth.

Among the etchings, the most memorable of all is perhaps *Our gudeman's a drucken carle* (plate 94) with its variant, *He's just gotten plenty for ae day* which Geikie also painted (col. plate 43). One group derives from the detail of a drunk man led home in the background of *Pitlessie Fair* and the other from the central group in *The Village Festival*, but the frankness of both is almost a critique of the cosy bucolic note in the latter picture. Geikie seems to return to the group's ultimate inspiration in Rembrandt's etching of the *Deposition*, which is clearly invoked in the detail of the boy holding the man's arm in *Our gudeman's a drucken carle*. By so doing Geikie gives pathos and dignity to the scene, while the empty jollity of the companions of Wilkie's drunk is replaced in both images by tolerant friendly sympathy.

Geikie was deaf and dumb, which led to his dismissal by later generations as merely naive. Robert Brydall wrote cruelly of him: 'as too often happens in the cases of mutes, he failed to develop any of the higher qualities which are necessary to constitute an artist.'[52] His own generation understood him better as a serious artist. Wilkie's friend Andrew Wilson took him under his wing after he had finished studying at the Trustees' Academy and promoted his work. He was elected to the Scottish Academy as an associate in 1831 and an academician in 1834. If he was not actually naive, however, he does seem to have had precocious ideas about naivety as an artistic attitude, perhaps developing something that was implicit in Wilkie's early work. In a number of etchings he touches on the theme of children's art. In his version of the *Origin of Painting*, for example, he shows a boy drawing a younger child's profile in an everyday environment, watched by two admiring adults. The beginning of art is located not in a remote and imaginary past, but in the present sensibility of a child. The same view of the importance of child art is implicit in another image where he shows a child drawing in the dust, also watched by two admiring adults (plate 96). The motif was used by Deuchar and had its origin in Rembrandt's etching *Christ Preaching the Remission of Sins*. Perhaps the idea of innocence is preserved from that original, as it was by Courbet when he used the image in his *Painter's Studio*, but it is given a different dimension by the admiring adults, Geikie's own addition.

This interest in naivety was adumbrated in Wilkie's *Pitlessie Fair* and perhaps also in *The Rabbit on the Wall*, Wilkie's own variant on the origin of painting theme. Geikie's relationship with the doctor and pioneer psychiatrist, Alexander Morison, also parallels Wilkie's relationship with Charles Bell. At least one and possibly several of Geikie's drawings were used as illustrations to Morison's *Physiognomy of Mental Disease*, published in 1840, three years after Geikie's death. Morison carried on from Bell's idea of 'the emanation of mind inspiring the features', and was also influenced by the French pioneer of modern psychiatry, Georget, in an attempt to classify mental disease according to physiognomy and expression. As physician to the Bethlehem Hospital, Morison later had the artist Richard Dadd under his care and encouraged him to continue to paint with remarkable results.

Geikie's connection with progressive medical thought in Edinburgh may have dated from his childhood, for he was a pupil of one of the pioneers of modern attitudes to the teaching of the deaf, Thomas Braidwood. He was himself a sociable and well-adjusted person but it would have been understandable if he had had an interest in outsiders and in abnormal states of mind. One of his most frequent models was Show Jamie, a simpleton who made pennies about the streets of Edinburgh with a children's peepshow. Geikie may have seen himself in Show Jamie. According to his great-grand-niece, who in 1985 was still living in Edinburgh, her grandmother, wife of the geologist Sir Archibald Geikie, could not approve at all of her husband's late artistic uncle for when he drew in the streets of Edinburgh, as he did constantly, he was surrounded by a horde of unwashed children, both to his delight and theirs. Thus practising his own art he shared the role of Show Jamie and the other street entertainers who appear in his work, or indeed joined Burns's 'Jolly Beggars', of which he did an illustration, in their sublime disregard of *decorum*.

> Life is all a VARIORUM
> We regard not how it goes;
> Let them cant about DECORUM
> Who have dignity to lose.

IX

Artists and Evangelicals

*'The Disruption is as extraordinary, and in its consequences
will prove as permanent, as any single transaction in the
history of Scotland, the Union alone excepted.'*
Henry Cockburn, JOURNALS, 1843

In the brief biographical note that Sir Thomas Dick
Lauder wrote as the introduction to the posthumous
publication of Walter Geikie's collected etchings,
Sketches of Scottish Life and Character, he devoted a large
part of the space available to him to an account of the
artist's piety (plate 97). To the modern eye, piety is an
unexpected characteristic in an artist whose work is
notable for its freedom and informality, for artistic
freedom is seen as progressive, piety is not. But the case of
Geikie is a reminder that the religious revival that was of
such importance in shaping nineteenth-century Scotland
was not simply the reassertion of some dark spirit of
intolerance which had been lying in wait till the
Enlightenment should lose momentum. Something of the
sort may have happened later in the century, but initially,
far from being reactionary in its origins, the revival sprang
in part from the ideas of the Enlightenment itself. George
Davie writes of Thomas Reid and Adam Smith that 'their
most remarkable contribution to Scottish life was that
their successful struggle against the vein of antinomian
scepticism in Hume prepared the way for a restatement
of Presbyterian values in terms comprehensible to an
industrial age.'[1]

The revival of Presbyterian values could not be merely
an intellectual thing. It was also fed by a strong emotional
current that flowed down from the Union. In a manner
closely linked to the interest of artists and poets in an
ideal, pastoral, pre-Union Scotland, Presbyterians could
look back to the heroic days of Knox and of the Con-
venanters and to the freedom and democratic simplicity
of the original Kirk as they saw it. In forming this vision
the Evangelical wing within the established Church was
chivvied from outside the Church by the threat of the
more radical dissenting churches seizing the initiative, and
a crisis developed following the move for Catholic eman-
cipation in the 1820s, in which the whole question of the
relationship of Church and state was at issue. Its focus
was the question of patronage, of non-intrusion, the right
of congregations to elect their own minister rather than

have him imposed on them by a patron. This basic right
of Presbyterian democracy had been removed by an Act
of Parliament in 1711, just four years after the Union, and,
encouraged by the successful agitation for political reform
that resulted in the Reform Bills of 1832, its re-
establishment became the central issue for the Evangelical
party within the established Church.

The final result of this was the Disruption of 1843, the
splitting of the Church of Scotland and the formation of
the Free Church, led by Thomas Chalmers and including
most liberal and progressive Scotsmen. The Disruption
is described by a modern historian as 'the most momen-
tous single event in the nineteenth century in Scotland'.[2]
This is how it was seen by a contemporary, Henry Cock-
burn, who was a Whig and co-drafter of the Scottish
Reform Bill of 1832:

> The Disruption is as extraordinary, and in its conse-
> quences will probably prove as permanent, as any
> single transaction in the history of Scotland, the Union
> alone excepted. The fact of above 450 clerical members
> of an establishment, being above a third of its total
> complement, casting it off, is sufficient to startle anyone
> who considers the general adhesiveness of churchmen
> to their sect and their endowments. But when this is
> done under no bodily persecution, with no accession
> of power, from no political motive, but purely from
> dictates of conscience, the sincerity of which is attested
> by the sacrifice, not merely of professional status and
> emoluments, but of all worldly interests, it is one of
> the rarest occurrences in modern history . . . They have
> abandoned that public station which was the ambition
> of their lives, and have descended from certainty to pre-
> cariousness, and most of them from comfort to destitu-
> tion, solely for their principles.[3]

Cockburn stresses the importance of principle, and the
Evangelical party consciously took its stand on the old
Scottish ground of argument from principle, in opposition
to the Moderates, whose belief in compromise could be

seen as Anglicizing. (The classic study of the collision of the English and Scottish systems of thought in the nineteenth century is George Elder Davie's *The Democratic Intellect*.) The Disruption was therefore the breaking of a wave that had rolled down from the shock of the Union and it invoked a whole set of real or imagined Scottish values that reached far beyond the immediate issue. It thus provides the denouement to this story for it is reflected profoundly in the work of Wilkie, even though he died two years before the final crisis, and in the calotypes of D. O. Hill.

Wilkie's father was an old-style minister of the Kirk and the painter's portrait of his parents, the Bible and Communion cup on the table beside them, captures with great sympathy the austerity of that tradition (National Gallery of Scotland). Wilkie himself retained a strong interest in religion. For example, Cunningham records how, on one occasion, James Northcote 'pained Wilkie by endeavouring to persuade (him) that much which the church believed was untrue.'[4] Nevertheless, he was tolerant and had a lively interest in the Catholic Church and its rituals (which an old-style Protestant would have found very dubious), yet there was no reflection of his religious belief in his painting until 1822. In a letter of 24 June in that year he mentions for the first time his painting of *John Knox Preaching*.[5] When he wrote, a sketch of the picture already existed. One drawing at least dates from the previous year, and *Tent preaching at*

Kilmartin, one of a pair of drawings on the theme of popular religion done in 1817 already shows the direction of his thoughts (plate 98). A sketch of the *Knox* had been shown to, and not surprisingly rejected by, the King. The picture itself was finally completed ten years later, to be exhibited in the Royal Academy in 1832 with the full title *The Preaching of John Knox before the Lords of Congregation, 10 June 1559* (col. plate 46).

The ten-year delay in completion was caused first by Wilkie's breakdown in 1825 which kept him from painting for two years, then by the multifarious demands on his time as he gradually returned to painting and by the great success of the Spanish pictures that marked that return, but the delay was also a reflection of the importance that the project had for him. In 1822 he travelled to Scotland for the visit to Edinburgh of George IV and he took the sketch of Knox with him so that he could consult his Scottish friends about it and gather materials. He continued his researches on his next visit to Scotland in 1824, taking great pains to make his work historically accurate. Cunningham described the finished painting as 'one of the noblest productions of the British school,'[6] and there can be no doubt that it was of exceptional importance to Wilkie himself, not least as final vindication of the claim made unsuccessfully with *Distraining for Rent* to be considered a serious painter.

The picture shows Knox in 1559 preaching in the cathedral at St Andrews to the Lords of Congregation,

97. Walter Geikie. *Reading a Tract*. 1820s. Etching. Private collection.

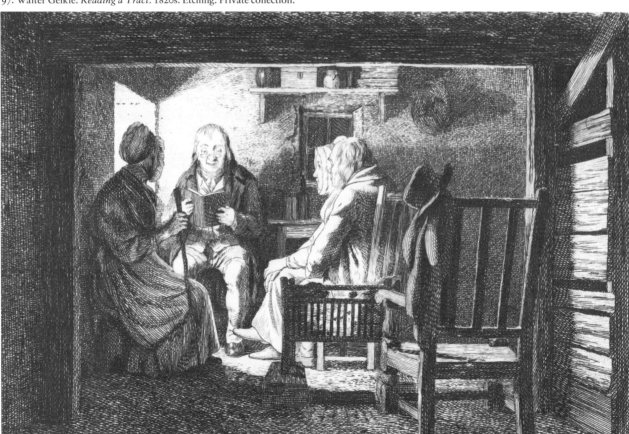

98. Sir David Wilkie. *Tent preaching at Kilmartin*. 1817. Cat. 200

the Protestant leadership who had recently invited him to return to Scotland. The Archbishop of St Andrews had threatened that if Knox did preach he would order his soldiers to fire upon him. The Lords of Congregation were not convinced of their ability to defend him, but he went ahead and preached nonetheless, by his courage rallying the Protestant support and effectively securing the success of the Reformation in Scotland. It was a moment when the history of the nation was shaped by the courage of a single individual, and the fact that these events took place only a few miles away from Wilkie's birthplace surely added to the significance that they held for him.

Wilkie was inspired by the charismatic preacher, Edward Irving, in the figure of Knox as he eventually painted him and also by Thomas Chalmers.[7] Irving, who went on to become founder of the Catholic Apostolic Church, arrived in London in July 1822, knowing no one, but with a letter of recommendation to Wilkie in his pocket.[8] The two men remained friends though Wilkie did not go along with Irving's more extravagant opinions. The initial inspiration for Knox, and perhaps for the whole choice of subject, however, cannot have been Irving, who arrived in London after the picture was already under way. It was more likely Thomas Chalmers. Irving had been Chalmers's assistant in Glasgow and the letter of introduction that he carried to Wilkie was almost certainly from Chalmers,

whom Wilkie had met in Glasgow in 1817. Chalmers was already by then celebrated as a preacher and a practical reformer. He went on to become leader of the Evangelical party and first Moderator of the Free Church of Scotland.

Chalmers was five years Wilkie's senior and also came from Fife. At the beginning of his career he was a typical figure of the Enlightenment, an ordained minister much more interested in physics and chemistry, which he taught at St Andrews, than in the affairs of his parish, but he underwent a conversion and turned from science to religion, conscious of the parallel with Pascal in the seventeenth century. By his preaching and by the practical example of the reconstruction of his parish, first in Fife where he began his ministry and then in Glasgow where he deliberately tackled the problems of urban poverty and deprivation, he instituted a new evangelicalism in Scotland. He gave intellectual as well as spiritual leadership and did more than anyone else to harness the energy of the Enlightenment to the purpose of religious revival.

Wilkie admired Chalmers. He expressed his admiration in his letters soon after meeting him and practically by promoting the idea of securing a worthy portrait of him. When he met him he did a small pencil drawing himself, but he considered it unworthy and so he consulted both Lawrence and Raeburn before eventually arranging for the portrait to be painted by his friend Andrew Geddes

(private collection).[9] In the correspondence about the portrait with the Glasgow bookseller, John Smith, Wilkie also comments on Chalmers's sermon in favour of Catholic emancipation, published in 1818 under the title, *The Doctrine of Christian Charity applied to the Case of Religious Differences*. It was, said Wilkie, 'the most perfect of any the Dr. has published and far before anything I have seen upon the question of Catholic Emancipation.' It is easy to see why he found in Chalmers someone he could wholeheartedly admire. Like Wilkie himself he was tolerant and fully conversant with the ideals and achievements of the Enlightenment, and, taking them as his guide, he succeeded in showing how the central tenets of the Presbyterian faith could be liberated from the stultifying history of sectarianism so cruelly caricatured by Scott in *Old Mortality*.

Knox, the hero of Wilkie's painting, may seem the very personification of old-style sectarianism, but Wilkie's subject was not the conventional caricature. He was the historical reformer, recovered for the nineteenth century by Thomas M'Crie whose *Life of Knox*, first published in 1812, was a central text of the Evangelical movement, though M'Crie himself was a radical secessionist outside the established Church. It had run to four editions by the time Wilkie embarked on his painting.

The picture was first commissioned by Lord Liverpool and on 22 July 1822, Allan Cunningham wrote to David Laing, the antiquarian, in Edinburgh: 'I had a call from Wilkie yesterday. He has received his final commission for John Knox's picture from Lord Liverpool. He carried M'Crie's History in his hand and read some of the more graphic passages to his Lordship who was much pleased and took a note of the book.'[10] When Wilkie finally exhibited the picture it was accompanied by a quotation from M'Crie, whom he may actually have known. When he was a student in Edinburgh he lived practically next door to the Secession church where M'Crie was minister and where he had already made some reputation.

When M'Crie published his *Life of Knox* it was widely hailed by both the Scottish and English press. The first reaction was in *The Edinburgh Review* for July 1812. Francis Jeffrey, a Whig and later joint drafter with Henry Cockburn of the Scottish Reform Bill, identified the book's central achievement:

It seems to be undeniable that the prevailing opinion about John Knox, even in this country (Scotland) has come to be that he was a fierce and gloomy bigot, equally a foe to polite learning and innocent enjoyment and that, not satisfied with exposing the abuses of the Romish superstitions, he laboured to substitute, for the rational religion and regulated worship of enlightened men, the ardent and unrectified spirit of vulgar enthusiasm, dashed with dreams of spiritual and political independence and all the impracticabilities of the earthly kingdom of the saints. How unfair, and how marvellously incorrect, these representations are, may be learned from the perusal of the book before us, a

work that has afforded us more amusement and more instruction than any we have ever read upon the subject and which, independent of its theological merits, we do not hesitate to pronounce as by far the best piece of history which has appeared since the commencement of our critical career.

The English *Quarterly Review* followed a year later: 'Here is no puling about "the interesting sufferer", "the patient saint", "the angelic preacher", Knox is plain Knox, in acting and in suffering always a hero; and his story is told as a hero would wish that it should be—with simplicity, precision and force.'

M'Crie not only re-established Knox as a hero of the Protestant Reformation, he also presented him as a model for the Evangelicals in another broader and more topical light, for he demonstrated how the history of political reform was linked indissolubly to that of religious reform. Presenting what he saw as one of Knox's central achievements he wrote:

Civil and ecclesiastical tyranny were so closely combined that it was impossible for men to emancipate themselves from the latter without throwing off the former: and from arguments which established their religious rights, the transition was easy . . . to disquisitions about their civil privileges.

Our national reformer had caught a large portion of the spirit of civil liberty . . . Extensive observations had convinced him of the glaring perversions of government in most of the European kingdoms . . . (and) that no class of men have an original, innate and indefeasible right to rule over a people, independently of their will and consent . . . The idea of a common wealth including the man of the people as well as the privileged order began to be entertained.[11]

It was presumably not this passage that Wilkie read out to the Tory Lord Liverpool; even less would he have brought it to the attention of George IV to whom he had previously proposed the picture.

Wilkie's political views were either well hidden or not very strong. He wrote to his friend Andrew Wilson, commenting on the French Revolution of 1830: 'At the time of the great fire in Edinburgh [1824] the French King sent a large subscription for the relief of the sufferers [the King had spent part of his exile in Edinburgh during the Revolutionary and Napoleonic Wars]. Judge of the ungracious return. Edinburgh is one of the two cities that has publicly organised a subscription for the relief of the insurgents who have thrown the aged King from his throne. For my own part I see no advantage in all these commotions for I see no advantage to art.'[12] Typically he expressed more concern for human right and wrong than for the fortunes of party, but he was not unaware of politics. It cannot have been merely fortuitous that such a potentially loaded picture as the *Knox* was exhibited in 1832, the year of the Reform Bills. In the same year he welcomed the presentation in the theatre of *Distraining*

for *Rent* and *The Rent Day* as dramatic tableaux staged in the cause of reform, but in those two pictures his primary concern had been moral, as in the *Knox* where it was also spiritual, before it was political.[13] In this he was at one with Thomas Chalmers whose politics were conservative. Wilkie's picture must have been planned shortly after the Scots 'Radical War' of 1820 on which Chalmers's work among the poor of Glasgow clearly had a bearing, but Chalmers's solution to such problems was the spiritual regeneration of society rather than its political reconstruction. If Chalmers was Wilkie's inspiration for *Knox* therefore, it was as the spiritual leader in a new Reformation, not as a radical reformer.

Wilkie's choice of subject had some precedent in various scenes from the life of Queen Mary painted by Hamilton, Runciman and David Allan. Compositionally it is derived ultimately from Raphael's *Paul preaching at Athens*, though it also relates quite pointedly to Hogarth's variant on that composition, *Paul before Felix*. In execution, the picture, before it was ruined by bitumen, must have been distinctly Rembrandtesque, but Wilkie's treatment of history as dramatic narrative described in authentic detail was novel. The inspiration of the Waverley novels lies behind this, though Wilkie was clearly at odds with his Tory friend Scott on the Evangelical issue, but as a pictorial invention it was original and even as a sketch it was widely influential. Wilkie's friend William Allan, following his lead, did a painting *John Knox admonishing Mary Queen of Scots* (plate 99) in 1822.[14] At the same time as his own Knox subject, Wilkie was toying with the idea of painting the murder of Archbishop Sharpe, one of the key incidents in the history of the Covenanters.[15] The murder took place on an open moor not far from Cults and so was, by a mile or two, even more local to Wilkie's birthplace than Knox's preaching at St Andrews. Though he was probably critical of Scott's treatment of the Covenanters in *Old Mortality*, which aroused a lot of protest, not least from Thomas M'Crie, it is likely that in this case Wilkie was nevertheless following the inspiration of Scott's dramatic interpretation of history, for the murder of Sharpe was a central event in the novel though it happened off stage. William Allan exhibited a painting of this subject at the Royal Academy in 1821, but here again Wilkie was probably sharing his ideas with him for it was undoubtedly Wilkie who took the lead in presenting such events as being significant in Scottish religious history, and he was followed by young painters like Sir George Harvey, Thomas Duncan, James Drummond and even William Dyce. In including the history of the Covenanters with the history of the Scottish Reformation, Wilkie established the basic themes of a new kind of religious painting, which was in an important way distinct from the historical painting inspired by the potent example of Walter Scott (plates 100, 101). One result was the direct representation of the events of the Disruption itself. These were seen, for example, in D. O. Hill's painting of the Disruption Assembly (Free Church of Scotland), or in publications such as *Illustrations of the Principles of Toleration in Scotland* (1846) with engravings, after James Drummond and others, of churchless Free Church congregations forced to meet in the open air, thus echoing the historic model of the persecuted Covenanters.

Wilkie himself embarked on one other related picture. It was to be a pendant for *Knox preaching* and although it was incomplete at his death it too was an important and influential project generating many imitations.[16] The subject was *John Knox dispensing the Sacrament at Calder House* (plate 102). Wilkie left a complete compositional sketch and the final panel with the principal figures painted in. Calder House was the home of Sir James Sandilands, one of the leading supporters of the Protestant cause. An inscription on the back of a portrait of Knox in the hall at Calder House read: 'The first Sacrament of super (sic) given in Scotland after the Reformation was dispensed in this hall.' When this was is not clear. M'Crie supposes it was in 1555 when Knox stayed at Calder House, but Wilkie was not so much concerned with the date as with the tradition that it was the first celebration of the sacrament in the history of the new Reformed Church.[17]

He began to plan the picture in 1837. On 4 December

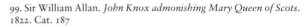

99. Sir William Allan. *John Knox admonishing Mary Queen of Scots.* 1822. Cat. 187

100. Sir William Allan. *Death of the Regent Moray.* 1829. Cat. 186

of that year he wrote to an unidentified correspondent to thank her for an account of Calder House.[18] This had clearly been given in response to a request for material for his picture, though he concludes the part of his letter relative to his project, 'your most obliging detail gives me a strong wish to begin the work, but my hands are so full I scarce know what to begin first.'

In his letter he calls Calder House 'the sanctuary of our early church', then goes on, 'the inner court, with the flight of steps and arched entrance to the paved hall, with its walls of adamantine thickness, and their once arched roof, seems a fitting scene for the restoration of a holy ordinance to its primitive simplicity.' Later in the letter he rejects a suggestion that the scene should be by night, because 'it savours too much of romance and the picturesque.' He then continues: 'the fact of the present custom in Scotland must be decisive, in the absence of history or tradition to the contrary, that the Sacrament must have been administered at Calder House by Knox in the open day. To make up for this, as you say, gentle and simple would be there alike seated at the same table: this makes the grand feature of the subject, characterizing not only those who sit at table, but the lookers on.'

It is certainly the case that, as Wilkie echoes Raphael in his first Knox picture, he aligns himself with Leonardo

in his second, for which Leonardo's *Last Supper* is one model.[19] In a preliminary drawing for the whole composition, the disposition of the figures and their relationship to a grand architectural background also recall very significantly Rembrandt's etching of *Christ presented to the People*, but considering what Wilkie is doing in his two Knox pictures together, Poussin, too, cannot have been far from his mind. He presents the church's rites in the simplicity of their historical origins, just as Poussin sought to do in his *Seven Sacraments*, though in place of Poussin's seven, Wilkie has only two central moments in the Scottish Protestant rite for which he presents the archetype: the sermon, the demonstration of the church's spiritual and intellectual leadership, and the Communion, the coming together in unity of all the church's members, gentle and simple, equal before God.

It may seem far-fetched to argue that when Wilkie used the phrase 'primitive simplicity' of the celebration of the sacrament in Calder House that he was consciously invoking the tradition that stretched back through Burns and David Allan to the poet Allan Ramsay's 'good old bards' and to the immediate aftermath of the Union, but that does seem to be what he intends. The evidence for this is in the picture that he exhibited in 1837, one of his last two great genre paintings, *The Cotter's Saturday*

Night. The other is *Grace before Meat*. These two form a complementary pair representing domestic religion with the two Knox pictures, which present the formal rites of the church.

The first crisis in the Intrusion controversy came in 1835. It resulted in a partial victory for the Evangelicals, the Veto Act which granted to congregations the right to veto a patron's nominee to a parish, though not themselves to elect him. It was the overturning of the Veto Act in 1843 that eventually led to the Disruption. Wilkie's *Cotter's Saturday Night* was painted after the events of 1835 and was itself followed immediately by his plans for *Knox dispensing the Sacrament at Calder House*.

The passage that he illustrates from Burns's poem 'The Cotter's Saturday Night', reads as follows:

> The cheerfu' supper done, wi' serious face,
> They round the ingle form a circle wide;
> The Sire turns o'er, with patriarchal grace,
> The big *ha'-Bible*, ance his *Father's* pride:
> His bonnet reverently laid aside,
> His lyart haffets wearing thin and bare;

> Those strains that once did sweet in Zion glide,
> He wales a portion with judicious care;
> '*And let us worship God!*' he says with solemn air.

> They chant their artless notes in simple guise;
> They tune their hearts, by far the noblest aim.

Wilkie's picture was clearly intended to have religious significance, but in addition he must have known through his friend George Thomson, who was still alive when he painted it, how David Allan had painted a version of the same subject as a compliment to Burns which Thomson himself had presented to the poet.[20] Though the immediate context of the picture was religious, therefore, Wilkie makes reference here to both the poetic and the artistic traditions of Scotland as he had done in *The Penny Wedding*.

In his poem Burns draws an implicit distinction between the simple dignity of primitive, domestic Presbyterianism which he describes and the practice of the established Church which he satirizes so mercilessly in poems like 'The Holy Fair' and 'Holy Willie's Prayer'. He also suggests, particularly in the line, 'their artless

101. Thomas Duncan. *Prince Charles Edward Stuart entering Edinburgh (Sketch)*. 1838. Cat. 188

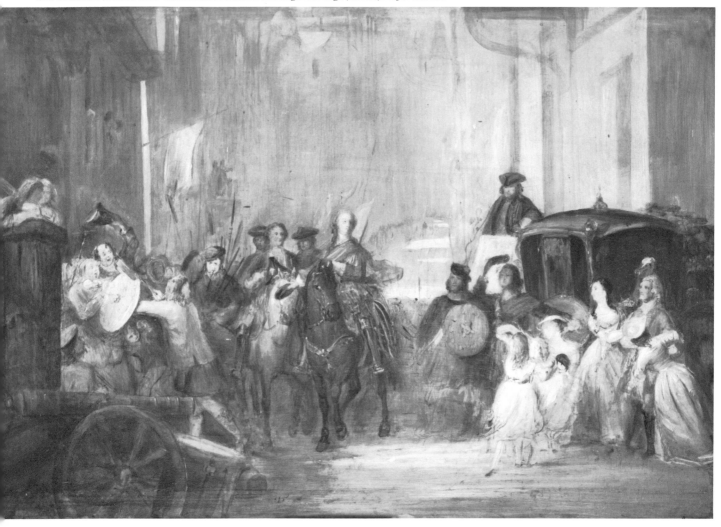

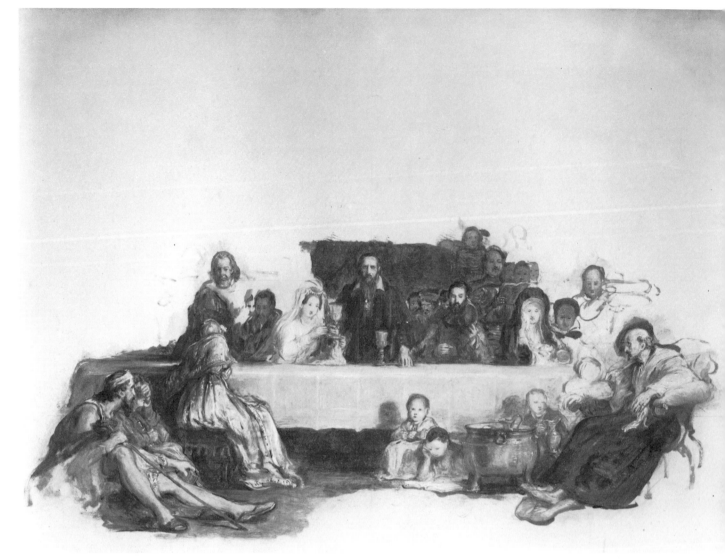

102. Sir David Wilkie. *John Knox dispensing the Sacrament at Calder House (Study). c. 1839. Cat. 202*

notes in simple guise', the extension of the concept of truth of sensibility, as it is identified in the simplicity of folk music, to include the kind of spiritual truth that is appropriate to religion. Wilkie was not alone in building on this idea. Chalmers cited 'The Cotter's Saturday Night' as a model when he described the new institution of family worship in his own household shortly after his marriage in 1812. Also, the poem had a great reputation in the nineteenth century.

Wilkie does not achieve his own image of spiritual simplicity by reductive means. The figures in his picture are not rustic clowns, nor does he simplify his style. On the contrary, the subtlety of his observation is greater in this picture than it had been since *The Penny Wedding*, and no one since Rembrandt, who was his model, had succeeded as he did here in integrating the portrayal of a religious event so completely into an account of ordinary human experience. An act of piety is the picture's focus, but it is only part of the scene. As well as the father, the

day-dreaming girl, the irreverent boy and the granny with the ear trumpet, for whom the simple act of hearing has become the principal object of her attention, are each portrayed with their due share of natural dignity. Their varied responses suggest how participation in this act of family worship is not at the expense of life's natural diversity. The fiddle hanging on the wall is a reminder too, not only of the musical analogy in Burns's poem, but of how this communal act is parallelled in the more demonstrative social pleasures also associated with music.

In *The Cotter's Saturday Night* Wilkie turned more to the inspiration of Rembrandt than he had ever done before, and the picture can be compared to the painting of the Holy Family in Amsterdam. He had first shown his admiration for the Dutch painter in *The Penny Wed-*

OPPOSITE 103. David Octavius Hill and Robert Adamson. *Thomas Chalmers with his Grandson.* 1845. Cat. 194

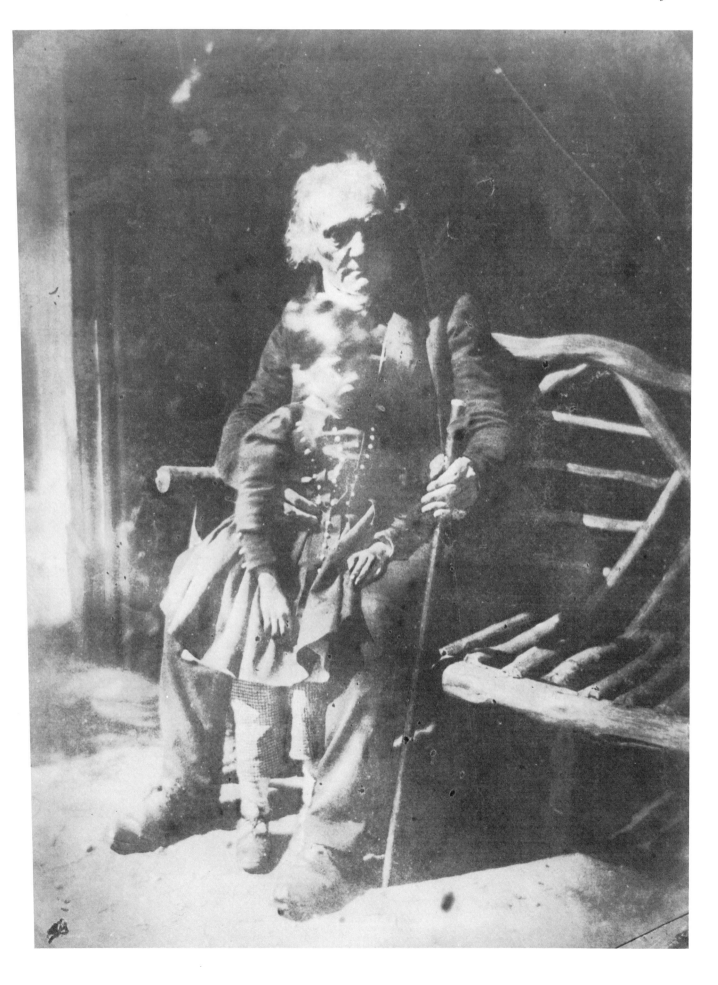

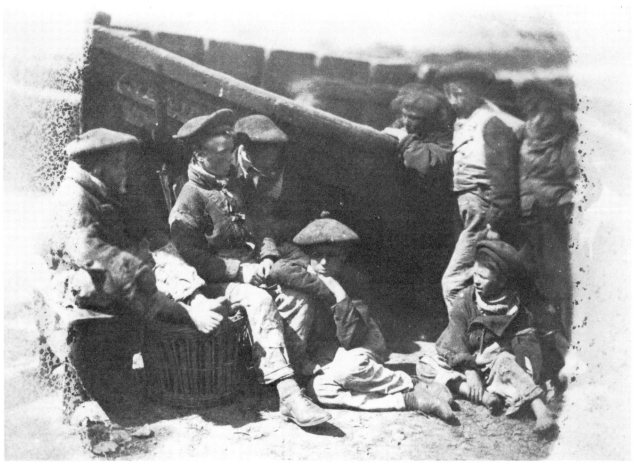

104. David Octavius Hill and Robert Adamson. *Fisher Lads, Newhaven.* 1845. Cat. 195

ding, a picture that he prepared during his visit to Scotland in 1817. There may be a link therefore with Raeburn's interest in Rembrandt which is apparent at just that time. Rembrandt's influence is also dominant in *Knox preaching* and in that picture Wilkie deliberately took issue with Knox's legacy on one specific point, his iconoclasm. While he was working on the picture he wrote about the pulpit (modelled on one associated with Knox, still in St Andrews), 'I am studding it with carvings in low and high relief of Saints, Apostles and Martyrs, with cheribine and seraphine supporting crowns over their heads. Perhaps some other specimens of this sort in the picture may be no bad indication of some of the labour which his preaching destroyed.'[21] Rembrandt refuted triumphantly this aspect of Protestant teaching by demonstrating not only the possibility of religious painting within the Protestant faith, but its capacity to focus the essential humanity of that faith. Wilkie's thoughts were running on the possibility of a revival of religious painting in the 1830s. In an undated draft, apparently for an article in a journal in that decade, he talks about 'the embellishing of our temples . . . augmenting a respect for religion' (his underlining) and he looks forward to 'times more auspicious to the rising talents of our country, when scriptural subjects may be permitted to enliven the walls

of our churches.'[22]

He himself turned to a scriptural subject for the first time in 1839. He did so in response to a suggestion from his friend Sir Willoughby Gordon and immediately after the completion of the enormous task of the monumental painting of *Sir David Baird at the Discovery of the Body of Tipoo Sahib* (National Gallery of Scotland). The suggestion was that he should paint the young Samuel in the temple—Samuel described suggestively and rather surprisingly by Sir Willoughby as the first President of the Hebrew republic, a phrase that Wilkie adopted.[23] He prepared a watercolour of the subject (col. plate 47). The picture itself was never completed, but he and his correspondent discussed at some length its details and the possibility of making them authentic by studying the people and furnishings of a synagogue. During the course of this correspondence David Roberts returned from his journey in the Holy Land (plate 70). Wilkie was very impressed by the pictures that Roberts had brought back and wrote to Sir Willoughby Gordon, 'the researches of this traveller must assist greatly in the presentation of scripture subjects.'[24] It was an easy sequence of ideas for him to follow in his friend Roberts's footsteps and he set out in 1840 to the Holy Land from which he never returned, for he died on the homeward voyage in 1841.

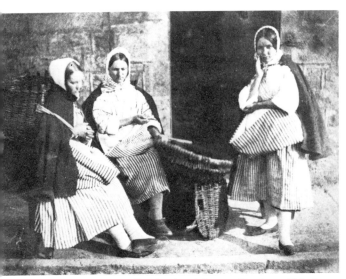

105. David Octavius Hill and Robert Adamson. *Newhaven Fishwives.* 1845. Cat. 198

ground, of spectators peering in through skylights, also recalls J. L. David's painting of *The Oath of the Tennis Court*, suggesting an unexpected analogy between the Disruption and the French Revolution. At a more practical level, too, Hill was faced with the same problem as David in painting his picture. In order to do justice to those present he had to prepare and incorporate a vast number of portraits into his composition.

The idea of using photography to solve this problem was suggested to Hill by Sir David Brewster, a scientist who was also an energetic supporter of the Free Church. Brewster was a man of diverse interests. According to one obituary he contributed on average one scientific paper to the press every two or three months for sixty years.[27] His central interest, however, was in light and in optics. He contributed significantly to the understanding of the polarization of light and of stereoscopic vision, inventing the kaleidoscope along the way. Like Sir Charles Bell, with whom he quarrelled bitterly over the details of the working of the eye, his starting point was the central place of perception in empirical philosophy as it was seen by

At one level Wilkie's journey to the Holy Land followed naturally on the journeys that he had made to Spain, to Ireland and even to the Highlands of Scotland in search of new subjects and new material, but on this occasion he was also looking for something more than picturesque detail and local colour (col. plate 48). He comments at one point on the authenticity of Rembrandt's religious painting, meaning that the Jewish community that Rembrandt knew provided a genuine link with biblical times.[25] He himself went in search of the same or even greater authenticity, acting in the belief that had inspired David Allan and that was professed by James Macpherson that there were societies which were historically static and which could therefore provide a living link with remote antiquity. He was following ultimately in the footsteps of Robert Wood, but, seeking a living witness to holy scripture, in contemporary eyes his objective was more elevated than that of any who had gone before him.

If Wilkie had lived only a little longer he would himself have witnessed the enrolling of the new invention of photography in the cause of artistic truth and he would surely have approved. The first artist to employ it on any scale was D. O. Hill, secretary to the Royal Scottish Academy, a landscape painter and pupil of Nasmyth, known to Wilkie personally. Moved by the spectacle of the Disruption, Hill decided to commemorate the occasion in a monumental painting. Appropriately the starting point for his composition was Wilkie's two paintings of Knox. The compositions were initially combined and adapted to show Thomas Chalmers, as the first Moderator of the new Free Church, preaching to the General Assembly.[26] The painting was not finished for more than twenty years by which time the subject had become the *Signing of the Deed of Demission.* Curiously in the finished picture, though the outline of Wilkie's *Knox at Calder House* is still visible in the central group, a detail in the back-

106. David Octavius Hill and Robert Adamson. *Sir William Allan.* c. 1844. Cat. 192

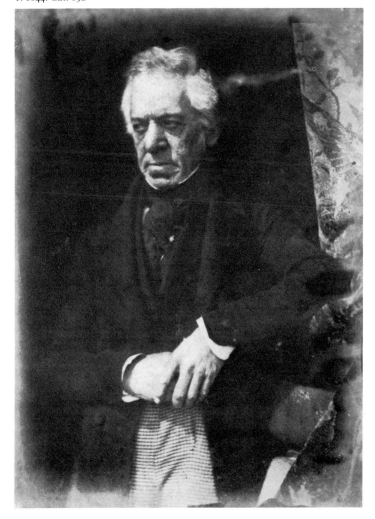

Thomas Reid. He was a friend of Nasmyth and was painted by Raeburn. He was also, incidentally, by his first marriage, son-in-law to James Macpherson.

Brewster's interest in optics brought him into contact at an early date with the research of Henry Fox Talbot which eventually led to the invention of the calotype, the first photographic process to use a negative. Once the process was perfected Fox Talbot transmitted it to Brewster. In St Andrews, where he was principal of the University, Brewster experimented with the new process in collaboration with Dr John Adamson and together they instructed Adamson's brother Robert who set up practice as a professional photographer in Edinburgh in 1843. Brewster then brought Hill and Adamson together and they formed a successful partnership till Adamson's death in 1848.

The calotypes that Hill and Adamson produced were predominantly portraits, but also include some remarkable genre studies reminiscent of Walter Geikie (plates 103–7). They have an abiding simplicity and strength and it was natural for the earliest commentators to compare them to Rembrandt and Raeburn. Although

we now see the beginnings of photography as the opening of a new era, such comments also point to the real continuity of these calotypes with what had gone before.

For Hill, the use of the new process did not present any profound aesthetic problem. In it, visual truth is recorded apparently entirely uncluttered by preconceived ideas, in keeping with Thomas Reid's ideas on perception. The grainy texture of his calotypes reduces detail and stresses light. Hill called them sun pictures. Raeburn and even Ramsay would have appreciated them immediately. At the same time the occasion that inspired them, the Disruption, which it was Hill's primary purpose to record, gave a new and urgent expression to ideas that can be traced back to their origins at the beginning of this story. A calotype like *The Dumbarton Presbytery* (plate 107) unites in a single image the ideals of the Disruption with the best scientific and philosophic traditions of the Enlightenment, but as a work of art too it is surely an equally appropriate and worthy realization of the poet Ramsay's vision of 'the natural Strength of Thought and Simplicity of Style that our Forefathers practised'.

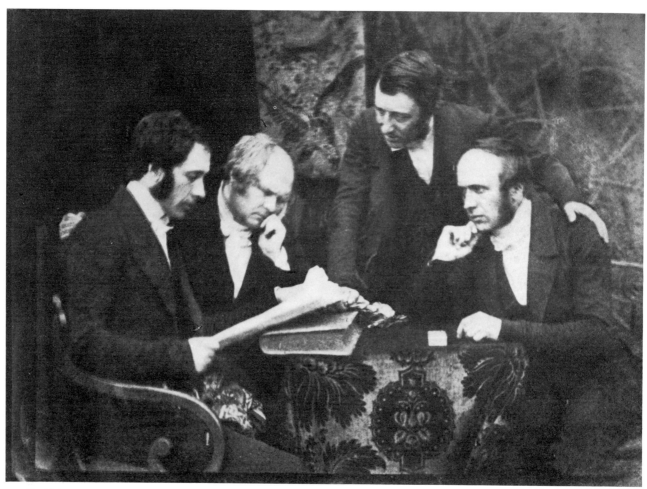

107. David Octavius Hill and Robert Adamson. *The Dumbarton Presbytery*. 1845. Cat. 193

Notes

I Artists and the Union (pp. 9–17)

1. Penicuik Papers, Register House, MS. GD 18 4571.
2. Aikman to Sir John Clerk, 27 January 1701, Penicuik Papers GD 18 4569.
3. Letters of Aikman to Baron Clerk, 8 December 1720 and 9 May 1723, Penicuik Papers GD 18 4579 and 4585.
4. Ed. various, *Works of Allan Ramsay* (Scottish Text Society, 1945–74), 6 volumes, II, p. 166.
5. Preserved in Penicuik Papers, Register House, from which the following details are drawn.
6. Aikman to Clerk, 8 December 1720, Penicuik Papers.
7. Aikman to Clerk, 9 May 1723, Penicuik Papers.
8. Aikman to Clerk, 8 October 1723, Penicuik Papers GD 18 4588.
9. Smart Lethieullier to Sir John Clerk, n.d., Penicuik Papers GD 18 4635.
10. Aikman to Clerk, 8 February 1729, Penicuik Papers GD 18 4616.
11. Aikman to Clerk, 17 August 1726, Penicuik Papers GD 18 4602.
12. Henry W. Foote, *John Smibert* (Cambridge, Mass., 1950); see also John Smibert, *The Notebook* (Boston, 1969) and Miles Chapell, 'A Note on Smibert's Italian Sojourn', *Art Bulletin*, CXIV (March 1982), pp. 132–38.
13. George Vertue, 'Diary', quoted Foote, *John Smibert*, p. 36.
14. Aikman to Clerk, 24 August 1723, Penicuik Papers GD 18 4587.
15. See above n. 4.
16. Ramsay, *Works*, I, p. 225.
17. Ibid, IV, p. 236.
18. James L. Caw, *Scottish Painting Past and Present 1620–1908* (1908; reprinted Bath, 1975), p. 26.
19. (Iain G. Brown), *Poet and Painter, Allan Ramsay, Father and Son* (National Library of Scotland, Edinburgh, 1984).
20. Caw, *Scottish Painting 1620–1908*, pp. 26–27.
21. Aikman to Clerk, 21 October 1727, Penicuik Papers GD 18 4608.
22. Walpole Society, XXII (1933–34), p. 36.
23. James Dennistoun, *Memoirs of Sir Robert Strange and of his brother-in-law, Andrew Lumsden* (London, 1855), 2 volumes.
24. Royal Scottish Academy, published in Robert Brydall, *Art in Scotland* (Edinburgh and London, 1889), p. 111.
25. Minutes of Edinburgh City Council.
26. David Laing, transcript of Minute Book of St Mary's Chapel, Edinburgh University Library, Laing MSS.

II Empirical Portraiture (pp. 18–30)

1. The story of Ramsay's life is told in full in Alastair Smart's admirable biography, *The Life and Art of Allan Ramsay* (London, 1952).
2. Aikman to Sir John Clerk, n.d. (June 1727), Penicuik Papers GD 18 4610.
3. Smart, *Ramsay*, p. 14.
4. Entry on *Margaret Calderwood* contributed by Alistair Smart to *Masterpieces of Scottish Portrait Painting* (Talbot Rice Art Centre, 1981).
5. Prestonfield Papers, quoted extensively in Smart, *Ramsay*, chapter II.
6. Aikman to Sir John Clerk (Baron Clerk), 15 July 1725, Penicuik Papers, Register House.
7. Quoted Smart, *Ramsay*, p. 45.
8. e.g. Ronald Paulson, *Hogarth his Life, Art and Times* (London, 1971), 2 volumes, I, p. 436.
9. Quoted *Hogarth* (Tate Gallery, 1972), p. 55.
10. Henry Fielding, *Joseph Andrews* (1742; Penguin edn., London, 1977), p. 28.
11. Quoted Smart, *Ramsay*, p. 40.
12. See below p. 26.
13. Ramsay, *On Ridicule* in *The Investigator* (1753; London 1762), p. 63, quoted Smart, *Ramsay*, p. 70.
14. David Hume, *A Treatise of Human Nature* (1739; ed. by L. A. Selby-Bigge, Oxford, 1762), p. 29.
15. Ramsay, *Dialogue on Taste* in *The Investigator* (1754; London, 1762), p. 29.
16. Ibid., p. 24.
17. Ibid., p. 21.
18. Francis Hutcheson, *An Inquiry into our Ideas of Beauty and Virtue* (London, 1726), p. 16.
19. Hume, *Treatise*, ed. Selby-Bigge, p. 623.
20. Ramsay, *On Ridicule*, quoted Smart, *Ramsay*, p. 70; Ramsay, *Dialogue on Taste*, p. 61.
21. Ramsay, *Dialogue on Taste*, quoted Smart, *Ramsay*, p. 88.
22. D. D. Raphael entry on Hume in *Companion to Scottish Culture*, ed. David Daiches (London, 1981).
23. Ramsay, *Dialogue on Taste*, p. 40.
24. Ibid., p. 43.
25. Ibid., p. 71.
26. Ibid., p. 74.
27. Allan Ramsay Senior, Preface to *The Evergreen* (1724).
28. Alastair Smart, Talbot Rice Memorial Lecture (Edinburgh, 1982).
29. Alastair Smart, 'A newly discovered portrait of Allan Ramsay's second wife', *Apollo*, 113 (May 1981), pp. 288, 291 n.4.
30. Quoted Smart, *Ramsay*, p. 106.

III The Epic Style (pp. 31–42)

1. Ramsay to Sir Alexander Dick-Cunynghame, 1755, quoted Brown, *Poet and Painter*, p. 44.
2. Ibid., pp. 43–47.
3. Thomas Blackwell, *An Inquiry into the Life, Times and Writings of Homer* (London, 1735), p. 34.
4. Robert Wood, *An Essay on the Original Genius and Writ-*

ings of Homer, with a comparative View of the Ancient and present State of the Troade (printed privately 1767; London, 1769), p. vi. For the friendship of Wood, Ramsay and Robert Adam, see John Fleming, 'Adam, Ramsay and Robert Wood in Italy,' *Connoisseur*, CXXXVII (March 1956), p. 99.

5. Andrew Stuart to Alexander Hamilton of Murdieston, National Library of Scotland, MS.8250.f.1.

6. Sir Ellis Waterhouse, 'The British Contribution to the Neo-Classical Style of Painting', *Proceedings of the British Academy*, XL (1954), 67, 69: and Abbé Grant to Sir James Grant of Grant, Rome, 31 May 1760, Seafield Papers, Register House. GD 248/177/1.

7. Letter of 31 May 1760 above; same correspondents 12 February 1763, Seafield Papers, Register House, GD/248/3/609; Daniel Crespin to Sir James Grant, Rome 11 March 1763, GD 248/49/2.

8. Gavin Hamilton to Lord Shelburne (Viscount Palmerston), n.d. (1766), quoted B. Connell, *Portrait of a Whig Peer* (London, 1957), pp. 55-58.

9. It was seen as a sketch by J. S. Copley in 1775, see Waterhouse, op. cit.

10. One is by Antonio Cavalluci still in the Accademia di San Luca. The other is by Anton Lasenko (Tretiakov Gallery, Moscow). It is so close that it must also be connected with the competition, though Lasenko died in 1773. The instructions for the competition are preserved in the Accademia and are presumably written by Hamilton, for they read like a description of his own picture.

11. Abbé Grant to Sir James Grant of Grant, Rome, 22 October 1760, Seafield Papers, Register House, GD 248/99/3.

12. John Aikman of the Ross to John Forbes, 29 August 1767, transcript of Forbes papers by B. C. Skinner.

13. e.g. David Irwin, 'Gavin Hamilton, Archaeologist, Painter, Dealer', *Art Bulletin*, XLIV (1962), p. 93, and Dora Wiebenson, 'Subjects from Homer in Neo-Classical Art', *Art Bulletin*, XLVI (1964).

14. David Irwin, *English Neo-Classical Art* (London, 1966), p. 36.

15. Abbé Grant to Sir James Grant of Grant, Rome, 14 June 1760, Seafield Papers, Register House, GD 248/99/3.

16. Comte de Caylus, *Tableaux Tirés de l'Iliade, et de l'Odyssée d'Homère et de l'Eneide de Vergile* etc. (Paris, 1757), p. iii.

17. Caylus, *Tableaux*, p. 41.

18. Smart, *Ramsay*, p. 88, quoting *Dialogue on Taste*, p. 29.

19. Anthony Ashley Cooper, 3rd Earl of Shaftesbury, *Characteristicks of Men, Manners, Opinions, Times*, etc. (2nd edn., London, 1714), 3 volumes, III, p. 381.

20. Ibid., III, p. 349.

21. Ibid., III, pp. 260-61n.

22. Ibid., I, pp. 143-44n.

23. Ibid., III, p. 396.

24. Francis Hutcheson, *An Inquiry into our Ideas of Beauty and Virtue* (London, 1726).

25. George Turnbull, *A Treatise on Ancient Painting* (London, 1740), p. xii.

26. Ibid, p. xxv.

27. Ibid., p. 67.

28. Hamilton to Carlo Bianconi, 16 July 1768 (in Italian), National Library of Scotland, MS. 3648/113.

29. Quoted B. Connell, *Portrait of a Whig Peer*, pp. 55-58.

30. Alexander Pope, *Iliad* (London, 1715), book xxiv, line 439n.

31. Wood, *Homer*, pp. xii-xiii.

32. Ibid., p. 74.

33. Sir John L. Myers, *Homer and his Critics* (London, 1958), p. 68.

34. Blackwell, *Homer*, p. 35.

35. Ibid., p. 24.

36. Ibid., p. 26.

37. Ibid., p. 34.

38. Hugh Blair, 'A Critical Dissertation on the Poems of Ossian', p. 4, in *Poems of Ossian* (3rd edn., Dublin, 1765), 2 volumes.

39. Abbé Grant to Sir James Grant of Grant, Rome, 12 September 1763, Seafield Papers, Register House, GD/248/3/609; Hamilton to unknown correspondent at Hopetoun House, n.d. but answered 20 November 1767, Hopetoun House Muniments; Waterhouse, op. cit., p. 72.

40. Abbé Grant to Sir James Grant of Grant, Rome, 20 January 1762, Seafield Papers, Register House, GD 248/99/3.

41. Abbé Grant to Sir James Grant of Grant, Rome, 18 May 1774, Seafield Papers, Register House, GD 248/226/4/2.

42. Correspondence printed in catalogue of sale at Lansdowne House, Christie, Manson and Wood, London, 1930.

IV An Ossian's Fancy and a Fingal's Fire (pp. 43–62)

1. See above p. 33.

2. See chapter III, n. 9.

3. James Clerk to Dalrymple, London, 2 February 1768, Dalrymple Papers, Register House, GD 248/839.

4. See J. D. Macmillan, 'Alexander Runciman in Rome', *Burlington Magazine*, CXII (January 1970).

5. Allan Ramsay 'Epistle to Mr H. S.', November 1738, lines 73-78; Ramsay, *Works*, Vol. III, pp. 248-49.

6. The papers of the Cape Club are preserved in the National Library of Scotland.

7. *Caledonian Mercury*, 28 April 1774, quoted M. P. McDiarmid, *The Poems of Robert Fergusson* (Edinburgh and London, 1954) 2 volumes, vol. I, chapter I, p. 36.

8. Clerk to Aikman, 22 October 1728, Penicuik Papers, Register House, GD 18.

9. *Edinburgh Evening Courant*, 5 March 1763.

10. See Macmillan, *Burlington Magazine*, CXII (1970), p. 23.

11. Sir James Clerk's Journal of Expenses, Penicuik Papers, Register House, GD 18 4614.

12. *The Good Samaritan*, formerly attributed to Rembrandt, private collection, Paris.

13. Paton to Cumming, 23 October 1766, National Library of Scotland, MS 3648 121.

14. Robert Fergusson, *Scots Poems* (Edinburgh, 1925), 'Auld Reekie', p. 80.

15. Runciman to James Cumming, 5 December 1767, Edinburgh University Library, Laing MSS.

16. 'Letter Book of Walter Ross', transcribed by David Laing, Laing MSS., Edinburgh University Library.

17. Forbes Correspondence; see Chapter III n. 12.

18. Runciman to James Cumming, Laing MSS., Edinburgh University Library.

19. Barry to Edmund Burke, Rome, n.d., *The Works of James Barry R.A.* (London, 1809), 2 volumes, I, p. 114.

20. 16 May 1770, Penicuik Papers, Register House, GD 18.

21. Runciman to Robert Alexander, 19 July 1769, Laing MSS. Edinburgh University Library.

22. Turnbull, *Ancient Painting*, p. 56.

23. Blair, 'A Critical Dissertation on the Poems of Ossian', p. 4.

24. Blackwell quoted above p. 39.

25. James Macpherson 'On the Poems of Ossian' in *The Works of Ossian, Son of Fingal* (3rd edn., Dublin, 1765), 2 volumes, I, p. vi.

26. Alexander Runciman's account with Walter Ross, Laing MSS. Edinburgh University Library.

27. Work will have commenced after completion of the plain painting of the ceiling in June, recorded in the Penicuik Accounts, Register House.

28. Three of the St Margaret pictures were dated 7 September, 6 October and 14 October 1772 respectively.

29. Pope, *Iliad*, preface.

30. Blair 'A Critical Dissertation on the Poems of Ossian', p. 4.

31. (Walter Ross), *A Description of the Paintings in the Hall of Ossian at Pennycuik near Edinburgh* (Edinburgh, 1773), p. 30.

32. The principal source is a sarcophagus relief published by Winckelmann as the *Marriage of Peleus and Thetis* in *Monumenti Antichi Inediti* (Rome, 1767), pp. 145–51.

33. John Gray, *Art Treasures at Penicuik* (Edinburgh, 1889), p. 58.

34. Runciman to George Paton, 12 October 1775, National Library of Scotland, Adv. MS. 29.2.81, published in 'Letters of Thomas Percy to George Paton', (Edinburgh, 1830).

35. The church was consecrated on 9 October 1774. His proposal to decorate the Trustees' boardroom is recorded in the Trustees' minutes book, 8 December 1775, Register House.

36. See Daniel Wilson, *Memorials of Edinburgh in Olden Time* (Edinburgh, 1891), 2 volumes, I, p. 222.

37. Quoted National Gallery of Scotland, *Catalogue of Scottish Drawings* (Edinburgh, 1960).

38. Runciman to Sir James Clerk, May 1770 (above n. 20); 'a subject from the Aeneid' mentioned in the letter is likely to be *Dido*, the only identifiable subject from the poem among the Roman drawings.

39. (Lord Gray), *Catalogue of the collection of pictures Antient and Modern at Kinfauns Castle chiefly collected by Francis Lord Gray* (Perth, 1828), p. 8.

40. Recorded by Richard Gough in *British Topography* (London, 1780).

41. John Brown to Lord Buchan, transcript Laing MSS., Edinburgh University Library.

42. J. H. Benton, *The Scot Abroad* (1864; 2nd. edn., Edinburgh, 1900), p. 463.

43. Transcript in Laing MSS., Edinburgh University Library, reprinted in George Walker, *A Descriptive Catalogue of a choice Assemblage of original pictures by some of the most esteemed Masters, etc.* (Edinburgh, 1807), pp. 57–58.

44. James Burnett, Lord Monboddo, introduction to John Brown, *Letters on the Italian Opera* (2nd. edn., Edinburgh, 1792).

V A Vision of Pastoral Simplicity (pp. 63–73)

1. David Laing, MS. Notes towards a History of Scottish Art, Edinburgh University Library.

2. Thomas Mercer, 'Arthur's Seat' in *Poems by the Author of a Sentimental Sailor* (London, 1774), p. 27.

3. Alasdair Mac Maighstir Alasdair, *Aiseiridh na Sean Chanoin Albannach, Resurrection of the Ancient Scottish Tongue* (Edinburgh, 1751), quoted John MacQueen, *Progress and Poetry* (Edinburgh, 1982), p. 75.

4. For the life of Fergusson see M. P. McDiarmid, *Poems of Robert Fergusson* (Scottish Text Society, Edinburgh, 1947, 1954), 2 volumes.

5. Fergusson, *Scots Poems*, p. 83; also see below p. 165.

6. See above p. 39.

7. See above p. 54.

8. Byers Papers, National Library of Scotland; see David Ridgeway, 'James Byers and the Ancient State of Italy, Secondo Congresso Internazionale Etrusco, Florence, 1985.

9. Quoted T. Crowther Gordon, *David Allan of Alloa, the Scottish Hogarth* (privately printed Alva, 1951), p. 32.

10. *Poems of Ossian* (Perth, 1795).

11. Henry Mackenzie, *Letters to Elizabeth Rose of Kilravock*, ed. H. W. Drescher (Edinburgh, 1967), p. 176.

12. Burns to Alexander Cunningham, 3 March 1794, in J. de L. Ferguson, *The Letters of Robert Burns* (Oxford, 1931), 2 volumes, II, p. 237.

13. 'A Drink Eclogue', Fergusson, *Scots Poems*, p. 55.

14. 'The Vision', *Poems of Robert Burns* (Oxford, 1969), p. 89, lines 241–42.

15. Fergusson, *Scots Poems*, p. 25.

16. *Ceci est la Couleur de mes Rêves*, Joan Miró in conversation with Georges Raillard (Paris, 1977), p. 121.

17. Allan Cunningham, *Lives of the Painters, Sculptors and Architects* (London, 1839), 6 volumes, VI, p. 481.

18. Edinburgh University Library, Laing MSS.

19. Crowther Gordon, *David Allan*, pp. 33–34.

20. Fergusson, *Scots Poems*, p. 9.

21. George Thomson, *A Select Collection of Original Scots Airs* (Edinburgh, 1793–1841), 6 volumes.

22. For the full correspondence see Ferguson, *Letters of Robert Burns*, where the letters are arranged by date and from which the following quotations are taken.

23. Burns to Alexander Cunningham, 3 March 1794, see n. 12 above.

24. National Library of Scotland, MS. 9835 17 2.

25. Allan Cunningham, *Life of Sir David Wilkie, RA* (London, 1843), 3 volumes, II, p. 9.

26. Ramsay, *Works*, II, p. 130, lines 28–32, 41–48.

27. John Brown, *Dissertation* etc. (London, 1763), p. 12.

28. Ramsay, *The Gentle Shepherd*, Act V, scene ii, lines 19–22.

VI The Portraiture of Common Sense (pp. 74–136)

1. Allan Cunningham, *Lives of the Painters* etc. (London, 1839), 6 volumes, V, pp. 234–35. The fullest account is given in E. R. Dibdin, *Raeburn* (London, 1925).

2. Anon., 'Caledonian Jottings', quoted Dibdin, *Raeburn*, p. 22; see also James Greig, *Sir Henry Raeburn RA* (London, 1911) p. xv for Deuchar family tradition.

3. W. Dunlop, *History of the Rise and Progress of Arts and Design in USA* (New York, 1834), I, p. 395, quoted D. and F. Irwin, *Scottish Painters at Home and Abroad 1700–1900* (London, 1975), p. 150.

4. Caw, *Scottish Painting*, p. 73; D. and F. Irwin, *Scottish Painters*, p. 150.

5. The picture is possibly identical with a painting copied by Andrew Robertson in Raeburn's studio about 1792; *Letters and Papers of Andrew Robertson AM*, ed. Emily Robertson (London, 1895), p. 4.

6. See above p. 61; Edinburgh University Library, Laing MSS. La IV 26.

7. Francina Irwin, 'Early Raeburn reconsidered', *Burlington Magazine*, CXV (1973), pp. 239–44.

8. D. and F. Irwin, *Scottish Painters*, p. 151.

9. Caw, *Scottish Painting*, p. 70; T. Whitley, *Art in England 1821–37* (Cambridge, 1930), p. 48.

10. Dibdin, *Raeburn*, p. 38.

11. See n. 7 above.

12. Cumberland Hill, *History and Reminiscences of Stockbridge* (Edinburgh, 1874), p. 59. Hill is partially paraphrasing Cunningham, V, pp. 234–35.

13. Thomas Reid, *Essays on the Powers of the Human Mind*, ed. Dugald Stewart (Edinburgh, 1803), 3 volumes, I, p. cxxxiv.

14. Photocopy, Scottish National Portrait Gallery.

15. James McCosh, *The Scottish Philosophy* (London, 1875), pp. 211–13.

16. Thomas Reid, 'Inquiry into the Human Mind', *The Works of Thomas Reid*, ed. Sir William Hamilton (6th edn., Edinburgh, 1863), 2 volumes, I, pp. 135–37.

17. Dugald Stewart, *Elements of the Human Mind* (London, 1792–1827), 3 volumes, I, p. 88.
18. Stewart, *Elements*, I, p. 68.
19. Ibid., p. 93.
20. Ibid., p. 92.
21. Archibald Alison, *Essays on the Nature and Principles of Taste* (1790; 2nd edn, Edinburgh, 1811), 2 volumes, II, pp. 426–27.
22. *The Farington Diary*, ed. James Greig (London, 1923), I, p. 323.
23. Cunningham quoted at length in Greig, *Raeburn*, p. xxxvi; see also Irwin, *Burlington Magazine*, CXV (1972) pp. 239–44.
24. See n. 12 above.
25. Thomas Reid, 'Essays on the Intellectual Powers of Man' in *Works* (1863), I, p. 258.
26. Cunningham, *Wilkie*, I, p. 280, quoting Wilkie's journal, 2 March 1810.
27. John Morrison, 'Reminiscences of Walter Scott, Henry Raeburn etc.', *Tait's Edinburgh Magazine*, NS XI (1844), pp. 16–17.
28. Catalogue of the National Gallery of Scotland (1957), p. 209.
29. 'Notes from a valuation of some of the pictures at Hamilton Palace made by Sir Henry Raeburn', Hamilton Bruce MSS., Scottish National Portrait Gallery.
30. Wilkie to Sir Robert Liston, 29 April 1829, National Library of Scotland, MS 5679 39.
31. For Skirving see Basil Skinner, *Transactions of East Lothian Antiquarian Society*, XII (1970), pp. 46–56.
32. *Letters and Papers of Andrew Robertson*, p. 4.
33. They are *Peter van Brush Livingstone* (see Mabel C. Weakes, 'Works by Raeburn in America', *Connoisseur*, 97 (1936), pp. 275–77) and *Lady Gordon Cumming* (see D. and F. Irwin, *Scottish Painters*, p. 162).
34. 21 September 1819, National Library of Scotland, MS. 1003.
35. Peebles, 9 September 1823, National Library of Scotland, MS. 9835 175.
36. See n. 27 above.

VII The Landscape Painters (pp. 137–155)

1. *James Nasmyth, Engineer, an Autobiography*, ed. Samuel Smiles (London, 1883), p. 23.
2. See anon. (D. A. Werschmidt), *James Norie, Painter* (Edinburgh, 1890), for some account of the Nories.
3. See Patricia Andrew, 'Jacob More', unpublished PhD. thesis, University of Edinburgh, 1982, for a detailed account of More's career.
4. Ibid.
5. *Noctes Ambrosianae* (collected edn., Edinburgh, 1868), 2 volumes, II, p. 332 (April 1830).
6. George Walker, *Descriptive Catalogue of a choice Assemblage of Pictures* etc. (Edinburgh, 1807), p. 30.
7. Thomson to William Cranstoun, *c.* 1 October 1725, in James Thomson, *Collected Letters*, ed. A. D. McKillop (Lawrence, 1958), p. 16.
8. James Beattie, *The Minstrel or The Progress of Genius* (Edinburgh, 1771), p. 13, verse xxi.
9. James Beattie, 'On Poetry and Music' in *Essays* (Edinburgh, 1777), p. 394.
10. George Walker, *Descriptive Catalogue* etc., p. 34.
11. See above chapter v, n. 8
12. Details of Nasmyth's early life are given in James Nasmyth, *Autobiography*; see also Janet Cooksey, 'Alexander Nasmyth', PhD. thesis, University of St Andrews, 1982.
13. James Nasmyth, *Autobiography*, pp. 57–59.

14. James Boswell, *Journal* for 1778, quoted Smart, *Ramsay*, p. 164.
15. James Byers to Philip Yorke, 4 June 1783, quoted W. T. Whitley, *Artists and their Friends in England*, II, p. 348.
16. James Nasmyth, *Autobiography*, p. 29.
17. Robert Burns, *Commonplace Book*, ed. R. L. Brown (1872; reprinted Edinburgh, 1969), p. 46 (August 1785).
18. James Nasmyth, *Autobiography*, p. 34. Nasmyth also quotes Lockhart's *Life of Burns*.
19. National Museum of Antiquities of Scotland.
20. James Nasmyth, *Autobiography*, p. 40.
21. Ibid., p. 33.
22. 9 September 1788 in *Letters of Burns*, ed. J. Ferguson, I, p. 252.
23. James Nasmyth, *Autobiography*, p. 42; James Ballantyne, *Life of David Roberts* (London, 1866), p. 228.
24. Scott Wilcox, 'The Panorama', unpublished M.Litt. thesis, University of Edinburgh 1976.
25. Thomas Reid, 'On the Active Powers of Man', in *Works* (1863), II, p. 538.
26. Allan MacKenzie, *History of Lodge Canongate, Kilwinning 2* (Edinburgh, 1888), p. 100. Nasmyth joined in 1778 shortly after Stewart.
27. James Nasmyth, *Autobiography*, p. 52.
28. From 'My Love is like a red, red rose'.
29. Burns to the *Evening Courant* (22 November 1788), *Letters*, I, p. 270.
30. See Thomas A. Markus ed., *Order and Space in Society* (Edinburgh, 1982), p. 138.
31. Quoted Cunningham, *Wilkie*, III, p. 279.
32. Ballantyne, *Life of David Roberts*, p. 228.
33. James Nasmyth, *Autobiography*, p. 50.
34. *Edinburgh Magazine and Literary Miscellany (The Scots Magazine)*, new series VI (January 1820), p. 49.
35. Burns to Alison in *Letters of Robert Burns*, ed. Ferguson, p. 337.
36. Above n. 35.
37. Alison, *On Taste* (1811), II, p. 433.
38. Alison, *On Taste* (1811), II, pp. 421–22.
39. Margaret Forbes, *James Beattie and his Friends* (London, 1904), p. 265.
40. Alison, *On Taste* (1811), II, p. 443.
41. W. Baird, *John Thomson of Duddingston* (Edinburgh, 1895), p. 139.
42. Wilkie to Perry Nursey, 5 November 1817, Trinity College, Cambridge, Dawson Turner MSS.
43. Thomson to Scott, March/April 1831, National Library of Scotland, MS. 3917.
44. Walter Scott, *The Bride of Lammermoor* (London, 1893), p. 98.
45. For Lauder see (Lindsay Errington), *Master Class: Robert Scott Lauder and his pupils* (National Gallery of Scotland, Edinburgh, 1983).

VIII Scenes of Scottish Life and Character (pp. 156–174)

1. Hume, *Treatise*, ed. Selby-Bigge, p. xix.
2. Sir Gordon Gordon Taylor and E. W. Wallis, *Sir Charles Bell his Life and Times* (Edinburgh and London, 1958), p. 9.
3. Thomas Reid, 'Of the Human Mind', *Works* (1863), I, p. 187.
4. Dugald Stewart, *Elements*, I, p. 116.
5. Thomas Reid, *Inquiry* in *Works* (1863), I, p. 163.
6. Taylor and Wallis, *Charles Bell*, p. 21.
7. Sir Charles Bell, *Essays on the Anatomy of Expression in Painting* (London, 1806), p. 177.
8. Bell, *Anatomy of Expression* (3rd edn., London, 1845),

Introduction; B. R. Haydon, *Autobiography and Memoirs of Benjamin Robert Haydon*, ed. Tom Taylor (London, 1926), p. 33.

9. *Letters to Sir Charles Bell selected from his correspondence with his brother George Joseph Bell* (London, 1870), pp. 65–66.

10. Quoted by John W. Mollet, *Sir David Wilkie* (London, 1881), p. 8.

11. Allan Cunningham, *Life of Sir David Wilkie* (London, 1843), 3 volumes, I, pp. 61, 352.

12. Bell, *Anatomy of Expression* (1806), p. 5.

13. 5 July 1805, *Letters of Sir Charles Bell*, p. 53.

14. Bell, *Anatomy of Expression* (1806), pp. 2–3.

15. Ibid., p. 7.

16. Ibid., p. 10.

7. See above p. 146.

18. Quoted Cunningham, *Wilkie*, I, p. 44.

19. Wilkie to Sir Robert Liston, 16 March 1824, National Library of Scotland, MS. 5671.

20. Cunningham, *Wilkie*, I, p. 57; Arthur Marks, 'The Paintings of Sir David Wilkie to 1825', unpublished PhD. thesis, University of London, 1968, p. 59.

21. Marks, op. cit. p. 43.

22. Robert Burns, *Complete Poems* (Oxford, 1968), p. 89.

23. Cunningham, *Wilkie*, I, p. 112.

24. Ibid., I, p. 161.

25. Ibid., I, p. 162.

26. Ibid., I, p. 235.

27. e.g. letter of 12 September 1812, to Mrs Coppard, National Library of Scotland, MS. 3649 52, and letter of 18 October 1816, to Perry Nursey, Trinity College, Cambridge, Dawson Turner MSS.

28. Bell, *Anatomy of Expression* (1806), pp. 10–11, 14.

29. Cunningham, *Wilkie*, I, p. 352.

30. National Library of Scotland, MSS. 5319.

31. Marks, op. cit., p. 212, citing William Wilkie, *Fables* (London, 1768).

32. Cunningham, *Wilkie*, I, pp. 3–4.

33. William Wilkie, *Fables*, 'A Dialogue'.

34. Fergusson, *Scots Poems*, p. 83.

35. Burns, *Poems* (Oxford, 1968), p. 110.

36. Thomas Robertson, *Outline*, p. 43.

37. Wilkie's Journal for 1808 in Cunningham, I, p. 227; Hector MacNeill, *Bygane Times and Late come Changes* (3rd edn., Edinburgh, 1811), p. 41.

38. John Galt to Wilkie, 12 May 1807, National Library of Scotland, MS. 9835.15, quoted D. and F. Irwin, *Scottish Painters*, p. 171.

39. John Galt, *The Last of the Lairds* (1826; Edinburgh, 1976), p. 130.

40. *Report on the Agricultural State of the Kingdom, March-April 1816* (London, 1816), pp. 105–06: Sir John Sinclair, *General Report on the Agricultural and Political State of Scotland 1816*, (London, 1816), 6 volumes, IV, p. 313.

41. *Memoirs and Recollections of the late Abraham Raimbach*, ed. M.T.S. Raimbach (London, 1843), p. 163.

42. Bell, *Anatomy of Expression* (1806), p. 156.

43. Ibid., pp. 19–20.

44. Ramsay, *The Gentle Shepherd*, Act I, Scene 2, lines 128, 138–41, Ramsay, *Works*, II, p. 222.

45. Cunningham, *Wilkie*, I, p. 233.

46. J. G. Lockhart, *Life of Sir Walter Scott* (Edinburgh, 1903), 10 volumes, V, p. 50.

47. Marx, op. cit., p. 262.

48. Quoted ibid., pp. 263–64.

49. See chapter v, n. 24.

50. 28 July 1822, Trinity College, Cambridge, Dawson Turner MSS.

51. See Duncan Macmillan, *Walter Geikie* (Talbot Rice Art Centre, 1984).

52. Brydall, *Art in Scotland*, p. 211.

IX Artists and Evangelicals (pp. 175–186)

1. George Elder Davie, *The Scottish Enlightenment* (Historical Association General Series 99, 1981), p. 18.

2. W. Ferguson, *Scotland 1689 to the Present* (Edinburgh, 1968), p. 313.

3. Henry Cockburn, *Journal of Henry Cockburn 1831–54* (Edinburgh, 1874), quoted David Daiches, *The Paradox of Scottish Culture* (London, 1964), p. 50.

4. Cunningham, *Wilkie*, I, p. 241.

5. Ibid., II, p. 80.

6. Ibid., III, p. 54.

7. Ibid., II, p. 93; see also (Lindsay Errington), *Tribute to Wilkie* (National Gallery of Scotland, Edinburgh, 1985), p. 73.

8. Cunningham, *Wilkie*, III, p. 123.

9. Wilkie to John Smith, 29 September and 7 October 1817 and 4 and 16 March 1818, National Library of Scotland, MS 10995.

10. Gilbert Goudie, *David Laing, LlD* (Edinburgh, 1913), p. 259.

11. Thomas M'Crie, *Life of John Knox* (Edinburgh, 1812), pp. 210–12; see also Ramsay, *On Taste*, quoted above p. 146.

12. 9 September 1830, National Library of Scotland, MS 3812.

13. Douglas Jerrold to Wilkie, 15 February 1832, National Library of Scotland, MS. 9836.47.

14. See Raeburn to Wilkie, 12 March 1823, National Library of Scotland, MS. 9835.162.

15. Professor Hamish Miles lecture in St Andrews, 1983.

16. Errington, *Tribute to Wilkie*, pp. 77–79.

17. M'Crie, *Knox*, p. 129.

18. Cunningham, *Wilkie*, III, p. 233.

19. Errington, *Tribute to Wilkie*, p. 77.

20. See above p. 71.

21. Wilkie to Sir William Knighton, 5 January 1831, Mitchell Library, Glasgow, quoted Errington, *Tribute to Wilkie*, p. 71.

22. National Library of Scotland, MS. 3278.75.

23. Wilkie to Sir Willoughby Gordon, 8 October 1839, and Gordon to Wilkie, 14 October 1839, National Library of Scotland, MS. 7901.

24. 5 October 1839, National Library of Scotland, MS. 7901.

25. Untraced reference. National Library of Scotland.

26. (Sara Stevenson), *D. O. Hill and Robert Adamson, Catalogue of Calotypes* (Scottish National Portrait Gallery, Edinburgh, 1981), pp. 8–9.

27. *Proceedings of the Royal Society 1868–9*, 17, pp. xix–xxiv.

Catalogue
of
Exhibited Works

The page reference at the end of the catalogue entry refers to the principal point in the text where the picture is discussed.

CHAPTER I (Cat. 1–11)

William Aikman (1682–1731)

1 *Self-Portrait* PLATE 1
Canvas, 77.4 × 62.9 cm. National
Galleries of Scotland, Edinburgh.
[p.9]

2 *William Carstares* c. 1712–15
PLATE 6
Canvas, 127 × 121.6 cm. University of
Edinburgh.
William Carstares (1649–1715) was
principal of the University of
Edinburgh and had previously been
Chaplain to William of Orange. He
was one of the principal architects of
the presbyterian settlement in
Scotland. [p.12]

3 *Lady Grisel Baillie* PLATE 5
Canvas, 76.2 × 63.3 cm. The Lord
Binning, Mellerstain.
Lady Grisel Baillie (1665–1746) was a
poetess and author of several well-
known Scots poems. She contributed
to Allan Ramsay's *Tea Table
Miscellany*. [p.14]

4 *Sir Hew Dalrymple, Lord North
Berwick* 1722 PLATE 7
Signed and dated. Canvas,
127 × 101.6 cm. Faculty of Advocates,
Edinburgh.
Sir Hew Dalrymple (1652–1737), was
a Scottish judge and Lord President of
the Court of Session from 1698. [p.14]

5 *Anne and Elizabeth Clerk* 1730
COLOUR PLATE 5
Canvas, 60.5 × 74.5 cm. Sir John
Clerk of Penicuik. [p.14]

Roderick Chalmers (op. 1721–30)

6 *The Edinburgh Trades at Holyrood*
1720 PLATE 8
Canvas, 104.4 × 182.1 cm. In the
collection of the Trades Maiden
Hospital on loan from the Joint
Incorporation of Wrights and Masons
of Edinburgh. [p.17]

Sir John Medina (1655/60–1710)

7 *Two of the Artist's Children* PLATE 3
Canvas, 75.9 × 63.5 cm. Private
collection. [p.9]

James Norie (1684–1757)

8 *Landscape with Classical Ruins*
PLATE 2
Canvas, 43 × 120 cm. James
Holloway Esq. [p.9]

9 *Landscape with an Imaginary View of
Linlithgow* c.1740 PLATE 26
Panel, 29.5 × 67.8 cm. Private
collection.
This was probably originally part of
the decoration of a panelled room like
that which survives at Drylaw House,
Edinburgh. [p.45]

John Smibert (1688–1751)

10 *Allan Ramsay Senior* 1717 PLATE 4
Canvas, 77.5 × 65.5 cm. National
Galleries of Scotland, Edinburgh.
Allan Ramsay (1685–1758) the poet
was father of Allan Ramsay the
painter. He was a wig maker by trade
but his energy and diverse interests
made him a central figure in Scottish
literary and artistic life. [p.12]

Richard Waitt (d. 1732)

11 *Still-Life with Cauliflowers and a
Leg of Lamb* 1724 COLOUR PLATE 2
Signed and dated. Canvas,
59.3 × 78.5 cm. National Galleries of
Scotland, Edinburgh. [p.13]

CHAPTER II (Cat. 12–30)

David Martin (1736/7–98)

12 *Hugh Blair*
Canvas, 75.6 × 62.5 cm. University of
Edinburgh.
Hugh Blair (1718–1800), professor of
rhetoric and belles-lettres in the
University of Edinburgh, was a
literary critic and champion of James
Macpherson. [pp.52, 54]

Allan Ramsay (1713–84)

13 *Agnes Murray Kynnynmond* 1739
COLOUR PLATE 1
Signed and dated. Canvas,
105 × 145 cm. Private collection.
[p.20]

14 *Anne Bayne, Mrs Allan Ramsay*
c. 1740 PLATE 10
Canvas, 68.3 × 54.7 cm. National
Galleries of Scotland, Edinburgh.
Anne Bayne was the artist's first wife,
whom he married in 1739. She died in
1743. [p.20]

15 *Self-Portrait* c.1740 PLATE 11
59.7 × 45.7 cm. National Portrait
Gallery, London. [p.20]

16 *Archibald Campbell, 3rd Duke of
Argyll* 1749 COLOUR PLATE 3
Canvas, 238.8 × 156.2 cm. Glasgow
Art Gallery and Museum. [p.21]

17 *Janet Dick* 1748 COLOUR PLATE 4
Signed and dated. Canvas,
73.5 × 61.5 cm. (sight size).
Prestonfield House Hotel.
In 1736 she secretly married her
cousin, Alexander Dick, Ramsay's
companion in Italy, later Sir
Alexander Dick Cunnynghame of
Prestonfield. [p.21]

18 *Sir Hew Dalrymple, Lord
Drummore* 1754 PLATE 13
Canvas, 127.6 × 99.7 cm. Private
collection.
Hew Dalrymple, Lord Drummore
(1690–1755), was the second son of
Sir Hew Dalrymple, Lord North
Berwick (see 4 above). He was created
Lord of Session in 1726. [p.23]

19 *Study for Sir Hew Dalrymple, Lord
Drummore* 1754 PLATE 12
Black and white chalk with red
shading on grey paper,
42.9 × 29.1 cm. National Galleries of
Scotland, Edinburgh. [p.23]

20 *A Man's Left and Right Hands (Lord
Drummore).* 1754
Red chalk on brown paper,
24.5 × 34.2 cm. National Galleries of
Scotland, Edinburgh. [p.23]

21 *Two Studies of a Lady's Right Forearm and Hand Holding a Fan (Queen Charlotte)* c. 1762–65
PLATE 14
Red and white chalk, 18.8 × 23.3 cm. National Galleries of Scotland, Edinburgh.
These studies for the portrait of Queen Charlotte holding a fan were formerly in Cullen House. [p.24]

22 *Margaret Lindsay, Mrs Allan Ramsay* c. 1757 COLOUR PLATE 6
Canvas, 76.2 × 63.5 cm. National Galleries of Scotland, Edinburgh.
Margaret Lindsay was the artist's second wife, whom he married in 1752 in Edinburgh without the consent of her father, Sir Alexander Lindsay of Evelick, with whom she was never reconciled. She died in 1780. [p.27]

23 *A Woman's Hand with a Rose, Study for Margaret Lindsay.*
Red chalk, 19.2 × 19.5 cm. National Galleries of Scotland, Edinburgh. [p.27]

24 *Margaret Lindsay* c. 1757 PLATE 15
Red chalk on grey paper, 37.1 × 27.1 cm. National Galleries of Scotland, Edinburgh. [p.27]

25 *Dr William Hunter* c. 1760 COLOUR PLATE 7
Canvas, 95.9 × 74.9 cm. Hunterian Art Gallery, University of Glasgow.
Doctor and anatomist, Hunter (1718–83), was the first professor of anatomy at the Royal Academy. He was a friend of Ramsay and left his remarkable collections, both artistic and scientific, to the University of Glasgow to found the Hunterian Museum. [p.27]

26 *Anne Broun* 1763 COLOUR PLATE 9
Canvas, 66 × 79 cm. Private collection. [p.27]

27 *Martha, Countess of Elgin* 1762
COLOUR PLATE 8
Canvas, 65 × 78 cm. Earl of Elgin and Kincardine KT.
Martha, Countess of Elgin (d. 1810), was the daughter of Thomas White and married Charles Bruce, Earl of Elgin, in 1759. [p.27]

28 *Two Studies for a Lady with a Muff (Martha, Countess of Elgin)* 1762
Black and white chalk, 26 × 40 cm. National Galleries of Scotland, Edinburgh. [p.19]

29 *David Hume* 1766 PLATE 17
Canvas, 76.2 × 63.5 cm. National Galleries of Scotland, Edinburgh.
The philosopher and historian David Hume was the leading international figure in the first stage of the Scottish Enlightenment and one of its most influential thinkers. [p.27]

30 *Anne Bruce, Mrs Bruce of Arnot* c.1765 COLOUR PLATE 10
Canvas, 73.7 × 61 cm. National Galleries of Scotland, Edinburgh.
Anne Bruce was the wife of Thomas Bruce and daughter of Sir John Bruce, Bart. [p.29]

CHAPTER III (Cat. 31–9)

Gavin Hamilton (1723–98)

31 *The Anger of Achilles for the Loss of Briseis* by Domenico Cunego after Gavin Hamilton, 1769 PLATE 18
Engraving. Private collection. [pp.33–40]

32 *Achilles mourning Patroclus* by Domenico Cunego after Gavin Hamilton, 1763 PLATE 20
Engraving. Private collection. [pp.33–40]

33 *Achilles' Revenge upon the Body of Hector* by Domenico Cunego after Gavin Hamilton, 1764 PLATE 21
Engraving. Private collection. [pp.33–40]

34 *Priam pleading with Achilles for the Body of Hector* by Domenico Cunego after Gavin Hamilton, 1775
Engraving. Private collection. [pp.33–40]

35 *Priam pleading with Achilles for the Body of Hector* c.1775 PLATE 22
Canvas, 63.5 × 99.1 cm. The Tate Gallery, London. [pp.33–40]

36 *Andromache mourning the Death of Hector* by Domenico Cunego after Gavin Hamilton, 1764 PLATE 23
Engraving. Private collection. [pp.33–40]

37 *Sketch for Andromache mourning the Death of Hector* c.1759
Canvas, 64.2 × 98.5 cm. National Galleries of Scotland, Edinburgh. [pp.33–40]

38 *Agrippina with the Ashes of Germanicus* Exhibited RA 1772
PLATE 25
Canvas, 182.2 × 257.2 cm. The Tate Gallery, London. [p.42]

39 *The Oath of Brutus* by Domenico Cunego after Gavin Hamilton, 1766
PLATE 24
Engraving, 35.6 × 38.1 cm. Private collection. [p.41]

CHAPTER IV (Cat. 40–76)

John Brown (1749–87)

40 *Basilica of Constantine and Maxentius, Rome, with a scene of Murder* c. 1774–76
Pen, 37 × 56.8 cm. National Galleries of Scotland, Edinburgh. [pp.61–2]

41 *Two Men in Conversation* c. 1775–80 PLATE 45
Ink, pencil, brown and grey washes, 25.6 × 22.2 cm. Witt Collection, Courtauld Institute, London. [p.62]

42 *A Mythological Scene*
Pen and wash, 32.5 × 21.4 cm. The Trustees of the British Museum. [p.62]

43 *Study of Heads of Monks* 1775–80
Pencil on paper, 24.9 × 18.2 cm. Kent County Museums Service. [p.62]

Alexander Runciman (1736–85)

44 *King Lear on the Heath* c. 1767
PLATE 30
Pen on paper, 27.9 × 48.9 cm. National Galleries of Scotland, Edinburgh. [p.47]

45 *The Tomb of the Horatii* 1767–68
Pen and wash, 20.3 × 30.5 cm. The Hon. W. G. Runciman. [p.45]

46 *Achilles among the Daughters of Lycomedes* 1770
Pen and wash, 22 × 31 cm (approx). Viscount Runciman of Doxford. [p.51]

47 *Achilles and Pallas* 1769–70
PLATE 34
Pen and ink, 35.6 × 22.4 cm. National Galleries of Scotland, Edinburgh.
Formerly identified as Perseus and the Medusa, this represents part of the opening scene of the *Iliad*, the quarrel of Achilles and Agamemnon. [pp.51–2]

48 *The Marriage of Peleus and Thetis* 1770–71
Pen and ink, 44.2 × 59.8 cm. National Galleries of Scotland, Edinburgh.
This was the first proposal for the central part of the ceiling at Penicuik House, which was eventually painted with the scene of Ossian singing. Peleus, a mortal, was married to the sea-nymph Thetis; according to Ovid this was against her will, but Homer (*Iliad* xxiv) describes their wedding. Achilles was their offspring. [pp.51–2]

49 *The Origin of Painting* 1773
COLOUR PLATE 16
Signed and dated. Canvas, 61 × 114.5 cm. Private collection. [p.52, *cf.* pp.161, 174]

50 *Ossian Singing* c. 1770 PLATE 35
Pen and ink, in a bound volume of
drawings. Viscount Runciman of
Doxford. [p.52]

51 *Ossian's Hall* by G. Carelli after
Alexander Runciman, 1878 COLOUR
PLATE 14
Watercolour. Private collection.
A nineteenth-century watercolour of
the Hall of Ossian at Penicuik House,
destroyed by fire in 1899. [p.52–8]

52 *Ossian Singing* 1772 COLOUR
PLATE 15
Pen and brown wash touched with
oil, oval, 46.7 × 59.9 cm. National
Galleries of Scotland, Edinburgh.
[p.54]

53 *The Death of Oscar* 1772 PLATE 36
Pencil, pen and wash, 34.3 × 49.2 cm.
National Galleries of Scotland,
Edinburgh.
A drawing for the painting in the
Hall of Ossian. It is inscribed '4 ft by
5 ft', the size of the painting. [p.54]

54 *Fingal and Conban Carglâ* c. 1772–
74 PLATE 39
Etching, 15 × 24.6 cm. Private
collection. (See 55 below.) [pp.55–6]

55 *Fingal and Conban Carglâ* c. 1772
Etching, 14.6 × 8.5 cm. Private
collection.
With 54, after the composition of this
subject in the Hall of Ossian.
[pp.55–6]

56 *Study of a Tree* c. 1772 PLATE 40
Red chalk, 50.2 × 31.8 cm. National
Galleries of Scotland, Edinburgh.
[p.56]

57 *St Margaret landing at Dunfermline*
c. 1772 PLATE 38
Etching, 22 × 18.4 cm. Private
collection.
After the composition of this subject
in the staircase at Penicuik House.
[pp.55–6]

58 *The Marriage of St Margaret and
King Malcolm* c. 1772
Etching, 22 × 18.3 cm. Private
collection.
After the composition of this subject
in the staircase at Penicuik House.
[pp.55–6]

59 *River God (The Tay)* 1772 PLATE 37
Pen on paper, in a bound volume of
drawings. Viscount Runciman of
Doxford.
A study for the ceiling of Ossian's
hall. [p.55]

60 *Moses* c. 1773 PLATE 41
Pen and wash. Private collection.
A study for one of the figures in the
Cowgate chapel (now St Patrick's
church), Edinburgh. [p.56]

61 *Agrippina with the Ashes of
Germanicus* Exhibited RA, 1780
COLOUR PLATE 17
Canvas, 101.6 × 127 cm. Viscount
Runciman of Doxford. [p.59, cf. p.42]

62 *Agrippina with the Ashes of
Germanicus* c. 1780
Pen and wash, 42.3 × 55.2 cm.
National Galleries of Scotland,
Edinburgh. [p.59, cf. p.42]

63 *Agrippina mourning over the Ashes
of Germanicus* c. 1772 PLATE 43
Etching, 14.6 × 10.1 cm. Private
collection. [p.59, cf. p.42]

64 *Self-Portrait with John Brown* 1784
COLOUR PLATE 19
Canvas, 63.6 × 76.5 cm. With the
permission of the Trustees of the
National Museum of Scotland (on
loan to the Scottish National Portrait
Gallery). [p.61]

65 *The Allegro with a Distant View of
Perth* 1773 COLOUR PLATE 18
Signed and inscribed. Canvas,
75 × 63.5 cm. The Hon. Sir Steven
Runciman.
The *Allegro* refers to Milton's poem
of that title, the imagery of which
Runciman has matched to the real
landscape near Perth. [p.64]

66 *An East Lothian Landscape with a
Pond in the Foreground*
Pen and watercolour, 19.7 × 32.4 cm.
National Galleries of Scotland,
Edinburgh. [p.60]

67 *Moonlit Landscape with Fountain*
Black and red chalk with grey wash
heightened with white, 21 × 27 cm.
The Trustees of the British Museum.
[p.60]

John Runciman (1744–68)

68 *The Taking down of the Netherbow
Port, Edinburgh* 1764 PLATE 28
Etching, 20.6 × 15.6 cm. National
Galleries of Scotland, Edinburgh.
The eastern gate of the city of
Edinburgh was taken down in 1764 to
improve traffic circulation. [pp.46–7]

69 *Hagar in the Desert* c. 1766
Canvas, 17.8 × 27.9 cm. Private
collection. [p.46]

70 *The Flight into Egypt* c. 1766
PLATE 29 (Not exhibited)
Panel, 29.9 × 22.3 cm. National
Galleries of Scotland, Edinburgh.
[p.46]

71 *Adoration of the Shepherds* c. 1766
COLOUR PLATE 13
Panel, 23.5 × 16.5 cm. The Hon. Sir
Steven Runciman. [p.46]

72 *King Lear in the Storm* 1767
COLOUR PLATE 12

Signed and dated. Panel, 44.4 × 61 cm.
National Galleries of Scotland,
Edinburgh. [pp.47–9]

73 *Portrait of Alexander Runciman and
a Study of a Satyr (the Belvedere
Torso)* 1767–68
Pencil, 16.1 × 13.0 cm. National
Galleries of Scotland, Edinburgh.
The figure of the satyr is a completion
of the Belvedere Torso. [p.50]

74 *Self-Portrait* 1767–68 PLATE 31
Canvas, 68.7 × 55.6 cm. With the
permission of the Trustees of the
National Museum of Scotland (on
loan to the Scottish National Portrait
Gallery).
This is the only large work to survive
from John Runciman's brief sojourn
in Rome. According to his brother, he
destroyed as much of his work as he
could shortly before his death. [p.49]

75 *The Return of the Prodigal Son*
c. 1768 PLATE 32
Etching, 15 × 18.7 cm. National
Galleries of Scotland, Edinburgh.
The identification of the subject is not
certain. [p.50]

David Scott (1806–49)

76 *Lear and Cordelia* PLATE 42
Oil on paper laid on panel,
13.3 × 19.7 cm. Private collection.
[p.60]

CHAPTER V (Cat. 77–97)

David Allan (1744–96)

77 *Neapolitan Dance* c. 1770
Pen and wash, 32.7 × 27.3 cm. From
the Dunimarle Album. On loan to the
National Galleries of Scotland.
A study for a large painting now lost.
This album was probably formerly
the property of Magdalene Sharpe
Erskine's brother, Sir James Erskine
of Torrie, a pupil of David Allan.
[p.65]

78 *The Opening of the Roman
Carnival* 1775
Pen and wash, 37.5 × 53.3 cm. By
gracious permission of Her Majesty
The Queen. [pp.65–6]

79 *The Victor conducted in Triumph
(from the Roman Carnival)* c. 1775
PLATE 46
Pen and wash, 39.8 × 55.1 cm. By
gracious permission of Her Majesty
The Queen. [pp.65–6]

80 *Romans, Polite to Strangers (from
the Roman Carnival)* c. 1775
Pen and wash, 38.8 × 55.1 cm. By
gracious permission of Her Majesty
the Queen. [pp.65–6]

81 *The Horse Race at Rome during the Corso (from the Roman Carnival)* c. 1775
Pen and wash, 38.8 × 52.56 cm. By gracious permission of Her Majesty The Queen. [p.65–6]

82 *The Procidan Girl* 1776 PLATE 47
Canvas, 50.1 × 34.3 cm. The Duke of Hamilton.
A costume study from the island of Procida in the Bay of Naples. [p.66]

83 *The Highland Dance* 1780 COLOUR PLATE 20
Canvas, 101.6 × 151.7 cm. Margaret Sharpe Erskine Trust (on loan to the National Galleries of Scotland). [p.66]

84 *The Stool of Repentance* 1795 PLATE 48
Pen and watercolour, 33.4 × 45.3 cm. National Galleries of Scotland, Edinburgh. [p.66]

85 Allan Ramsay's *The Gentle Shepherd with twelve plates by David Allan*
Glasgow, 1788. Edinburgh University Library, from the library of Dugald Stewart. [pp.66–9]

86 *Sir William Worthy and Patie (from The Gentle Shepherd)* 1789
Pen and watercolour, 23.5 × 17.5 cm. National Galleries of Scotland, Edinburgh. [pp.66–9]

87 *Glaud and Peggy (from The Gentle Shepherd)* 1789 PLATE 49
Etched outline and watercolour, 23.1 × 18.2 cm. National Galleries of Scotland, Edinburgh. [pp.66–9]

88 *Madge and Bauldy (from The Gentle Shepherd)* 1789
Pen and watercolour, 23.3 × 18.1 cm. National Galleries of Scotland, Edinburgh. [pp.66–9]

89 *Sir William Worthy, Symon and Bauldy (from The Gentle Shepherd)* 1789.
Etched outline and watercolour, 23 × 18 cm. National Galleries of Scotland, Edinburgh. [pp.66–9]

90 *Sir William Worthy and Patie (from The Gentle Shepherd)* 1789
Outline etching and watercolour, 23 × 18 cm. National Galleries of Scotland, Edinburgh. [pp.66–9]

91 *Original designs for Scottish Songs* c. 1790
Bound volume of drawings. Royal Scottish Academy, Edinburgh.
The volume was probably formerly the property of George Thomson. [p.70]

92 *Songs of the Lowlands of Scotland. Carefully compared with the original editions and embellished with characteristic designs composed and engraved by the late David Allan.*
Edinburgh, 1798. Edinburgh City Library. [p.70]

93 *The Gaberlunzie Man* 1793–94
Black and white chalk on prepared paper, oval, 28.2 × 42 cm. The Trustees of the British Museum.
A large version of a drawing that was etched and published in *Songs of the Lowlands of Scotland*. [pp.70–1]

94 *John Anderson, My Jo* 1793
Etching, oval, 14.9 × 18.2 cm. National Galleries of Scotland, Edinburgh. [pp.70–1]

95 *The Gaberlunzie Man* c. 1794 PLATE 51
Etching, 12.7 × 8.5 cm. National Galleries of Scotland, Edinburgh. [pp.70–1]

96 *The Penny Wedding* 1795 PLATE 50
Pen and watercolour, 33.4 × 45.1 cm. National Galleries of Scotland, Edinburgh. [pp.71–3]

James Cumming (1732–93)

97 *William Macgregor, an Edinburgh Porter* c. 1780
Canvas, 76.2 × 62.3 cm. City of Edinburgh Art Centre. [p.63]

CHAPTER VI (Cat. 98–122)

David Deuchar (1745–1808)

98 *Skating Figure* from *A Collection of Etchings After The Most Eminent Masters* 1803 PLATE 53
Private collection. [p.75, *cf.* p.159]

William Dyce (1806–64)

99 *John Small and his Son* c. 1834
Canvas, 75.6 × 62.5 cm. University of Edinburgh.
John Small (d. 1854) and his son John Small junior (1828–86), were both librarians to the University of Edinburgh. [p.136]

Robert Scott Lauder (1803–69)

100 *John Gibson Lockhart and his Wife, Charlotte Sophia Scott* c. 1844 COLOUR PLATE 28
Canvas, 76.8 × 64.8 cm. National Galleries of Scotland, Edinburgh.
The portrait of Mrs Lockhart is posthumous. [p.136]

Sir Henry Raeburn (1756–1823)

101 *James Veitch, Lord Eliock* c. 1787
Canvas, 127 × 101.6 cm. Faculty of Advocates, Edinburgh.
James Veitch (1712–93), was a judge, Lord of Session, scholar, and a friend and correspondent of Frederick the Great of Prussia. [p.75]

102 *Neil Gow* c. 1793 COLOUR PLATE 21
Canvas, 123.2 × 97.8 cm. National Galleries of Scotland, Edinburgh.
Neil Gow (1727–1807), the most celebrated exponent of Scots fiddle music, was born and died at Inver near Dunkeld. [pp.74, 77–8]

103 *Janet Dundas* c. 1790 COLOUR PLATE 23
Canvas, 76 × 61.5 cm. Private collection. [p.77]

104 *Dr Nathaniel Spens* 1791 PLATE 54
Canvas, 236.8 × 149.2 cm. Queen's Bodyguard for Scotland (Royal Company of Archers).
The portrait was commissioned in 1791 by the Queen's Bodyguard for Scotland, the Royal Company of Archers, whose uniform Spens wears. [p.77]

105 *Sir John and Lady Clerk of Penicuik* 1792 COLOUR PLATE 22
Canvas, 145 × 206 cm. The Beit Collection, Russborough, Co. Wicklow.
This was Raeburn's first picture to be exhibited in London, being shown at Boydell's Shakespeare Gallery in 1792. The background is the estate at Penicuik, and the landscape that inspired Ramsay's *The Gentle Shepherd*. [p.77]

106 *Isabella McLeod, Mrs James Gregory* c. 1798 COLOUR PLATE 25
Canvas, 127 × 101.6 cm. National Trust for Scotland (on display at Fyvie Castle, Aberdeenshire).
Isabella McLeod married in 1796 Dr James Gregory, a friend of Raeburn and cousin and correspondent of Thomas Reid. [pp.80, 129]

107 *Baillie William Galloway* 1798 PLATE 56
Canvas, 74 × 61 cm. The Company of Merchants of the City of Edinburgh. [p.131]

108 *Mrs James Campbell* c. 1805 PLATE 55
Canvas, 76.2 × 63.5 cm. Private collection.
A first cousin of James Watt, she is reputed to have been the mother of sixteen children. [p.129]

109 *Lord Newton* c. 1806 COLOUR PLATE 26
Canvas, 127 × 101.6 cm. The Earl of Rosebery.
Lord Newton (1740–1811) is seen in the robes of a Lord of Session which he became in 1806. [p.131]

110 *General Francis Dundas and his Wife (Eliza Cumming)* c. 1812
PLATE 57
Canvas, 101.6 × 127 cm. Private collection.
Dundas was a distinguished soldier and became a general in 1812. [pp.132–3]

111 *Colonel Alasdair Mcdonnell of Glengarry* 1812 COLOUR PLATE 27
Canvas, 241.3 × 149.9 cm. National Galleries of Scotland, Edinburgh.
Alasdair Mcdonnell (1771–1828) was chief of the Mcdonnells of Glengarry. [p.132]

112 *Mrs Jameson (née Haig)* c. 1822
PLATE 60
Canvas, 86.3 × 77.3 cm. Irish Distillers Group. [p.134]

113 *Professor George Joseph Bell*
Canvas, 127 × 101.6 cm. Faculty of Advocates, Edinburgh.
Bell (1770–1843) was professor of law at the University of Edinburgh, brother of Sir Charles Bell and close friend of Raeburn. [p.156]

114 *Francis Horner* c. 1816
Canvas, 76.2 × 63.5 cm. National Galleries of Scotland, Edinburgh.
The political economist Francis Horner (1778–1817) was a member of the *Edinburgh Review* circle. He trained at the English bar and became a member of parliament. [p.134]

115 *John Clerk, Lord Eldin* 1820
PLATE 58
Canvas, 128.2 × 101.6 cm. National Galleries of Scotland, Edinburgh.
Lord Eldin (1757–1832) was a Scottish judge and Lord of Session. He was the son of John Clerk of Eldin (see Cat. 118) and a lifelong friend of Raeburn. Lord Eldin formed an important art collection which was dispersed at his death. [p.134]

116 *Mrs Pitcairn* c. 1820
Canvas, 101.6 × 76.2 cm. Royal Scottish Academy, Edinburgh. [p.134]

117 *John Pitcairn of Pitcairn* c. 1820
PLATE 59
Canvas, 101.6 × 76.2 cm. Royal Scottish Academy, Edinburgh. [p.134]

Archibald Skirving (1749–1819)

118 *John Clerk of Eldin* c. 1795
PLATE 61
Pastel, 58.7 × 49.2 cm. Private collection.
John Clerk of Eldin (1728–1812) was the son of Sir John Clerk of Penicuik and was an amateur etcher (see Cat. 115). He wrote *Naval Tactics* a book that was influential in naval warfare but was also indirectly the

stimulus for Patrick Miller's steamship (see plate 66). [p.135]

119 *Gavin Hamilton* COLOUR PLATE 11
Pastel, 61 × 48.7 cm. National Galleries of Scotland, Edinburgh. [p.135]

120 *Portrait drawing of an unknown boy*
Red chalk, 26 × 19.5 cm. Private collection. [p.135]

121 *Portrait drawing of an unknown woman*
Red chalk, 26 × 20 cm. Private collection. [p.135]

John Watson Gordon (1788–1864)

122 *Margaret Oliphant of Gask* 1829
Panel, 26.7 × 21.6 cm. Private collection. [p.136]

CHAPTER VII (Cat. 123–55)

Robert Barker (1739–1806)

123 *Panorama of Edinburgh from the Calton Hill* 1792
Watercolour, 41 × 326 cm. Edinburgh University Library
The drawing encompasses the whole of a 360° view. [p.144]

John Clerk of Eldin (1728–1812)

124 *View of Edinburgh with Salisbury Crags and the Wrytes Houses* c. 1775
PLATE 62
Etching, 15.4 × 38.5 cm. W. Jackson Esq. [p.137]

John Knox (1778–1845)

125 *The Trongate, Glasgow* c. 1826
PLATE 68
Canvas, 90.2 × 125.1 cm. Glasgow Art Gallery and Museum . [p.146]

Robert Scott Lauder (1803–69)

126 *A Border Keep* c. 1831 COLOUR PLATE 36
Canvas laid on panel, 40.6 × 53.3 cm. James Holloway Esq. [p.155]

127 *View in the Campagna* c. 1833
PLATE 77
Canvas, 38.1 × 88.5 cm. (sight size). Private collection. [p.155]

Horatio McCulloch (1805–67)

128 *Cadzow Forest* c. 1835
Canvas, 68.6 × 40.6 cm. James Lees-Milne Esq. [p.155]

Jacob More (1740?–93)

129 *Cora Linn* 1771 COLOUR PLATE 29
Canvas, 79.4 × 100.4 cm. National Galleries of Scotland. [pp.138–40]

130 *Stonebyres Linn* 1771–73
FRONTISPIECE
Canvas, 80.3 × 100.6 cm. The Tate Gallery, London. [pp.138–40]

131 *Bonnington Linn* 1771–73
PLATE 63
Canvas, 80 × 100 cm. The Syndics of the Fitzwilliam Museum, Cambridge. [pp.138–40]

132 *Morning* 1785 COLOUR PLATE 30
Canvas, 152.4 × 203.2 cm. Glasgow Art Gallery and Museum. [p.139]

133 *Evening* 1785
Canvas, 152.4 × 203.2 cm. Glasgow Art Gallery and Museum. [p.139]

Alexander Nasmyth (1758–1840)

134 *Edinburgh from St Anthony's Chapel* 1789 PLATE 67
Signed and dated. Pen, watercolour and bodycolour, 32 × 45.3 cm. National Galleries of Scotland, Edinburgh. [p.143]

135 *Castle Huntly and the Tay* c. 1800
PLATE 65
Canvas, 114.9 × 170.8 cm. Dundee Art Gallery and Museums. [pp.141, 144]

136 *West Loch Tarbert looking Southwest from Escart* c. 1802
Canvas, 85.1 × 121.9 cm. Private collection. [pp.144–5]

137 *East Loch Tarbert with Castle and Harbour of Tarbert* c. 1802
Canvas, 85.1 × 121.9 cm. Private collection. [pp.144–5]

138 *West Loch Tarbert looking South with the Road to Campbelltown over the Carrick* c. 1802 COLOUR PLATE 32
Canvas, 85.1 × 121.9 cm. Private collection. [p.144–5]

139 *West Loch Tarbert looking North* 1802 COLOUR PLATE 33
Signed and dated. Canvas, 85.1 × 121.9 cm. Private collection. [p.144–5]

140 *A Farmyard Gate* 1807 PLATE 64
Signed and dated. Black chalk on paper, 14.5 × 22.6 cm. In the same mount: *A Barn*, 14.5 × 22.8 cm. National Galleries of Scotland, Edinburgh. [pp.140–1, cf. p.160]

141 *Two Walkers*
Coloured chalk on paper, 10.8 × 12.6 cm. In the same mount: *Women at a Well*, 10.5 × 13.3 cm. National Galleries of Scotland, Edinburgh. [pp.140–1, cf. p.160]

142 *Shipping at Leith* 1824
Canvas, 114 × 149.9 cm. City of Edinburgh Art Centre. [p.146]

143 *Princes Street with the Royal Institution Building under Construction* 1825 COLOUR PLATE 34
Signed and dated. Canvas, 119.4 × 160 cm. Sir David C. Baird, Bt.
The Royal Institution building, now known as the Royal Scottish Academy, was begun in 1822. The small figure in black seen from behind directing the workmen is probably the architect, William Playfair. [p.146]

144 *Edinburgh from the Calton Hill* 1825 COLOUR PLATE 35
Signed and dated. Canvas, 119.9 × 164.5 cm. Clydesdale Bank, Glasgow.
The marked northwest angle of the setting sun indicates midsummer. The fenced area in the foreground may denote the site of the new Royal High School, begun in 1825. The rock to the right had to be removed to make room for the new building. [p.146]

145 *Inveraray from the Sea* c. 1801 COLOUR PLATE 31
Canvas, 106.7 × 163.7 cm. Private collection. [p.145]

David Roberts (1796–1864)

146 *Church of the Nativity, Bethlehem* 1840 PLATE 70
Canvas, 111.8 × 142.2 cm. Paisley Museum and Art Gallery. [p.147, cf. p.184]

147 *Melrose Abbey* 1830 PLATE 69
Watercolour, 32.4 × 23.5 cm. Birmingham City Art Gallery. [p.147]

John Thomson of Duddingston (1778–1840)

148 *Fast Castle on a Calm Day* COLOUR PLATE 37
Panel, 46.5 × 59.5 cm. James Holloway Esq. [p.153]

149 *Newark Castle* c. 1829
Panel, 83.8 × 73.7 cm. The Duke of Buccleuch and Queensberry, KT., at Bowhill, Selkirk, Scotland. [p.155]

150 *Landscape Composition* PLATE 74
Canvas, 50.8 × 66.2 cm. National Galleries of Scotland, Edinburgh. [p.151]

151 *Urquhart Castle and Loch Ness* PLATE 76
Canvas, 91.5 × 122 cm. From a Scottish collection. [p.155]

152 *Fast Castle from Below, St Abb's Head in the Distance* PLATE 75
Panel, 50.2 × 76.2 cm. National Galleries of Scotland, Edinburgh.
The picture can possibly be identified with one exhibited in the Royal Institution for the Encouragement of the Fine Arts in Edinburgh in 1824. [p.153]

Hugh William Williams (1773–1829)

153 *View of Dunfermline Abbey* c. 1795 PLATE 71
Watercolour, 40.6 × 52.3 cm. Private collection. [p.171]

154 *The Ancient Temple at Corinth* 1820 PLATE 72
Watercolour on paper, laid on board, 42 × 61 cm. Thaddeus Crenshaw Esq. [p.148]

155 *The Falls of Braan*
Oil on panel, 23.8 × 33.3 cm. Royal Scottish Academy, Edinburgh. [p.148]

CHAPTER VIII (Cat. 156–185)

Sir William Allan (1782–1850)

156 *Christmas Eve* PLATE 88
Canvas, 73.5 × 90.2 cm. Aberdeen Art Gallery and Museums.
This picture was formerly known as *The Penny Wedding*. [p.173]

William Bonnar (1800–53)

157 *The Daughters of Thomas Chalmers* c. 1840 PLATE 91
Oil on board, 44.4 × 43.1 cm. Private collection. [p.173]

Alexander Carse (op. 1808–36)

158 *Oldhamstocks Fair* 1795 PLATE 80
Watercolour, 39.5 × 63.2 cm. National Galleries of Scotland, Edinburgh. [pp.157, 173]

159 *The Arrival of the Country Relations* c. 1812 PLATE 87
Canvas, 48.2 × 63.5 cm. The Duke of Buccleuch and Queensberry, KT., at Bowhill, Selkirk, Scotland. [p.173]

160 *The Return from the Hunt* COLOUR PLATE 44
Canvas, 62.2 × 73.7 cm. Private collection. [p.173]

Walter Geikie (1795–1837)

161 *Girl scouring a Pot Lid* c. 1830 PLATE 93
Pencil, 16 × 10.5 cm. Private collection.
The girl is possibly the same as in Cat. 162. [pp.173–4]

162 *May Rennie peeling Potatoes* 1830 PLATE 92
Black chalk, 18.5 × 14.4 cm. National Galleries of Scotland, Edinburgh.
This drawing was etched in *Studies from Nature* (see Cat. 163). [pp.173–4]

163 *Studies from Nature drawn and etched by Walter Geikie*. Published by H. Paton, Head of Horse Wynd, College, Edinburgh, 1831
Royal Scottish Academy, Edinburgh. [pp.173–4]

164 *The Drunk Man* c. 1830 COLOUR PLATE 43
Oil on millboard, 18.5 × 14 cm. Private collection. (Study for Cat. 166.) [p.174]

165 *Our Gudeman's a Drucken Carle* 1830 PLATE 94
Etching, 15.3 × 14.7 cm. Private collection. [p.174]

166 *He's just gotten Plenty for ae Day* 1830
Etching, 16 × 12.4 cm. Private collection. [p.174]

167 *They are Real Comfortable* 1830 PLATE 95
Etching, 14 × 12.3 cm. Private collection. [p.174]

168 *Show Jamie, James Beatson* c. 1826
Etching, 22.5 × 17.4 cm. Private collection. [p.174]

William Kidd (c. 1790–1863)

169 *John Toole the Actor in a Character Part* PLATE 90
Panel, 37 × 27 cm. Mr and Mrs Basil Skinner. [p.173]

Robert Scott Lauder (1803–69)

170 *The Italian Goatherd* c. 1833–38
Canvas, 43.5 × 31 cm. Dr Helena Taylor.

William Home Lizars (1788–1859)

171 *Engravings of the Great Fire, Edinburgh* 1824
Edinburgh City Libraries.
In November 1824 a great fire in the centre of the old town of Edinburgh destroyed a large number of the buildings in the vicinity of St Giles. [p.173]

172 *Interior of a Church*
Panel (unfinished), 121.3 × 95.3 cm. Royal Scottish Academy, Edinburgh. [p.173]

173 *Study for Interior of a Church*
Panel, 25.8 × 21 cm. Royal Scottish Academy, Edinburgh. [p.173]

Sir David Wilkie (1785–1841)

174 *Pitlessie Fair* 1804 PLATE 78
Signed and dated. Canvas, 58.5 × 106.7 cm. National Galleries of Scotland, Edinburgh. [pp.157–60]

175 *Study of a Cow and other Studies for Pitlessie Fair* c. 1804 PLATE 79

Pencil, 5.7 × 10.8 cm. National
Galleries of Scotland, Edinburgh.
[pp.157, 160]

176 *William Chalmers-Bethune, his
Wife Isabella Morison and their
Daughter Isabella* 1804 COLOUR
PLATE 39
Signed and dated. Canvas,
124.46 × 101.6 cm. National Galleries
of Scotland, Edinburgh. [p.157]

177 *The Blind Fiddler* 1806 COLOUR
PLATE 38
Oil on panel, 57.8 × 79.4 cm. The
Tate Gallery, London. [p.162]

178 *The Rent Day* 1807 (RA 1809)
Signed and dated. Panel, 63 × 88 cm.
Private collection. [pp.162–3]

179 *Blind Man's Buff; Sketch for the
picture in the Royal Collection*
1811 PLATE 81
Oil on panel, 30.1 × 45.7 cm. The
Tate Gallery, London. [pp.159, 163]

180a *Boys digging for a Rat* 1811
Oil on panel, 36 × 30 cm. Royal
Academy, London.
Wilkie's Diploma picture. [pp.159,
163]

180b *Studies for Boys digging for a Rat*
1811
Black and red chalk heightened with
white, 19.1 × 27.8 cm. The Trustees of
the British Museum. [p.163]

181 *Three Studies for The Letter of
Introduction* 1813
Head of a Boy PLATE 84 Black, red
and white chalk, 19.8 × 16.7 cm.
Study of Hands Black and red chalk,
21.6 × 27.9 cm. *Compositional Study*
Pen, 13 × 11.1 cm. National Galleries
of Scotland, Edinburgh. [p.165]

182 *Distraining for Rent* 1815 COLOUR
PLATE 40 and PLATE 83
Signed and dated. Panel,
81.3 × 123 cm. National Galleries of
Scotland, Edinburgh. [pp.166–70]

183 *The Penny Wedding* 1818 COLOUR
PLATE 42 and PLATE 82
Signed and dated. Exhibited RA 1819.
Oil on panel, 64.4 × 95.6 cm. By
gracious permission of Her Majesty
The Queen. [p.171]

184 *Five Studies for The Penny
Wedding* 1818
The Trustees of the British Museum.
[p.171]

185 *Pitlessie Mill* 1824 PLATE 86
Black and red chalk and watercolour,
33.3 × 51.4 cm. Ashmolean Museum,
Oxford.
The mill at Pitlessie, Fife, Wilkie's
home, belonged to his maternal
grandfather. [p.162]

CHAPTER IX (Cat. 186–207)

Sir William Allan (1782–1850)

186 *Death of the Regent Moray*
Exhibited 1829 PLATE 100
Canvas, 30 × 48.5 cm. Mr and Mrs
Basil Skinner.
James Stewart, Earl of Moray, Regent
of Scotland and leader of the
opposition to Queen Mary, was
murdered in Linlithgow in January
1570. [p.179]

187 *John Knox admonishing Mary
Queen of Scots on the Day that her
Intended Marriage to Darnley was
made Public* 1822 PLATE 99
Signed and dated. Exhibited 1823.
Panel, 45.7 × 35.6 cm. James
Holloway Esq. [p.179]

Thomas Duncan (1807–45)

188 *Prince Charles Edward Stuart
entering Edinburgh (Sketch)* 1838
PLATE 101
Canvas, 35.6 × 50.8 cm. Private
collection [p.179].

Sir George Harvey (1806–76)

189 *The Covenanters' Baptism* 1831
Canvas, 103.8 × 89.1 cm. Aberdeen
Art Gallery and Museum. [pp.173,
179]

190 *Study for The Covenanters'
Baptism* 1831
Oil on paper, 19.6 × 20.6 cm. Stirling
Smith Art Gallery, Stirling. [pp.173,
179]

191 *Study of a Man with an Arm
Outstretched* c. 1831 PLATE 89
Oil on paper, 15.8 × 20.3 cm. Stirling
Smith Art Gallery, Stirling. [pp.173,
179]

David Octavius Hill (1802–70) and Robert Adamson (1821–48)

192 *Sir William Allan* c. 1844
PLATE 106
Calotype, 20.8 × 15.7 cm. Edinburgh
City Library. (Photograph, National
Galleries of Scotland.) [p.186]

193 *The Dumbarton Presbytery* 1845
PLATE 107
Calotype, 20.8 × 15.7 cm. University
of Glasgow. (Photograph, National
Galleries of Scotland.) [p.186]

194 *Thomas Chalmers with his
Grandson* 1845 PLATE 103
Calotype, 29.9 × 26.7 cm. University
of Glasgow. [p.186]

195 *Fisher Lads, Newhaven* 1845
PLATE 104
Calotype, 20.8 × 15.7 cm. University
of Glasgow. [p.186]

196 *Fishermen at Home, Newhaven*
1845
Calotype, 20.8 × 15.7 cm. Glasgow
University. [p.186]

197 *Mrs Jameson* 1845
Calotype, 20.8 × 15.7 cm. Glasgow
University. [p.186]

198 *Newhaven Fishwives* 1845
PLATE 105
Calotype, 20.8 × 15.7 cm. Glasgow
University. [p.186]

Robert Scott Lauder (1803–69)

199 *Sketch for the Bride of
Lammermoor* c. 1831
Millboard, 14.5 × 20.3 cm. Richard
and Vanessa Emerson. [p.179]

Sir David Wilkie (1785–1841)

200 *Tent preaching at Kilmartin* 1817
PLATE 98
Pencil on grey-green paper,
22 × 31.3 cm. The Governing Body,
Christ Church, Oxford. [p.176]

201 *The Preaching of John Knox before
the Lords of Congregation, 10 June
1559* COLOUR PLATE 46
Sketch for the finished picture
(exhibited RA 1832) begun before
1822. National Trust, Petworth
House. [pp.176–9, 184]

202 *John Knox dispensing the
Sacrament at Calder House (Study)*
c. 1839 PLATE 102
Oil on panel, 45.1 × 60.2 cm. National
Galleries of Scotland, Edinburgh.
[pp.179–80]

203 *Six Studies for John Knox
dispensing the Sacrament at Calder
House* 1838–39
Royal Scottish Academy, Edinburgh
[pp.179–80]

204 *The Cotter's Saturday Night*
Exhibited RA 1837 COLOUR PLATE 45
Oil on panel, 83.8 × 108 cm. Glasgow
Art Gallery and Museum. [pp.181–2]

205 *Samuel in the Temple* 1839
COLOUR PLATE 47
Watercolour, 19.6 × 22 cm. National
Galleries of Scotland, Edinburgh.
[p.184]

206 *Seated Lady of Constantinople*
1840 COLOUR PLATE 48
Black, white and red chalk with red,
blue and white washes, 43.8 × 23 cm.
The Trustees of the British Museum.
[p.185]

207 *Figures kneeling in a Mosque* 1840
Black and red chalk and watercolour,
31.4 × 38.4 cm. Ashmolean Museum,
Oxford. [p.185]

Bibliography

The recent or available literature on Scottish Art is not extensive. The main general book is David & Francina Irwin, *Scottish Painters at Home and Abroad 1700–1900*, London 1975. This also has an excellent detailed bibliography. It may be supplemented in the later part of the period by William Hardie, *Scottish Painting 1837–1939*, London 1976. Other general books that have a continuing usefulness in spite of their age are Robert Brydall, *Art in Scotland*, London 1889, W. D. MacKay, *The Scottish School of Painting*, London 1906, and James L. Caw, *Scottish Painting Past and Present 1620–1908*, first published 1908 (reprinted Bath 1975). Some account of Scottish art may also be found in the general literature on British art, most notably in Sir Ellis Waterhouse, *Painting in Britain 1530–1790*, London 1955, and in *The Thames and Hudson Encyclopedia of British Art*, ed. David Bindman, London 1985.

For other reading in the general history of the period in Scotland, see William Ferguson, *Scotland 1689 to the Present*, The Edinburgh History of Scotland Vol. 4, Edinburgh 1968, Bruce Lenman, *Integration, Enlightenment and Industrialisation: Scotland 1746–1832*, New History of Scotland, Vol. VI, London 1981, and T. C. Smout, *History of the Scottish People, 1560–1830*, London 1969.

For intellectual and literary history see George Elder Davie, *The Democratic Intellect*, Edinburgh 1961, George Elder Davie, *The Scottish Enlightenment*, Historical Association Pamphlets General Series 99, London 1981, Anand Chitnis, *The Scottish Enlightenment, a Social History*, London 1976, Douglas Young et al., *Edinburgh in the Age of Reason*, Edinburgh 1967, and John MacQueen, *Progress and Poetry*, Edinburgh 1982. See also James McCosh, *The History of Scottish Philosophy*, London 1875, Maurice Lindsay, *History of Scottish Literature*, Edinburgh 1977, Kurt Wittig, *The Scottish Tradition in Literature*, Edinburgh 1958, and Trevor Royle, *The Macmillan Companion to Scottish Literature*, London 1983.

The following is a list of the principal modern publications relevant to each chapter together with a number of significant items to supplement references given in the notes.

CHAPTERS I AND II: Alistair Smart, *The Life and Art of Allan Ramsay*, London 1952; Alistair Smart, 'A newly discovered portrait of Allan Ramsay's second wife', *Apollo*, 113 (May 1981); (Iain G Brown), *Poet and Painter, Allan Ramsay, Father and Son, 1684–1984*, National Library of Scotland, Edinburgh 1984; Iain G. Brown, *Allan Ramsay's Rise and Reputation*, Walpole Society, Vol. 50, 1984; John Fleming, *Robert Adam and his Circle*, London 1962.

CHAPTER III: David Irwin, *English Neoclassical Art*, London 1966; Hugh Honour, *Neoclassicism*, London 1968; (R. Cum-

mings and A. Staley), *Romantic Art in Britain*, Detroit and Philadelphia, 1968; (Basil Skinner), *The Scots in Italy in the eighteenth century*, Scottish National Portrait Gallery, Edinburgh 1966; Lindsay Errington, 'Gavin Hamilton's Sentimental Iliad', *Burlington Magazine*, CXX, Jan. 1978.

CHAPTER IV: J. D. Macmillan, 'Alexander Runciman in Rome', *Burlington Magazine*, CXII, Jan. 1970; S. Booth, 'The Early Career of Alexander Runciman', *Journal of the Warburg and Courtauld Institutes*, Vol. 32, 1969; J. D. Macmillan, 'Truly National Designs; Runciman at Penicuik', *Art History*, I 1978; (Peter Tomory), *The Poetical Circle*, n.p. (Australia and New Zealand) 1979; (Nancy Pressley) *Fuseli and his Circle in Rome*, Yale Center for British Art, New Haven, 1977; *Ossian und die Kunst um 1800*, Kunsthalle, Hamburg 1974; F. W. Freeman, *Robert Fergusson and the Scots Humanist Compromise*, Edinburgh 1984.

CHAPTER V: T. Crowther Gordon, *David Allan of Alloa*, Alva 1951; (Basil Skinner) *The Indefatigable Mr Allan*, Scottish Arts Council, Edinburgh 1973; (Lindsay Errington), *David Allan's Seven Sacraments*, National Gallery of Scotland, Edinburgh 1982; Duncan Macmillan, 'Old and Plain, music and song in Scottish art', *The People's Past*, ed. E. J. Cowan, Edinburgh 1980; David Johnson, *Music and Society in Lowland Scotland in the eighteenth century*, London 1972.

CHAPTER VI: Sir Walter Armstrong and James L. Caw, *Sir Henry Raeburn*, London and New York 1901; James Greig, *Sir Henry Raeburn*, London 1911; E. R. Dibdin, *Raeburn*, London 1925; (David Baxendall), *Raeburn Bicentenary Exhibition*, Arts Council of Great Britain, Edinburgh 1956.

CHAPTER VII: James Nasmyth, *Engineer; an Autobiography*, ed. Samuel Smiles, London 1883; J. P. Cooksey, *Alexander Nasmyth* (forthcoming 1986); (Lindsay Errington and James Holloway), *The Discovery of Scotland*, National Gallery of Scotland, Edinburgh 1978; Thomas A. Markus, *Order and Space in Society*, Edinburgh 1982; A. J. Youngson, *The Making of Classical Edinburgh*, Edinburgh 1967.

CHAPTER VIII & IX: (Lindsay Errington) *A Tribute to Wilkie*, National Gallery of Scotland, Edinburgh 1985; (Lindsay Errington), *Master Class: Robert Scott Lauder and his pupils*, National Gallery of Scotland, Edinburgh 1983; Ashmolean Museum, *Catalogue of Drawings and Sketches by Sir David Wilkie*, compiled by David Blaney Brown, Oxford and London 1985; Smith Institute, Stirling, *Sir George Harvey PRSA*, 1985, Edinburgh 1984; (Duncan Macmillan), *Walter Geikie*, Talbot Rice Art Centre, Edinburgh 1984; (Sara Stevenson), *David Octavius Hill and Robert Adamson, Catalogue of Calotypes* Scottish National Portrait Gallery, Edinburgh 1981.

LIST OF LENDERS

References are to catalogue numbers.

Her Majesty The Queen, 78–81, 183
Aberdeen Art Gallery and Museums, 156, 189
The Visitors of the Ashmolean Museum, Oxford, 185, 207
Sir David C. Baird, Bt., 143
The Beit Collection, Russborough, Co. Wicklow, 105
The Lord Binning, 3
Birmingham City Art Gallery, 147
The Trustees of The British Museum, 42, 67, 93, 180b, 184, 206
The Duke of Buccleuch & Queensbury, KT., 149, 159
The Governing Body, Christ Church College, Oxford, 200
Sir John Clerk of Penicuik, 5
The Clydesdale Bank, Glasgow, 144
Courtauld Institute Galleries, Witt Collection, 41
Thaddeus Crenshaw Esq, 154
Dundee Art Gallery and Museums, 135
City of Edinburgh Art Centre, 97, 142
Edinburgh City Libraries, 92, 171, 192
Earl of Elgin and Kincardine, KT., 27
Richard and Vanessa Emerson, 199
The Faculty of Advocates, Edinburgh, 4, 101, 113
The Syndics of the Fitzwilliam Museum, Cambridge, 131
Glasgow Art Gallery and Museum, 16, 125, 132–3, 204
The Duke of Hamilton, 82
James Holloway, Esq., 8, 126, 148, 187
The Hunterian Art Gallery, Glasgow University, 25
The Incorporated Trades of Edinburgh, 6
The Irish Distillers Group plc, 112
W. Jackson Esq., 124
Kent County Museums Service, 43
The Company of Merchants of the City of Edinburgh, 107

James Lees-Milne Esq., 128
The National Galleries of Scotland, 1, 10, 11, 14, 19–24, 28–30, 37, 40, 44, 47–8, 52–3, 56, 62, 64, 66, 68, 70, 72–5, 77, 83–4, 86–90, 94–6, 100, 102, 111, 114–15, 119, 129, 134, 140–1, 150, 152, 158, 162, 174–6, 181–2, 202, 205
The National Portrait Gallery, London, 15
The National Trust, 201
The National Trust for Scotland, 106
Prestonfield House Hotel, Edinburgh, 17
Private collections, 9, 13, 18, 26, 31–2, 33, 34, 36, 39, 49, 51, 54–5, 57–8, 60, 63, 69, 76, 98, 103, 108, 110, 118, 120–2, 127, 136–8, 145, 151, 153, 157, 160–1, 164–8, 178, 188
Renfrew District Council Museums and Art Galleries Service, 146
The Earl of Rosebery, 109
The Royal Academy of Arts, London, 180a
The Royal Company of Archers, Edinburgh, 104
The Royal Scottish Academy, Edinburgh, 91, 116–17, 155, 163, 172–3, 203
Viscount Runciman of Doxford, 46, 50, 59, 61
The Hon. Sir Steven Runciman, 65, 71
The Hon. W. G. Runciman, 45
Mr and Mrs Basil Skinner, 169, 186
The Stirling Smith Art Gallery and Museum, 190–1
The Tate Gallery, London, 35, 38, 130, 177, 179
Dr Helena Taylor, 170
The University of Edinburgh, 2, 12, 99
The University of Edinburgh Library, 85, 123
The University of Glasgow Library, 194–8
Earl of Wemyss and March, KT., 7, ex-cat.

PHOTOGRAPHIC ACKNOWLEDGEMENTS

The publishers are grateful to all those institutions and individuals who have supplied photographic material for this catalogue or have given permission for its use. Further acknowledgement is made to the following:

Aberdeen Art Gallery, *pl.* 88
Ashmolean Museum, *pl.*86
Birmingham City Art Gallery, *pl.* 69
British Museum, *col. pl.* 48
Christ Church, Oxford, *pl.* 98
Courtauld Institute, *pl.* 45
Dundee Museum and Art Gallery, *pl.* 65
Edinburgh University, *pl.* 52
The Fine Art Society, *col. pl.* 44
Fitzwilliam Museum, *pl.* 63
Glasgow Art Gallery and Museum, *pl.* 68; *col pls.* 3, 30, 45
Glasgow University, *pl.* 103
Reproduced by gracious permission of Her Majesty The Queen, *pls.* 16, 46, 82; *col. pl.* 42

Hunterian Art Gallery, *pl.* 19; *col. pl.* 7
National Gallery of Ireland, *pl.* 60; *col. pl.* 22
National Galleries of Scotland, *pls.* 1, 4, 10, 12, 14, 15, 17, 27, 28, 29, 30, 31, 32, 34, 36, 40, 44, 48, 49, 50, 51, 52, 58, 64, 67, 73, 74, 75, 78, 79, 80, 83, 84, 85, 92, 102, 104, 105, 106, 107; *col. pls.* 2, 6, 10, 11, 12, 15, 19, 20, 21, 27, 29, 39, 40, 41, 47
National Portrait Gallery, *pl.* 11
The National Trust, *col. pl.* 46
Renfrew District Council Museums and Art Galleries, *pl.* 70
Joe Rock, *pls.* 2, 6, 9, 18, 20, 21, 23, 24, 26, 33, 37, 38, 39, 41, 42, 43, 53, 54, 56, 77, 90, 91, 93, 94, 95, 96, 97, 99, 100, 101; *col. pls.* 1, 4, 5, 8, 9, 13, 14, 16, 17, 18, 23, 24, 25, 26, 28, 32, 33, 34, 35, 37, 43
Science Museum, *pl.* 66
Tom Scott, *pls.* 3, 5, 7, 8, 13, 47, 55, 57, 59, 61, 71, 72, 76, 87, 101
Stirling Smith Art Gallery, *pl.* 89
The Tate Gallery, frontispiece, *pls.* 22, 25, 81; *col. pls.* 31, 38

Index